Texas Flags

Major corporate sponsorship for
the "Texas Flags 1836–1945"
exhibition and catalog
was generously provided by

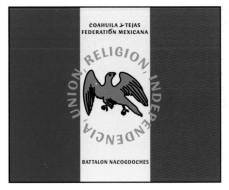

Texas Flags

Robert Maberry, Jr.

Foreword by Peter C. Marzio

Texas A&M University Press, College Station
in association with the
Museum of Fine Arts, Houston

Texas Flags was published in conjunction with
the exhibition organized by the Museum of Fine Arts,
Houston, and presented January 13 through April 28, 2002,
at the Museum of Fine Arts, Houston.

Funding for the exhibition and this book was generously
provided by Ethel G. Carruth in memory of Allen H. Carruth

Photo credits:
 Kevin McGowan Photography, Houston: figures 37, 50, 91
 The State Preservation Board, Austin, Texas: plate 1
 Courtesy of Dan Hatzenbuehler: plates 3, 4, 9, 10, 11, 12,
 15, 16, 17, 20, 21, 26
 Courtesy Impact Photography/R. L. Cross: plates 2, 5, 6,
 7, 8, 13, 14, 18, 19, 22, 23, 24, 25, 27, 28, 29, 30, 31, 32

Library of Congress Cataloging-in-Publication Data

Maberry, Robert, 1949–
 Texas flags / Robert Maberry, Jr. — 1st ed.
 p. cm.
 Includes bibliographical references (p.) and index.
 ISBN 1-58544-151-1 (cloth : acid-free paper) —
ISBN 1-58544-166-X (paper : acid-free paper)
 1. Flags—Texas. I. Title.
 CR114.T4 M33 2001
 929.9′2′09764—dc21
 2001001513

For my father

Contents

List of Illustrations

List of Maps

Foreword

For more than two hundred years, the American flag has served as a proud symbol of this country's ideals. Americans love and treasure the flag for its power to inspire awe and to stimulate patriotic pride.

Texans are no exception when it comes to revering flags. In fact, few subjects hold more allure to Texans than the flags documenting their fabled state's history. The five-point Lone Star that dominates the design of the Texas flag is the most widely recognized symbol of the state, and Texans regard the Lone Star as exclusively their own. Since 1835, the Lone Star has adorned almost every flag made and flown by Texans.

The origin of the Lone Star, like many popular icons, is couched in myth and folklore. Perhaps like no other, the Lone Star flag has become a larger-than-life symbol, instantly recognized well beyond Texas. Tracing the Lone Star's ascent, along with lesser-known Texas flags, unveils an incredibly colorful history that spans more than one hundred years.

Despite Texans' fascination with their state's flags, surprisingly, no scholarly work has been published on the subject. *Texas Flags* corrects that oversight. Robert Maberry, Jr., the foremost authority on the history of Texas flags, was invited by the Museum of Fine Arts, Houston, to write this book, and we are very proud of his significant contribution to the field. Dr. Maberry also served as guest curator of the major exhibition of the same title. Both the exhibition and this book were generously funded by Ethel G. Carruth in memory of Allen H. Carruth.

All of the flags featured in the exhibition and accompanying publication are icons of Texas history. The majority of flags have not been displayed publicly nor grouped historically in a book. *Texas Flags* provides an exceptional opportunity for us all to experience the beauty and majesty of Texas' flags.

Peter C. Marzio, Director
Museum of Fine Arts, Houston

Preface

"The whole flag is historic," proclaimed a San Felipe newspaper in 1836, referring to an early lone-star banner. And so it is with the Lone Star Flag Texans honor today. The red-white-and-blue standard with its single five-point star is much more than simply the state flag of Texas. It is the visual distillation of more than a hundred years of history. Yet the story of Texas is as much about myth as it is about history. Not "myth" in the pejorative sense of something fanciful or incredible, but in the didactic, Homeric sense. Myth serves an indispensable purpose in all societies. The great classicist Robert Graves has asserted that one of its main functions "is to justify an existing social system and account for traditional rites and customs." [1] In short, myth teaches us who we are and how we should act. The epic of Texas is particularly rich in myth. The myths of the Alamo and San Jacinto, the myth of the Lost Cause, the myth of the western frontier, and dozens more inundate the deep reservoirs of the Texas collective consciousness.

Historian Stephen A. Hardin has labeled the saga of Texas' struggle for independence the "Texian Iliad." The phrase is apt. As the events of the Trojan War related in Homer's *Iliad* established the basic mythos of the Greek world, so too has the Texas Revolution endowed generations of Texans with a foundation to understand and know how to act in their world. Homer instructed the Greeks in their values and modes of conduct. Texans inherited from the heroes of the Alamo and San Jacinto the mythic virtues of self-reliance, honor, self-sacrifice, and perseverance.

To stretch the metaphor further, later events and stories interpreted by subsequent Hellenic historians, poets, and playwrights built on the values expressed in Homer and brought Greek civilization into its full flowering. Likewise, the trials with Mexico, the Civil War, Reconstruction, and the vanishing frontier accreted more strata to the already firm bedrock of Texas tradition. Thus, the hundred years after independence can be seen as the Texas equivalent of the Greeks' heroic age. From the revolution to the great centennial exhibition of 1936, Texans came to view themselves as distinct from other Americans.

Today, the Lone Star Flag is the physical embodiment of the myths of Texas. As the state emerged from its "heroic age," veneration for this simple banner was enshrined as part of the Texas psyche. Although today we are as likely to see the Lone Star Flag flying over car dealerships and commercial storage facilities as places of honor, and though we abuse its colorful folds with advertising slogans and contort it into bizarre logos, it still reminds us of what it means to be a Texan. The treasured flag affects us in a deep, almost subliminal fashion. Only the most cynical Texan could fail to experience a profound sense of belonging in the presence of the Lone Star Flag.

Yet this has not always been the case. Devotion to this particular lone-star flag has been a fairly recent development. Its present status as the state's chief icon evolved in the late nineteenth and early twentieth centuries. This was roughly the same time that the longhorn steer, the bluebonnet, and the Six Flags over Texas motif became popular as graphic symbols. Not coincidentally, during these years an intense nationalism enveloped America, and Texans also became fully communicant in the sacraments of the cult of the Stars and Stripes.

In the nineteenth century, Texas' most important symbol was not the Lone Star Flag but the lone star itself. Patriotic Texans wore lone-star buttons and badges and conducted official business with lone-star seals. What we call the Lone Star Flag, the banner with a five-point star on a vertical blue band abutted by horizontal stripes of white and red, originated in 1839. Generations of Texans referred to it as the Texian Flag or the flag of the Republic. It was, however, only one of many Texas flags that displayed a star. Until well after the War Between the States, the term "lone-star flag" did not connote a particular design but referred to any banner that displayed a prominent five-point star. For much of Texas' heroic age, the Texian Flag was not a common sight. It had been the national flag during the last six years of the Republic, but when Texas became a state, the people discarded it in favor of the Stars and Stripes. At the time none imagined there would ever be a need for a distinct state flag, and by 1860 few Texans knew what their former national standard had looked like. During the years of secession and Civil War, Texans became reacquainted with the old flag of the Republic, but they made and displayed relatively few examples of it.

Since the early days of its revolt against Mexico, however, Texas has abounded with lone-star flags. Banners displaying the lone star antedated the Texian Flag and flew long after its use had declined. During the secession crisis dozens of lone-star flags of various designs proclaimed the state's desire to leave the Union, and most Confederate battle flags that Texas soldiers carried displayed a prominent lone star. Only as a result of a 1933 statute, which Texas schoolteachers promoted, did the Texian Flag became the official and unchallenged Lone Star Flag.

The historic diversity of lone-star flags can be attributed to the fact that their design and construction were the manifestations of the people's will. Both the lone-star banners of the Texas revolution and of the secession crisis were spontaneous popular political expressions. Texans frequently ignored the wishes of higher authority when it came to selecting patterns for their banners. Even when statute and custom required a particular design, as in the case of the Texian Flag and the various Confederate national flags, Texans tended to modify them to reflect their own preferences.

The Texas flags that concern us in this book, besides being conveyers of myth, were also historical objects of considerable artistry and the accoutrements of great events. Flags sustained Travis and the rest at the Alamo and led the Army of the People at San Jacinto. The Texian Flag bestowed confidence and a sense of national identity on a young republic. Texas volunteers fought and died under the lone star in such great Civil War conflagrations as the Battles of Antietam, the Wilderness, and Franklin. The army's Stars and Stripes came to symbolize Texas' full reunion with the rest of the country following the trials of the Civil War and Reconstruction. Some of these historic flags still exist and remain sources of inspiration.

Even though Texans cherished their banners, before the War Between the States they made little effort to preserve them for posterity. While the government of the Republic of Texas kept three Mexican flags captured at San Jacinto, it saw no reason to preserve its own battle flag of that unforgettable day and returned it to the family who had originally presented it. The government, perhaps more concerned with the practical matters of defense and governance, made no official efforts to preserve any other flags of the revolution or the republic. Most of the Texas flags known to exist from this crucial period survived only because Mexican forces captured them and have since held them as spoils of war.

Plenty of historic Texas flags remain; however, they are mostly Confederate flags. Relatively more Texans served in the Confederate Army than in any other fighting force, and every one of the dozens of rebel units had it own flag — often more than one. Even if Texans had not made a concerted effort to preserve these "banners of the Lost Cause," sheer weight of numbers would have assured that many would still be around today.

Studying Texas flags can reveal the political, cultural, and aesthetic preferences of the age in which they were fabricated. The five-point star displayed on unfurled revolutionary banners and the design of the Texian Flag closely reflected the true direction of the political winds that blew across Texas during the stormy days of conflict with Mexico. The raising of lone-star secession flags and the ready acceptance of Confederate national colors affirmed the kinship Texans held with the rest of the South. Many Texas flags were homespun, and most were homemade. As such they constitute genuine objects of folk art. Along with a few quilts and articles of clothing, they are the only textile handcrafts that remain from many of Texas' momentous times.

Ironically, despite the potential importance of flags to our understanding of Texas, scholars have generally ignored them as a subject for study. While flags occasionally spark a flicker of passing interest, historians have commonly regarded the topic as being the domain of heraldry aficionados, military men, dilettantes, jingoes, and buffs. Most of what Texans have known about their flags has come from traditional stories found in popular almanacs, newspaper articles, reminiscences, and a few brief mentions in some early histories of Texas.

The only true effort to construct a comprehensive history of Texas flags was by Mamie Wynne Cox in her 1936 book, *The Romantic Flags of Texas*. This amateur historian and club woman did yeoman service in compiling the traditional lore of Texas flags. Her approach, however, was not scholarly, and the omission of footnotes and bibliography make it impossible to consider her book authoritative. Furthermore, Cox's emphasis was not on objectively relat-

ing flags to the state's history but on glorifying its past. This bias, shared by many writers and historians of Texas, has rendered much of her diligent effort obsolete.

The dearth of scholarly interest in flags is especially telling. Historians have produced well-researched and imaginative works on nearly every aspect of Texas' past, but rarely do these contain more than passing references to flags. Most do not even provide an index entry for the subject. Flag information, therefore, must be laboriously excavated, pried, and teased from every possible source on Texas history.

In recent years the advent of the field of vexillology has placed the general study of flags on a firmer foundation. Dr. Whitney Smith, who invented the discipline and coined the term in 1959, defines "vexillology" as "the scientific study of the history, symbolism, and usage of flags, or by extension, an interest in flags in general."[2] The most important contribution of this new field has been the application of the same humanistic research principles common in serious scholarship to the study of flags. Texas vexillologists are examining a variety of sources to study subjects as wide-ranging as the legal history of the lone star to cataloging the boat pennants in the Galveston yacht basin. As these studies accumulate, the task of writing about Texas flags will be greatly facilitated.

A special challenge to those researching Texas flags is the problem of extracting reality from the old accounts. All historians face this problem to a varying extent. Of significant concern is the tradition and bias that cloud the story of flags in Texas. Flags, as expressions of the people, carry strong political and cultural baggage. The symbolism of a certain design or the use of a particular flag can be supremely important, even today. To understand this, one needs look no further than the present controversy swirling around the Confederate flag.

Unexamined tradition has provided most of what Texans have known about their flags. At least one reason for this is that interest in recording the histories of Texas flags came fairly late in the nineteenth century. For instance, during the Texas Revolution flags were ephemeral objects of great momentary significance, but with independence won, they were discarded. By the time aged veterans got around to writing memoirs and histories, their recollections of the early banners were hazy. The resulting descriptions were often at variance with one another, or amounted to little more than the repetition of unsubstantiated stories based on the day's conventional historic viewpoint. Thus Texans were left with such misconceptions as a Mexican tricolor inscribed with the date 1824 flew over the besieged Alamo, and Joanna Troutman's Georgia-made flag was the first to bear the lone star.

Later flags also have presented historians with difficulties. After Reconstruction had ended and Rebel flags had begun to accumulate in various repositories, often no one could recall which flag belonged to which unit. Even when the old flags could be identified, curators usually neglected to record their histories. In the late nineteenth and early twentieth centuries, Texans ignored and denigrated the considerable efforts of the U.S. Army, and especially black soldiers who had helped to make the western part of the state habitable. Until recently most Texans were unaware that any significant flags existed from that era.

This book was originally conceived as a catalog to accompany the exhibition "Texas Flags, 1836–1945," organized by the Museum of Fine Arts, Houston. The narrative was to be constructed around a selection of significant flags that still existed, could be displayed, and had strong Texas connections. This core of exhibition flags remains and is highlighted in the color-plate section, but in the course of my preliminary research I uncovered a larger story that merited more extensive treatment. Since Mrs. Cox, no historian has undertaken the comprehensive study of the flags of Texas, their symbols, and their relationship to the state's history. This present work endeavors to bridge that gap and still serve as a catalog documenting a groundbreaking exhibition. It is by no means meant as a complete guide to Texas flags. The state has much too rich a vexillological tradition to include every known flag with Texas associations in a single volume. Instead I have limited the study to the formative years of Texas history — what I have termed the "heroic age." These were the times when designs were evolving and flags were not only symbols, as they are today, but served practical functions as well. The most common, of course, was to lead fighting men — something Texas has never had a shortage of. As a result, the text and examples are heavily weighed in favor of flags carried

by Texas military forces and by troops associated with Texas. Although the exhibition includes flags used during World War II, I have chosen to end my narrative with the passage of the 1933 law that reestablished the Texian Flag as the state's official flag. By this time the reverence Texans held for the flag of the Republic had been confirmed, and otherwise their general flag use differed little from that of other Americans.

I have approached this study of Texas flags from the point of view of a historian. In so doing I have avoided recounting the standard Six Flags of Texas saga in its familiar triumphalist context. Nevertheless, those of a traditional bent should find much to reinforce their notions of patriotism and Texas particularism. Part of my purpose, however, is to correct some of the misapprehensions of Texas' past by examining the history of its flags. This means that much of the narrative deals with flags not normally considered Texas flags. Nor is the present work strictly about flags; it is just as much about the people who made, designed, and flew them. These include not only the Anglo-Celtic Americans who have received the lion's share of credit for making modern Texas, but also the Mexicans, African Americans, and Native Americans who bore flags of their own and contributed their own cantos to the state's great epic.

In summary, I have tried to tell a good story, which is, after all, what the best history really is. My hope is that readers will share my fascination with Texas flags and will become inspired to explore the myths they represent. In 1861 an Alabama newspaperman put the subject in perspective when he wrote, "Flags might appear of 'trifling consequence to some,' but they always exert 'a great influence on the popular heart.'"[3]

Notes on Usage

Throughout this book I have allowed Texans and others, insofar as possible, to speak in their own voices about their lives and their flags. Some of their statements are verbose and grandiloquent, while others reflect the uncertain syntax, imaginative spellings, and vocabulary of nineteenth-century Texas.

The use of the word "Texian" is a case in point. The people of early Texas strongly favored the term. When Texas became a state, however, other Americans already were using the term "Texan."[4]

Those who had lived through the days of the Revolution and Republic, however, took exception to this practice. In contemporary newspapers, letters, diaries, and memoirs, Texas writers usually referred to themselves as Texians. Some continued to do so until well after the Civil War. To those who revered the term, "Texian" had a heroic quality, and they believed that its scansion alone made it more appropriate for use in the great epics that bards would surely compose in the ages to come. The 1857 *Texas Almanac* asserted, "Texian . . . has more euphony, and is better adapted to the convenience of poets who shall hereafter celebrate our deeds in sonorous strains than the harsh, abrupt, ungainly, appellation, Texan — impossible to rhyme with anything but the merest doggerel."[5]

Alas, for all the potential Texian Virgils, waves of immigrants continued to flow into the state from the United States and brought with them the convention of being "Texans." The name stuck, and Texans we are. Based roughly on the way the use evolved, I have followed both practices in this present work. I have referred to the people of Texas before annexation as "Texians" and those afterward as "Texans."[6]

Another conundrum involved the use of terms to define the various types of Texas flags and their component parts. Like every discipline, vexillology has its own vocabulary and its own jargon. Authorities tell us flags can be described by function: for instance, civil ensign, battle flag, standard, guidon; shape: rectangle, square, burgee, gonfalon, schwenkel; and use: banner, courtesy flag, jack, drum banner, and the like. Old-time Texans, often poetic by nature, abhorred restrictions placed on them by formal usage in any field. This was especially true for the flags they flew, and Texans tended to use terms interchangeably. Thus a single writer may refer to the same rectangular flag as a "color," a "banner," a "standard," a "battle flag," or an "ensign," all terms that should have distinct meanings. With apologies to my vexillologist friends, I have not followed strict convention either, and my words may perhaps inadvertently encourage still more terminological anarchy. For the sake of clarity, however, I have listed below some more-or-less standard definitions used in the book.[7]

Terms Used for Individual Flags

Obverse: The side of a flag with the pole to the left.

Reverse: The side of the flag with pole to the right.

Leading edge: The part of the flag nearest the pole. Also called the hoist.

Fly: The part of the flag farthest from the pole.

Canton: Taken from the French word for "corner," the square or rectangle in the upper hoist, or a rectangle spanning the upper edge to the lower edge of the hoist. The canton of the modern U.S. flag is blue with fifty white five-point stars.

Field: The background of a flag. The U.S. flag has a field of red and white stripes.

Fimbriation: The laws of heraldry dictate that no two heraldic colors should touch. In Britain there are five heraldic colors: azure (blue), gules (red), sable (black), vert (green), and purpure (purple). To separate these colors are two metals: or (gold) and argent (silver). On cloth, yellow and white represent the metals. The fimbriation is a white or yellow strip interposed so the heraldic colors will not touch.[8] On the Confederate battle flag of the Army of Northern Virginia, white fimbriation edges the blue St. Andrew's cross.

National arms: The coat of arms of a nation. The national arms of Mexico displayed on its tricolor flag depicts an eagle with a snake in its mouth perched atop a cactus.

Finial: The ornament on the top of the staff. On most flags, the finial takes the form of a spear point or, in the case of many U.S. flags, an eagle.

Battle honors: The names of the engagements inscribed on a flag, in which the unit carrying the flag has participated. During the period covered by this book, these were usually painted or sewn on the field from separately cut letters.

Color(s): The name for the flag of a military unit. In older literature "colors" can mean one or more flags. During the Civil War the term "stand of colors" was sometimes used interchangeably and could also mean one or more flags.

Border: A band of material sewn onto the outer edges of the field of contrasting color for decoration or to prevent fraying.

Fringe: Twisted threads or metal attached to the edges of a flag for decoration.

Acknowledgments

A venerable professor once observed to me that historical research is a lonely business. Every historian who has invested those interminable hours sifting through near-unintelligible documents and pursuing tenuous leads in obscure repositories will no doubt concur with this opinion. While the study of Texas flags included an ample portion of solitary labor, I was pleasantly surprised to discover that the subject aroused an intense interest not just in Texans but in history-minded and flag-conscious individuals almost everywhere. Many of these, including dozens of scholars, curators, and interested laypeople, were eager to aid my quest, which, as it turned out, was far from a "lonely business." The present work would not have been possible without their active collaboration, and for their help I am grateful.

My deepest appreciation, which all true Texans should share, is to those selfless individuals who have donated their time and money to assure that the existing historic flags of Texas will be preserved for future generations. A particular hero in this regard is the former congressman from Houston's Fifth District, Mike Andrews. The modern era of flag conservation in the state began in 1986 when he alerted Texans to the fact that many of their historic flags were rapidly deteriorating. Without his timely intervention it is possible that these precious objects might have been lost for all time.

First to respond to Andrew's admonition were members of the Texas Division of the United Daughters of the Confederacy (UDC), whose important collection of Civil War flags was in particular danger. Led by Sherry Davis and Cindy Harriman, the organization raised the hundreds of thousands of dollars necessary to professionally conserve these treasures. I would like to thank these two dedicated women along with Dickie Gerig for their work in preservation and for making the UDC flag records available to me.

In 1997, Mike Andrews and John Nau, chairman of the Texas Historical Commission, initiated the Historic Flags of Texas Project, which aimed at identifying, documenting, and conserving the flags of the Texas State Library and Archives Commission. Thanks to T. Michael Parrish of the Lyndon Baines Johnson Library, I was fortunate to be selected to lead this endeavor. I greatly appreciate the opportunity and wish to thank those historians and museum curators who served on the project's advisory committee. I would also like to extend my gratitude to Linda Lee, executive secretary of the Friends of the Texas Historical Commission, whose donors provided funding for the project.

A major reason that the preservation of the state's historic flags was so long in coming was that effective techniques for the long-term conservation of textiles did not exist until recently. Today, Fonda Thomsen, founder and owner of Textile Preservation Associates of Sharpsburg, Maryland, is the nation's most accomplished practitioner of flag conservation, and it was to her that the state of Texas and the UDC turned to preserve their collections. Thomsen, her assistant, Cathy Heffner, and the rest of her staff were very generous in teaching me to understand the process and in sharing the forensic secrets that close study of individual flags revealed.

It was always understood that a major component of the Historical Flags of Texas Project would be to produce a book cataloging the various flags. T. Lindsay Baker, creator and director of Hill College's fine Texas Heritage Museum, gave me valuable advice in the beginning and generously provided a bundle of his own research materials to get me off to a good start. I also wish to thank Ron Tyler, director of the Texas Historical Society, for advising me in the planning of the manuscript.

My work on Texas flags was utterly transformed by the involvement of the Museum of Fine Arts, Houston. Peter Marzio, the museum's innovative director, viewed the flags not only as historical artifacts, but also as true exemplars of American artistic traditions — objects worthy of display in one of the world's finest museums. He concluded that they should be shared with the people of Texas and initiated planning for a major exhibition to display them. It has been my special privilege to work with Marzio and his outstanding staff in this ground-breaking project. I especially wish to thank Michael Brown, curator of the Bayou Bend Collection, my co-curator for the Texas Flags show, for sharing with me some of his considerable experience in the "museum world."

I would also like to express my gratitude to Mr. Marzio for giving me free rein for this comprehensive history of flags in Texas and for placing his institution's resources behind its publication. While

many of the museum's staff have proved helpful, I would like to state my appreciation to Diane Lovejoy, publications director, for coordinating her department's efforts and to Jennifer Lawrence, editor, whose good advice and sharp eye helped greatly to improve the final text. Kate Hansen's tenacity in locating images and obtaining usage permissions also deserves kudos, as does Karen Marrow, a museum volunteer, whose legwork in exploring various photographic collections saved me many vital hours.

Archival sources dealing with Texas history can be rich, but sometimes difficult to access, and experienced guides are often required to negotiate the labyrinths of books, documents, and images. I was particularly fortunate to have the enthusiastic help and support of Chris LaPlante and his staff at the Archives Division of the Texas State Library. Through their good offices I was privileged to receive physical access to the flags of the state's collection and to documents pertaining to them. John Anderson, curator of photography, went far beyond the call of duty to help me locate important images.

Others who collaborated with me were Elaine B. Davis and Martha Utterback of the Daughters of the Republic of Texas Library at the Alamo; Peggy Fox and Buddy Patterson of the Harold B. Simpson Research Center at Hill College; Brain Butcher, collections curator for the San Jacinto Museum of History; Elaine B. Harmon, curator of the Fort Davis Historical Site; Ann Westerlin-Howell, collections director of the Dallas Historical Society; Les Jensen of the U.S. Army Center of Military History; Will Michaels, a curator of the Battleship Texas; Sheila Green of the Tennessee State Library; Charles Spain, leading authority on the laws governing Texas flags; and my former graduate school colleague Richard B. Winders, historian at the Alamo. Thanks are also in order to independent researchers Thomas Ricks Lindley of Austin for piloting me though some unfamiliar archival waters and Kevin Young for providing valuable source information and for reading and commenting on parts of the manuscript.

I also wish to recognize and pay tribute to Brig. Gen. John Scribner, director of the Texas Military Forces Museum at Austin's Camp Mabry. His assistance, and that of his legion of dedicated volunteers, proved crucial in divulging to me the mysteries of U.S. military flag usage in Texas history. Scribner's generosity in allowing me free access to the museum's extensive library and flag collection is much appreciated.

The development of the internet has brought with it opportunities for the exchange of information that scholars of the past would have found astounding. One such opportunity of which I was able to take advantage was to participate in a unique online association devoted to the detailed study of historic Confederate flags. Known aptly as the Flag Fanatics, this international group of writers, historians, and museum professionals functions as an information cooperative and clearinghouse for cutting-edge research. While I am grateful to all who have participated, several individuals are worthy of special praise. Thanks first to Greg Biggs, a displaced and homesick Georgian presently enduring exile in Ohio, who is the founder of the Flag Fanatics. His extensive knowledge about the myriad configurations and issues of Rebel flags, which he is always eager to share, is surpassed by only one other living individual. That individual, who is also a founding member of our association, is the dean of nineteenth-century vexillology, Howard Michael Madaus. Years of active research have transformed him into a veritable walking encyclopedia of Civil War flags, and serious work on the subject cannot be contemplated without his help and advice. Fortunately, Howard is also generous with the accretia of his life's work as well as his time. This book would have been impossible without his help. One of the truly fortuitous aspects of belonging to the Flag Fanatics was that the diligent newspaper research of Vicki Betts, librarian of the University of Texas at Tyler, became available to me. Other members of our group who were particularly helpful were Devereaux Cannon, author of several works on flags, Bob Bradley of the Alabama Archives, Mark D. Jaeger, director of special collections at Purdue University, author Al Sumeral, and Louisiana's Ken Legendre.

I have been particularly blessed by the friendships I made during my graduate school days at Texas Christian University. Most significant of these was with my mentor there, Grady McWhiney, who accepted me as a serious student when others were reluctant. Besides endowing me with the basic tools of research and writing, he generously made time to read and comment on this present work.

It is not overstatement to credit him with any merit it may possess. My fellow students from those days remain among my best friends and closest colleagues. Thanks to Donald S. Frazier and Robert F. Pace, professors at McMurry University, for their diligent reading of the first draft. I believe they are both still a little bemused that I would write an entire book about flags. No catalog of gratitude could be complete without special mention of Stephen L. Hardin, professor at Victoria College and the universe's foremost authority on the military aspects of the Texas Revolution. Since our earliest days together in graduate school, he has proved an unselfish and dedicated friend. His suggestions for improving the manuscript have made it a much better work.

Finally, the greatest appreciation belongs to my most important supporters: my wife, Anita, and children, Eric and Elizabeth. Their patience and understanding through the years has allowed me to continue tilting at windmills until I actually vanquished a few.

Texas Flags

(1) Tricolor y Tejas

The first flag of Texas' "heroic age" was the Mexican tricolor. In 1823 empresario Stephen F. Austin received permission to bring three hundred American families into Mexico's remote province of Tejas. In the decade that followed, thousands more arrived, until by 1835 these immigrants far outnumbered Tejanos, or Mexican Texans. While it is impossible to determine the degree of allegiance American settlers felt toward their adopted country, there is little doubt regarding Austin's original intentions. He strove to integrate his colony into the political, social, and economic life of the Mexican republic. In the beginning it appeared he would be successful. For a decade Texians were loyal citizens of Mexico and honored its flag as their own. Yet in the fullness of time even the well-intentioned Austin came to grasp that the chasm between the traditions of his people and those of Mexico yawned too widely to be bridged.[1]

The eagle, snake, and cactus symbols on the green-white-and-red tricolor represented cultural and political traditions that were wholly alien to Anglo-Celtic immigrants in Texas.[2] The flag, like modern Mexico itself, emerged from the cathartic chaos of civil war. The experience of this continuing cataclysm was something all Mexicans held in common. The tricolor, with its reminders of ancient glories and present hopes for the future, had often been all that held the nation together. Texian settlers, who were mostly from the southern frontier of the United States and imprinted with Jacksonian traditions, could never truly grasp what the tricolor meant to the Mexican people.[3]

National flags rarely spring fully formed into the arena of history. Their designs undergo change and development dictated by events and ideology. No republic underwent more severe birth pangs than did Mexico. Shifting currents of loyalties and alliances brought with them a series of flag designs, each representative of an important stage of the country's difficult political evolution.

Flags of Mexican Independence

Near the western periphery of European hegemony lay the province of New Spain. For three hundred years the regime imposed on this rich and varied land had existed primarily for the enrichment of the Spanish Crown and its Mexican adherents of the European-born upper classes. For much of the colonial epoch, a red-and-gold

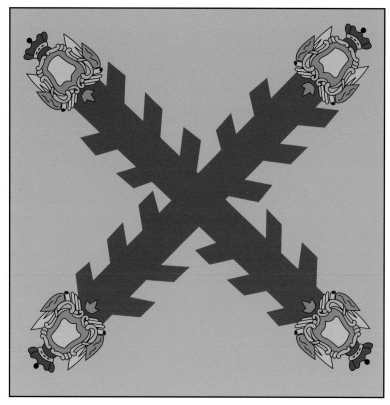

Figure 1. *Spanish Viceroy's Flag. The banner with red Burgundy cross was a familiar sight during the last century of Spanish rule in Latin America. On each arm is the crest of Ferdinand and Isabella. Drawing by Anne McLaughlin, Blue Lake Design, Dickinson, Texas. (Image based on photograph)*

banner with the arms of Ferdinand and Isabella flew over the viceroy's palace, the customs houses, the presidios, and from the masts of the treasure fleets carrying the riches of Mexico home to Spain.[4]

In 1810 this long era of exploitation began to come to an end, and so did the use of the King of Spain's flag. Long-repressed resentments of the *criollos* (Mexican-born Europeans), *mestizos,* (people of Indian and European descent), and Indians boiled to the surface. The subsequent rebellion and civil war that roiled Mexico for almost a generation ended Spanish rule and led to the founding of a great republic. In the end, Spain's red-and-gold banner gave way to a glorious new tricolor, whose symbols were both republican and true to Mexico's ancient culture.

The first flag of that struggle was a simple church banner emblazoned with the image of the Virgin Mary. Father Miguel Hidalgo y Costilla, a well-educated criollo priest of Delores, in central Mexico, lit the fire of Mexican independence. For centuries the Indians and mestizos had bridled under the rule of the Spaniards, or *gachupínes.* On September 16, 1810, Hidalgo gave the most famous speech in Mexican history, the *Grito de Delores.* In it he called on the people to free themselves from centuries of Spanish rule. Almost spontaneously they rose, and the criollo priest found himself at the head of a peasant army bent on redress. Events had transpired so quickly that there had been no opportunity to design and make a flag to represent the cause to his mostly illiterate followers. In the village of Atotonilco, Hidalgo entered the local church, where he found a banner with the likeness of the Virgin of Guadalupe.[5]

This design was well known in Mexico. It not only implied religious devotion but also reminded Hidalgo's Indian followers that their ancestors had played important roles in the country's history. Tradition had it that the Virgin of Guadalupe had appeared to an Indian peasant in 1531 and spoken to him in Nahuatl, the language of the Aztecs. The image of the apparition was miraculously imprinted on his cloak, which became Mexico's most important religious relic. In the picture, an angel with wings of green, white, and red rests at the Virgin's feet. These hues would become the colors of the Mexican flag. The poor people of Mexico took great pride in the fact that Jesus' mother had selected one of their own to grace with this vision. Pope Benedict XIV had observed that God had blessed no other nation with such a vision. Hidalgo's banner, modeled on the sacred icon, became the unifying symbol and rallying point for the first years of the revolt.[6]

The Spanish viceroy and his royalist supporters, however, were far from willing to abdicate their privileges to the priest's rabble. The struggle that followed caused great destruction and bloodshed. Seizing the initiative, the royalists defeated the insurgent army and captured Hidalgo, whom they executed on July 31, 1811. The priest's death, however, only intensified resistance; his followers vowed revenge. Soon a flag appeared that symbolized their grim resolve. José María Cos organized a force of peasants to defend the city of Zitácuaro from the Spanish onslaught. His men called themselves *el Regimiento de la Muerta,* "death's regiment." Cos presented to his fighters a red flag with a black Saint George's

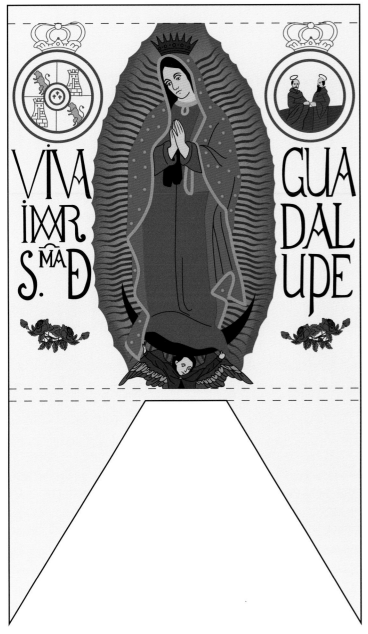

Figure 2. *Hidalgo's Virgin of Guadalupe Banner. This flag, modeled on Mexico's most sacred icon, became the unifying symbol for the first years of the revolt against Spain. Drawing by Anne McLaughlin, Blue Lake Design, Dickinson, Texas.*

cross, from the center of which glared a grizzly skull and cross-bones. In black across the top were the words *El Doliente de Hidalgo,* "the suffering of Hidalgo." To even the simplest peon, there could be no mistaking the grim message. "War to the death without quarter, Let the oppressors feel the pain of Hidalgo."[7]

After Hidalgo's death, the revolt gradually became better organized, and its leadership fell to another priest, José María Morelos y Pavón. He designed a flag with symbols calculated to inspire the masses by suggesting the glories of preconquest Mexico. On August 19, 1812, Morelos unfurled an elaborate white silk flag edged in pale blue that displayed the image of a three-arched bridge in the center. Within each arch was a letter of "V.V.M.," signifying *Viva la Vergen Maria,* "Long Live the Virgin Mary." The colors were those popularly associated with the Aztec Empire. The flag also contained the independence movement's first representation of Mexico's most important symbol. Growing out of the bridge was a cactus, upon which perched an eagle. With this flag, Morelos proclaimed independence under the name "Kingdom of Anáhuac."[8] This new realm, however, was stillborn. Three years later the rebel priest became a prisoner, and he too went before a firing squad.

The most significant element of Morelos's flag was the eagle-and-cactus motif, which in a few years would became the national arms of Mexico. It is one of the most famous and ancient designs in the Western Hemisphere, and its origin hearkens back to the mythic beginnings of the nation. The story it tells is well known in Mexican folklore. Indian legend maintains that the sun god Huitzilopochtli ordered the Mexica people to settle where they found a cactus growing out of a rock. While wandering in the valley of Anáhuac, they came across this sign in the middle of a lake. Here, they built their city and called it Tenochtitlán, the place of the cactus in a rock. Representations of the event customarily show an eagle with a snake in its mouth on the cactus.[9] Tenochtitlán, of course, became the heart of the nation, Mexico City.

Throughout the recorded history of Mexico, the design has been ubiquitous. The Mendoza Codex, one of the few surviving books from the Aztec times, displays the earliest extant image.[10] Throughout the Spanish-colonial period, representations of the eagle and cactus adorned official seals, architecture, and everyday objects.[11] It was also an apt symbol for the independence movement. Hi-

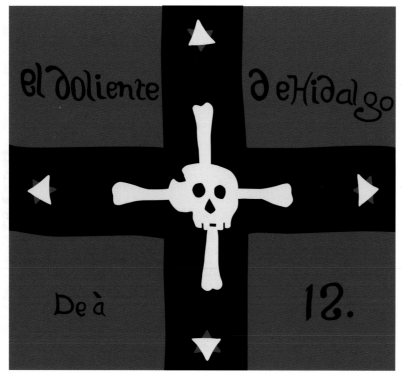

Figure 3. *Death's Head Flag. The grim message on this flag is clear: "War to the death in revenge for the suffering of Hidalgo." Drawing by Anne McLaughlin, Blue Lake Design, Dickinson, Texas. (Image based on photograph)*

Figure 4. *Morelos's Flag. The symbolism of Morelos's flag was calculated to suggest the glories of preconquest Mexico. Drawing by Anne McLaughlin, Blue Lake Design, Dickinson, Texas. (Image based on photograph)*

dalgo had inspired his followers with reminders of Indian glories of the past; Morelos, in the names of the Aztec emperors Cuauhtémoc and Moctezuma, called on the people to avenge the centuries of mistreatment by the Spaniards.[12]

After the death of Morelos, resistance by the independence movement took the form of small-scale but wide-spread guerilla warfare. The seemingly interminable fighting gradually wore down the forces of the Spanish viceroy. During this period Vincente Guerrero became one of the rebellion's most active leaders. Inspired by the liberal ideals of the French republic, he designed a flag for Mexico that incorporated a tricolor. The colors of the three bands were white near the staff, blue in the center, and red on the outer panel. Mexican ships flew it in the Gulf of Mexico, and some scholars be-

lieve it to have been the first maritime ensign of independence to receive the salute of the United States.[13]

In 1820 the viceroy appointed Augustín de Iturbide, an ambitious royalist officer, to lead an offensive against Guerrero's forces. After some desultory skirmishing, Iturbide elected instead to meet with the rebel commander with the intention of negotiating an end to the fighting. On February 24, 1821, the two leaders came to agreement and proclaimed the *Plan de Iguala*. In this declaration of independence, Mexico was to separate from Spain and become a constitutional monarchy. The decree also established the *Trigarantes*, or the Three Guarantees: the primacy of the Catholic church, independence, and equality of gachupínes and native-born Mexicans. To impose the agreement, a new army, *el Ejército de las Tres*

Garantías, was assembled from the forces of both sides and placed under Iturbide's command.

A few months later the former royalist general ordered a flag made that embodied the tenets of the Three Guarantees. Mexican tradition credits José Magdaleno Ocampo, an Iguala tailor, with sewing the original *bandera trigarante*. The flag was a rectangle with three diagonal bars of red, green, and white. Within each bar was a six-point star of contrasting color. In the center of Ocampo's flag perched a crowned eagle.[14]

Around May 1, Iturbide ordered the battalions of his army to have flags made that conformed to this general design. Each was to have the three bars, but he substituted a gold crown emblem for the eagle of Ocampo's flag. The regulations stipulated that this center badge should bear the words *"Religión, Independencia, Unión"* above the crown, and the name or number of the battalion below. As with Ocampo's flag, a six-point star in contrasting color embellished each diagonal band. As a further decoration, the flag-staffs were covered in crimson velvet and the flag attached with yellow tacks.[15]

A flag of one of Iturbide's units, the *Regimiento de Infantería de Línea Provincial de Puebla*, that conforms to this regulation still exists. It is a square military color with the three diagonals on the obverse running from upper left to lower right. The white bar is on the lower left and the red on the upper right. Within the green bar in the middle is a crown centered in a white oval. Curving above the crown just inside the oval are the words *"RELIGIÓN, YNDEPEND, UNIÓN,"* and below in the same manner, *"REGIMIENTO YNFAN-TERI."* On each bar is a six-point star of contrasting color, green on white, white on red, red on green.[16]

In November, the provisional government decreed another change in the flags of the national army. Officials chose to move the colored bars from diagonal to vertical in the order green, white, red. A crowned eagle with open wings perching on a cactus replaced the crown. For at least the next 180 years, this would be the basic design of the Mexican flag.[17]

On July 21, 1822, Iturbide was crowned emperor of Mexico; the country, however, did not thrive. The civil wars had crippled the economy, and Iturbide's insistence on maintaining the gaudy trap-

Figure 5. *Eagle and Snake from the Mendoza Codex. This image, recalling the legend of the founding of Mexico City, is one of Mexico's most ancient and enduring symbols. Drawing by Anne McLaughlin, Blue Lake Design, Dickinson, Texas.*

Figure 6. *Guerrero Flag. Inspired by the banners of the French Revolution, this tricolor was the first flag of Mexican independence to receive the salute of U.S. ships. Drawing by Anne McLaughlin, Blue Lake Design, Dickinson, Texas.*

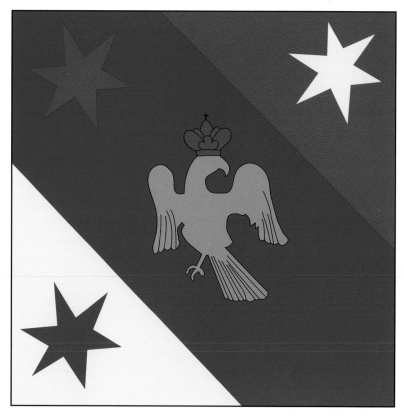

Figure 7. *Ocampo* bandera trigarante. *Mexican tradition credits José Magdaleno Ocampo, an Iguala tailor, with producing the original Flag of the Three Guarantees. Drawing by Anne McLaughlin, Blue Lake Design, Dickinson, Texas.*

pings of his office threatened to exacerbate an already critical financial situation. The emperor began imprisoning his opponents and dissolved the national legislature; opposition grew. In December, 1822, one of Iturbide's young officers, Antonio López de Santa Anna, led a revolt against him that spread rapidly. On February 1, 1823, the insurgents issued the *Plan de Casa Mata,* which called for an end to the monarchy. His position hopeless, Iturbide abdicated and the rebel army marched into the capital. Mexico became a republic.

Two months later the new government modified the pattern of the national arms to reflect the new political reality. To represent the republic, the imperial crown was removed from the eagle,

and the figure of a snake was added. As the traditional symbols of strength and victory, branches of laurel and oak now wreathed the base of the cactus.[18]

After the fall of Iturbide, domestic peace still eluded Mexico. The country's elite immediately fractured into two antagonistic factions: the centralists, or conservatives, who favored concentrating political power with the central government in Mexico City; and the federalists, or liberals, who wanted a system that would balance central authority with that of the states. In 1824 a federalist-dominated congress produced a constitution that combined elements of the U.S. Constitution with the language of Spain's 1812 constitution. The Constitution of 1824 divided power between the

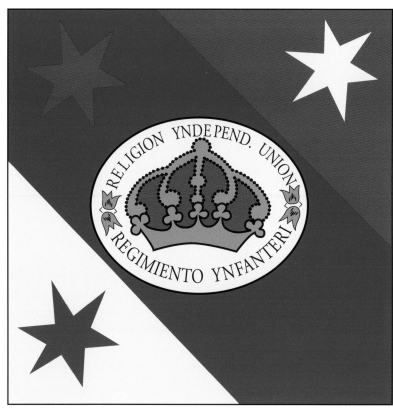

Figure 8. *Puebla Infantry* bandera trigarante. *This was a battle flag of one of the units in Iturbide's Army of the Three Guarantees. Drawing by Anne McLaughlin, Blue Lake Design, Dickinson, Texas. (Image based on photograph)*

president and congress on the one hand, and the governors and legislatures of the nineteen Mexican states on the other.[19] Neither side, however, was above using force or other extraconstitutional means for achieving political dominance. For decades control of the government seesawed between the two factions.

The nation's flag reflected the ongoing conflict. During some periods a cactus with fronds that represented the Mexican states was added to the eagle and snake of the national arms. During the sparring over national sovereignty, when the centralists held the upper hand and the states were stripped of power, the cactus disappeared from the flag. These were restored when the federalists regained power.[20] It is not coincidental that of the three flags captured at

San Jacinto, only that of the battalion named for federalist leader Vincente Guerrero displays the cactus.

The Tricolor in Texas

The majority of colonial Texians found themselves unwilling participants in Mexico's interminable political conflicts. It became evident that their interests were best served by supporting the Constitution of 1824. Thus when Santa Anna seized power as a centralist in 1835, most Texians sided with his enemies. After provocations by both factions, open revolt erupted against the centralists at Gonzales. The first stage of this insurgency led to the humiliating capture of San Antonio de Béxar by a ragtag army of untrained Texian colonists and American volunteers. Whether the majority of Anglo-Celtic settlers in 1835 truly favored reconciliation with Mexico under the terms of the Constitution of 1824, complete independence, or annexation to the United States are questions historians continue to debate.

Texas flags have always been the people's flags. Settlers had arrived in Texas steeped in the traditions of the American Revolution and Jacksonian democracy. They well understood that flags were symbols of their political aspirations and never hesitated to employ them for this purpose. There is no better way to gauge the transition from loyalty to independence than by surveying the designs of the flags flown by politically minded Texians.

It is unclear just how common the green-white-and-red tricolor of the republic was in Mexican Texas. Everyday flag use in civil society was much less common in the early nineteenth century than it is today. The tricolor must have flown over official buildings where government agents collected duties and over presidios. Some militias of the American settlements displayed variants of the Mexican flag. An 1828 law called for Tejas to provide two battalions of infantry and two cavalry units for the common defense. Each unit was to have a color of the following specifications: "The flag shall be of silk, five-quarters square, in three vertical stripes, green at the staff, white in the centre, and red in the extremity. In the white square shall be stamped an eagle in the attitude of flying, and around it, in letters of gold, the words 'Religion, Independencia, Union.' In the upper part of the white stripe shall be placed the

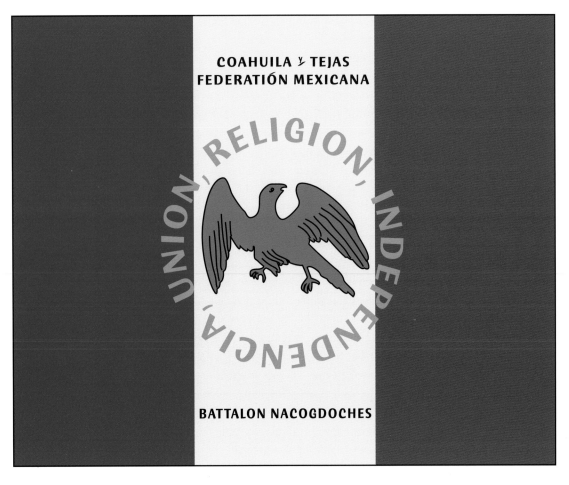

COAHUILA Y TEJAS
FEDERATIÓN MEXICANA

UNION, RELIGION, INDEPENDENCIA

BATTALON NACOGDOCHES

Figure 9. *Texas Colonial Militia Tricolor. An 1828 law of Coahuila and Texas specified this design for the flags of Texas militia units. Drawing by Anne McLaughlin, Blue Lake Design, Dickinson, Texas.*

name of the state; under the eagle, *'Federation Mexicana';* and below this the name of the town and number of the battalion, should there be more than one.[21] Even after fighting broke out at Gonzales, some local military units continued to exhibit their Mexican colors. A recruit from the United States on his way to join the Texian army recalled that the San Augustine militia paraded through the town "led by a drummer and by the tricolor of Mexico."[22]

Hostilities at least nominally began as protest against the centralist usurpation of the Mexican government. Much like the colonists in the American Revolution, most Texians were ambivalent about their ultimate aims. Flag use increased as a way of showing where sympathies lay. The employment of variants of the Mexican tricolor in the beginning of the conflict reflected caution. Perhaps

the majority of Texians feared defying the Mexican government and believed the best hope for reconciliation was under the precepts of the Constitution of 1824. During the early days of the American Revolution, colonists also had been cautious. They had modified the British flag to reflect their desire for reform without independence.

In the same manner, Texians exchanged the eagle and snake on the Mexican tricolor for the date 1824. By retaining the tricolor they proclaimed loyalty to the nation but insisted upon the rights granted by the Constitution of 1824. Phillip Dimmitt, an early leader in the struggle, wrote Stephen F. Austin from Goliad on October 27, 1835, "I have had a flag made — the colours, and their arrangement as same as the old one — with words and figure, 'Constitution of 1824,' displayed on the white, in the center."[23]

While some Texians were sincere in their desire for reconciliation, for others the use of the tricolor merely masked their true aims. In early October, Adolphus Sterne, a prominent citizen of Nacogdoches, warned a young volunteer that he was not to mention Texas independence. As he explained, "we are too weak to stand alone, and only by combining with the liberal party can we overthrow Santa Anna."[24] A few days later, to honor the newly arrived volunteer company from New Orleans, Sterne and the Nacogdoches citizenry hosted the most sumptuous feast ever recorded in the history of early Texas. Under the shade of the pines they set a 150-foot table with roasted ox quarters, vast quantities of raccoon, squirrel, and turkey, along with foaming beakers of champagne and bottle after bottle of sparkling Rhine wine. But most impressive of all at this Texian version of the Banquet of Trimalchio was the great centerpiece, a large black bear in festive decorations, nicknamed by the celebrants "Mr. Petz." He lay prone in all his roasted glory, "hide and bones, meat and claws, and between his grim teeth he held the flag of the Constitution of 1824."[25]

In November, 1835, Texians organized a provisional government that, like the 1775 Continental Congress, called for the creation of an army. The representatives were, however, unwilling to discard completely the hope for a settlement with their adopted country. Their dilemma was reflected by an ordinance authorizing naval privateers to prey on Mexican commerce, while insisting that ships so commissioned fly the modified tricolor. "All vessels,"

Figure 10. *Constitution of 1824 Tricolor. Phillip Dimmitt's 1835 flag proclaimed loyalty to Mexico while demanding the rights granted under the Constitution of 1824. Drawing by Anne McLaughlin, Blue Lake Design, Dickinson, Texas.*

Figure 11. *"1824" Tricolor. This first official flag of Texas' provisional government was meant for use by privateers. Later tradition erroneously identified it as the flag of the Alamo. Drawing by Anne McLaughlin, Blue Lake Design, Dickinson, Texas.*

read the ordinance, "sailing under licenses as Letters of Marque and Reprisal . . . shall carry the flag of the Republic of the United States of Mexico, and shall have the figures 1, 8, 2, 4, cyphered in large Arabics on the white ground thereof." [26] This tricolor was the first legal flag of revolutionary Texas, and some government-commissioned ships displayed it until at least February, 1836.

The most famous of the "1824" tricolors was that which allegedly flew during the siege of the Alamo. Until recently, students of Texas history took this as a matter of faith. Alex Dienst, a noted Texas historian, wrote in 1923, "Every student of Texas history knows absolutely that the flag flying over the Alamo . . . was the Mexican Constitution flag of 1824 with the numerals in large letters — 1824." [27] In the 1930s Amelia Williams, writing in the state's most prestigious historical journal, insisted that Texas historians agreed that "the Alamo flag was a Mexican tricolor with the black numerals 1824 on the white bar. The tenet is logical," she added, "for that was the flag of the federal party of Mexico, and at

the beginning of the revolution, the Texans officially held to the principles of that party." [28]

The siege of the Alamo, however, did not occur at the beginning of the revolution, and in recent years researchers have questioned the assertion that an "1824" tricolor flew over the San Antonio fortress. Popular historian Walter Lord demonstrated that period sources do not mention this particular flag. He maintained that the story did not appear until 1860, when Capt. R. M. Potter published the first of several Alamo accounts that included the description of the 1824 flag. According to Lord, the presence of such a flag at the Alamo was mere conjecture, based "on Potter's theory that the Texans were fighting for the Mexican Constitution of 1824, until the Declaration of Independence was formally passed on March 2, 1836." [29]

Other modern writers have pointed out that it is highly unlikely that the Alamo defenders would have fought and died under this flag. "During the last days of December 1835," wrote well-known

Figure 12. *Two-Star Alamo Tricolor. One of at least three flags flown at the Alamo, this tricolor displayed stars representing Texas and Coahuila and was probably associated with the Tejanos of the garrison. Drawing by Anne McLaughlin, Blue Lake Design, Dickinson, Texas.*

Alamo researcher Thomas Ricks Lindley, "the Béxar forces abandoned the federalist cause and the Mexican flag."[30] Another student of the period concluded, "It is clear from their writings that the men who stayed in Béxar to defend the Alamo wanted no part in restoring the Mexican Constitution."[31]

Two eyewitnesses, however, do associate a tricolor with the Alamo defenders. Mexican Col. Juan N. Almonte noted in his journal that as Santa Anna's army approached the town plaza of San Antonio de Béxar, "The enemy . . . hoisted the tricolored flag with two stars, designed to represent Coahuila and Texas." As the first skirmishers advanced, the defenders "lowered the flag and fled."[32] Another participant, Lt. Col. José Juan Sanchez-Navarro, produced an elevation sketch of the fort that depicts the tricolor with two six-point stars flying from a pole within the walls.[33] Alamo historians, however, generally discount the notion that this particular flag could have been the main banner of the fort and speculate it was associated with the Tejanos of the garrison.[34] "By February,"

argued Walter Lord, "only Seguin's handful of Mexicans seemed hesitant; the rest wanted no part of 1824."[35] The true flag of the Alamo displayed the design and colors of the American republic, not the Mexican.

The Army of Operations

Despite their own considerable political differences, most Mexicans viewed the potential loss of Texas as a threat to the very foundations of their nation. Gen. Antonio López de Santa Anna, in power as national autocrat, began assembling an army to recover Mexico's threatened province.

Organizing such a force proved no easy matter. Civil war, corruption, and political interference had enfeebled the army of the Republic of Mexico. According to one of Santa Anna's senior officers, during the fighting of the previous years "the flower of the veterans had perished without glory, killing one another."[36] What remained was top heavy with officers who absorbed into their own pockets most of the resources a bankrupt government could appropriate.[37] Justified fears of the army's power to intervene in government had led politicians in Mexico City to drastically reduce its numbers, and a lack of funds and demoralization played havoc with military efficiency.[38] These weaknesses had reached such a point that when Santa Anna began organizing his Army of Operations to retake Texas, he found only some 3,500 trained troops available and no funds to finance the expedition.[39]

As his career continually demonstrated, however, Santa Anna possessed an exceptional talent for raising and organizing armies with scant resources. He established San Luis Potosí as his base of operations and, undeterred by the failure of the government to provide promised funds, extracted forced loans from the church and merchants of the surrounding states.[40] Conscription from Mexico's northern provinces brought the army's numbers up to more than six thousand *soldados*.[41] Santa Anna, who styled himself the "Napoleon of the West," assembled an army that had been modeled along the lines of European armies of the Napoleonic Wars, but with elements unique to the Mexican setting. Its basic tactical unit was the battalion. By regulation each Mexican army battalion consisted of eight companies of eighty men each. In practice, battalions were seldom up to strength. In Santa Anna's army many

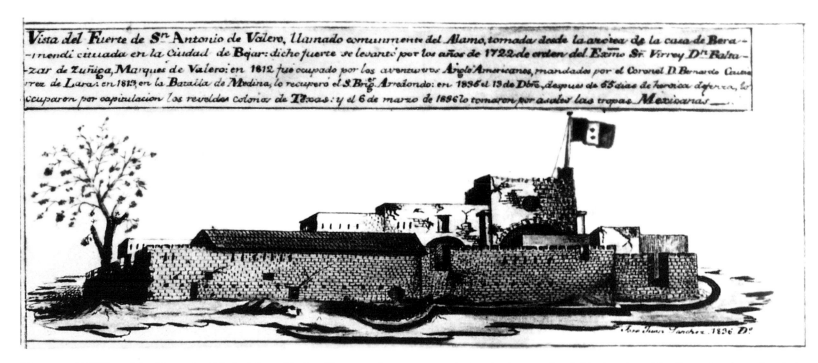

Figure 13. *1836 View of the Alamo. Lt. Col. José Juan Sánchez-Navarro, who was present during the siege, produced this elevation of the Alamo that shows the tricolor with the stars of Coahuila and Texas. Courtesy of the Benson Latin American Collection, the University of Texas at Austin.*

companies counted less than forty men, and most battalions began the Texas campaign with fewer than three hundred soldados.[42]

The Mexican battalions were of two general types; *permanentes* and *activos*. Permanentes were units of the regular national army. These were named in honor of prominent figures of the revolution and subsequent civil wars. Permanente battalions in the 1830s usually contained a core of experienced soldados led by officers who had seen at least some action. In the Army of Operations, however, at least half the complement of most of his battalions was filled by untrained conscripts. Activos were battalions of the national guard, whose function was to augment the regular army in times of crisis. These were raised from specific geographic areas for which they were named. Because of long-term association with a particular place, there was more continuity of personnel in activos, and they frequently contained more-experienced and better-trained soldados than the permanentes.[43]

Along the lines of European practice, each Mexican infantry battalion contained three types of troops. Six companies were designated as center companies. These men, sometimes called fusiliers, were usually the least-skilled and -experienced soldiers. The two remaining companies, because of their more elevated status, were variously referred to as "preference" or "select" companies. The first of these, the grenadier company, consisted of steadier and more-experienced troops. The grenadiers functioned as a reserve to be inserted at some decisive point in a battle. The remaining company, the light troops, or *cazadores*, were the elite of the battalion. These men, who served as skirmishers and scouts, were selected because of their skill, intelligence, and initiative.[44]

As in Napoleon's army, each Mexican infantry and cavalry battalion received a single battle flag.[45] These were versions of the green-white-and-red tricolor of the republic. The three infantry battalion colors captured at San Jacinto demonstrate a remarkable

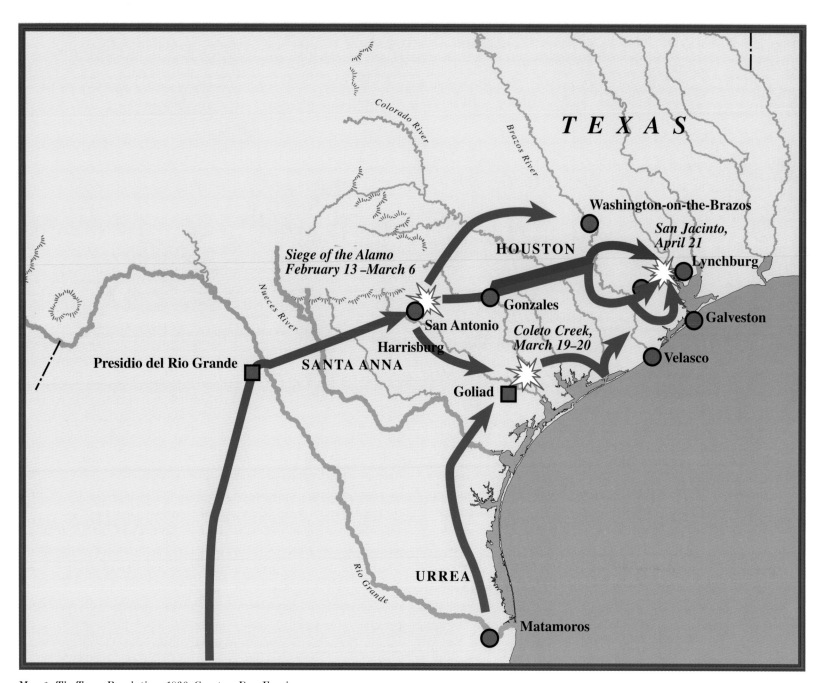

Map 1. *The Texas Revolution, 1836. Courtesy Don Frazier.*

lack of uniformity. All display battalion designation along with the eagle and snake. These images, however, are far from consistent. Each displays an eagle with widespread wings, but these differ in size and shape. Only one flag, that of the Guerrero Battalion, depicts the cactus and laurel and oak leaves suggestive of federalist loyalties (see plates 2, 3, and 4). This flag is also unusual in that its finished side—that is, the face meant to be viewed—is on the reverse. None of the three battalion colors is the same size. Such differences suggest that flag makers had considerable latitude and that detailed regulations for Mexican army flags did not exist or were ignored.[46] It is likely, therefore, that Santa Anna's battle flags, like his army, represented a conglomeration of the practical, the available, and the expedient.

Doomed Battalions

The campaign did not go as the Mexicans had expected. The march to San Antonio was a nightmare of privation; mismanagement by the army's commanders, great distances, and foul weather assured illness, hunger, and fatigue as constant companions. The soldados suffered heavy casualties in the assault on the Alamo, an attack most believed was unnecessary. Despite the suffering the stalwart Mexicans persevered, and as they pursued the fleeing rebels through the verdant and prosperous lands to the east, morale improved. Santa Anna proved an erratic general as well as a tyrant, and his unfortunate troops were as much his victims as the Texians who died at the Alamo and Goliad.

The battalions of Toluca and Matamoros numbered among Santa Anna's best units. They bore the brunt of the fighting in the Texas campaign and were annihilated along the banks of the San Jacinto. The Guerrero Battalion took no part in the struggle for the Alamo, but most of its soldados suffered the misfortune of being reinforcements for the generalísimo's army on that fateful April day. Only the ragged silk battle flags of the three battalions remain as their testaments.

To accomplish his *entrada* into Texas, Santa Anna divided his army into three main portions: the Vanguard Brigade and the First and Second Infantry Brigades. The 1,500-man Vanguard Brigade was commanded by Gen. Joaquin Ramirez y Sesma.[47] The best battalion in his force was the 350-man Matamoros Permanente.

The unit, named for a hero of the war for independence, Mariano Matamoros, contained a reliable core of experienced men and officers.[48] Time after time during the Texas campaign, Santa Anna would call on them when he needed his best troops. On February 23, 1836, the Vanguard Brigade entered San Antonio de Béxar, and skirmishers from the Matamoros Battalion led the way, driving the Texian defenders into the Alamo.[49] Two days later, as the siege got under way, six of its soldados became the army's first battle casualties.[50]

With the five battalions of the First Infantry Brigade was the 364-man Toluca Activo, led by valiant Col. Francisco Duque. This battalion, despite its reserve status, was, after the famed Zapadores,[51] probably the finest unit in the Mexican army. When the siege of the Alamo began, this second division was still far away. Santa Anna ordered the Toluca Activo and two other battalions to break off and force-march the rest of the way. After arriving on the outskirts of Béxar on March 3, and notwithstanding their intense fatigue, Colonel Duque ordered his men into their dress uniforms and arranged them in parade formation. As they marched into the town with flags flying, their comrades greeted them with cheers, massed bands, and the ringing of the town's bells. From across the river, the soldados could hear curses and insults directed at them by the Alamo's defenders.[52]

In the March 6 attack that decided the Alamo's fate, both battalions played important roles. The men of the Toluca Activo spearheaded the crucial assault on the north wall and paid a terrible price. A single discharge from a Texian cannon cut down half the battalion's light company as it led the attacking column. A second artillery volley opened more gaps in the activo's shredded ranks and grievously wounded Colonel Duque.[53] The Toluca Battalion suffered the Mexican army's largest number of casualties in the assault. Out of some three hundred men, ninety-eight were killed or wounded, including most of the officers.[54]

Companies of the Matamoros Battalion took part in the attacks on the south and east ramparts of the Alamo. As the defenders fell back from the north wall, the cazadores of the Matamoros Permanente were among the soldados who succeeded in scaling the south wall. With the Mexicans now pouring in from all sides, the surviving Texians barricaded themselves in the long barracks. In-

dividuals of the Matamoros Battalion joined the frenzied slaughter of the remaining defenders in vicious room-to-room fighting.[55] As the army's surviving soldados reformed around their smoke-blackened banners, they could not help but notice the carnage around them. According to an eyewitness, the "devastated" Alamo was "littered with corpses, [and] scattered limbs." Bodies in "torn uniforms "and with "blackened and bloody faces disfigured by a desperate death" lay "in the midst of the groans of the wounded and the last breaths of the dying."[56]

The days after the battle brought continued misery. Aside from the two hundred or so Texian dead, hundreds of Mexican soldados had fallen. Santa Anna's negligence in not providing surgeons for his army sealed the doom of most of the wounded, who, untreated, died lingering deaths over the next days and weeks.[57] The attacking troops had been the cream of the army, and those who died were among the best of the Mexican soldados.

The Guerrero Permanente had not been present for the battle. As part of Gen. Eugenio Tolsa's Second Infantry Brigade, it had still been on the march from the Rio Grande when the assault had occurred and did not arrive in Béxar until March 11.[58] The battalion had been fortunate to have escaped that slaughter, but its luck would not hold. For the next few weeks Santa Anna led his forces with skill and vigor as he pursued the retreating rebel army across the settled areas of eastern Texas. To increase his speed and mobility, the generalísimo selected the best of his battalions to be the strike force he would personally lead. This elite unit included the Matamoros Battalion, the cazadore and grenadier companies of the Guerrero, and most of what was left of the valiant Toluca Activo.[59] For the soldados, the honor of their selection would exact a fearful price.

April 20 found these elements of Santa Anna's army camped by the San Jacinto River. The men were tired, and though their commander knew the Texians were nearby, he was careless in his troop dispositions. For protection the Mexicans had constructed a breastwork of sorts out of saddles, supply containers, baggage, brush, and tree branches. But the army's back was to the river, with no room to maneuver and no place to retreat.[60] That afternoon, Santa Anna sent forward the cazadores of the Toluca Battalion to skirmish with Texian riflemen in a nearby copse. After an exchange of artillery rounds, the fighting died down for the night.[61]

April 21, 1836, began well for the Mexicans. At nine in the morning five hundred reinforcements under Gen. Martín Perfecto de Cos arrived. These were "greeted with the roll of drums and with joyful shouts." The largest contingent of the new arrivals were three hundred men of the Guerrero Battalion. All were exhausted from their march, and Santa Anna gave the men permission to stack arms and go to sleep in an adjoining grove.[62] All was quiet until 4:30. The Toluca cazadores guarded the woods on the right of the Mexican army, and the trusted Matamoros Battalion defended the center of the barricades that shielded the camp.[63] The army, exhausted from lack of sleep, was far from vigilant. Many, including Santa Anna, were dozing. Others were eating or gathering wood, and the horses of the cavalry were not saddled.[64] For most of the soldados the first evidence of their approaching doom was the blare from a solitary bugler warning of the Texian attack.[65] All was instant confusion. The Texians took the Toluca cazadores in the woods unawares and quickly overwhelmed them. Col. Pedro Delgado raced to the camp barricade in time to see Sam Houston's long single line advancing behind the Texas flag. After delivering a shattering volley of musket balls and grapeshot, the rebel army was upon them.[66] The Texians swept over the makeshift breastworks and, according to Delgado, "meeting no resistance, dashed lightning-like, upon our deserted camp."[67] For eighteen minutes fighting swirled around the breastworks and tents of the Mexican bivouac. Houston's men shot and clubbed the dazed defenders, but for a moment the veteran Matamoros Battalion held its ground in the center. Attempts by desperate officers failed to rally reinforcements from the rear, and soon resistance faltered.[68] The line collapsed, and soldados in small groups fled toward the river. Inexperienced men of the Guerrero Battalion bunched together in panic, hindering the veterans from rallying. The fleeing Mexicans soon found themselves trapped by the bayou and nearby marshy ground. As one of their officers recalled, the men crowded "helplessly together and were shot down by the enemy, who were close enough not to miss their aim. It was here the greatest carnage took place."[69] The Texians extracted a full measure of revenge for the Alamo and Go-

liad. The Toluca Activo and Matamoros Permanente, both badly bloodied in the Alamo assault, were annihilated. The soldados of the Guerrero Battalion were more fortunate. Many of its men were far back from the front line when the attack had come, and the slaughter of their comrades bought time for many to escape death and become prisoners.[70]

Houston's victory at San Jacinto was complete. Six hundred and thirty soldados and their officers lay dead on the marshy ground. As late as the middle of June, their decomposing bodies still lay there unburied.[71] In addition, more than 200 Mexicans had been wounded and 730 taken prisoner. Fewer than 200 escaped to report the dreadful carnage. Santa Anna himself was brought into Houston's camp the day after the battle. The victors also collected considerable booty. Nearly a thousand firearms, three hundred sabers, all of the stores and baggage, and Santa Anna's still-loaded field piece, the "Golden Standard," became property of the Texian army. The final tally also included hundreds of horses and mules and $12,000 in gold.[72] When they overran the Mexican camp, the Texians seized "four stand of colors."[73] Three of these were the standards of the Toluca, Matamoros, and Guerrero battalions. The fourth was a swallow-tailed, tricolor cavalry guidon that probably had belonged to Santa Anna's bodyguard. All were in fairly good condition when they were captured, although the Guerrero Permanente color was drenched in blood.[74] Henry P. Brewster, Houston's personal secretary, kept the Mexican guidon for himself, and it never became part of the Texian army's formal inventory of spoils. Brewster sent the flag to friends in Alabama, where it remained until well into the twentieth century.[75]

The three battalion flags remained with the victorious army as trophies of war. But because early Texas lacked a Battle Abbey or Smithsonian Institution, there was never a venue for their formal display. The colors, however, were witness to at least one more of Texas' watershed events. During the February 19, 1846, ceremony on the steps of the old capitol that proclaimed Texas' annexation to the United States, the three flags decorated the speaker's platform next to a portrait of Stephen F. Austin.[76] The Mexican colors stayed in the care of the state adjutant general's office for the rest of the century. Beginning in 1900 they were displayed at the head-

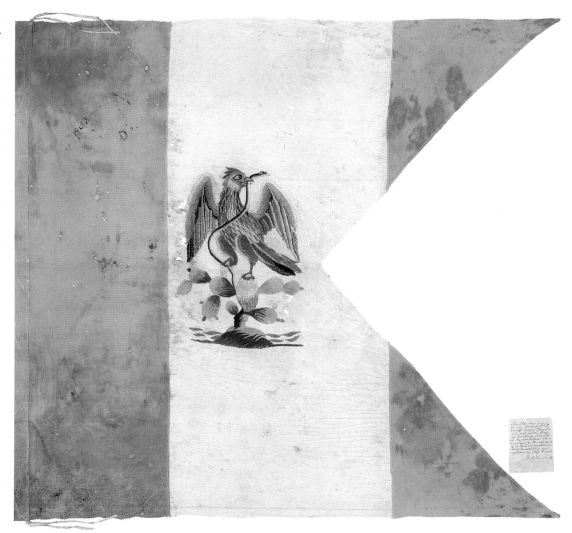

Figure 14. *Mexican Cavalry Guidon. This flag of Santa Anna's Cavalry escort was taken at the battle of San Jacinto. Hatzenbuehler Photography © 2000 Dan Hatzenbuehler.*

quarters of the Frontier Battalion, but by the 1920s had joined other historical flags in the Texas State Library collections.[77] Today the tattered silk tricolor banners are almost all that remain in Texas of Santa Anna's proud army.

The revolution that culminated at San Jacinto brought more than a century of ill will between the peoples of Texas and Mexico. Many Tejanos were squeezed out of their lands and possessions as the Americans increased their power and wealth. Decades of border disputes and brutal warfare served to maintain the blood

feud. The tricolor that the early settlers had once honored became anathema to Anglo-Celtic Texans. Today things are different. In the early days of the twenty-first century the tricolor of the Mexican republic is again a common sight in Texas. New waves of immigrants have brought it back into the state. The old republican flag is now an accompanying ornament for happier occasions. Anglo-Texans have become used to its presence flying next to the Stars and Stripes and the Lone Star Flag from private homes, businesses, and at public gatherings that celebrate the Mexican American heritage. No longer the banner of marauding armies and a symbol of an intolerant age, the flag of Mexico is a physical manifestation of the cosmopolitan and diverse qualities of modern Texas.

**(2)
Lone
Stars
and
Stripes**

The most widely recognized symbol of Texas is the five-point Lone Star. Since 1835 it has adorned almost every flag made and flown by Texans, and it serves as an icon on everything from the official state seal to rodeo belt buckles. So intertwined is the single five-point star with the state's image and psyche that Texas was and is known throughout the world as the "Lone Star State." The origins of this potent symbol date from the first days of the conflict that brought independence, and its early usage on flags and as badges reflected the coalescing resolve of Texas settlers to break the bonds with Mexico. The Lone Star came to embody a desire for independence and a will to join American kinsmen in the constellation that symbolized the United States. The obvious question, but one historians have never successfully addressed, concerns the origin of the Lone Star and how it became the vital symbol of Texas. As with most important issues that a particular society finds crucial to its identity, the genesis of the Lone Star is couched in myth and folklore.

One explanation presents a celestial origin. On an evening in 1835 a young Georgia girl named Joanna Troutman, afire with passion sprung from recent news of revolt in Texas, sat on her porch gazing at the night sky. In a manner not unlike that which inspired the biblical Magi, a single star in the heavens seemed to her to shine more brightly than the rest. "That star reminds me of Texas," Joanna was said to have exclaimed. The girl then hurried inside and by lamplight drew a five-point star under which she wrote "Texas." Her motif soon adorned a silk flag that was presented to a company of Georgia volunteers as it departed to fight for Texas independence. In the nineteenth century many believed this Troutman Flag, as it came to be called, was the first representation of the Texas Lone Star.[1]

Often societies associate their great men with origin myths about important symbols, and Texas is no exception. One story ascribes the Lone Star to Texas' greatest hero, Sam Houston. At his first inaugural, as the new president was signing his message to the people of Texas, he realized that there was no official seal to affix to the document. He thus tore off a cuff link that bore a five-point star and made its impression in sealing wax. A nearly identical story is told about Henry Smith, the provisional president of Texas, who, finding himself in similar straits, cut a large brass but-

Figure 15. *Grand Union Flag. Colonists produced this flag, which was also known as the Continental Colors, by laying six white stripes over the field of the Meteor Flag. Drawing by Anne McLaughlin, Blue Lake Design, Dickinson, Texas.*

ton off his overcoat. This button sported not only a five-point star, but an oak wreath as well, thus birthing what would become the official seal of the Republic of Texas. The designer of at least one revolutionary flag also credited a military-style brass button as the inspiration for the Lone Star.[2] As is usually the case, such stories shield a more mundane and, in retrospect, more obvious reality. The Lone Star of Texas was not of heavenly origin, nor the product of the improvisation of its heroes, but derives in a direct line from the flag of the United States.

The five-point star as a political symbol originated during the American Revolution. In the Old World the icon that resembles such a star was an insignificant emblem that British and French heraldry labeled a "mullet." This symbol does not connote a star of the heavens but is rather a schematic representation of the rowel of a spur, which in heraldry adored the arms of the third-born son in a noble family. The celestial star is the *estoile,* with six wavy points, which by the seventeenth century had become a common charge in heraldry.[3] Before its incorporation into the U.S. flag, the five-point star was rare on flags or other heraldic devices.[4]

One of the earliest and most persistent American traditions has

been the use of flags "for political expressions of loyalty and dissent, of debating such usage, and of adapting official flags for unofficial purposes."[5] Puritans in early Massachusetts had defied the Crown and the state church by altering official flags to reflect their religious convictions. During the Revolutionary years American dissidents inscribed British flags with protest slogans and created new flags with words and symbols calculated to provoke the ruling authority. In more recent times student protesters modified and mutilated American flags to demonstrate their disapproval of the "establishment" and the United States' involvement in Vietnam. During the late 1950s and early '60s, civil rights activists marched beneath the Stars and Stripes and brandished it in defiance of those who would preserve segregation.[6] Throughout history political symbolism more than any other factor has guided the evolving designs of flags in America.

The first semiofficial flag of colonial defiance during the Revolutionary period was the Grand Union Flag, or Continental Colors, as it was sometimes called, first raised on January 1, 1776. Designed when Americans still debated independence, it was fabricated simply by adding six evenly placed horizontal white stripes to the red field of the British Meteor Flag, a Royal Navy ensign. The canton of this beautiful flag displayed the Grand Union, which was the combined crosses of St. George and St. Andrew on a blue background. The new flag's thirteen stripes symbolized the colonies united in defense of their liberties, while retention of the symbolic crosses of Britain for the time being proclaimed their hypothetical loyalty to the mother country.

As political conditions evolved, Americans opted for a clean break and independence. This new resolve dictated the need for a new flag. On June 14, 1777, Congress passed a resolution stating "that the flag of the United States be made of thirteen stripes, alternate red and white; that the union be thirteen stars, white in a blue field, representing a new constellation."[7] No mystical or conventional heraldic symbolism inspired the use of stars; the practice was merely a practical means for representing the thirteen colonies and providing a meaningful replacement for the Grand Union on the Continental Colors. Having little regard for Old World formalities, colonial Americans opted to represent their heavenly star with five points rather than the more proper six points of the es-

Figure 16. *Meteor Flag.*
This handsome flag was a late
eighteenth-century Royal
Navy ensign. Drawing by
Anne McLaughlin, Blue
Lake Design, Dickinson,
Texas.

in Spanish control. Americans seeking economic improvement nevertheless poured into the region. These incursions, coupled with the weakness of the Spanish presence, all but assured its eventual loss to the United States. In September, 1810, a group of settlers raised an armed force, captured the fort at Baton Rouge, and seized the Spanish governor. Intent on offering the so-called West Florida Republic for immediate annexation to the United States, a convention of the insurrectionists declared independence on September 26.[9] President James Madison readily accepted its offer, and the region became a part of the United States a month later.

A blue flag with a single five-point star had flown over the convention. For the insurgents, the symbolism of this first lone-star flag was twofold. It graphically demonstrated their desire to overthrow Spanish hegemony and announced their intention of aligning with the United States.[10] Thus, early-nineteenth-century Americans adopted the five-point star as a symbol of "enlightened revolution against old-world monarchies — a moral crusade for the rights of man."[11] It was natural that American Revolutionaries in Texas would embrace this sentiment.

The next recorded manifestation of a lone-star flag accompanied another blow aimed at the Hispanic Southwest. In 1818 conflicting claims over the extent of the Louisiana Purchase resulted in the Adams-Onís Treaty, signed the next year, which confirmed Texas as a part of Mexico. This agreement enraged the land-hungry citizens of the lower South, who believed the sparsely populated province properly belonged to the United States. In Natchez a group organized for the purpose of seizing the Spanish province of Tejas by force. Proponents of expansion funded an armed expedition and chose James Long, a local physician, to head it. Eventually, "General" Long attracted more than three hundred followers. On June 23, 1818, the vanguard of this band arrived at Nacogdoches and declared the province independent from Spain, intending to hand it over to the United States. This early success proved short-lived, however, and Spanish authorities soon drove Long's filibusters back across the Sabine River.[12] In the course of the incursion, Long's party flew a silk lone-star flag. A single white five-point star placed in a red canton proclaimed the familiar desire for independence, or "liberation" of foreign territory.[13] Lest anyone doubt that the design connoted anything but annexation to the

toile. The genius of using stars as symbols became apparent as additional states joined the union. In 1795 Congress decided to add not just a new star but also a new stripe for each new American state, so that by the time Kentucky and Vermont had joined the union, an official U.S. flag displayed fifteen stars and fifteen stripes. Government officials soon recognized that the further addition of new states would render the national flag grotesquely disproportionate. Consequently, by 1818 Congress had decided to revert to thirteen stripes to honor the original colonies, but would add a five-point star to the blue canton for every new state, confirming the symbolism of one star being equivalent to one state. The design of the U.S. flag became immensely influential for other nations. Soon the five-point star became one of the most common flag symbols, signifying unity, independence, or the constituent parts of a nation.[8] When revolution came to Texas, it was appropriate that such a star became its chief icon.

The First Lone-Star Flags

After the Revolutionary War, aggressive Americans once more took up the march westward. New land was their objective, and frontiersmen had little compunction about how they obtained it. In the Southwest, lightly populated and poorly defended Hispanic possessions became early targets.

The Louisiana Purchase of 1803 had left the territory of West Florida — the area between the Pearl and the Mississippi Rivers —

Figure 17. *West Florida Republic Flag. This was the first known flag to express a political sentiment with the display of a five-point lone star. Drawing by Anne McLaughlin, Blue Lake Design, Dickinson, Texas.*

American republic, the field consisted of the thirteen alternating red and white stripes of the United States flag. A member of Long's expedition, Eli Harris, later claimed that he had designed the flag. In an 1842 letter to President M. B. Lamar, he asserted that "I established the flag which you now use — I was proud of being the man to establish the star and flag of Texas."[14]

In 1821 Tejas ceased to be Spain's problem. Revolutionaries disgusted by centuries of European control seized power. With the Treaty of Iguala, New Spain became the Republic of Mexico. Years of strife followed as factions struggled for the soul of the nation. In 1835, when Gen. Antonio López de Santa Anna overthrew the Constitution of 1824 and assumed dictatorial powers, Mexican liberals rallied to the federalist banner. So too, for a time, did many Texans.

Revolutionary Lone Stars

In nineteenth-century America and especially in the South, a citizen's most important duty was to participate actively in the defense of the community. He might expect to join a legally established militia unit or an impromptu volunteer company assembled to deal with an immediate threat, such as an Indian raid. An essential element in the organization of a military unit was to obtain a flag. During the Texas Revolution the selection of such a flag's design had important political consequences.

Texian armed resistance to centralist authority began near the community of Gonzales. In September, 1835, Santa Anna's military commander of Texas, Domingo Ugartechea, ordered the return of a six-pound bronze cannon. Four years earlier government authorities had supplied the gun to the settlers for protection against Indians. When the colonists refused this request, Ugartechea dispatched one hundred dragoons from San Antonio de Béxar to retrieve it. In the meantime, volunteers from surrounding settlements poured in to assist in the defense. On October 2, the Texians fired on the dragoons, who, with no expectation of reinforcements, retreated to San Antonio.[15]

The skirmish at Gonzales, known aptly as the "Lexington of Texas," was a watershed for the colonists, but would the upcoming fight be to defend the Constitution of 1824 or to establish an independent Texas? The Texians appointed five community leaders

Figure 18. *Long Expedition Flag. This flag with its lone star and stripes was the first of a pattern that would become common in early Texas. Drawing by Anne McLaughlin, Blue Lake Design, Dickinson, Texas.*

COME AND TAKE IT

Figure 19. *Gonzales Flag. With the design of the "Old Cannon Flag," Gonzales colonists rejected the Mexican tricolor and proclaimed defiance to Santa Anna's government. Drawing by Anne McLaughlin, Blue Lake Design, Dickinson, Texas.*

to design a flag for the citizen army that continued to gather at Gonzales. The debate over their choice reflected the political mood of the volunteers. "Some of our leaders," recalled a participant, "wanted to fight under the Mexican national colors; others wanted the eagle and snake eliminated. But it was soon ascertained that the boys wanted nothing that bore the slightest resemblance to the flag of Mexico."[16] The design of the new flag, therefore, would proclaim defiance and separation. The colonists were all aware that on the morning of the recent fight, Lt. Francisco Castañeda, in command of the centralist dragoons, had one last time requested the return of the cannon, which was in position some two hundred yards away. In reply the Texians pointed to the gun and exclaimed: "There it is — come and take it!"[17] The volunteers decided to memorialize the incident. The flag they made "consisted of a breadth of white cotton cloth about six feet long, in the center of which was painted in black a picture of the old cannon, above it a lone star and beneath it the words, 'Come and take it.'"[18] The "Old Cannon Flag" did not remain long with the Texian Army of the People. As

the armed settlers set off for San Antonio on October 13, a horseman proudly bore the Gonzales flag, which the men cheered lustily.[19] Despite their enthusiasm, however, Texians would never follow it into battle. Creed Taylor, one of the volunteers, recalled that the flag was left behind near a creek along with the Gonzales cannon itself, whose makeshift carriage had broken down. When he last saw the flag, "it had been furled and was resting on a sapling nearby."[20]

In the fall of 1835 the people of Gonzales were not the only settlers trying to decide where their loyalties lay. At about the same time, volunteer companies that assembled around Lynchburg and Harrisburg were making their own flags. The designs they selected indicated their political allegiances.

In September, William Scott, one of Stephen F. Austin's original colonists, was elected captain of the thirty-man Lynchburg volunteers. Before departing to join the Texian army, Scott decided his command needed a flag. He scared up four yards of blue silk and sent it with his second lieutenant, James S. McGahey, to have a flag made. In Lynchburg, McGahey enlisted the help of Mrs. Joseph Lynch, who cut the silk and sewed it into a flag. He then asked Charles Lanco, a local painter, to place a large white five-point star in the middle of the blue cloth. Lanco, according to later accounts, remarked that the flag still looked rather plain. McGahey, apparently in a burst of inspiration, told him to paint the word "Independence" under the star. The lone star coupled with the word "Independence" delivered an emphatic political statement. When Captain Scott saw the flag he was taken aback. After some hesitation he acquiesced to the sentiments it expressed.[21] Scott was not the only person compelled by the flag's design to consider the question of Texas independence. A party of volunteers on their way to San Felipe saw the flag and admired its message. "It was just the course for Texas to take," some were heard to remark. Yet when word of the flag spread to another company assembled at Harrisburg, strong disagreement ensued. Some of these volunteers denounced the message, declaring, "They would shoot any man who attempted to raise a flag with the word independence on it."[22]

This threat was almost made good. The next day, just as Scott's company assembled on the banks of the San Jacinto River, two large boats full of armed men pulled up to shore. Lieutenant

INDEPENDENCE

Figure 20. *Captain Scott's Lynchburg Flag. The lone star coupled with the word "Independence" delivered an unmistakable political statement. Drawing by Anne McLaughlin, Blue Lake Design, Dickinson, Texas.*

cepción, he passed the flag into the care of his close friend Thomas Bell.[24] According to historian Hobart Huson, Bell displayed the flag during the Grass Fight and may have carried it in the storming of Béxar.[25]

In nearby Harrisburg, out of the same revolutionary substrate, another lone-star flag emerged. In the eventful time just before the fight at Gonzales, Andrew Robinson mustered a company of locals. Sarah Dodson, wife of his lieutenant, pieced together three squares of calico into a blue-white-and-red tricolor flag. In the inner-most panel, which was blue, shown a six-inch white five-point lone star.[26] For a flag of revolution, its symbolism could not have been stronger — the lone star of independence fused with a tricolor similar to that which embodied the French Revolution. In reality, how-ever, the colors of the flag were less inspired by Jacobins and Mon-tagnards than by the well-known hues of the U.S. flag. The message of the star was, as usual, defiance and separation. When Lt. Arche-leus Dodson unveiled his wife's flag, he explained to his comrades that "the single star was like Texas, alone in her opposition to the autocratic government that had been established in Mexico."[27]

During its brief period of use, the symbolism of the homemade calico banner proved effective. Decades later soldiers who had served in the Texian army recalled having seen 2d Lt. Jim Fergu-son proudly bearing the flag along the line of march from Harris-burg to Béxar. At Gonzales Stephen F. Austin was so alarmed by the flag's unmistakable message that he asked that it no longer be used. He feared tipping his hand to the government commander at Béxar, who would rightly interpret the flag as subversive.[28] Aus-tin's concerns must have soon been overcome, however, because the Dodson flag accompanied the army to Cibolo Creek and may have been the first banner raised over San Antonio after its cap-ture. When Texians formally agreed on independence, the Dodson flag was present. On March 2, 1836 — Texas Independence Day — it was one of two flags that flew over the small, one-room cabin where the delegates ratified the momentous declaration.[29]

Enthusiasm for Texian resistance was not limited to the resi-dent colonists. In locations throughout the South and as far north as Zanesville, Ohio, American volunteers assembled in response to calls for assistance. These would-be soldiers displayed little am-

McGahey set his musket down, went to a nearby house, took the flag from a rack, strode the center of the company line, unfurled and planted it "with a firm stroke in the ground." For a few tense moments the two sides faced one another with weapons primed and cocked. A deadly silence prevailed. Presently, the captain of one of the boats ordered his men to push away from the bank, and once out in the stream, stood up, waved his hat, and shouted, "Hurrah for the Lone Star" — and the rest of his crew joined in. The occupants of the other boat sullenly cast off and "departed with-out demonstration of any kind whatever."[23] Scott's company soon joined the Texian army and fought at the battle of Concepción and the siege of Béxar. On the march to Béxar, McGahey carried the flag on its staff as far as San Felipe, where he neatly folded it and placed it in his knapsack. After receiving a serious wound at Con-

Figure 21. *Dodson Lone-Star Tricolor. This tricolored flag with the lone star alarmed Stephen F. Austin because its message of revolt and independence was too clear. Drawing by Anne McLaughlin, Blue Lake Design, Dickinson, Texas.*

bivalence about their aims in Texas. They were coming to fight, not for constitutional reform and a better Mexico, but for Texas independence, land, and annexation. One of the best known of these units was the Georgia Battalion. On November 12, 1835, a public meeting was held in Macon, Georgia, to discuss opposing the "tyrant and oppressor, Santa Anna." After several hours of patriotic harangue, those present decided nothing less than full independence for Texas would suffice. A local soldier, William Ward, offered to raise a company of infantry to join the Texian army. Thirty-two men volunteered that night, and the delighted citizens collected $3,150 to outfit them. Georgia officials offered them arms from the state arsenal. Over the next weeks, as the men journeyed from Macon to New Orleans, enthusiastic recruits along the route joined the battalion, swelling its numbers to 220 men, a substantial force for the time.[30]

When the volunteers passed through Knoxville, Georgia, Joanna Troutman and her celestially inspired banner were there to greet them. Some said that Joanna, with the help of other young women in the neighborhood, had fashioned the flag in an upstairs room of her father's inn. They made the banner of white dress silk and appliquéd a blue five-point lone star on each side. Not content with the symbolism of a single star, on one side they inscribed

"Texas and Liberty," and on the other the Latin inscription *"Ubi libertas habitat, ibi nostra patria est."*[31] Many Texans in the nineteenth century and first half of the twentieth considered the Troutman banner to have been the original lone-star flag.

Love of liberty was not the only factor that attracted recruits from the United States to the Georgia Battalion. The promise of land lured the majority of the young volunteers. In Montgomery, Alabama, the battalion paraded Joanna Troutman's flag around town to raise recruits. Ned Hanrick, one of its officers, only half-jokingly declared they would attract more volunteers if the flag were inscribed with the word "Land" instead of "Liberty."[32]

Just after the first of the year, the Georgia Battalion arrived at Velasco by ship from New Orleans. This tiny port was the chief point of entry for American volunteers and thus a hotbed of support for Texas independence. On January 8, 1836, the battalion formed into ranks and marched from their camp into town. The Troutman lone-star flag and a thirteen-stripe banner flew on a staff at the local hotel. Those assembled cheered wildly and fired a salute with their Georgia-issued muskets. To climax the celebration, a band played the "Star-Spangled Banner."[33] There was no pretense to restore the Mexican Constitution of 1824.

The Troutman flag accompanied the Georgia Battalion when it

Figure 22. *Troutman Lone-Star Flag. Many nineteenth-century Americans believed Joanna Troutman's celestially inspired banner was the first Texas lone-star flag. Drawing by Anne McLaughlin, Blue Lake Design, Dickinson, Texas.*

joined Col. James W. Fannin's command at Goliad. Soon the flag was again the focus of political fervor. On March 8, word of the Texas declaration of independence reached the troops assembled at Goliad, and the news sparked a general celebration. Shouting, musket salutes, and martial music greeted the flag as it was raised over the walls of the Presidio La Bahía.[34] Unfortunately, at sunset, as the fragile silk flag was being lowered, it became entangled in the halyard and was ripped to pieces.[35] When the Texians evacuated the fort, a few melancholy shreds of the banner still hung from the staff like an evil omen. The Georgia Battalion did not long survive its flag's destruction; most of its men went to their deaths with Fannin and the rest at the Goliad massacre.

Other Flags, Other Symbols

Not all volunteer units streaming from the United States into Texas brought flags with the lone star. Some, like the all-red company color of the Alabama Red Rovers, carried no overt political message, while others sported elaborate, even artistic, symbols. One of the most impressive flags of the Texas Revolution was that belonging to Sidney Sherman's company from Kentucky. The field

of the flag, originally blue, displayed a painting of a mythical liberty figure gripping a sword, over which is draped a streamer with the words "Liberty or Death." Tradition holds, wrongly, that Sherman's was the only Texian battle flag at San Jacinto (see plate 1).

Just as famous is the azure flag of the First Company of the New Orleans Grays. In October, 1835, 120 volunteers in New Orleans formed two companies for the purpose of fighting with the Texians. One of these, under Capt. Thomas Breece, marched overland from Alexandria. After the men had crossed the Sabine River into Texas between Natchitoches and San Augustine, a delegation of local citizens met them. One of the recruits recalled, "The tender hand of a Texas woman gave us in the name of the beauties of the land a splendid blue silk flag on which the following inscription appeared: 'To the first company of Texas Volunteers from New Orleans.'"[36] In the center of the flag was an American eagle with spread wings. The designers apparently had patterned this small company color after the U.S. Army regimental standards of the period. Breece's volunteers rejoined the Second Company of the New Orleans Grays, which had traveled much of the way by ship, at Béxar. Both took an active part in the capture of the city. After its fall, all

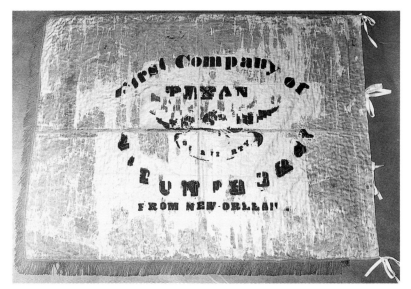

Figure 23. *New Orleans Grays Flag. This photograph of the New Orleans Grays Flag was made in Mexico around 1980. The flag's present condition and whereabouts are unknown. Courtesy of the Daughters of the Republic of Texas Library at the Alamo.* Flag of the New Orleans Grays, *Charles J. Long, photographer, Mexico, © 1980, Daughters of the Republic of Texas Library, NV 96.14, fr. 9.*

Figure 24. *Dimmitt's "Bloody Arm" Flag. Philip Dimmitt raised his fierce flag of independence over Goliad's La Bahía presidio in December, 1835. Drawing by Anne McLaughlin, Blue Lake Design, Dickinson, Texas.*

but twenty-two of Breece's company joined Dr. James Grant's ill-considered expedition against Matamoros. Most of these eventually turned up in Col. James Fannin's command, and nineteen were killed in the Goliad massacre. The remainder of the Grays stayed in Béxar and died at the Alamo. The First Company's flag became Santa Anna's trophy of war.

Philip Dimmitt, a successful merchant and one of the colony's earliest settlers, did not readily embrace independence. His string of trading posts had brought him into close contact with Tejanos, who held him in high regard and schooled him in the bewildering politics of northern Mexico. In October, 1835, he joined the force of Anglo settlers and Tejanos who had originally captured the Presidio La Bahía at Goliad, and Dimmitt commanded the garrison there until mid-January. Early on, to demonstrate his loyalty to Mexico, he had fabricated the famous "1824" tricolor, but, as in the case of most old settlers who had resisted Santa Anna's regime, he eventually advocated Texas independence. In December, 1835, his small force from the La Bahía garrison arrived in San Antonio in

time for the final assault on the Mexican garrison. Those who accept the tradition that an "1824" tricolor flew over the Alamo assume that it was Dimmitt's Goliad flag, which he had left behind.

Certainly, Dimmitt had no more use for such a flag. Back in Goliad and no longer interested in constitutional reform, he acted for Texas independence. On December 20, 1835, with the assent of local Americans and Tejanos alike, he helped promulgate the Goliad declaration of independence, which stated that Texas ought to be "a free, sovereign, and independent state."[37] As other Texians had done and were doing, he cast aside the Mexican flag and made one with his own hands that symbolized this important change. Dimmitt's new design was both unusual and unfortunate. According to an account based on the testimony of two eyewitnesses, the flag was "of white domestic, two yards in length and one in width, and in the center was a sinewy arm and hand, painted red, grasping a drawn sword of crimson."[38] For decades scholars have puzzled over this obscure symbolism. At least one has concluded that it might have referred to an incident in Irish folklore. Its macabre design is

also suggestive of a cipher borrowed from the freebooters' pictorial vocabulary.[39] To Santa Anna and the Mexican authorities, it would have looked much like the flags flown by Caribbean and Gulf pirates — for the Texians an unfortunate association. The design seemed to justify the Mexican government's insistence that the rebels were mere "pirates and outlaws," the argument used to justify Santa Anna's policy of granting no quarter.[40]

Whatever the origins of the symbol, the flag's message in favor of independence was unambiguous to those who saw it. Nicholas Fagan, a prominent citizen of the region, constructed a sycamore flagpole and placed it in the center of the La Bahía fort. When he unfurled the bloody-arm flag, it was immediately rent by a bullet fired from the streets outside the wall.[41] The desire for independence was by no means universal.

The Lone Star and Stripes

Out of the many designs revolutionary patriots had created, a generally recognized and semiofficial flag of Texas emerged in late 1835. This banner, or one of its variants, probably flew over the Alamo, led the volunteers at San Jacinto, identified the warships of the new republic's navy, and portrayed Texas to the world until at least 1839. Its basic design consisted of a field of thirteen red and white stripes with a blue canton that displayed the white five-point lone star. Known today as the Texas Naval Flag, the Lone Star and Stripes flag proclaimed the chief aspirations of the majority of Texians — separation from Mexico and union with the United States.

Contemporary sources allude to the existence of a de facto Texian flag in general use during the revolutionary period. Eduard Harkort, a German engineer serving with the Texian army, noted such a flag in his diary but failed to describe it. The March 8, 1836, entry stated that upon his arrival at Columbia he observed "*the* Texas flag . . . flying on a storehouse [where] . . . volunteers are assembling" (italics added).[42] Harkort had just come from Washington-on-the-Brazos, where he had been privy to the politicians' wrangling over the creation of an official Texas flag. Had a particular flag been in general use, he would certainly have been aware of it. Mexican authorities also seemed to have recognized a common Texas flag. Pedro Delgado, colonel in Santa Anna's army and participant in the battle of San Jacinto, recalled that when Houston attacked, "in their centre was *the* Texas flag" (italics added).[43] It is unlikely that he referred to Sidney Sherman's baroque liberty flag, which historians have traditionally regarded as the only Texian flag on the field that day. Delgado might have recognized the flag because Mexican authorities had warned their forces — both on land and at sea — to be on the lookout for it. In January, 1836, Santa Anna's secretary of war issued a circular stating, "The Supreme Government has received official notice that the Texas rebels have adopted a strange flag which consists of bands like the ones of the U.S. of North America, bearing in place of the blue field with stars, a white field with a cross and the number 1824. It is also known that boats armed by these traitors, fly this device."[44] The flag mentioned is clearly a variant of the Lone Star and Stripes. The imperfect vision of a distant observer or a garbled intelligence report could have mistaken a cross in the canton for a lone star.

The Texians' adoption of a U.S.-flag variant with a single star in the canton as the standard of their revolution ought not be surprising. It was already a common design in the Gulf Coast region. The first recorded version had been Dr. Long's 1818 filibustering flag, and Texians familiar with it were still living. An 1834 bill of lading for cargo assigned to the schooner *Brazoria*, bound from New Orleans to the port of that name, depicts on its letterhead an image of a side-wheeled steamboat with the Lone Star and Stripes flag flying unmistakably from the fantail.[45]

The first recorded adoption of this design by Texian revolutionaries was the flag of William S. Brown. He was an early convert to the revolutionary cause and participated in the siege of Béxar. During the fighting there Texians flew a Lone Star and Stripes flag, which, after the Mexican surrender, came into Brown's possession. On December 20 he was at La Bahía and signed the Goliad declaration of independence. To commemorate the event, he modified the flag by adding Dimmitt's bloody-arm-and-sword motif to the field with the lone star and inscribing "Independence" on the middle white stripe.[46] Around January 1, 1836, Brown, taking the flag with him, departed for New Orleans to become captain of the Texian sloop of war *Liberty*. During the month of February,

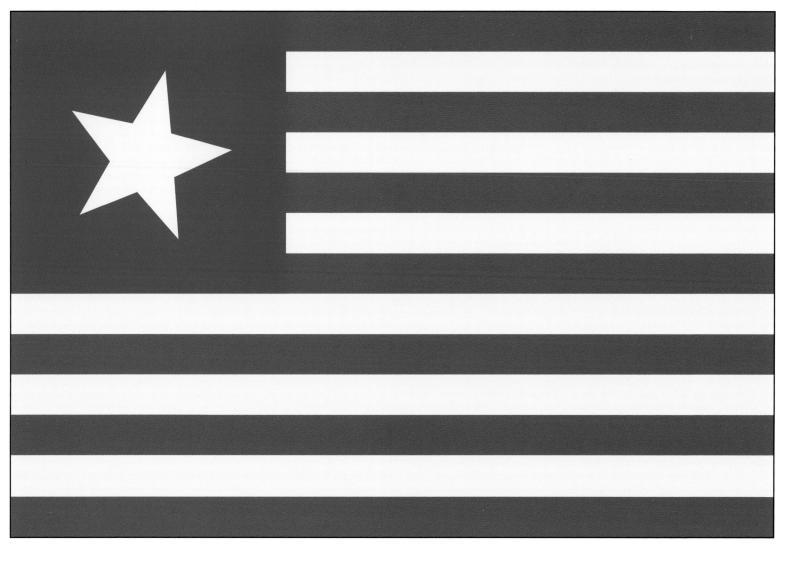

Figure 25. *Lone Star and Stripes. This banner, with stripes representing the United States and the lone star of Texas, was the de facto flag of the Texas Revolution. Drawing by Anne McLaughlin, Blue Lake Design, Dickinson, Texas.*

Shipped, in good order and well conditioned, by **TOURNE & BECKWITH,** on board the Steam Boat called the *Schooner Brazoria* whereof *T. Rowland* is Master now lying in the Port of NEW ORLEANS, and bound for *Brazoria* To say:

Printed and sold by HOTCHKISS & Co. **No. 6, Canal Street,** NEW ORLEANS.

Figure 26. Brazoria *Bill of Lading. The letterhead on an 1834 bill of lading for cargo assigned to the schooner* Brazoria *demonstrates that the design of the Lone Star and Stripes was known before the Texas Revolution. Courtesy of the Center for American History, the University of Texas at Austin, CT Number 0367 (front).*

"a blue field, and in the upper corner a star of five points, over which is stretched a blood-red arm and hand, holding a naked sword: the rest, red and white stripes alternately." And in the center stripe "the word 'Independence,' in large letters reaching its whole length."[47]

Meanwhile, other variants of the same flag appeared around Velasco. In the course of the January 8 demonstration by the Georgia battalion, a flag like Brown's flew along with the Troutman lone-star banner over the town's hotel. It "bore stripes like the United States flag," with the word "Independence" imprinted on the middle white stripe. A version of Dimmitt's icon, the arm grasping an upraised "bloody sword," decorated the blue field, but no period accounts mentioned a star.[48] The clearest contemporary description of the de facto Texian flag on land comes from a January 28, 1836, letter written in Velasco by a young volunteer from Cincinnati. "Yesterday," he related, "our battalion was paraded, marched into town, drawn up in a line opposite to the Flag-staff, and at the firing of a signal cannon, a flag containing a single star and stripes, and the word 'Independence' was run up."[49]

Evidence also suggests the Lone Star and Stripes flag superceded Dimmitt's bloody-arm banner at Goliad. In March, 1836, Joseph M. Chadwick, aide-de-camp to Fannin, produced a drawing of the Presidio La Bahía that depicted an aerial view of the post, complete with details not only of structures, but also of the arrangement of tents, limbers, and guns. Just before his execution at Goliad, Chadwick sent the picture to his mother in New Hampshire. Within months, a New York lithographer redrew and published the sketch in more elaborate form. Most striking in the new version was the addition of a line of troops at attention on the parade ground. Flying from the garrison's flagpole is a striped banner with a lone star encircled by "TEXAS" in the canton. Across the way, a color-bearer holds a smaller version of the same flag. The New York lithographer, apparently a friend and correspondent of the Chadwick family, could have learned of the flag's design only from someone with firsthand knowledge of it.

One of the most enduring conundrums of Texas history concerns which flag or flags flew over the Alamo. Joseph Hefter, one of the twentieth century's foremost authorities on the Mexican army,

the *Liberty,* flying the "1824" Mexican tricolor, raided the coast of Yucatán. Back in home waters after a successful cruise, Brown anchored near Matagorda. It was there that he and his crew received word that Texas delegates had declared independence. Brown ordered his striped flag to be "fastened to the halliards and hoist[ed] up." The flag, as described by one of Brown's seamen, had

asserts that there were actually three flags at the Alamo. Eyewitnesses agreed that the tricolor with the stars of Tejas y Coahuila was present. Hefter maintains that the second flag was the small blue banner of the First Company of the New Orleans Grays, which floated over the long barracks.[50] It seems unlikely, however, that either of these flags could have inspired William Barret Travis's immortal appeal "To the People of Texas & All Americans in the World," which exulted, "Our flag still waves proudly from the walls."[51] Hefter believed that the "true" flag of the Alamo floated proudly over the fort's tallest structure, the hospital building, and displayed the stripes of the United States and the Lone Star of Texas.[52] This was indeed the sort of flag Anglo-Celtic Texans fighting for independence would have chosen to die under.

Shortly after the Battle of San Jacinto, a book was published in Philadelphia entitled *Colonel Crockett's Exploits and Adventures in Texas as Written by Himself*. The publishers claimed the book was based on a diary by David Crockett, part of which described the last days of the Alamo garrison. A man named Charles T. Beale allegedly visited San Antonio soon after the fall of the fort and had come into possession of the diary Crockett had kept during his final hours. Using information from the diary, Beale produced a manuscript describing those momentous events and sent it east for publication. Scholars are nearly unanimous in condemning this work as a fraud. A preponderance of internal evidence makes it unlikely that Crockett could have left behind such a work, much less that it could have survived the conflagration of the battle.[53] From a historian's perspective, it matters little whether the famous frontiersman himself supplied the information found in *Exploits*. Ironically, this bogus book may contain one of the earliest accounts of the last days of the Alamo, and whoever wrote it had at least a modicum of accurate, firsthand knowledge. The author was clearly near the scene; even detractors agree that he wrote the Alamo chapters in Texas within two months of the battle.[54] He was familiar with such details as the names of Santa Anna's battalions and their commanders; had a reasonable knowledge of Béxar, its people, and environs; and knew the chronology of events. Beale even reported correctly the number of Mexican attackers — about 1,600 — a fact modern historians sometimes report incorrectly.[55] Although his

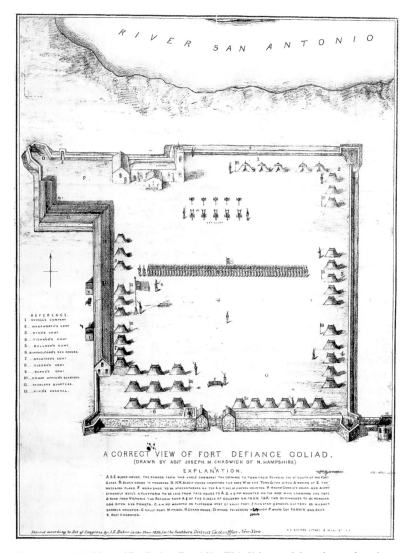

Figure 29. *1836 View of La Bahía Presidio. This lithograph based on a drawing of Fannin's aide-de-camp, Joseph M. Chadwick, depicts several Lone Star and Stripes flags. The UT Institute of Texan Cultures at San Antonio, Courtesy of May M. Chadwick, No. 71-692.*

information could have derived from contemporary newspaper accounts, the author would have had ample opportunity to question eyewitnesses to the events that had only just occurred. For this reason, a passage that describes the Alamo flag should not be dismissed as outright fabrication.

Figure 30. *Crockett Alamo Flag. The Lone Star and Stripes described in the alleged Crockett diary was the "true" flag of the Alamo garrison. Drawing by Anne McLaughlin, Blue Lake Design, Dickinson, Texas.*

The "entry" for February 23 reads, "We have had a large national flag made; it is composed of thirteen stripes, red and white, alternating on a blue ground, with a large white star, of five points, in the center, and between the points the letters TEXAS."[56] Whether the striped flag really flew over the Alamo is less important than the description of it. This is the same flag as in the Goliad drawing and is similar to the others that had appeared in the previous months. Beale clearly did not invent the design; either he had seen such a flag or someone had described it to him.[57] If the author of *Exploits* was at San Jacinto after the battle, he could have spoken to individuals who knew which flag flew over the Alamo, or he might have seen the Texians of Houston's victorious army with a flag like the one he described. Although tradition maintains that only Sidney Sherman's flag appeared at San Jacinto, there are clues that another may have accompanied the assault against Santa Anna's force.

During the convention at Washington-on-the-Brazos, the delegates had endorsed the already prevalent symbolism of the lone star. A resolution declared that "the single star of five points, either gold or silver, be adopted as the particular emblem of this republic: & that every officer and soldier of the army and members of this convention, and all friends of Texas, be requested to wear it on their hats and bosoms."[58] It seems inconceivable that the Texians of Houston's army, many of whom had already shown themselves to be flag-conscious, would not have made some sort of lone-star banner to go with their badges. An 1874 letter from F. W. Johnson, an early leader of the Texas Revolution, to John Forbes, who had been commissary-general of Texian forces and present at the war's climactic battle, confirms that there had been other lone-star flags with the army. "The Lone Star Flag," Johnson reminded Forbes, "was not flung to the breeze for the first time in Texas by the Army at San Jacinto."[59]

Some participants at San Jacinto recalled that Texians had carried a striped flag like that of the United States. John G. Moore claimed to have been General Houston's standard-bearer. He later related to family members that there had been two Texian flags at the battle: "a blue silk flag privately owned by a small company that had volunteered to help the Texans [the Sherman company flag] and the small Union [Star and Stripes] flag."[60] Some veterans recalled that the Lone Star and Stripes flag at San Jacinto may have been that of Mosely Baker's company.[61]

These clues suggest the probability that there was a striped flag with a lone star in the canton present on the field that day. If Houston's army did not possess such a flag at the beginning of its retreat across Texas, it could easily have obtained one. A great advantage of this design was the ease with which it could be fabricated. All that one required was a Stars and Stripes, which must have been readily available to the 1836 volunteers, a square of blue cloth for the canton, and some white or yellow paint for the star. An enterprising quartermaster like John Forbes, or one of his assistants, could have painted a star on the cloth and with it replaced the original starry canton.

As prevalent as the Lone Star and Stripes flag was in the Texas Revolution, it never became the legal national flag. This may be the major reason why its true importance is so little known. Texas officials during this critical period never sanctioned a national flag. Even though the nascent government desperately needed a flag to

assert its place among the nations of the world, choosing a design proved difficult. Politicians had little time available to address the matter; nevertheless, many insisted on contributing their own particular notions regarding the colors and symbols of a national standard. Most proposed designs, however, featured the lone star and thirteen stripes in some form.

Political Flagsmiths

Stephen F. Austin himself submitted one of the earliest patterns for a national flag. In November, 1835, the provisional government had selected him, along with William H. Wharton and Branch T. Archer, to serve as commissioners to the United States, where they would solicit loans, weapons, and volunteers. From New Orleans in January, 1836, Austin wrote Gail Borden, Jr., at San Felipe proposing a national flag based on the Lone Star and Stripes.[62] Austin, clearly a better nation builder than flag designer, suggested adding an English Union Jack and a Mexican tricolor to a field of thirteen stripes that would also display a five-point star.

Borden and his San Felipe neighbors took this notion to heart. In February they presented a flag similar to the one Austin had proposed to Mosely Baker's volunteer company. A local newspaper trumpeted the jumbled symbolism: "The whole flag is historic. . . . [and] was made according to the pattern of the flag proposed for the flag of Texas and of independence. The following is its device: The English Jack, showing the origin of the Anglo-Americans; thirteen stripes, representing that most of the colonists in Texas are from the United States; the star is Texas, the only state in Mexico retaining the least spark of the light of liberty; tricolor is Mexican, showing we once belonged to that confederacy."[63] Even though this description allows only speculation as to the flag's precise appearance, the excessive elements would have rendered it difficult to understand and complicated to make. The chief virtue of the Austin/Baker flag was that it was not as poorly designed as the one the three commissioners in New Orleans subsequently submitted.

Sometime later in an undated letter, Austin, Archer, and Wharton, with perhaps too much time on their hands and consumed with the political implications of the symbolism, revised Austin's original design. "In the place of the star," the letter read, "put the head

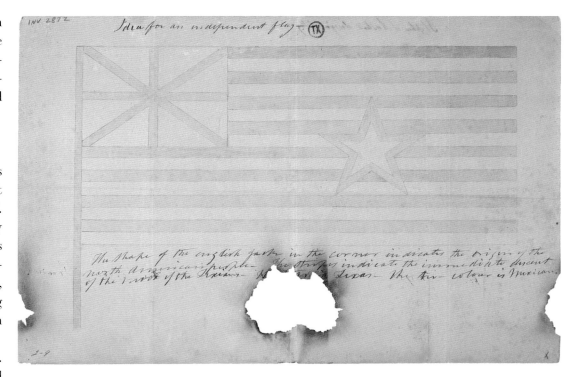

Figure 31. *Austin's Proposal for a National Flag. Courtesy of the Texas State Library and Archives Commission.*

of George Washington in the center, and the rays, representing the light of liberty, radiating all round — Outside of them and above put the motto — 'Where liberty dwells there is my country.'" They further suggested changing the colors of the stripes and making the background of the Union Jack either white or yellow. Wharton, commenting on the suggested motto, which was the same as that displayed on the Georgia Battalion flag, sniffed, "I object to the hackneyed quotation. . . . Its frequent use by school boys . . . [and] by volunteer companies on their banners have rendered it stale & fulsome." He wanted to substitute "Light of Liberty" or "*Lux Libertas*," and underneath the portrait of Washington to add "In his example — there is safety."[64] Fortunately no official adoption was forthcoming regarding the cluttered design.[65]

Decades after the Texas revolution, a myth sprang up that credits Tejano patriot Lorenzo de Zavala with designing the first official Texas flag. According to Mamie Wynn Cox's book, *The Romantic Flags of Texas*, "To this superb patriot we owe a debt of honor as the man who designed the first official Lone Star National Flag of

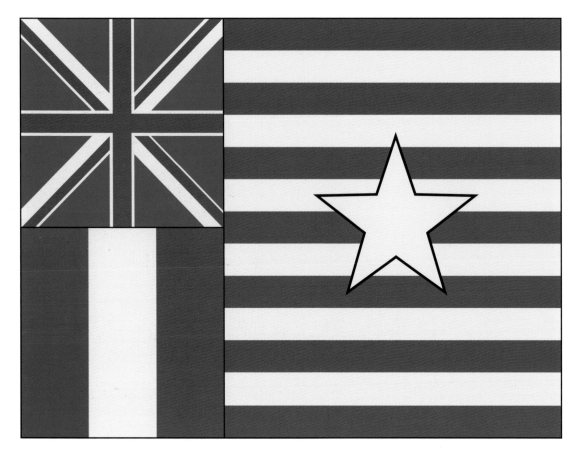

Figure 32. *Mosely Baker Flag. The flag of Mosely Baker's San Felipe volunteer company was inspired by Austin's jumbled design for a national flag. Drawing by Anne McLaughlin, Blue Lake Design, Dickinson, Texas.*

the Republic of Texas."[66] The flag that de Zavala supposedly invented was a white five-point star, with "TEXAS" inscribed one letter between each point, set on a blue field. Representations of this elegant design identifying it as the first flag of the republic still appear today. Unfortunately, no flag of this description was ever proposed, much less adopted.[67]

The General Convention first gave official consideration to the selection of a national flag when it met at Washington-on-the-Brazos. After declaring independence on March 2, the delegates immediately turned their attention to selecting a "suitable flag for the Republic of Texas." The next day they appointed a five-man committee consisting of Thomas J. Gazley, William B. Scates, Sterling C. Robinson, Thomas Barnett, and Lorenzo de Zavala to devise a flag and submit it for adoption by the full convention.[68]

Sometime during the next week, Zavala did indeed propose the basic design for a new flag, and the committee accepted it on Friday, March 11. Yet all that historians can say with certainty about this design is that at least *part* of it consisted of a blue square or rectangle with a white five-point star. On March 12, in a session attended by members of the public, the committee met to make a final recommendation. Having brooded over the question overnight, the members were no longer satisfied with the pattern they had accepted the day before and voted to add other elements. "On a motion of Mr. Scates," reads the official record, a "rainbow and star above the western horizon; and the star of six points sinking below was added to the flag of Mr. Zavala." The members even specified the order of colors for the rainbow. In attendance at the session was Eduard Harkort, who elaborated in his diary a few days later: "A rainbow color scheme must be added to the Texian flag, and as a matter of fact in the following order, Red, Orange, Yellow, Green, Blue, Indigo, Violet." Afterward, Charles Taylor of Nacogdoches proposed a resolution that the "word 'Texas' be placed, one letter between each point on the national flag."[69]

One can speculate that the "flag of Mr. Zavala" the committee had accepted on March 11 was probably not simply the white star on blue field for which Mrs. Cox credited him. Instead the basic design might have been the Lone Star and Stripes flag. Such a conclusion makes practical and aesthetic sense. The meager records of the committee report that a white five-point star on a blue background was an *element* of the Zavala suggestion. If his proposed flag incorporated a striped field, all flag makers would have had to do in order to include the additional elements — stars, rainbow, and horizon — in a symmetrical pattern would have been to enlarge the canton until it reached the lower edge of the flag. This had been the general shape of the Austin/Baker flags and similar variants. Admittedly, Texian politicians had so far not shown themselves particularly able flag designers. Even so, placing two stars, the horizon, and a rainbow on a square or a horizontally rectangular flag would have created an obvious asymmetry.

Had delegates adopted this flag, with or without stripes, it would have proven a poor choice. The symbolism was cluttered and the message obscure. The metaphor of a five-point star, in this case

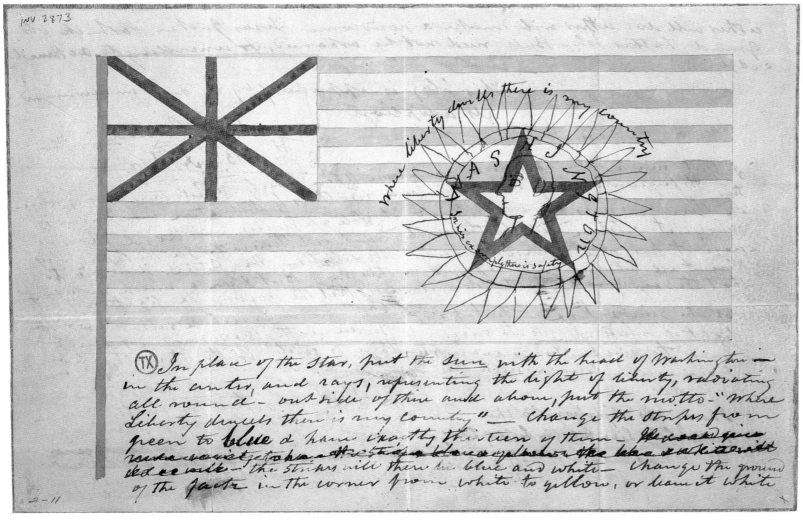

actually labeled with the letters of "TEXAS" rising over the horizon and the six-point star of Mexico sinking beneath it, is clear. The meaning of the rainbow icon remains puzzling. If the image represented a Masonic symbol or some other figure well known to the convention delegates, its presence on the national flag would have required continual explanation to the world at large. Even if the canton with its elaborate patterns could have been grafted easily onto an existing U.S. flag, manufacture would have proven too costly and time-consuming for general use. Flags of this design would require constant replacement, since the vegetable dyes and paints necessitated by the complex rainbow pattern would have faded rapidly under the onslaught of the harsh Texas climate. Whatever design the flag displayed proved moot. By the middle of March, as Santa Anna's army approached, the delegates fled without adopting any flag. Not until December, 1836, when the Republic's first congress convened, did officials take formal action on this matter. In the interim, the striped lone-star flag continued to serve.

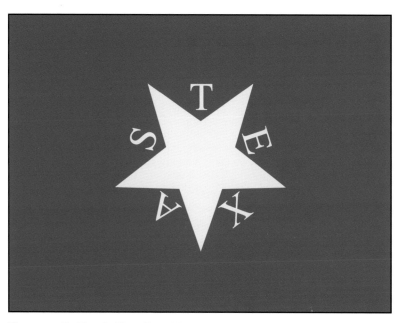

Figure 34. *De Zavala Flag. Some historians have asserted that Tejano patriot Lorenzo de Zavala designed this flag and that it was the first official standard of the Republic of Texas. No flag of this description, however, was ever proposed, much less adopted. Drawing by Anne McLaughlin, Blue Lake Design, Dickinson, Texas.*

Figure 35. *General Convention Proposal for a National Flag. A committee of the general convention that met in Washington-on-the-Brazos proposed adding a rainbow and a six-point star to the Lone Star and Stripes. Drawing by Anne McLaughlin, Blue Lake Design, Dickinson, Texas.*

The Lone Star and Stripes at Sea

During the nineteenth century the most important use for a national flag was at sea. It was critical in an age of transoceanic commerce, piracy, and maritime war that a nation have a flag that clearly identified its seagoing vessels. Ships waging war without a recognized flag could be treated as pirates under international law.

In the first months of the revolution, Texas warships and merchantmen flew the Mexican tricolor authorized for privateers. On January 13, 1836, a Texian sailor observed that as a Texas-bound convoy assembled off the Louisiana coast, "our colors were first hoisted, under a salute of thirteen guns. The flag was that of the Mexican Republic — red, white, and green, with the addition of the figures 1824." [70]

Toward the end of February, when the sloop of war *Liberty* returned from its successful voyage to Yucatán, Capt. William Brown became aware of the altered political conditions by the flags he observed being flown from other Texian vessels. Off Matagorda he came alongside three ships in Texas service; the sloops of war *Independence* and *Brutus* and the merchantman *Durango*. Rather than the tricolor, each of these ships now flew at its masthead a U.S. Stars and Stripes. The commander of the little flotilla informed Brown that foreign warships did not recognize the "1824" tricolor and ordered him to "haul down the Mexican flag . . . and substitute the American flag in its place." [71] The sailors hoped that this subterfuge would protect Texas shipping until the politicians made up their minds for independence and bestowed a flag that other nations would honor. Soon, as we have seen, Brown would hoist his own Lone Star and Stripes flag.

In the March convention, delegates had failed to agree on a design for the national flag, but concerns for international maritime law dictated that they sanction some ensign for the Republic's navy and merchantmen. The expedient choice was for the flag already in general service. On April 9, David G. Burnet, president of the ad interim government, halted his headlong flight from Santa Anna in Harrisburg long enough to sign a decree making the Lone Star and Stripes the first official flag of the Republic of Texas. [72] While the flag made an important political statement when used on land, at sea the Lone Star and Stripes design proved an inspired

choice. Already embraced by Texians, it bestowed a colossal advantage — at a distance or in calm wind, the ensign looked nearly identical to the U.S. flag. After Texas had won independence, the flag proved particularly valuable. The Republic, free but bankrupt, had to scrap most of its warships, leaving merchant ships unprotected while Mexican animosity continued unabated. The flag that other nations easily mistook for that of the powerful United States provided valuable camouflage. Texas officials credited this confusion with "many instances . . . beneficial to our Navy and Merchantmen." [73]

A Flag for the World to See

Even with the defeat of Santa Anna at San Jacinto, the young Texas republic faced an uncertain future. Houston's army melted away to be replaced by more than two thousand rowdy American volunteers who had arrived too late for the fighting. Mexico's congress rejected Santa Anna's peace treaty recognizing Texas independence, so hostilities temporarily in lull would continue. Immediate annexation by the United States would have solved most of Texas' problems, but that would not occur for almost ten years.

Nevertheless, the process of organizing the government went forward. On July 23 ad interim president Burnet proclaimed that elections be held on the first Monday of September to ratify the new constitution and select a president, vice-president, senators, and congressmen. Also on the ballot was a proposition seeking Texian opinion on the question of annexation. Voters overwhelmingly chose Sam Houston for president and confirmed the principle symbolized by the lone star on so many battle flags. Texans voted 3,277 to 91 in favor of annexation.

In December the congress got back to the task of selecting official flags and emblems. An act approved on the tenth of that month confirmed the Lone Star and Stripes for naval service but rejected it as the de jure national flag.[74] That same day, however, congress ratified the primacy of the lone-star emblem by adopting a state seal that consisted of "a single star, with the letters 'Republic of Texas,' circular.'"[75] Then lawmakers decided that the first official flag of the Republic would be a new design, which they labeled the "National Standard of Texas." Also called the Burnet

Figure 36. *National Standard. Although a law passed in December, 1836, made the National Standard the first official flag of the Republic of Texas, it never saw general use. Drawing by Anne McLaughlin, Blue Lake Design, Dickinson, Texas.*

Flag because the ad interim president had proposed it, the national standard consisted of "an azure ground, with a large golden Star central."[76] This handsome banner was the official national flag of the Republic of Texas until January 25, 1839, when congress adopted a now more famous lone-star flag.

The origins of the National Standard remain a mystery. One can only speculate why Texians separated the star from the stripes of their previous flag. Annexation to the United States was far from a fait accompli. Perhaps Texians calculated that the new flag would reinforce the notion that their revolution had been motivated not by any imperialist conspiracy by Americans but only by the desire to form an independent nation. The new National Standard, however, never saw general use. No contemporary representations of it survive, and few Texians seem to have even been aware of it.[77] In 1839, when Texians were debating the need for a new flag, Senator Oliver Jones referred to the Lone Star and Stripes as if *it* were the national flag and the National Standard had never existed. Presi-

Figure 37. *Detail from Flags of the Principle Nations in the World, 1837. The Lone Star and Stripes remained the most recognized flag of Texas until a new national flag was adopted. Courtesy of Sam Lanham.*

dent Burnet, Jones explained, had "devised the national flag [in 1836] . . . [and] as it was a case of emergency, adopt[ed] the flag of the United States of American with little variation."[78] To the rest of the world, the Lone Star and Stripes remained the Texas flag, at least until 1839. An 1837 color chart printed in Philadelphia depicting the "flags of the principle nations in the world" confirms this. It pictures both national flags and naval ensigns for those countries that possessed them. The chart shows only one flag for the Republic of Texas — the Lone Star and Stripes.[79]

Despite the hopes of Anglo-Celtic settlers, Santa Anna's defeat had not allowed Texas to join the North American union. Thus, the lone five-point star that they had borne on so many battlefields would not immediately take its place in the canton of the Stars and Stripes. Texians, however, had gained a symbol that they would come to regard as their birthright.

(3)
Republic of the Lone Star

Almost ten years would pass before the lone star of Texas joined the U.S. constellation. The people of Texas desired annexation, but in Washington clouds of sectional discord were gathering. The northern states, with their burgeoning industrial and commercial interests, feared that adding Texas to the Union would upset the precarious balance of political power they shared with the slave-holding, agrarian South. In August, 1837, President Martin Van Buren's administration informed the Texas minister to the United States that the proposition of annexation would not even be considered.

To Mirabeau B. Lamar, who became the second president of the Republic, and to many of his fellow Texians, this rejection was just as well. Lamar, who had been vice-president under Houston and himself a hero of the battle of San Jacinto, believed Texas' destiny was to remain independent and eventually expand its territory all the way to the Pacific Ocean. In 1836, with more than a hint of hubris, the Texas Congress had set the borders of the republic to include all the territory east of the Rio Grande. Even more optimistically, in 1842 the government added claims for both upper and lower California, all of New Mexico, and great swaths of what is now northern Mexico. While union with the United States remained a forlorn hope, the Republic of Texas would grasp for ways to implement this grandiose destiny, and for this task a new national banner was required.

Within weeks of Lamar's December 10, 1838, inauguration, efforts began to change the flag to reflect this new aggressiveness. Until that time, the Lone Star and Stripes banner with its close resemblance to the U.S. flag had well reflected the aspirations of most Texians. But according to Sen. Oliver Jones, "the future prospects of Texas are of such a flattering nature that the National Independence requires that her Arms, Seal, and Standard assume also an independent character, by a form which will not blend with those of any other nation." [1]

History does not record with certainty who suggested the design for the new lone-star flag.[2] But on December 28, 1838, Sen. William H. Wharton introduced a bill containing a description of the proposed flag, which was referred to a committee chaired by Senator Jones. The statute specified that "the national flag of Texas shall consist of a blue perpendicular stripe of the width of one third

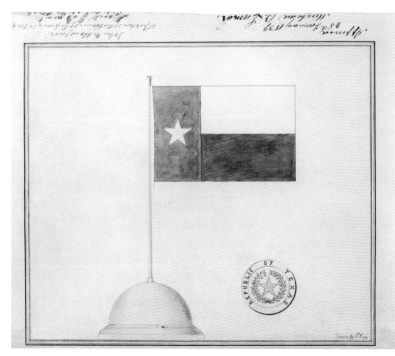

Figure 38. *Texian Flag. Austin artist Peter Krag made the original color sketch of the design for a flag of the Republic approved by congress on January 25, 1839. Courtesy of the Texas State Library and Archives Commission.*

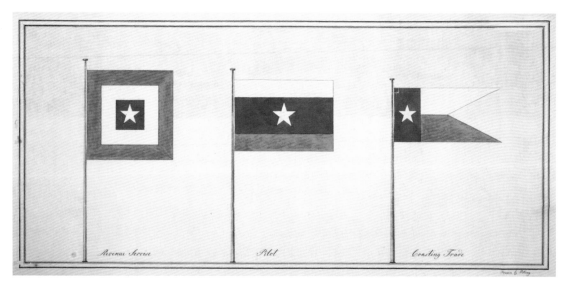

Figure 39. *Texian Maritime Auxiliary Flags. Krag also sketched the pennants selected for use by Texas merchant vessels. Courtesy of the Texas State Library and Archives Commission.*

the whole length of the flag, with a white star of five points in the centre thereof, and two horizontal stripes of equal breadth, the upper stripe white, the lower red. Of the length of two thirds of the whole length of the flag."[3] On January 4, 1839, Jones reported his committee's version of the bill to the senate and for a ten-dollar fee commissioned Austin artist Peter Krag to produce a color likeness of the proposed flag.[4] The committee's design must have pleased the members, because on January 25, 1839, congress adopted Jones's bill and Texas had a new national flag.[5] The new banner would also supersede the Lone Star and Stripes as the Republic's naval ensign, and the people of Texas referred to the new lone-star banner as the "Flag of the Republic" or simply the "Texian Flag."[6]

The design, brilliant in its simplicity and visually unforgettable, remains one of the best-known symbols in the world. Despite the Texians' intention to create a flag that would emphasize their independence, they had self-consciously produced a design that was nothing more than a simplified version of the U.S. Stars and Stripes. Jones's report of January 4 had made this quite explicit. The features of the Texian Flag would not blend into the Stars and Stripes. Instead, he wrote, Texas would "maintain its independent station among the nations of the earth," and "the transition of the single star into the American constellation and the merging of the single Texas stripe with the thirteen stripes of the United States" would be unadvisable.[7]

Congress did not completely discard the previous national flag. A provision designated the National Standard with the yellow star on a blue field, which had been adopted in December, 1836, as the Republic's war flag.[8] It seems doubtful that this flag was ever employed in such a capacity. No contemporary account mentions its use by either the army or the militia, and no authenticated example has survived. Instead, the evidence makes clear that soldiers and volunteers of the Republic usually carried the new Texian Flag (see plate 5).

Farseeing Texians shared the aspiration that their country would become a great commercial power. Even though congress could not provide funds to build dock facilities, dredge harbors, and encourage trade, they at least created a set of flags that any fully equipped maritime nation would require. The January flag

statute included provisions for a pilot's flag, a revenue-service flag, and a flag to be flown by coastal trading vessels. Peter Krag produced renderings of these flags, whose designs were all variants of the Texian Flag.[9] Texas sea traders and port and customs officials, however, made do with the Flag of the Republic for most functions. There is nothing to indicate that any examples of these auxiliary flags were ever made.

The first known official military application of the Texian Flag came only a few months after its adoption. On May 23, 1839, Secretary of War Albert Sidney Johnston issued an order prescribing uniforms and equipment for the Texas army. A section dealing with cavalry flags dictated that each mounted regiment "will have a silken standard . . . the same as the national color, with the number and name of the regiment, in a scroll above the star. The flag of the standard will be two feet six inches wide, and two feet four inches on the lance." [10] No orders for regulations regarding the use of the national flag by the infantry or militia companies are known, but the new colors would soon be a common sight when Texians again took the field against their old enemies.[11]

Continued Conflict

Houston's victory at San Jacinto had not ended the war between Texas and Mexico, and throughout the era of the Republic, the conflict smoldered and flared. After the April, 1836, battle, the undefeated portion of the Army of Operations withdrew below the Rio Grande, but Mexico had every intention of continuing the war and reclaiming what it had lost. In preparation for a fresh invasion of Texas, the government immediately dispatched reinforcements. These replacement troops, however, did not reach the Rio Grande until late January, 1837. By that time Mexican forces there were in such poor condition that offensive action in the near future was out of the question.

No advance would come for nearly five years. In 1837 the central government in Mexico City faced two separate uprisings in the interior, and the army on the Rio Grande had to dispatch troops to suppress these rebels. From 1838 until 1840, internal turmoil and foreign interference continued to distract Mexico from its mission to recover Texas. The so-called Pastry War against French intervention lasted from November, 1838, to March, 1839, and a revolt

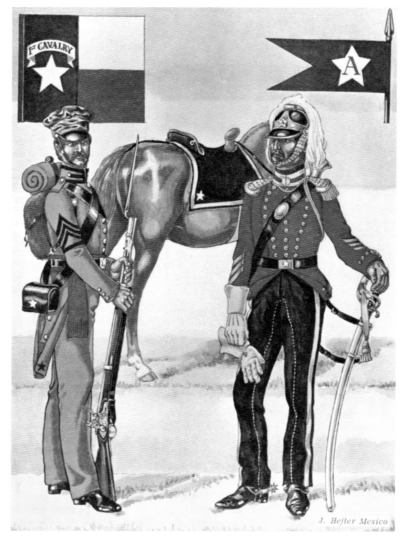

Figure 40. *Cavalry Flags of the Republic of Texas according to 1839 Regulations. On the left above the infantryman is a Texas regimental color, and to the right above the cavalry trumpeter is a troop guidon. Both soldiers wear regulation uniforms of the Texian army. From the collection of the Old Army Press, copyright © 1971.*

by federalists, which for a time threatened the lower Rio Grande, ended only in March, 1840. Not until 1842 would the various conflicts and uprisings abate long enough for Mexico to consider offensive action against the impudent Anglos to the north.[12]

Conflict with Mexico exposed basic weaknesses of the young Texas republic and gave pause to its dreams of empire. Substantial

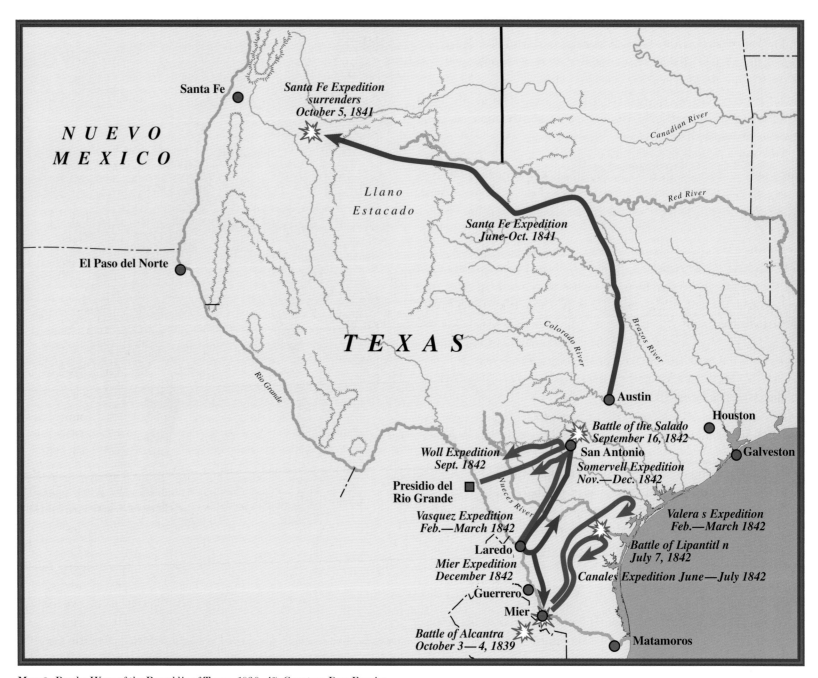

Map 2. *Border Wars of the Republic of Texas, 1836–47. Courtesy Don Frazier.*

forces of Mexican raiders moved almost at will across Texian territory, and lack of training, discipline, and resources hobbled military retaliation. In New Mexico, Lamar's feeble attempt to implement his grand design was easily crushed by hastily gathered detachments of militia and rancheros. Yet Mexico, also stretched to the limit of wealth and manpower, profited little from its small victories. Texas remained independent, and Mexico gained only a handful of flags for the effort. In the period from 1839 to 1843, Texian forces lost at least eight flags. The Mexican government, always in a precarious position politically, highly prized these captured banners as tangible evidence of its army's prowess. Seven were sent to Mexico City, where they were unfurled in patriotic celebrations and displayed in national shrines. Six still exist today and ironically account for all but one of the flags of the Texas republic known to have survived. The first to be lost came as a consequence of Texian adventurers' involvement in the fighting between federalists and centralists along the Rio Grande.

In 1839 the Texas government commissioned Reuben Ross, a former army official and captain of a ranging company, to raise a volunteer regiment to defend the southwest frontier. The region, which was subject to frequent depredations by bandit gangs made up of Anglos as well as Mexicans and Indians, encompassed San Patricio, Refugio, and Victoria Counties. Part of the gear the government authorized for Ross's regiment was a Texian Flag. About this time revolt erupted along the lower Rio Grande between the central government and federalists rebels of northern Mexico, who desired to reimplement the liberal constitution of 1824. The federalist leader, the unctuous Laredo lawyer Antonio Canales, desperate for help and not particular about where it came from, called for Texas volunteers to join in the fight. Colonel Ross concluded that the best way to protect the frontier and at the same time distract Mexico was to offer his regiment to Canales. The federalists lured additional Texian volunteers by offering the possibility of spoils, a monthly stipend of twenty-five dollars, and the promise of a half-league of land when the war successfully concluded.[13] The rebels agreed to the further condition that the Texians could operate as a separate command and fight under their own flag.[14] Canales, however, soon realized that the presence in his forces of a unit flying the

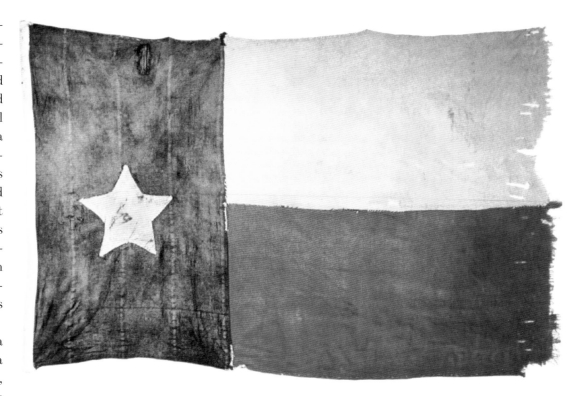

flag of his nation's enemy would seem sinister to his countrymen. Over the protests of Ross and his men, he ordered that their Texian Flag be left behind.[15] The Texians ignored the order. At least one account of the campaign reported the flag flying in triumph over the town of Mier.[16]

This unusual alliance between Mexican and Texian proved successful at first. On September 30, 1839, Ross's 229 Texians joined Canales's 400 federalist troops and crossed the Rio Grande. The little army forced the centralists out of the town of Guerrero and pushed on to capture Mier. A few days later, twelve miles southwest of Mier, the federalists, with Ross's men in the vanguard, overtook a retreating enemy force of five hundred Mexican army regulars and four pieces of artillery. In the pitched battle that followed, and with the Texians doing most of the fighting, the rebels heavily defeated the centralist army and forced its surrender.[17] The defeated commander, Col. Francisco Pavon, disdained Canales and his Mexicans as traitors and refused to treat with them. "To the

Figure 41. *Texian Flag of Ross's Regiment. When Reuben Ross led a force of Texian soldiers to fight with the federalists in northern Mexico in 1839, they carried this flag with them. Collection of the Star of the Republic Museum. Gift of L. Cletus Brown, Jr.*

brave Texans I surrender," he announced, "they are my conquerors," and handed over his battalion's flag and his sword to Maj. Joseph Dolan of Ross's command.[18]

After the victory, the uneasy alliance between Texian and federalists began to unravel. For forty days after the battle, Canales refused to order any further operations, and while his little army languished in Mier, the centralists regrouped. In mid-December, when Canales finally stirred and federalist forces advanced on Matamoros, they found a substantial army of Mexican regulars firmly entrenched around the town. Even though the Texians had offered to storm the defenses alone if need be, Canales decided against an attack. Disillusioned by this lack of resolve, Colonel Ross and fifty of his men departed for home.[19] Other Texians would come and go from the mongrel army, but any hopes of defeating the centralists ultimately proved futile. Canales himself would abandon the federalist cause and later become the bane of his former Texian allies.

At the time of the uprising along the Rio Grande, and despite his expansionist ambitions, President Lamar still hoped the Mexican government would recognize Texas independence. To keep diplomatic channels open he acted to assure the centralists in power that the Texians fighting alongside federalist rebels did so without official sanction. The volunteers who had originally ridden with Ross were technically still enlisted in the Texas army, so Lamar dispatched his assistant adjutant general, Lt. Col. Benjamin H. Johnson, to the Rio Grande to order Ross and his men home. If they refused, they would be declared deserters. Johnson was also to reclaim any government property still in possession of the federalist-allied Texians.[20]

Johnson journeyed to the Rio Grande and delivered his message to the Texians there in mid-November but failed to induce any of the them to return. He was so unconvincing that several members of his own party, induced by promises of land and plunder, deserted to Canales. His message delivered but his mission a failure, Johnson headed for home. He did not, however, leave completely empty-handed. Johnson had been able to reclaim the Texian Flag the government had authorized for Ross's regiment. Johnson and his party of seven, which included two Mexican servants, crossed the Rio Grande at Mier and headed up the road to San Patricio. Along the way a band of Indians and Mexican outlaws ambushed

them. The outlaws stripped the unfortunate Texians of their clothes, murdered them, and hung them from trees by their heels. The servants, one severely wounded, somehow escaped to Matamoros. The marauders also took Ross's flag. Unlike other Texas flags captured during this period, the one Johnson's party lost never became an official Mexican trophy of war. Historian John Milton Nance speculated that the bandits kept the flag rather than turning it over to Mexican authorities for the reward customary for such articles because they feared their crime would be exposed and justice would be delivered by the Texians in federalist service. By the middle of the twentieth century, the flag had ended up in the town of Camargo, where for decades it hung on the wall of the local police station.[21]

Lamar's desire not to provoke Mexico, however, did not check his expansionist impulse indefinitely. The president's dream was for the Republic to extend its boundaries to the Pacific Ocean, but before this could be contemplated Texas would have to establish its claim to the Rio Grande as its western boundary. Most of the population of New Mexico resided on the eastern bank of the river and thus, in the opinion of the government, within Texas. Heeding reports that the inhabitants of the region favored union with the Republic, Lamar, on his own authority, raised and equipped an expedition to occupy the region. According to a participant in the events that ensued, "The universal impression in Texas was that the inhabitants of Santa Fe were anxious to throw off a yoke . . . and rally under the 'lone star' banner."[22]

Just after the middle of June, 1841, the "New Mexico Pioneers," as the members of the expedition were called, gathered at Brushy Creek just north of Austin. The civilian contingent included three government commissioners and an assortment of fifty "merchants, tourists, and servants." The expedition's leaders assembled a train of twenty-one wagons to convey supplies and trade goods, and rounded up a large herd of cattle to provide food for the journey. For protection against Mexican bandits and hostile Indians, Lamar assembled the most splendid body of Republic of Texas troops since San Jacinto. The 265 volunteers and 10 officers were organized in 5 infantry companies, an artillery company complete with a brass six-pounder, and a band of 5 musicians. All wore new blue uniforms, and even though only two companies were equipped as

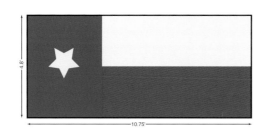
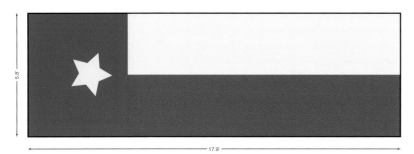

tured the unresisting survivors in two groups. The Mexican commander reported that the Texians "surrendered unconditionally without firing a single shot, their war equipment and everything of interest they carried with them, was left at my disposal, along with two flags." [25] The Mexicans treated the unfortunate Texian prisoners brutally, and during the horrendous forced march to Mexico City, many died. Armijo sent the two captured flags to the Mexican capital.[26]

As a result of the Santa Fe incursion, Sam Houston, who had regained the Texas presidency in 1841, now had to face an alarmed and newly aggressive Mexico. Toward the end of that year the old nemesis Santa Anna had reestablished himself as Mexican president and was determined to wage active war against his country's impertinent former province. Although he lacked sufficient forces to invade and hold Texas at that time, Santa Anna, to remind the world that hostilities still existed, ordered a series of raids. The first of these came in January, 1842, when Col. Raphael Vasquez led seven hundred picked troops to penetrate and harass the Texas frontier. This unexpected move forced the residents of San Antonio to flee, and the Mexicans occupied the town on March 5. Two days later, his purpose fulfilled, Vasquez ordered his troops back to the Rio Grande. At the same time another force under Capt. Ramon Valera briefly took Goliad.

Now it was the Texians who caught "war fever." The raids led to a general clamor for reprisals, and Houston agreed to retaliate. Volunteer companies began assembling at Lipantitlán on the Nueces River for a foray into Mexico. The government also sent out calls to the United States for emigrants to arm themselves, form into military companies, and come to the aid of the Republic. Many of the volunteers from southern states came by ship to Galveston and Corpus Christi and marched overland to the Nueces camp.[27] By June four hundred would-be soldiers, mostly from the United States, were under the command of Gen. James Davis and in camp at Lipantitlán.[28] The Texas government, however, lacking both money and credit, could not find the resources to sustain a campaign, and the soldiers were soon short of supplies. Bored and often hungry, the volunteers fell into drunkenness, fighting, gambling, and other vices. Desertion became common, and whole companies departed without permission. Within a month the

Figure 42. (top) Texian Flag of the Santa Fe Expedition. Pictured is one of two Texian Flags captured from the ill-fated 1841 Santa Fe expedition. (middle) Lipantitlán Texian Flag. This "tricolor of red, white, and blue," taken in the abandoned camp, may have been the Texian garrison flag. (bottom) Texian Flag of the San Antonio Garrison. When Mexican general Adrian Woll's forces took San Antonio in September, 1842, they captured the town's Texian Flag. Drawings by Anne McLaughlin, Blue Lake Design, Dickinson, Texas. (Images based on photographs)

cavalry, each soldier was mounted. As their color they carried the Flag of the Republic. The citizens of Austin gave the "pioneers" a "handsome farewell demonstration." A lady on their behalf presented Gen. Hugh McLeod, the expedition's leader, with a second Texian Flag. Lamar also visited the camp and, on horseback, reviewed the troops and delivered what was termed an "inspiring speech."[23] Under two "lone star banners," the ill-fated caravan departed on June 20, 1841.

None of the participants was prepared for what lay ahead. The expedition suffered horribly on its trek across West Texas. With little real knowledge of this brutal wilderness, the exhausted men were often lost, experienced shortages of food and water, and were frequently harassed by Comanches. Worse, when they finally stumbled into New Mexico, the Texians discovered the inhabitants were hostile to Lamar's proposal of union.[24] By early October Gov. Manuel Armijo, leading a force of New Mexico militia, had cap-

Figure 43. *Galveston
Invincibles Flag. The
Galveston Invincibles,
a volunteer company,
abandoned its flag when it
departed the Texian camp at
Lipantitlán on the Nueces
River. Drawing by Anne
McLaughlin, Blue Lake
Design, Dickinson, Texas.
(Image based on photograph)*

Texas commander watched his forces melt away to less than two hundred.[29]

Word of the Texians' disarray soon reached the Mexican settlements on the Rio Grande. Ironically, in command of seven hundred government troops near Matamoros was Antonio Canales, former leader of the federalist rebellion. Now, with his coat well turned and at peace with the centralists and Santa Anna, he intended no mercy toward his former allies. Mustering his forces, Canales marched for the Nueces. After an uneventful trek, he and his army arrived near the Texian camp at Lipantitlán on the night of July 6, 1842.

Davis became aware of the Mexican approach and hastened to preserve his outnumbered command. The Texian encampment had been pitched on a small hill surrounded on three sides by the high banks of the Nueces River. The fourth side, however, was unprotected by either artillery or fortifications. Davis judged his position to be untenable, and with tents standing and campfires burning, he abandoned most of his supplies and ordered his men into a clump of nearby trees. At dawn the Mexicans overran the abandoned position. Scouts soon discovered the Texians, and Canales immediately ordered an attack. Holding their fire until the last minute, Davis's men loosed a volley that halted the main assault. The Mexicans became more cautious, and the fighting diminished to desultory skirmishing that died out at sundown.

The casualties on both sides were light, one Texian and three Mexicans killed, but the Texians had lost their camp and most of their possessions. With them went Davis's official papers, all the gear the volunteers were not carrying: tents, blankets, kettles, barrels of powder, nearly seventy fire arms, "some filthy rags, and two flags and one standard."[30] The most conspicuous flag Canales's men had scavenged from the Texian camp was that of the Galveston Invincibles. The impressive red silk banner displays a white lone star in the center with the words "Galveston Invincibles" painted above and "Our Independence" below. The volunteers who carried the banner never got the opportunity to discover if their company was indeed invincible, because by the time the Mexicans approached, these "fair-weather" patriots were long departed. Having no more use for their fine flag, they had left it behind. When the camp was overrun, the captain of Canales's rifle company claimed the banner for the glory of Mexico.[31] A contem-

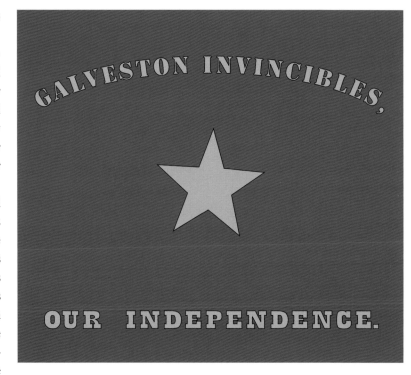

porary American newspaper account informed its readers that the taking of the abandoned flag was unimportant because "had it not been captured with the old kettles . . . it would have been made a dish cloth, instead of a splendid trophy of Mexican victory."[32]

A second flag left behind was what the captors referred to as a "standard." This captured color was a Georgia militia flag that a volunteer company from that state had brought to Texas. The obverse shows a beautifully painted rendition of the Georgia state seal on a blue field. The design of the seal dates from 1799 and depicts three pillars, labeled "Wisdom," "Truth," and "Moderation," supporting an arch that represents the Constitution. Next to the arch stands a minuteman of 1776 with sword drawn ready to protect the Constitution.[33] The reverse reveals an oil portrait of a mounted knight in golden armor set against an expansive pastoral landscape.[34]

Canales referred to the third flag taken at Lipantitlán, which was recovered by a corporal of the Mier cavalry, as a "Texas banner."[35] A contemporary account by one of the Anglo participants

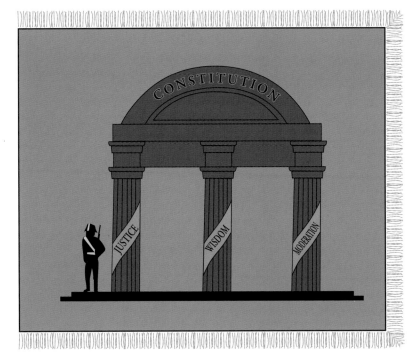

Figure 44. *Georgia Militia Flag. This flag of a Georgia volunteer company, which displays the state seal on the obverse and a knight in golden armor on the reverse, was also abandoned at Lipantitlán. Drawing by Anne McLaughlin, Blue Lake Design, Dickinson, Texas. (Image based on photograph)*

makes it clear that this was a Texian Flag. He described it as being a "tricolor of red, white, and blue worsted with a white star sewn to the blue band."[36] Since there were no other volunteer companies from Texas at the fort, the "Texas banner" was probably the garrison flag (see fig. 42).

All three captured flags became cherished trophies of war. After Canales distributed the camp loot to his troops, he placed the three flags in the care of Capt. Gabriel Trevino of the Reynosa Auxiliaries. Trevino rode south with them to the capitol, where he presented them to the minister of war on July 22. The flags soon went on display in Mexico City. There, amid general rejoicing, Santa Anna celebrated the occasion with fireworks and a review of his troops.[37]

A few months after Canales drove Davis out of Lipantitlán, Santa Anna sent the most formidable of his marauding expeditions into Texas. Beginning on September 11, 1842, Gen. Adrian Woll, a Frenchman long in Mexican service, with 1,200 soldiers retraced the path of the 1836 invasion. When the Mexicans moved on San Antonio, the citizenry was completely unprepared for the surprise attack and quickly surrendered. In victory Woll's soldiers behaved well, treating captured Texians as prisoners of war, and no organized looting was tolerated. The Mexican general allowed many of the residents to depart with all their possessions except for arms.[38] As a matter of honor the defenders had tried to prevent the capture of the town's large Texian Flag. They removed it from the pole where it had flown and hid it beneath a large pile of rocks. Mexican troops soon discovered the banner, however, and presented it to General Woll. The Mexican commander dispatched to the ministry of war in Mexico City his report of the campaign along with the flag of the San Antonio garrison, which joined the other captured Texas flags (see fig. 42).[39]

As soon as Houston heard of this new Mexican entrada, he called a general mobilization of the militia. Companies from all over southeast Texas formed at their muster points, elected officers, and headed to San Antonio by the most direct route. As was customary, local citizens presented their departing volunteer com-

panies with homemade battle flags. For instance, in a formal ceremony the residents of Houston presented a "handsome flag" to the Harris County militia when it assembled in the town square.[40] Citizens of Washington-on-the-Brazos cheered as the Montgomery County volunteers marched through town beneath a "very large blood red flag, with a lone white star and the motto, Independence, emblazoned on it."[41] Other gathering companies mustered under locally produced versions of the Texian Flag.

Within a few days of the town's capture, advance elements of this Texas citizens' army began to encircle San Antonio. On September 18, a company of rangers led by Capt. Jack Hayes entered the town hoping to lure some of the soldados into a trap. Some miles away, concealed in the woods along the bed of Salado Creek, was a force of two hundred Texians lying in ambush for any Mexicans Hayes and his cohorts could lead their way. The plan succeeded too well. When pickets spotted Hayes's intruders, Woll called out not the small detachment the Texians had planned for but the main Mexican body of five hundred infantry, cavalry, and artillery. In a mad dash across the prairie, the rangers barely escaped hard-riding Mexican horsemen to the relative safety of the Texas positions. For most of the rest of the day, the outnumbered Texians sniped at Woll's men from the cottonwoods, cedars, and live oaks that lined the creek bed. Near dusk, the Mexican commander launched a general assault that was repulsed by the marksmanship of the concealed Texas riflemen. When the Mexicans fell back they left sixty dead on the field. Only one Texian was killed. Two days later General Woll evacuated San Antonio.

While the Texians were turning back the Mexicans on the Salado, nearby a volunteer company from La Grange in Fayette County met disaster. As they hurried toward the sound of the gunfire, Capt. Nicholas Dawson and his fifty-three men collided with a force of several hundred Mexican horsemen and two cannon. Even though trapped on the open prairie, the stubborn Texians at first refused to surrender. Only after the enemy cannon had cut down half his men did the wounded Dawson raise a white flag. The Mexicans, however, had passed the point of granting quarter and continued to pour on with musket balls and grapeshot. Only seventeen Texians survived the massacre.[42] The victorious Mexicans carried

the flag of Dawson's unlucky company off the field, and Woll must have seen that it got to Mexico City. Contemporary sources do not mention the capture, but today the homespun cotton flag survives in the Museo Nacional de Historia. It is a Texian flag with a motto painted on the white bar that time has mostly obliterated.

Only the words "Fayette" and "Try" are still legible, but these are enough to identify the flag as that of the hapless volunteers from La Grange.[43]

With Woll's departure, the infuriated Texian militiamen who continued to descend on San Antonio clamored for a full-scale counteroffensive. The citizens of LaGrange, whose friends and neighbors had been slain along with Captain Dawson, were particularly thirsty for retribution. They elected Dawson's cousin William Eastland captain of a second Fayette County volunteer company, and, in what must have been a grim ceremony, the ladies of the area presented them with a Texian Flag similar to the one lost. The words inscribed on the white bar, "Revenge or Death," unambiguously proclaimed their grim purpose.[44]

In mid-November the Texas army, now numbering more than seven hundred men under the command of Gen. Alexander Somerville, departed from San Antonio for the Rio Grande. The marching column probably bristled with lone-star flags. A few weeks later the volunteer army took Laredo and Guerrero without a fight. But short on supplies and apprehensive that a large Mexican army lurked nearby, Somerville ordered a retreat to the settled areas above the Nueces. The captains of six companies, including Eastland's LaGrange volunteers, asked Somerville for permission to continue with their troops down the Rio Grande to obtain supplies, horses, and collect tribute from the settlements along the river. Somerville refused and began the journey back. Three hundred men intent on mayhem toward the Mexicans disobeyed orders and vowed to press ahead.[45]

Events endorsed Somerville's prudence. A large Mexican army under Gen. Pedro de Ampudia intercepted the interlopers at the town of Mier, and, after losing a desperate battle there, the Texians surrendered on the day after Christmas. The only color the Texians flew at Mier was the Texian flag of the LaGrange company. General Ampudia demanded its surrender as part of the terms of capitulation, but the color-bearer, James L. Blanton, tore the flag to bits to prevent its capture. When he heard the news, Ampudia offered one hundred dollars for the pieces, but Blanton apparently had burned them.[46] For once Santa Anna was deprived of a trophy.[47]

The fate of the Mier prisoners is well known. They were forced into a long and brutal overland march to Mexico City, during which the legendary black-bean episode occurred. Those who had escaped the nightmarish journey and the decimation were placed in Perote Castle along with survivors of the Santa Fe Expedition and some of those taken at San Antonio.[48] The eventual release of all these prisoners, coupled with the impracticality of either side launching further forays, led to a cooling of the hostilities between Texas and Mexico that lasted until 1846.

One outcome of the trouble with Mexico was the emergence of the Texian Flag as the popular symbol of Texas. Although many volunteer companies flew lone-star banners of various designs, most probably mustered and marched under the Flag of the Republic. No source mentions the use of the war flag with the blue field and yellow star. In the summer of 1842, Sam Houston himself had ordered that all Texas troops in the field were to carry the Texian Flag.[49]

In those days, no two Texian Flags were exactly the same. Flag makers tended to ignore the proportions prescribed by the 1839 law, and the statute was vague about the dimensions and position of the star. As a result, flags of the Texas republic came in various sizes and symmetries. Of the six surviving Texian Flags, no two are the same size; four have tilted stars, and none looks exactly like Krag's 1839 painting. The orientation of the Texian flag could also be a source of confusion. Well into the 1860s artists made images of the national flag that appear to show it upside down — that is, with the red stripe above the white. A reason for this seeming inaccuracy could have been confusion on the part of those who had never seen a Texian Flag in person. A more likely explanation, however, is that Texians were careless or insouciant when they raised their flags, with the occasional result that they flew them upside down. There is evidence, however, that regardless of the 1839 statute requirements, some Texians preferred the red stripe uppermost. The orientation of the inscription on the Texian Flag of Dawson's Fayette County company suggests it was intentionally made with the red stripe on top. Since most Texian Flags had no writing on them and because the lone star was rarely displayed fully upright, Texians felt free to fly their flags in any position they desired — and apparently did so.

CHURCH and FORT of the ALAMO, Sanantonia de Texas. 1839.

Figure 46. *Texian Flag over the Alamo, 1839. This drawing probably depicts the flag Mexican forces captured in 1842. Texians often displayed the Flag of the Republic with red stripe uppermost, and some were constructed in that manner. Courtesy of the Center for American History, the University of Texas at Austin.*

Until well after the Civil War, Texas flags were literally made by the hands of the people. It fell to local women to sew flags for their communities. These rustic flag makers used whatever material was available. Silk was the first choice, but in Texas it was often unavailable. Thus, when the need arose, women converted their silk dresses and bolts of silk fabric meant for ball gowns into flags. When even this silk ran out, seamstresses resorted to using homespun cotton and wool. These materials deteriorated rapidly and did not hold dye or "fly" as well as silk. Each Texas flag produced in this manner was a unique expression of its maker and in a sense an authentic work of folk art.

The Texian Flag Discarded

The discord with Mexico had contributed to a renewed interest in Texas by the people of the United States. Sympathy for the prisoners of Mier and Santa Fe, coupled with apprehension of inter-

ference by Britain and France in the region, led President John Tyler in 1843 to open negotiations with Houston's government for a treaty that would annex Texas. The two parties reached an agreement the following year, but animosity between North and South remained strong, and the U.S. Senate rejected the treaty. The question, however, was far from being settled. The presidential election of 1844 developed as a national referendum on the annexation of Texas. The Democrats who favored annexation nominated James K. Polk of Tennessee. The Whig party, which represented the business and commercial interests of the North, was opposed to the addition of any more slave states. Its delegates chose Henry Clay to carry their standard.

Politics in the 1840s was a raucous business. Beginning in 1828 Andrew Jackson and his adherents had changed the way elections were conducted. Under the general heading of Jacksonian Democracy, Old Hickory's partisans appealed for the participation and votes of the mass of common citizens. Elections became as much about entertainment as ideology. Rallies with musical acts, torchlight processions, and balls were held—punctuated with high-flown rhetoric and lubricated with abundant supplies of alcohol. In the three national elections, from 1829 to 1840, Democrats pummeled the more staid Whigs, putting Jackson in office twice and electing Martin Van Buren his successor.

The Whigs, however, overcame their distaste for democratic electioneering, and in 1840 the Party leadership resolved to "out-Jackson" the Jacksonians. They selected their own "Old Hickory" in the person of William Henry Harrison, a nondescript politician whose fame rested on his military victory over the Shawnees at the battle of Tippecanoe. With the masses in mind, Whig handlers fabricated the famous "Log Cabin and Hard Cider" campaign that depicted Harrison, who was in reality a man of some means and sophistication, as a hard-drinking, rustic champion of the common man. Their selection of John Tyler for vice-president resulted in one of the most famous campaign slogans in U.S. history, "Tippecanoe and Tyler Too."

In an era when literacy was not universal, political symbols were particularly important. Whigs flooded voters with images of log cabins on such items as lithographs, shaving mugs, and porcelain plates. They stamped "Tippecanoe and Tyler Too" on medallions,

Figure 47. *1840 Whig Party Flag, "Hero of Tippecanoe." In 1840 the Whig Party began using variants of the Stars and Stripes to advertise its candidates to the masses. Drawing by Anne McLaughlin, Blue Lake Design, Dickinson, Texas.*

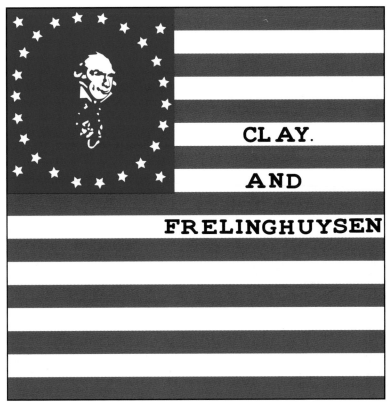

Figure 48. *1844 Whig Party Stars and Stripes Campaign Banner. "Clay and Frelinghuysen." The Democrats copied this design for their own campaign flag and added a blue star outside the canton to represent Texas. Drawing by Anne McLaughlin, Blue Lake Design, Dickinson, Texas.*

pins, buttons, and dozens of other everyday objects. The Whigs even modified and subverted the U.S. flag as a partisan political device. A rare surviving cotton banner from that year is a square variant of the Stars and Stripes, with seventeen stripes in the field. The blue canton contains a large five-point star orbited by twelve smaller stars. In the center of the seventeen stripes is painted a cameo portrait of Harrison, under which is inscribed "The Hero of Tippecanoe."[50] This sort of candidate's flag would become a staple of American electoral politics until 1905, when Congress outlawed the practice.

During the 1844 presidential election, flags assumed a central role in the pageantry of the campaign. Two surviving Whig flags from that election are also variants of the Stars and Stripes. One

was similar to the 1840 model, with its central star and orbiting constellation, but instead of candidate Henry Clay's portrait, a cartoon of a raccoon, which was the Whig Party symbol, adorns the stripes of the field. The second flag is closer to the pattern that would be common in presidential elections for the rest of the century. It is a square, eighteen-striped flag with the names of the Whig candidates, "Clay and Frelinghuysen," painted on the middle white stripes. A portrait of Clay surrounded by a wreath of twenty-six stars decorates the canton.

The Democrats, knowing a good thing when they saw it, borrowed the pattern and expanded its symbolism to reflect their chief issue—the annexation of Texas. A surviving rectangular cotton banner displays "Polk and Dallas" on the middle white

AUSTIN ABOUT 1839 OR 1841.

Polk, his campaign crystallized by the symbolism of the lone star, won the election. Before he left office, President Tyler interpreted the narrow victory as a mandate for action on Texas. He requested that Congress offer annexation by means of a joint resolution. The bill passed, and as one of his last acts as president, on March 1, 1845, John Tyler signed the document by which the United States offered Texas statehood. Despite the flirtations with expansionism and almost ten years of independence, most of the people of Texas still desired statehood and voted overwhelmingly to accept its offer. The signature of President James K. Polk on December 29, 1845, officially made Texas the twenty-eighth state.

A solemn ceremony at the state capitol proclaimed the end of the Republic of Texas. On February 19, 1846, a large crowd, which included officials of the old government and the recently elected members of the new, gathered by the steps of the capitol in Austin. Anson Jones, last president of the republic, standing on a platform decorated with a portrait of Stephen F. Austin and flanked by the banners seized from the Mexican battalions at San Jacinto, delivered the valedictory.[54] At the end of his remarks, which were frequently interrupted by applause, he lowered and reverently furled the Texian Flag. Jones declared "amidst breathless silence, 'The republic of Texas is no more.'" Noah Smithwick, who was present that day, recalled at that moment "many a head was bowed, many a broad chest heaved, and many a manly cheek was wet with tears when that broad field of blue, in the center of which . . . glowed the lone star, emblem of the sovereignty of Texas, was furled."[55]

Elation soon dissipated the momentary nostalgia for the Republic. As the Stars and Stripes was run up the same pole where the old flag had fluttered, a nearby cannon boomed out a salute (see plate 7). The Texians gathered below had achieved the thing most of them wanted most — to be reunited with the nation of their origin. As the flag caught the breeze, "cheer after cheer rent the air."[56] This particular style of lone-star flag had served its purpose, and Texans had no intention of unfurling it again. According to Jones, the Texian Flag should assume its place "among the relics of the dead republic."[57] It would take the greatest tragedy America ever suffered to bring it out again.

Figure 49. Texian Flag atop Capitol. This color sketch shows the Flag of the Republic flying over the capitol in Austin. When the flag was lowered from this spot in 1845, Texans intended that it should take its place "among the relics of the dead republic." Courtesy of the Austin History Center, Austin Public Library.

stripes of the field. The twenty-six-white-star canton is nearly identical to that of the second 1844 Whig flag, but with a portrait of Polk in the place of Clay. Just outside the canton, poised as if pleading for entry, is a single blue star representing Texas. The symbolism was obvious to all; only when the lone star of Texas joins the stars of the other states will the American constellation be complete (see plate 6).[51] Voters understood that the lone star on banners and other campaign gewgaws represented Texas. A newspaper observed that in rallies for the Democrats in both North and South, "the Lone Star was blazoned on high beside the Stars and Stripes."[52] During their demonstrations, Whigs sometimes carried flags representing Texas but draped them in black and were escorted by a young ladies dressed for mourning.[53]

**(4)
Secession's
Lone Star**

In 1860 Texans assigned their lone star a new significance. Americans in the first part of the nineteenth century had recognized the five-point single star as a symbol for the overthrow of tyranny and union with the United States. Its usage during the Revolution and Republic transformed the lone star into the special badge of the Texas community. With annexation Texas became the "Lone Star State," but lone-star flags would be discarded. In the later part of 1860, however, they reappeared in great numbers, not just in Texas, but throughout the South.

For the people of the region the symbolism was similar to that of the 1830s, but with a major difference. The lone star still meant resistance to tyranny — in this case to that of the government of the United States. Now, the southern states wished to reclaim their stars from the canton of the federal flag. In the midst of secession's turmoil, they would reassemble each star into a constellation that crowned the red and white bars of a new national flag.

Manifest Destiny's Harvest

The annexation of Texas brought war with Mexico. In July, 1845, President James K. Polk had sent an army under the command of Gen. Zachary Taylor to Corpus Christi to monitor Texas' claim to the Rio Grande as its southern boundary. The following April, after diplomatic efforts had failed to produce an agreement with Mexico, the president ordered Taylor into the disputed region south of the Nueces. A Mexican army awaited him on the Rio Grande, and inevitable clashes between the two sides quickly escalated into a general war.

The U.S. victories that followed fulfilled even the ambitious Polk's most lofty goals for Manifest Destiny. Taylor triumphed along the Rio Grande, and Gen. Winfield Scott led an American army overland from Vera Cruz to conquer Mexico City. Parties of regulars and volunteers occupied the provinces of northern Mexico. The February, 1848, Treaty of Guadalupe Hidalgo ended the war and forced Mexico to relinquish California, New Mexico, and all claims to Texas, in return for $15 million. The Mexican War had been largely a victory of the regular U.S. Army, but volunteers, including those from Texas, also played major roles.

As in past conflicts, Texas volunteer companies went to war under flags presented by their communities.[1] Although the designs

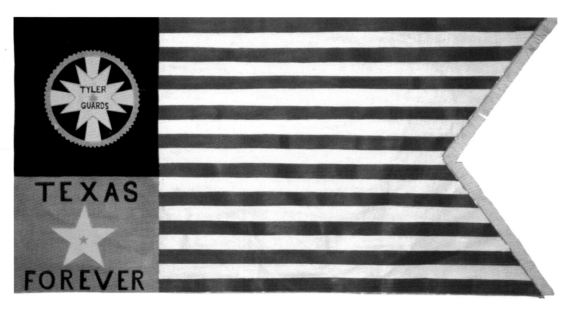

Figure 50. *Tyler Guards Flag. The symbols displayed on this standard identify it as a flag of the Tyler castle of the Knights of the Golden Circle. Courtesy of Eakin Press, Austin, Texas.*

are unrecorded, their banners must have resembled those flown during previous conflicts with Mexico. Lone stars on various backgrounds again would have been the dominant motif. This war with Mexico, however, was different; no longer did Texas face the power of Mexico alone. Flags reflected this happy new reality. Texans, like their fellow countrymen, were proud to fight under the Stars and Stripes.[2] As volunteer companies combined to form regiments, they discarded their community flags when army commanders bestowed banners that were variants of the U.S. colors. Nevertheless, Texans continued to honor the lone star by wearing it as badges and devices on clothing and uniforms.[3]

The conquest of Mexico and the gain of so much new territory should have been one of America's greatest triumphs. Instead it provided fertile ground out of which sprouted the malignant seed of disunity and fratricide. Throughout the 1850s the question of whether or not to allow slavery in the territories gained from Mexico divided America and exposed the deep cultural, social, and political animosities that festered between North and South. The nation's institutions proved unable to arbitrate the bitter sectional rivalry. Northerners defied federal fugitive slave laws, and some denounced the Constitution itself for allowing slavery. Southerners, fearing the loss of power in Washington, refused all reason regard-

ing any restrictions on slavery and states' rights. In 1856 such questions led to the outbreak of fighting in the Kansas territory. Civility in the United States all but died there.

The last straw for many Southerners, however, came in 1859. In October, John Brown and twenty-one followers seized the federal arsenal at Harpers Ferry, Virginia, with the intention of fomenting a violent slave uprising. Militia and a detachment of U.S. Marines quickly killed or captured the raiders. Brown, who was hanged for treason, became a martyr for many Northerners. The implications of the affair shocked Southerners. It seemed to them that Northerners would resort to any means, even violence and murder, to eliminate the southern way of life and its "peculiar institution."

Within a year, the focus of this growing dread shifted to the Republican Party and the pending election of Abraham Lincoln. The party, founded in 1854, was a purely regional organization that represented the interests of the commercial North in contravention to nearly every issue the agrarian South held dear. No southern politician belonged to the Republican Party or helped formulate policy. The party's continuing success traumatized the South because it diminished the traditional influence Southerners had in government — an influence they felt protected their liberty. Lincoln won the election of 1860 without southern votes, and on December 17, a convention convened in Columbia, South Carolina, to discuss secession.

Texans followed the events of the 1850s with growing anxiety. The strife in Kansas particularly alarmed residents in the northern regions of the state. Many there believed it would be just a matter of time before militant free-staters swept south to spread fire, death — and abolition.[4] The John Brown raid and its aftermath spread this paranoia throughout the rest of Texas. Everywhere local defense companies began to form and drill in anticipation of the coming storm. The women of Texas again began to sew flags.

Internal forces also pushed Texas toward the abyss. A shadowy organization known as the Knights of the Golden Circle, or KGC, had gained particular influence in the state. This group aimed at augmenting southern clout by the annexation of Cuba, Mexico, and parts of Central America in a great slave-holding empire — the "Golden Circle." Attempts by the KGC in 1860 to mount a filibustering expedition against Mexico failed, but its activities in

encouraging secessionist sentiment in Texas were significant. The organization of the KGC was military in structure. Within the state, thirty-two local chapters, or "castles," were essentially military companies.[5] A Texas KGC flag survives from those uncertain times, and its symbolism is striking. In 1858 George Chilton, a local KGC official and state legislator, presented a swallow-tail flag displaying nineteen red and white stripes to the Tyler Guards.[6] The canton, which spreads from upper to lower edge, is divided into two sections. On top is a blue square containing KGC symbols — a Maltese cross surrounded by a golden circle. The canton's lower section is a reddish square within which lays a large white lone star and the inscription "Texas Forever."[7] This KCG unit and others like it would form the nuclei of some of the state's first Confederate regiments.

When events reached a crisis, notwithstanding the efforts of Sam Houston and a few others to keep the state in the Union, or at least neutral, there was little question where the sympathies of most Texans lay. Their roots were in the South. The majority of the original colonists and those who had come after had been Southerners. Even though Texas enjoyed the reputation of being a wild and wooly frontier state, most newcomers in the 1850s avoided the frontier and settled in established communities little different from those they had left behind. Cotton was the major crop, and slave labor produced most of it. Like their brethren in South Carolina, many Texans could not imagine that their way of life could survive Lincoln's presidency.[8]

In 1860, most of the state's residents had no personal memory of the Texas Revolution, the Republic, or even the Mexican War. When they were introduced to the lone star, it carried a very different meaning than it had in the 1830s.

Lone Stars over the South

Few doubted that Lincoln's election on November 6, 1860, would result in South Carolina's secession from the Union. In anticipation of this momentous event, Texans began holding mass meetings to voice their support. In Waco and Marshall, lone-star flags flew for the first time since annexation.[9] On Wharton's courthouse square, excited citizens ran up a large lone-star flag on a seventy-foot pole. Throughout the state secessionists unfurled lone-star banners to encourage Texans to follow South Carolina's lead.[10] Yet in 1860 the lone star for a time ceased to be solely Texas' icon; spontaneously, it became the South's secession symbol.[11]

As the citizens of the lower South moved to sever their ties to the North, they reasoned that the display of a single star would signal their intentions. Each star represented a state in the constellation of the American flag. If stars can be added, they can be taken away in the same manner. The lone star thus embodied the central constitutional argument of the South — that the Union was a voluntary compact between sovereign states that could be annulled if any of the parties believed this action to be in its best interests.

Southerners understood secession to be the ultimate exercise of their constitutional rights and thus wished to avoid any actions that could be construed as illegal. The Constitution clearly stated that agreements or compacts between states were treasonous. Thus, before the seceded states could join together to form a new government, each would have to withdraw from the Union and become independent.[12] In order to bolster this legalistic construct, southern states other than Texas adopted flags of their own for the first time. In prosecession demonstrations and in ceremonies after secession declarations, all the states of the lower South initially hoisted some type of lone-star flag. The day after South Carolina voted for secession, the citizens of Charleston raised over the customs house a red swallow-tail flag with a white star and a crescent.[13] When Florida seceded in January, 1861, its lawmakers produced a flag that was identical to the Lone Star and Stripes of revolutionary Texas.[14] The passage of the Georgia ordinance of secession saw lone-star flags unfurled throughout that state, most notable being a red flag with a white star raised over the captured federal arsenal in Augusta.[15]

The best-known secession banner was Mississippi's Bonny Blue Flag. The simple blue banner with a white five-point star first appeared on January 9, 1861, during the state's secession convention. Harry McCarthy, an English variety entertainer, immortalized the event in his stirring song "The Bonny Blue Flag." First performed in Jackson, Mississippi, in the spring, it soon rivaled "Dixie" in popularity as the anthem of the Confederacy. The flag itself was not unique. Blue secession banners with white lone stars were common throughout the South.[16]

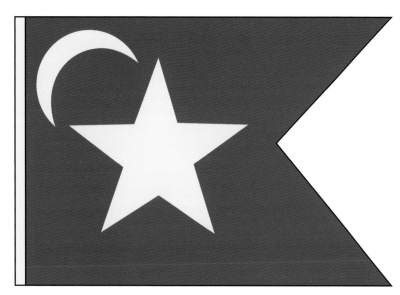

Figure 51. *South Carolina Secession Flag. This early secession flag, which signified South Carolina's reclaimed sovereignty from the federal government, combined the lone star with the state's traditional crescent. Drawing by Anne McLaughlin, Blue Lake Design, Dickinson, Texas.*

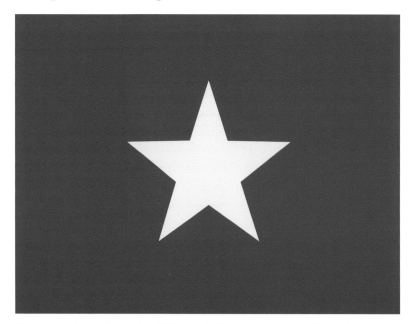

Figure 52. *Bonny Blue Flag. This simple blue banner is today the best-known of the South's secession flags. Drawing by Anne McLaughlin, Blue Lake Design, Dickinson, Texas.*

Beginning in the fall of 1860, the lone star became a common sight in Alabama. The most representative of these was a solid blue banner with a gold five-point star in the center, over which the word "Alabama" arched. When secession came in December, 1860, a mass meeting took place in front of the capitol at Montgomery, during which an elaborate secession flag flew over the statehouse. It displayed a liberty figure holding the Alabama lone-star flag. In Mobile the news from Montgomery caused a general uproar, and a "Southern" flag was run up a secession pole "amid the shouts of the multitude and the thunder of cannon." Later, while the crowd processed to the U.S. customs house and as bands played the "Southern Marseillaise," the "lone star flag was waved amid enthusiastic shouts." [17]

After the first blush of secession, several of the states opted to incorporate symbols of their own histories into official state flags. South Carolina produced a flag that displayed the crescent and palmetto tree, and Mississippi's flag featured the magnolia. Georgia, which had used its baroque state seal on military flags for decades, reverted to this practice. [18]

The delegates to the February, 1861, Louisiana secession convention rejected the incorporation of what is today that state's best-known symbol. During the opening session, a flag displaying the image of a pelican was unfurled "while the spectators and delegates, swayed with excitement, cheered vehemently." But many of the convention members did not regard this bird as a symbol sufficiently elevated for the matters at hand. The pelican was, according to some, a bird, "in form unsightly, in habits filthy, and in nature cowardly." [19] Instead the delegates chose a lone-star flag whose appearance was very similar to the Lone Star and Stripes of early Texas but with colors selected to reflect the French and Spanish aspects of Louisiana's history. The thirteen stripes were three red, six white, and four blue, and the canton was red with a lone yellow star. [20]

In Texas the clamor for secession had rekindled a fierce affection for the lone star, and its incorporation in flags of sister states had annoyed even some of the state's secessionists. Caleb G. Forshey, superintendent of Bastrop's Texas Military Institute, complained, "This wandering, Revolutionary Star is . . . no longer liable to

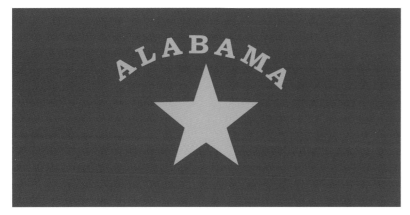

Figure 53. *Alabama Secession Flag. As secession became a reality, Alabama joined her sister states in hoisting the lone star. Drawing by Anne McLaughlin, Blue Lake Design, Dickinson, Texas.*

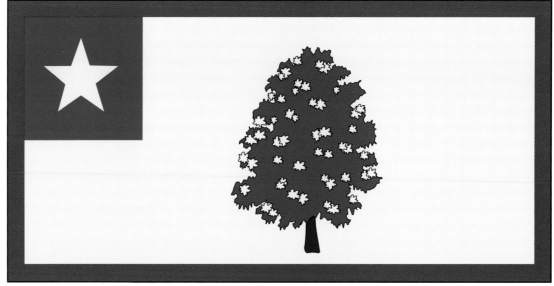

Figure 54. *Alabama Liberty Flag. The ladies of Montgomery presented this elaborately painted banner to the state's secession convention. Drawing by Anne McLaughlin, Blue Lake Design, Dickinson, Texas.*

national approbation. It finished its sublimest achievement, when it conquered the vast and fertile empire of Texas. It is fit . . . that here it should find rest, and here dispense its perennial lustre upon the banner that floats over its noblest conquest." [21] He reserved his strongest objection for the new Louisiana state flag. Ironically, the "banner" to which Forshey refers was not the Texian Flag of the Republic but the Lone Star and Stripes of the Revolution, which it superseded. [22]

Despite the proliferation of lone stars in Texas during secession, the Texian Flag, famous today as the Lone Star Flag, was nowhere to be seen. In the same letter, Caleb Forshey, a man with considerable historic knowledge, made clear that he believed the presence of the lone star alone determined what constituted a Texas flag: "During the whole of her history as a State . . . this flag (with a five pointed star in a blue field) has been her banner; and the addition of thirteen stripes or sometimes a mere sheet of white and red has been a matter of option with those who made or used it." [23] Forshey's knowledge of the design of the Texian flag is in itself unusual; in 1860 few Texans had any idea what the flag of the republic had looked like. A reader had asked a Houston newspaper editor what the design of the old flag was, and he could not answer. Con-

Figure 55. *Mississippi Flag. Mississippi's new official state flag retained the lone star but added a magnolia tree. Drawing by Anne McLaughlin, Blue Lake Design, Dickinson, Texas.*

Figure 56. *Louisiana Flag. Some Texans were annoyed that Louisiana's new state flag seemed to copy the design of the Lone Star and Stripes of the revolution and early days of the Republic of Texas. Drawing by Anne McLaughlin, Blue Lake Design, Dickinson, Texas.*

cluding that a description would be of interest "to the great majority of our people who never saw it," the newspaperman began to dig through his files. In a November issue of the *Houston Telegram* he announced with pride that the old flag of the Republic was properly called the "National Standard of Texas" and the design was "an azure ground with a large gold star central." The Houston editor was, of course, mistaken. The source he had consulted was the 1836 law.[24]

So few people knew about the Texian Flag that nearly a month would pass before anyone was able to point out the error. John J. Good, a judge active in the secession movement, had traveled to Austin and consulted the records of the Republic's Department of State. There he discovered the 1839 flag statute that had replaced the law of 1836. It told him the proper flag of the Republic of Texas was a blue canton with a single lone star joined to a field consisting of a white stripe uppermost and a red one below — in short, the Texian Flag. Thus did Texans rediscover their old flag.[25] Nevertheless, this design never saw widespread use during the Civil War era.

New Lone Stars over Texas

Nowhere in the South was the lone-star flag of secession more prominent than in Texas. Yet when eyewitness accounts mention such a banner in this context, they are not referring to any particular design. To Texans, a lone-star flag was simply any flag that displayed a prominent five-point star. The first of these appeared in the state on the eve of Lincoln's election, and after South Carolina's secession lone-star banners waved everywhere. A Texas newspaper reported in December, 1860, "The Lone Star flag of the Republic floats in majestic splendor from the housetop and from the steeple, in almost every principle town and city in the state."[26] A Galveston reporter observed that "so many 'Lone Stars' were never before seen in this city — even in the days of the Republic."[27]

The appearance of lone-star secession flags had indeed stimulated memories of Texas' early history. In Houston, citizens raised a flag they believed had been the battle flag of General Houston's army. "The flag that waved in the thick of the fight at San Jacinto," related a news item, "was yesterday flung to the breeze from the tallest flag staff in the city, in a token of the love many of our citizens feel for the 'Lone Star.' "[28] At least some Texans remembered the true flag of the revolution. At a public meeting in Collin County, secessionists unfurled a Lone Star and Stripes flag.[29]

Amidst the pageantry and hoopla of mass rallies in favor of disunion, the lone star was the dominant icon. On December 19 in Austin, a demonstration took place that involved "a large portion of [the] most important citizens." In a torchlight procession led by a brass band, prosecessionists marched to the houses of prominent leaders, who delivered stirring speeches favoring resistance. The crowd "wore lone star badges and lone star banners were seen throughout."[30] College students, emulating their elders, took up the symbol. "Hurrah for the Girls," reported the *Austin State Gazette*. "The young ladies of Baylor University . . . have made, and with their own hands hoisted the Lone Star from the cupola of the University building."[31]

Perhaps the most spectacular use of lone-star flags in Texas was atop the so-called secession poles that various communities erected. These were towering masts, some almost two hundred feet in height, from which flew flags so large they could be seen for miles around. The construction of secession poles and the unfurling

of the lone-star banners represented exercises in civic solidarity. From the town of Palace, Texas, a correspondent reported that the townsfolk, "being . . . well collected . . . began their work, by sinking a pit, after which we began to raise the pole . . . [and] the staff being raised and well-braced, the flag was soon floating on the breeze."[32] In Waco the citizens built a pole over 160 feet tall, "braced by guy wires."[33] The flags raised on these masts displayed variants of the lone star that could be remarkable in their size. A flag flown from a pole in McKinney measured twenty-four feet by ten feet, while in the city of Austin a 130-foot secession pole supported a mammoth sixty-by-twenty-foot lone-star flag.[34]

Although written descriptions are scanty, the designs of secessionist lone-star flags in Texas seem to have varied according to the colors of whatever cloth was locally available and the imaginations and skills of their makers. In many cases they comprised simply a single five-point star painted on a rectangular cloth. Some flags combined the star with the names of southern leaders. At a February, 1861, barbecue in Milam County, two lone-star flags decorated the speakers' stand. One displayed the name of Jefferson Davis, newly elected president of the Confederacy, while the other had the name of secessionist firebrand L. T. Wigfall painted on it.[35] In Washington County the citizens erected a "lofty flag-staff, from the summit of which float[ed] a Lone Star banner, bearing upon its folds the honored name of Gen. Jefferson Davis."[36]

One lone-star design, however, eventually became dominant. This was a blue flag that usually displayed fifteen white stars — fourteen orbiting a larger lone star. Although the number sometimes varied as the political winds shifted, the stars represented the slave states. From the heady days of late 1860 until the spring of 1861, this design was the de facto flag of the state of Texas. The configuration of the fifteen-star flag was a common element in many of the flags during this era of strife. In Texas an early variant was a flag presented to the Texas Military Academy in April, 1857. "It bears a large white star of five points on the center of a blue field, with thirteen small stars forming a circle around it, and thirteen stripes of red and white, forming the body of the flag."[37] A fifteen-star flag was displayed in the hall when the South Carolina delegates signed their ordinance of secession in December, 1860. A number of early Virginia Confederate flags have cantons

Figure 57. *Texas Secession Flag. After secession and before adoption of the Confederate Stars and Bars, this blue lone-star banner was the de facto flag of Texas. Drawing by Anne McLaughlin, Blue Lake Design, Dickinson, Texas.*

Figure 58. *Texas Military Academy Flag, 1857. The fourteen stars orbiting a central lone star were not unique to the Texas secession flag. Four years earlier the design had been incorporated into the flag of the Bastrop school and was displayed on Texas military colors and on secession flags in other states. Drawing by Anne McLaughlin, Blue Lake Design, Dickinson, Texas.*

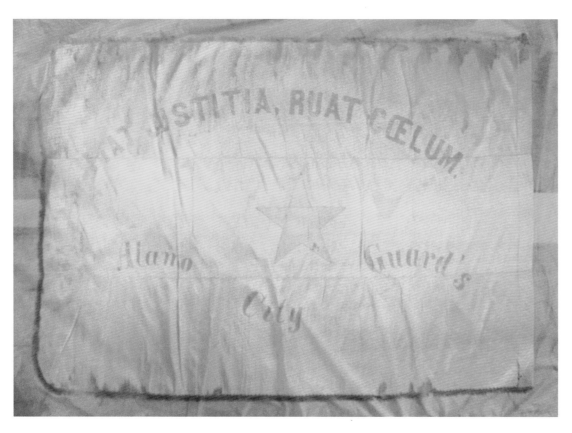

an azure field, on which glittered a galaxy of silver stars, amongst which the Lone Star shone."[41] Use of the flag spread as a decision on secession neared. In January a group calling itself the Friends of Secession and Southern Rights made and hoisted a ten-by-twenty-four-foot fifteen-star flag on a secession pole in McKinney. A mass demonstration in Austin made a banner of this design the focus of attention. On January 5, 1861, famed Texas Ranger John S. "Rip" Ford headed a procession of three hundred persons down Congress Avenue to the capitol. A contingent of ladies on horseback carrying the coats of arms of each southern state—South Carolina first—led the parade. Next came other women bearing lone-star flags, escorted by men mounted and on foot. Citizens in carriages, each of which displayed a lone-star flag, brought up the rear. More than a thousand people, many waiting at the capitol, cheered the procession. Amidst a fifteen-gun salute and general applause, the secessionists raised their massive sixty-by-twenty-foot-flag on its 130-foot pole. The great blue banner displayed the lone star of Texas in the center, surrounded by a "constellation of smaller stars representing her sister Southern States."[42] This impressive flag floated over the capitol until Texas formally joined the Confederacy and a newer flag supplanted it.

On January 28 a convention met in Austin and less than a week later voted an ordinance of secession. The first order of business after the vote, as in all the states that had already seceded, was the presentation of a flag. In anticipation of the event, the ladies of Travis County had already made a fifteen-star flag. After receiving it, Attorney General George Flournoy hoisted the banner over his head and made his way through the surging mass of delegates and spectators to the speaker's stand. There he was met by John A. Wharton, who accepted the flag on behalf of the convention. Wild applause greeted the brief but eloquent speeches the two men made.[43]

Actual secession did not occur until ratification by a vote of the people of Texas, which took place in late February. Thus, on March 4 the convention delegates declared Texas "a sovereign and independent state." Coincidentally, it was the same day as Abraham Lincoln's inaugural in Washington. With cannon booming in the background, the flag that had been presented to the convention was raised upon the dome of the capitol. Another fifteen-star

that displayed oversized central stars usually orbited by ten smaller stars.[38] Variants of the fifteen-star design also figured in at least two Texas Confederate military colors. The flag of the Lone Star Rifles, which became Company L of the First Texas Infantry, originally possessed a flag that combined a blue vertical rectangle bearing a large central lone star within a circle of smaller ones, with the three-bar field of the Confederate First National Flag (see fig. 70).[39] The original flag of the Seventeenth Texas Cavalry was red with a large blue disc, within which thirteen stars surround a larger white star.[40]

The first recorded use in Texas of the fifteen-star flag during the secession crisis was in Dallas in mid-November, 1860. In a formal ceremony the people of the town presented one to a local military unit, the Dallas County Company of Rangers. "The banner," reported a local newspaper, "was constructed of white satin, with

flag, a gift of the ladies of Dallas, flew down the street at the Avenue Hotel. Other businesses around town also displayed the flag, but high above all floated the "magnificent banner" the citizenry had raised in January.[44] Later that month the convention gave the flag official sanction of a sort. The delegates voted that the fifteen-star flag atop the capitol should be annually hoisted on Texas Independence Day, and on "other important anniversaries of the state."[45]

As soon as the ordinance of secession had been passed on February 1, the delegates voted to establish a committee of public safety that would raise military companies to secure possession of federal property within the state. Toward this end the committee authorized Ben McCulloch to lead volunteers to impel the surrender of U.S. Army facilities in San Antonio. His brother, Henry McCulloch, was to push westward with his followers and negotiate the withdrawal of federal troops from the forts of the western frontier. John S. "Rip" Ford had orders to raise a third force that would sail to the mouth of the Rio Grande and occupy the military installations at Point Isabel and other sites along the river.[46]

On February 15 there was an uproar when the citizens of San Antonio discovered that Ben McCulloch had camped outside the city with five hundred armed men. At four o'clock the next morning, this force of "rangers" entered the town, where several military companies from the city and a contingent of 150 Knights of the Golden Circle joined them. "In the dim light," recalled an eye-witness, "I saw the revolutionists appearing two by two, on mule-back and horseback, mounted and on foot, — a motley but quite orderly crowd, carrying the Lone Star flag before them."[47] The secessionists quickly surrounded the Alamo commissary and arsenals. At 6 A.M. McCulloch sent a demand to Gen. David Twiggs that he surrender his command along with all supplies and equipment. By noon Twiggs, himself a southern sympathizer, had relinquished not only the San Antonio garrison, but all U.S. posts and stores in Texas.

The "Lone Star" flag McCulloch's men carried was that of Capt. W. M. Edgar's Alamo City Guards. It was blue with a gold silk fringe and a large white star in the center. A Latin inscription above the star, when translated, reads "Let justice be done though the heavens should fall." Underneath are the words "Alamo City

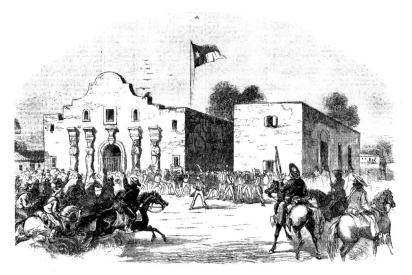

Figure 60. *Texian Flag Flying over the Alamo. This imaginative image of McCulloch's secessionists at the Alamo depicts the Seguin flag with red stripe uppermost. This was a rare instance of the Texian Flag being used as a secession banner. The UT Institute of Texan Cultures at San Antonio, No. 72-324.*

Guards."[48] A sketch of the tumultuous scene in front of the Alamo by the renowned Texas artist Carl G. von Iwonski produced for *Harper's Weekly* shows the scruffy secessionists flying Edgar's flag from horseback.[49] Just after Twiggs's surrender, some of McCulloch's men climbed atop the Alamo, tore down the Stars and Stripes flying there, and raised the Alamo City Guards flag in its place.[50] There it remained for the next week. On February 21, at McCulloch's request, the ladies of Seguin, Texas, sent to San Antonio a homespun Texian flag they had made for a local military company (see plate 8). With it the Texas commander replaced Edgar's flag, and it flew over the Alamo for seven days.[51] A well-known picture that appeared in the March 23, 1861, *Harper's Weekly* depicts the Seguin flag — upside down — floating over the Alamo.[52] McCulloch's use of this flag is a rare recorded instance of the Texian pattern being employed by secessionists.

Farewell to the Star-Spangled Banner

Despite the roil of the secessionists and the statewide harvest of their lone stars, a minority of Texans held Unionist sentiments, or at least hoped the state would reclaim independence. Once seces-

sion had become a fait accompli, some Texans, including many of the early settlers, hoped to prevent the state from joining the Confederacy. For them the lone star signified resistance to the majority. Throughout the state they formed so-called lone-star associations. Advocating the reestablishment of the Republic of Texas, these took as their symbol the lone star, hitherto the universal sign of secession. The movement, however, was short-lived. The eruption of war with the northern states assured that the organization was stillborn.[53]

As a counter to the clamor for secession, some of the women of Kaufman, Texas, resolved to make and present their neighbors with a U.S. flag. At noon on a day in late November, 1860, the church bells rang and the citizens assembled for a flag ceremony. The ladies presented the local judge with a "handsomely wrought" Stars and Stripes. One of the women delivered a lengthy address "abounding with allusions to the Union and the star spangled banner." The judge countered with a speech "about the rights of the states and the legality and necessity of secession." A procession of pro-Union citizens then formed and, to the strains of patriotic music, proceeded to a local mercantile building, from which the flag was raised amid cheers from the participants. "There was no violence or ill feeling manifested" by the crowd, which was evenly divided on the issue of dissolving the Union.[54]

The next day the secessionists had their say. Church bells again tolled, and the citizens gathered for another "patriotic display." A second group of local women had made a secession flag, which they presented to the town. Theirs was the familiar "flag of Azure, bespangled with fifteen stars, one more prominent than the rest." After a series of prosecession orations, "the flag was borne in procession and placed on top of the new Court House."[55]

Even though Austin was the epicenter of secessionist activity, many Unionists resided there, and dueling flags were in evidence. At Hancock's Store on the edge of town, John Hancock, a Unionist attorney, had erected a tall "Union Pole" from which he flew a Stars and Stripes in defiance of the secessionist flag on the site of the old capitol. This U.S. flag floated unmolested until the day Texas formally seceded, when, to the displeasure of many of residents, it was hauled down.[56] The pole itself remained forlornly erect until August, 1862, when some soldiers of Tom Green's Regi-

ment, no doubt rendered bad-tempered by their recent whipping by Union troops in New Mexico, cut it down and burned it. Nearby a number of citizens unsympathetic to the Confederacy "stood by with sullen looks and inaudible mutterings."[57]

Yet even secessionist Texans felt nostalgia and regret as the Star-Spangled Banner came down throughout the state. In late February five hundred state troops commanded by Ford landed at Brazos Santiago and seized the federal post there. As they lowered the Stars and Stripes, the rebels paid homage to their old icon of freedom with a salute of thirty-two guns while standing at attention in respectful silence.[58] Henry McCulloch's mission to claim the federal forts on the western frontier was going well, and after the occupation of Camp Cooper, near present-day Albany, he sent its garrison flag to Dallas. The Stars and Stripes was accepted, according to a local newspaper account, "with feelings of mingled pride and sorrow." The editor exhorted his readers that "the glorious old banner . . . shall always be honored."[59]

The Rebel Constellation

On February 4, 1861, the six states of the lower South that had seceded from the Union met in Montgomery, Alabama, to form a government. Within days the thirty-seven delegates had drafted a constitution that was very much like that of the United States. They then elected Jefferson Davis, former senator, cabinet officer, and hero of the Mexican War, president of the neonate Confederate States of America. On February 18 Davis took the oath of office. As he made his way by carriage to the steps of the state capitol, bands rang out "Dixie" and the throngs along the route cheered wildly. After the ceremony there were more bands, fireworks, and a hundred-gun salute. One important element was missing from the pageantry; no flag represented the new republic. The only two flags present that day were the newly minted Alabama Liberty flag, which hung from the capitol, and the flag of Georgia, borne by a militia company from that state.[60]

Thus, among the first orders of business for the new provisional congress was to provide a national flag. The members appointed William Porcher Miles of South Carolina to chair a committee that would address the question. Because the flag would represent the Confederacy to the world, its design would be of immense political

consequence. Some on the committee believed that because Southerners had played such a crucial part in the history of the United States and its institutions, the Confederacy should simply retain the Stars and Stripes. Texan Caleb Forshey echoed those sentiments when he wrote, "The noble banner is a common heritage, and for our confederate flag, I hope to see no alteration of the old banner of the Union, except the number of the Stars shall be different." [61] Others quickly pointed out the lunacy of retaining the flag of a nation from which they had just departed and the absurdity of two hostile countries on the same continent flying the same flag. Several committee members favored designing a flag that would share no features with the Stars and Stripes, thus asserting the Confederacy's complete break with the past. [62] In the end the committee followed a middle course. They recommended a flag that was similar to the old one but not identical. It retained the colors and general shape of the U.S. flag and accepted the principle of one star corresponding to each state. The committee recommendation specified: "The flag of the Confederate States of America shall consist of a red field with a white space extending horizontally to the centre, and equal to one-third the width of the flag; the red space below to be of the same width as the white. The Union blue, extending down through the white space, and stopping at the lower red space; in the center of the Union, a circle of white stars corresponding to the stars of the Confederacy." [63] Thus was the Confederate First National Flag, or "Stars and Bars," born.

On March 4, 1861, the Confederate government introduced the new flag to its citizens. In a ceremony on the steps of the Montgomery capitol, Letitia Christian Tyler, granddaughter of former president John Tyler, hoisted the Stars and Bars for the first time. [64] News of Texas' decision to join the Confederacy was expected momentarily, so this first flag displayed seven stars in the canton. [65] In its haste to adopt a flag and hold the ceremony to introduce it, the Confederate congress failed to formally enact a flag law. Notwithstanding continual use by the government for more than two years, the Confederate First National design was never ratified by statute. [66]

In some ways it would be the most important of all wartime Confederate flags. The design was more versatile than the Stars and Stripes. Like the American flag, the canton could accommodate as

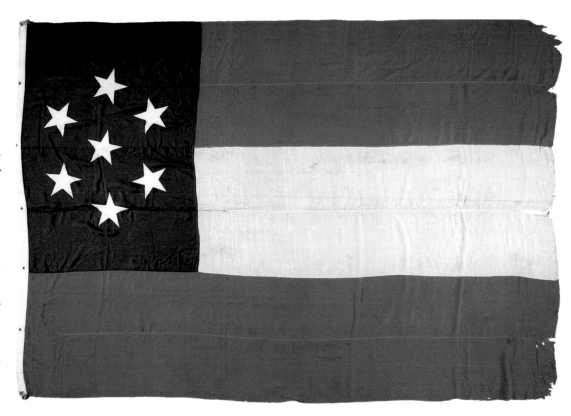

many stars as states that joined the new nation. Furthermore, stars could be arranged to form any shape the maker pleased, and there was still room for mottoes and additional designs. Unlike the U.S. flag, the white central stripe of the field provided a "billboard" for whatever figures and slogans soldiers and citizens cared to inscribe. Besides being a flag of civil government, the Stars and Bars was also a battle flag. Even though other designs superseded it, the First National was the only Confederate flag to fly in combat from the beginning of the Civil War until the end.

Within a few weeks of its first display in Montgomery, Texans learned of the Stars and Bars. On March 23, an article appeared in the *Austin State Gazette* that described the design and Porcher Miles's rationale for its selection. By early April, small silk models of the flag had been made and distributed. [67] In Texas, the design at first proved very popular. Almost overnight lone-star flags, but not lone stars, began to disappear. After March 23, Texas newspapers

Figure 61. *Confederate First National Flag. The original Stars and Bars displayed stars representing the first seven states to secede and join the Confederacy. Courtesy of the Texas State Library and Archives Commission.*

were still full of accounts of flag presentations and flag raisings, but the flags mentioned are invariably referred to as "the Confederate flag" or the "Stars and Bars." Texans, however, had not lost their affection for the lone star. During the next four years, most Confederate flags that Texas troops bore into battle would feature a prominent star.

Battle Flags

On April 12, 1861, Confederate forces attacked Fort Sumter, and the great sectional war began. Three days later President Lincoln declared that an insurrection existed and called for 75,000 troops to invade and conquer the rebellious states. His action convinced four states of the upper South — Arkansas, Virginia, North Carolina, and Tennessee — which had wavered on the question of secession, to leave the Union and join the Confederacy. Thus, by the end of June, the Confederate flag had eleven stars.[68] With war now a reality, volunteers began to assemble throughout Texas and the South to defend the new republic.

The most basic military unit of the American Civil War was the company. Ideally, it consisted of about a hundred men under the command of a captain. In Texas communities, a prominent citizen would announce that he was forming a company and call for volunteers. The citizen, who became the captain, was almost always an important community leader. Among the men who formed companies in Texas were large landholders, lawyers, physicians, local lawmen, and even a newspaper editor or two. Volunteers came from surrounding areas, and the response to the call was directly proportional to the esteem neighbors held for the captain. While they organized, the captain, sometimes with the help of donations from the local community, often paid the company's expenses out of his own pocket. Texas volunteer companies were intensely local institutions. Members usually came from the same county or small town, often from the same neighborhood. Soldiers, in most cases, had known one another and each other's families for years. This unusually strong bond produced some of the best soldiers and military units America has ever seen. Elemental to the identity of the company and symbolic of the community was its flag.

As soon as a company had mustered, local women went to work producing a flag for it. They used materials that were handy, although silk was preferred. In the early days of the Confederacy the design of the flag was left to the imaginations of the seamstresses. By late spring and summer of 1861, however, most were variations of the Stars and Bars that displayed the state's traditional lone star in some fashion. Sometimes designs for company flags were quite elaborate. Even those produced by Texans in rustic settings could be classed as works of art. In May, 1861, for example, the people of Harrison County presented one of their local companies with an especially ornate silk flag. On one side, beneath the words "Texas Hunters," was painted a scene depicting the end of the chase for a deer. The details of the painting clearly impressed young soldier A. B. Blocker, who wrote, "It showed the aim of the hunters in the chase had been true by the large dead stag lying dead on the ground, and the huntsmen standing round, admiring and discussing his beautiful form and the many points of his antlers, and the troop of hounds looking on with sides heaving in rapid respiration caused by the long chase." The other side of the flag displayed a simple Stars and Bars.[69]

Once the seamstresses had completed a flag, they presented it to the company in an elaborate ceremony in which the entire community participated. Typically, the company would line up in the town square, on the courthouse steps, or at the local picnic ground. Here, a representative of the women of the community, often a young and pretty girl, would make a short presentation speech exhorting the men to preserve their honor by protecting the flag. The captain then would rise, accept the banner on behalf of his command, and in florid, patriotic style pledge the lives of his men to this charge. Local politicians then took their turns regaling the crowd with long and flowery orations on honor and sacrifice.

In the late spring and summer of 1861 such scenes were repeated throughout the South. Sam Watkins, a young Tennessee volunteer, recalled these rituals and their effect on those present: "Flags made by the ladies were presented to the companies, and to hear the young orators tell how they would protect the flag, and that they would come back with the flag or not at all, and if they fell they would fall with their backs to the field and their feet to the foe, would fairly make our hair stand on end with intense patriotism,

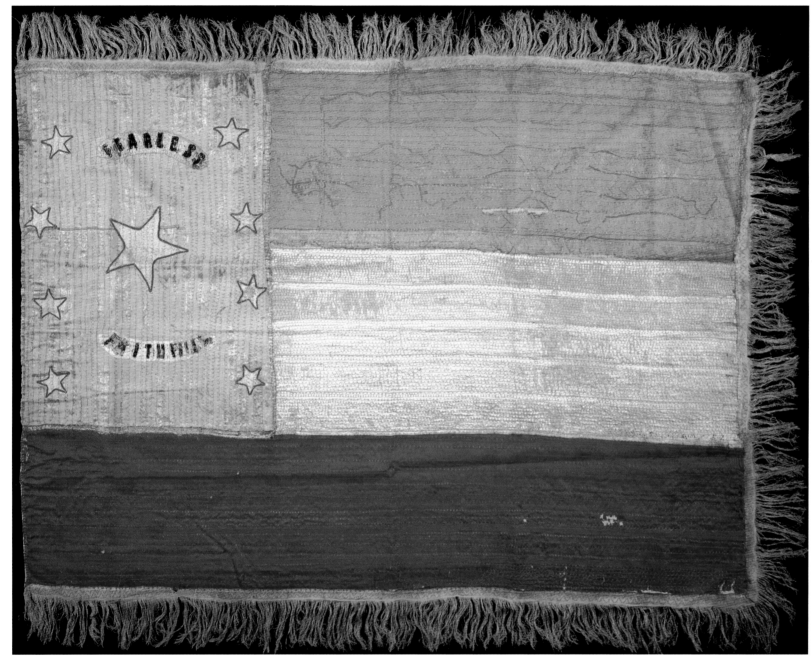

Figure 62. *Stars and Bars with Lone Star, Company F, Seventeenth Texas Infantry. Texas citizens typically presented their volunteer companies with Confederate Flag variants that displayed a lone star. Not all Confederate First National Flags displayed the stars in a circle. Hatzenbuehler Photography © 2000 Dan Hatzenbuehler.*

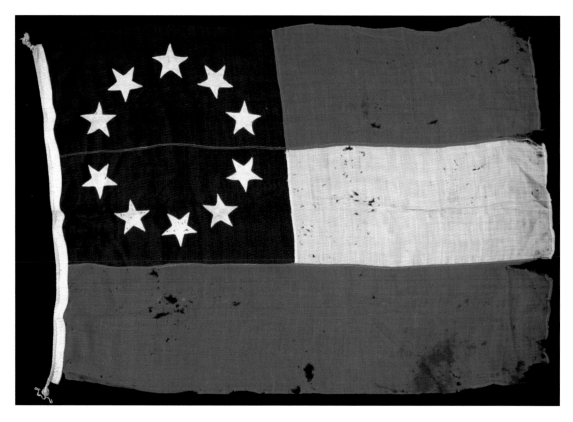

Figure 63. *Corpus Christi Light Infantry Flag. The Stars and Bars presented to this Corpus Christi company was unusual for a Texas unit because it had been commercially made, and did not display a lone star. Hatzenbuehler Photography © 2000 Dan Hatzenbuehler.*

bestowed their precious flag, a Stars and Bars, to the troops, they showered the soldiers with bouquets of flowers. The young volunteers showed their appreciation by marching and countermarching around the courthouse. Afterward they broke ranks and mingled with their fellow citizens, enjoying a great picnic the women of the town had prepared.[71]

Some cynics, however, underestimated the importance of the flag presentation and groused about the expense and impracticality of the practice. An editor for the *Austin State Gazette* noted, "Every day we read of accounts of flags being presented to military companies. . . . But we beg to say it is a useless expenditure of money. . . . In actual service, flags are not always carried by regiments, and by companies they are ignored altogether."[72] The writer proved correct about company flags, but each regiment would require its own color. Ten companies under the command of a colonel made up a regiment in the Confederate Army. In Texas regiments the governor or the Confederate government appointed the colonel, usually a prominent politician who possessed some sort of military experience. The new colonel then would order his assigned companies to rendezvous at a designated camp of instruction, where they would begin training. If ten companies were unavailable, Confederate and state authorities, instead of a regiment, might form a five- or six-company battalion, which was commanded by a lieutenant colonel.

In the Confederate Army, a regiment required only one flag. Sometimes the officers selected a particularly fine company color for the regimental flag, but usually company flags were sent back home or placed in storage. The ladies of nearby communities often made colors for newly formed regiments and presented them with the same patriotism and pride that they had demonstrated when bestowing company flags. Texas regiments serving away from home in need of a battle flag sometimes received one from the grateful citizens of other states. While most regimental flags were homemade, some, as the Austin newspaperman asserted, could involve a considerable "expenditure of money." The citizens of Galveston, for instance, retained a commercial printing firm to produce a flag for Nichols's regiment that was unusually elaborate and must have been quite expensive. Using a large silk Stars and Bars as their canvas, artisans applied gold leaf to shape a circle of thir-

and we wanted to march right off and whip twenty Yankees."[70] After the speeches were done, the company usually formed up and marched around the square and down the main streets with bands blaring and the new flag biting the breeze — all to the cheers of their fellow citizens. The homefolks then treated the proud volunteers to a barbecue, and everyone celebrated long into the night.

In larger towns flag presentation ceremonies could be particularly grand. On June 11, 1861, nearly the entire population of Corpus Christi and the surrounding area turned out to demonstrate their support for the local volunteers. The young soldiers assembled on the outskirts of town and marched in full uniform through cheering throngs to the main square. On the courthouse steps a committee of the ladies of Corpus Christi, dressed in white crinoline hoopskirts, awaited their heroes. A local belle delivered a sentimental and patriotic valedictory addressed to the "gentlemen of the Light Infantry." The company's newly elected lieutenant made an equally eloquent response on behalf of his men. As the ladies

teen stars and inscribe the motto "Our Homes, Our Rights" within it on the fine blue canton. In the same manner, they fashioned "Nichols Regiment" on the upper red bar and "Texas Volunteers" on the lower. Barely visible today is the remnant of a pastoral or patriotic scene an anonymous artist painted on the white middle stripe. Yet even extravagant Galvestonians could sometimes be frugal. When Nichols's Regiment broke up in the fall of 1861 after the expiration of its six-month enlistment, a new regiment "recycled" its flag. The Twentieth Texas Infantry, which formed in the county shortly afterward, made the beautiful banner their own by simply painting over "Nichols" with "20th" in new gold leaf (see plate 19).

By the summer of 1861, the Stars and Bars had become a unifying symbol throughout the South. Everywhere Texas volunteers marched, its presence cheered them. When the Seventh Texas Infantry passed through Minden, Louisiana, on its way to the fighting, the sight of the local people displaying the national flag touched the heart of at least one young soldier. "I saw a great many pretty women . . . waving small flags," wrote Khleber Van Zandt of Marshall, Texas. "As I walked along by a fine dwelling a very pretty young woman was standing by the fence, and calling to me, asked me to accept a small Confederate flag made of red, white, and blue and which was attached to a sprig of Cape Jassamine with a beautiful flower on the end." The card that accompanied the patriotic flag bouquet read, "A simple flower with a maiden prayer, May it prove to banish care." Notwithstanding the great issues of slavery and states' rights, young Van Zandt always cherished this intimate display of solidarity.[73]

The flag also signaled unity with some of the Texan's more unconventional allies. Many of the tribesmen of the Indian Territory were adherents of the southern cause. At a meeting of Confederate commissioners and the Seminole tribal council in August, 1861, the flag told the story. "The Confederate flag flies over the camp," wrote a reporter for the *Fort Smith Times.* "In its blue field are eleven white stars, in a circle, and inside that circle, the commissioner had placed four red stars . . . for the four nations, the Choctaws, Chickasaws, Creeks, and Seminoles."[74] All five nations, including the Cherokees, would eventually sign treaties of alliance with the Confederates and to varying degrees provide military support.[75] That summer, signs of solidarity abounded in the Indian

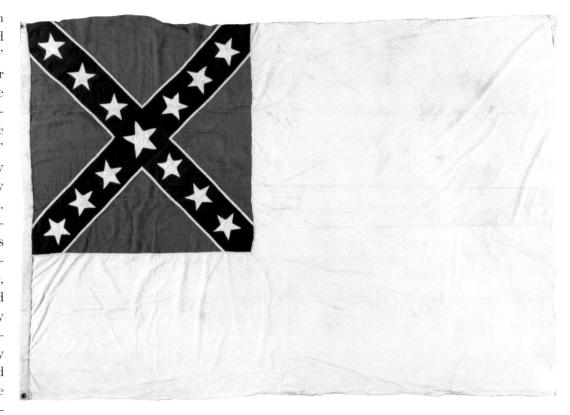

Territory. While his regiment passed through the Choctaw lands just above the Red River, a trooper in the Third Texas Cavalry noted that there were "people of mixed blood living along the road in fine houses and in good style. . . . Numbers of these had small Confederate flags flying over their front gatepost and all seemed loyal to the cause."[76] The regiment, departing Dallas in haste to meet the federals in Missouri, had ridden out before the local citizens could provide a regimental color.[77] While in the Indian Territory, members of the Choctaw and the Cherokee tribes each presented the troopers with battle flags. One they carried for the next two years "until it was many times pierced by bullets" and had to be retired.[78]

With its own flag, at least one Texas regiment honored the Native American allies. The white citizens of northeast Texas who produced the original battle flag of the Tenth Cavalry left little question about the position of the Indian nations in the Confederacy. Their homespun Stars and Bars displayed a single large star in

Figure 64. *Confederate Second National Flag, "The Stainless Banner." Confusion between the Stars and Bars and Stars and Stripes led the Confederate congress to adopt a second national flag that incorporated the Army of Northern Virginia's battle flag in its design. Courtesy of the Texas State Library and Archives Commission.*

its canton around which was the orbit of the usual ten stars. Sewn in each of the four corners of the canton was a red star representing four of the allied Indian tribes: the Chickasaw, Choctaw, Creek, and Cherokee (see plate 18).[79]

New National Flags

By 1863 Southerners had become dissatisfied with the Stars and Bars as their national flag. As a result of the bitter fighting, Confederate citizens had lost any sentimental attachment they had felt for the Stars and Stripes and now wanted a flag that bore no resemblance to it. From a practical standpoint, the similarity between the Confederate First National and the U.S. flag had caused considerable confusion on battlefields and at sea. Discussions about a new official flag had begun in Richmond as early as the spring of 1862, but it took the politicians a year to make a change.

Military forces in Virginia had taken the most effective steps toward addressing the problem of misidentification. In the fall of

Figure 65. *Waul's Legion Flag. Only a few Confederate Second National Flags found their way to Texas troops. The flag of Waul's Legion with its "Vicksburg" battle honor was one of these. Hatzenbuehler Photography © 2000 Dan Hatzenbuehler.*

1861 the Confederate Army of Northern Virginia had adopted the now-famous Southern Cross battle flag. The soldiers soon developed a veneration of the new pattern that had spread, along with its usage, to the rest of the South. Politicians in Richmond determined to incorporate this Army of Northern Virginia, or ANV, pattern into a new national flag. On May 1, 1863, congress passed a law establishing the design of the Confederate Second National Flag as "a white field, with the battle flag for a union, which shall be square, and occupy two-thirds the width," with the length double the width.[80] Although many military units continued to carry it, most Southerners were pleased to be rid of the Stars and Bars. "The new flag," reported the *Richmond Dispatch*, "gives universal satisfaction. Almost any sort of a flag to take the place of the detested parody upon the stars and stripes would have been hailed with pleasure."[81]

Referred to as the "Stainless Banner" because of its white field and the "purity" of the cause it represented, the flag went into immediate but limited service.[82] Its first recorded use, however, was an unhappy one. On May 12 the body of the slain Confederate general Stonewall Jackson lay in state in the house of representatives in Richmond. By order of President Jefferson Davis, the first new national flag was draped over the great warrior's coffin.[83] The Stainless Banner would see only limited service as a battle flag but proudly flew from the yardarms of some of the Confederacy's most famous warships, including the CSS *Alabama* and the CSS *Shenandoah*.

In Texas examples of the new flag began to appear in late June.[84] Of the Texas units serving east of the Mississippi, only one, Douglas's Battery, is thought to have flown it. Within the state, two important examples survive. Waul's Legion, posted to Galveston in the fall of 1863, used a Confederate Second National as its regimental color. The flag's makers inscribed the battle honor "Vicksburg" in the center of the white field to commemorate the unit's previous service. A large garrison version of the Stainless Banner also flew over the "Island City."[85] Neither of these flags displayed a prominent lone star. Although no known examples survive, it seems likely that, as the official flag of the Confederacy, the Second National flew over government and military installations in Texas until the end of the war.

Even though it was a beautiful flag aesthetically, the design of the Confederate Second National Flag caused as many problems as it solved. On land, in calm weather, the Stainless Banner looked like the white flag of truce, a circumstance not likely to endear it to the struggling Rebel armies in the field. At sea, at a distance, the naval version closely resembled the famous White Ensign of the Great Britain's Royal Navy.[86] Even though it could be advantageous to have a Confederate ship misidentified as a vessel of the most powerful navy on earth, some southern naval officers found the confusion intolerable.

In early 1865 Confederate lawmakers agreed on a design they believed would remedy the confusion. The new law stipulated that a simple vertical band of red be added to the fly of the Stainless Banner's white field. On March 4, 1865, just weeks before Lee's surrender at Appomattox, Jefferson Davis signed a bill creating the Confederacy's third national flag. Since the Confederacy was on the verge of collapse, few flags of this pattern were made.[87] No Texas units were known to have flown the Confederate Third National.[88]

After the war, Texans largely forgot the Confederate national flags, which now had become the relics of yet another dead republic. The flags the soldiers carried into harm's way, however, were a different matter. Confederate battle flags, as the living embodiments of honor and sacrifice, would evoke an ever-deepening veneration in later generations of Texans for the cause the tattered banners had served.

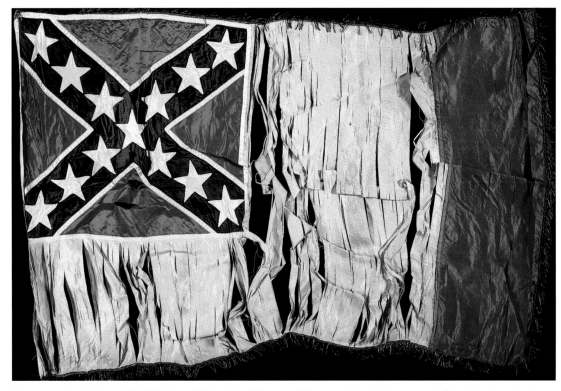

Figure 66. *Confederate Third National Flag. Confederate soldiers soon found that on a windless day the stainless banner looked much like a surrender flag. To eliminate this problem, the Confederate congress adopted a third national flag with a red vertical stripe appended to the fly. Hatzenbuehler Photography © 2000 Dan Hatzenbuehler.*

(5)
Texas
Star in
Virginia

Civil War regimental flags occupied a position of prominence on the battlefield unknown to modern armies. While national banners exerted a strong hold over the minds of nineteenth-century Americans, this could not compare to the devotion soldiers manifested toward the flags that led them into battle. For Blue and Gray, one of the most important pieces of military equipment was the regimental color. The tactics of the age dictated that infantrymen stand nearly shoulder to shoulder in well-ordered lines to deliver effective fire. Battlefields, however, were usually obscured by the grayish smoke of black-powder weapons, and often flags waving overhead were all the soldiers could see. Officers directing troops used flags to identify units and locate their positions. To maneuver, dress ranks, and rally if broken, the soldiers had to be able to concentrate on the position of the flag, or the regiment might cease to function as a unit. Thus, from a utilitarian point of view, the loss of the regimental color was a crippling blow that could render the unit unfit for further effective combat.[1]

To Civil War soldiers, a captured flag was more grave than the loss of unit cohesion; it was a blow to their personal honor. When taking a flag the enemy gained a moral and psychological victory that soldiers would go to almost any lengths to prevent. Countless stories relate the conduct of individuals who risked death to retain their colors or took disproportionate chances to seize those of the enemy even when there was no tactical advantage to be gained. Sometimes generals measured victories not by the count of enemy casualties or by territory seized but by the number of "stands of colors" taken. So important was this calculation that the U.S. government awarded the Congressional Medal of Honor to any soldier who captured a Rebel flag. Decades after the war, veterans still fretted or exulted over the loss or gain of a battle flag.[2]

Regulations required that Union regiments carry two colors. The first was the national standard, a six-by-six-and-a-half-foot silk Stars and Stripes with the name and number of the regiment embroidered on the center stripe. The second flag was the regimental color. This blue silk banner displayed the U.S. eagle in the center, beneath which the name and number of the regiment was inscribed on a red scroll.[3] Private contractors manufactured most of the colors that states and the federal government issued to Union regiments. Sometimes local citizens presented regimental flags that

Map 3. *Battle Honors: Texans' Service in the Civil War. Courtesy Don Frazier.*

were more diverse in pattern. These could have a range of canton sizes and star patterns, and variations in the widths of the stripes. Often they incorporated state seals into the designs.[4] Despite these minor variations and compared to those of their opponents, Union battle flags looked much the same. The United States, a powerful economic colossus that could manufacture an endless stream of weapons and munitions, had little difficulty mass-producing high-quality silk flags.

Confederate regiments carried only one flag each, and these came in a host of materials and colors. In the course of the conflict, the Richmond government largely succeeded in providing its Virginia army with uniform battle flags, but farther west Confederate forces flew a variety of designs, many of which were homemade. Silk deteriorated rapidly under the harsh conditions of campaigning and, after the first months of the war, was all but unobtainable because of the blockade of southern ports. Army quartermasters then began supplying colors made out of wool bunting. But this material, especially in the West, proved hard to come by, and necessity forced Rebels to fabricate flags out of homespun cotton or wool. Nor were these colors particularly well made. Most parts of the South lacked high-quality dyes, and flag makers employed tints produced from locally available vegetable pigments that fared poorly under harsh use. Yet Southerners revered their rustic flags just as highly as the Northerners regarded their fine silk banners.

Texas soldiers probably employed more different styles of battle flags than the troops of any other state. Fighting from Maryland to Arizona, Texans served in dozens of different Confederate commands. Many of these maintained their own distinctive battle flags. Whether serving on far-flung fields or within the state, Texans whenever possible would add a prominent lone star to whichever battle flag they flew, "to remind them of home."

The Southern Cross

It was four o'clock on the afternoon of July 21, 1861. Near Manassas, Virginia, along the banks of the Bull Run, the first battle of the Civil War had raged inconclusively since before dawn. The Confederate commander, Gen. P. G. T. Beauregard, gazed in apprehen-

Figure 67. *Sergeant of 108th U.S. Colored Troops with Regimental Color. In addition to the Stars and Stripes national color, each Union regiment carried a blue regimental color. Courtesy of the Collection of Michael J. McAfee.*

sion at a body of troops advancing on his army's left flank. The similarity of the uniforms and the clouds of dust made it impossible for him to decide if they were Union or Confederate. An officer sent word that he had sighted a flag at the head of the column, but because of the still air it was drooping, and he could not tell whether it was Stars and Stripes or Stars and Bars.

The battle had reached its climax. If the advancing troops proved to be federals, Beauregard would have to retreat or risk being enveloped. Again and again, he tried to make out which colors they carried. The Rebel general decided to gamble and hold his ground, but as the mysterious column moved closer, his anxiety grew. Suddenly, a puff of wind caught the flag. It was the Stars and Bars. The now-identified Confederate troops fell on the Union flank. Elated, Beauregard called out, "The day is ours!" and ordered his drummers to beat the advance. "Within an hour not an enemy was seen south of Bull Run," he recalled. In the course of those harrowing moments General Beauregard resolved that "the Confederate soldier must have a flag so distinct from that of the enemy that no doubt should ever again endanger his cause on the field of battle." [5]

In every theater of war that summer and fall, Confederate commanders were learning the same lesson. Soldiers fired on friendly troops and columns were misidentified; lives were lost and battle plans foiled. The Stars and Bars resembled the Stars and Strips too closely to function as an effective battle flag. Throughout the South, Confederate officers undertook the task of remedying this problem by creating more distinctive colors. Beauregard himself was instrumental in the creation of the most famous of these.

During the debate over the design of the Confederate national flag, William Porcher Miles had suggested a rectangular red flag with a blue St. Andrew's cross displaying a star for each state. Critics had argued that with such a design there was no symmetrical way to place the seven stars of the states that then composed the Confederacy. One congressman ridiculed the proposed flag for resembling a "pair of suspenders." [6] Late that summer, Miles, who had served as an aid during the battle at Manassas, resurrected his design and suggested it to Beauregard as a flag to be used "only in battle." The pattern pleased the Creole general, who offered it to

Figure 68. *Army of Northern Virginia Battle Flag, Prototype. Gen. Joseph E. Johnston's headquarters flag, pictured here, was one of the three original ANV battle flags. The Museum of the Confederacy, Richmond, Virginia. Photography by Katherine Wetzel.*

his superior, Gen. Joseph E. Johnston, overall commander of Confederate troops in Virginia. Johnston agreed with Beauregard's recommendation but suggested changing the flag's proposed rectangular shape into a square to make it more convenient for use in the field and to save on fabric. [7] Thus was born the famous Army of Northern Virginia, or ANV, battle flag. [8]

In September Johnston ordered army quartermasters to make flags of this Southern Cross design for distribution to his troops. Government agents proceeded to purchase the entire silk supply of Richmond and contracted local sewing circles to make them. The resulting flags were forty-eight inches square and displayed twelve

stars in either gold or white on the arms of the cross. Some variants had gold or yellow fringes, while others were bound in two-inch yellow silk borders. There was not enough scarlet silk on hand to assure uniformity, so the flags varied in color from red to pink or rose. In November, 1861, the first of these battle flags were presented to Confederate regiments around Centreville.[9]

As additional regiments gathered in Virginia during the spring of 1862, the need for more of the new battle flags increased. The silk supply, however, had been all but exhausted. As a stopgap, Richmond quartermasters substituted a much less elegant wool-cotton blend that was commonly used in everyday clothing. Flags of this so-called cotton issue received limited distribution. Among the few units that received them was at least one regiment of Hood's Texas Brigade (see plate 10).[10] Wool bunting, however, became the material of choice for ANV battle flags. Though bunting did not "fly" as well as silk, it endured the rigor of the elements much better. Moreover, the seizure of United States naval stores from Norfolk's Gosport Navy Yard assured Richmond quartermasters of ample supplies of fine English bunting.[11]

As time passed, the Confederate supply network in Virginia became well organized. Toward the end of 1861 the government established the Richmond Clothing Depot, whose function was to supply uniforms, shoes, and flags for the Army of Northern Virginia. Much of the work of producing battle flags remained the milieu of the women of the region. Craftsmen at the depot cut up the newly acquired bunting and distributed it in "flag kits" for women to sew at home.[12] By late spring of 1862 the depot and its "jobbers" were producing large numbers of bunting ANV flags and continued to do so for the rest of the war.[13]

In all there were seven separate issues of wool-bunting ANV battle flags, and all shared similar characteristics. While there were minor variations in size, position of stars, and width of the crosses, the general pattern of the most famous battle flag in American history had been established. It can be recognized as being a forty-eight-inch red square displaying a blue Southern cross with thirteen stars, surrounded on all four sides by a white border. Texans, like their Confederate brethren, came to revere the design as the icon of their cause. When possible, however, they added their own special touch — the lone star.

Mrs. Wigfall's Wedding Dress

None of the state's fighting men gathered more glory than the soldiers of Hood's Texas Brigade. Composed of the First, Fourth, and Fifth Texas Infantries, and augmented at various times by regiments from South Carolina, Georgia, and Arkansas, the brigade was perhaps the finest fighting unit of Gen. Robert E. Lee's legendary Army of Northern Virginia. It won fame in twenty-four major fights and played key roles in the battles of Gaines Mill, Second Manassas, Antietam, Gettysburg, Chickamauga, and the Wilderness. The behavior of the Texas Brigade rivaled the defenders of the Alamo in bravery and self-sacrifice. In all, some 4,480 Texans served in Hood's Brigade, but fewer than 600 remained to participate in the bitter surrender of Lee's army at Appomattox in April of 1865.[14]

After Lincoln's election, military companies formed throughout Texas; the most enthusiastic of the volunteers wished to go to Virginia, where the common wisdom had it the "fighting would be the hottest."[15] By late July eight of these independent companies had journeyed to Richmond and were organized as the Texas Battalion. The Confederate government placed Louis T. Wigfall, a prominent Texas politician and ardent secessionist, in command. After the election of officers, the next order of business was to consecrate the new unit with a battle flag. When the Texas Battalion formed, the pattern of flags in the Virginia army had not been settled. Before adopting the Southern Cross pattern, General Johnston had ordered his troops to use their state flags to alleviate the confusion between Stars and Stripes and Stars and Bars.[16] The Wigfall family made it their duty to provide a battle flag for the Texas Battalion. Unlike most of the people back home, they knew what the old banner of the Republic had looked like, so in line with Johnston's orders they chose the Texian Flag as the pattern (see plate 9).

Tradition has maintained that Wigfall's wife, Fannie, sewed the battle flag out of her wedding dress. This was partially true. Daughter Lula, who was fifteen years old at the time, recalled that "the large white star was the special work and pride of her mother. It was made from her wedding dress, as was also the white stripe."[17] Recent analysis of the original flag, however, revealed that most of the flag was made from previously unused dress silk.[18] A contemporary newspaper article also credited Mrs. Jefferson Davis and

Figure 69. *Louis T. Wigfall. This Texas politician and secessionist firebrand was the Texas Brigade's first commander. He and his family provided the original battle flags of its three regiments. Courtesy of the Harold B. Simpson Hill College Research Center, Hillsboro, Texas.*

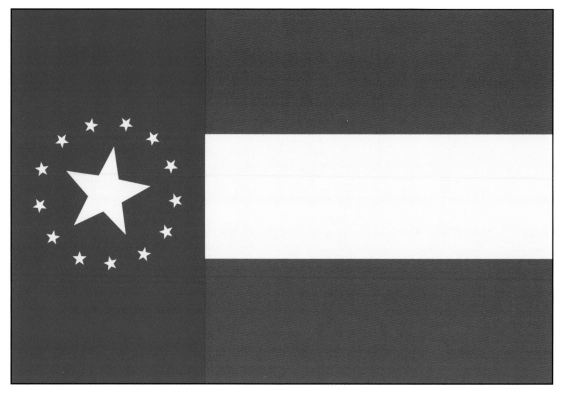

Mrs. Thomas Waul, wife of another Texas politician, with helping to sew the flag.[19]

When it was completed, an impressive presentation ceremony took place. On July 31, 1861, the eight companies of the Texas Battalion formed in column on the Richmond fairgrounds. Present were thousands of spectators, many of them soldiers. Soon President Jefferson Davis approached on horseback, accompanied by a brass band and hundreds of citizens. Alighting with the Wigfall flag in hand, he stood in front of the battalion and delivered, in the words of an eyewitness, "one of the most eloquent addresses I ever heard."[20] Davis presented the flag in the name of young Lula Wigfall. The Confederate president then spoke directly to the pride of the young soldiers. "Texans!" he exclaimed, "The troops from other states have their reputations to gain, but the sons of the defenders of the Alamo have theirs to maintain."[21] Louis Wigfall, as colonel of the battalion, replied with an appropriate oration of his own, pledging that "the boys would maintain [the flag] or die." As the throng dispersed, a newspaper correspondent recalled, "we felt about six inches taller hearing our Texas boys so praised and applauded."[22]

By the end of the summer, twenty-three more companies had arrived from Texas. The original battalion grew to twelve companies and reorganized as the First Texas Infantry Regiment. Two

Figure 70. *Lone Star Rifles Company Flag. This company flag combined the design of the Texas secession flag with the bars of the Confederate First National pattern. Company flags usually were sent home or placed in storage when regiments formed. Drawing by Anne McLaughlin, Blue Lake Design, Dickinson, Texas.*

Figure 71. *Lula Wigfall. The original battle flags of Hood's Texas Brigade were presented in the name of fifteen-year-old Lula Wigfall. Courtesy of the Harold B. Simpson Hill College Research Center, Hillsboro, Texas.*

Figure 72. *Finial of the Fourth Texas Battle Flag. When the Fourth Texas received a battle flag from the Wigfall family, its staff was mounted with this brass finial, which was engraved with the words "Fear not, I am with thee. Say to the North, give up, and to the South, keep not back," and "Lula Wigfall," fille de regiment. The finial was pierced by a bullet at the battle of Second Manassas.*

other regiments, the Fourth and Fifth Texas, were also activated from the new arrivals. The Confederate government, recognizing the desirability of keeping soldiers from the same state together, organized the three regiments as the Texas Brigade on October 22, 1861. Wigfall was its first commander, but his temperament proved unsuitable for service in the field, and he resigned his commission to accept a seat in the Confederate Senate. In early March, 1862, the colonel of the Fourth Texas, John Bell Hood, was promoted to brigadier-general and given the command of the Texas Brigade. Even though he would lead the unit for only six months, to history it would be best known as Hood's Texas Brigade.

Most, if not all, Texas companies arrived in Virginia with flags the homefolks had presented to them. The designs of only two of these flags, however, are known today. One was the Texian flag that the ladies of Seguin had sent to Ben McCulloch to fly over the Alamo, which they subsequently presented to the Knights of Guadalupe County (see plate 8).[23] This unit became Company D of the Fourth Texas. The other was that of Galveston's Lone Star Rifles, one of the original companies of the Texas Battalion.[24] These volunteers brought a flag that combined elements of the Texas secession flag and the Stars and Bars. Its vertical blue bar displayed the familiar lone star surrounded by a circle of fourteen smaller stars. The field showed the red, white, red bars of the Confederate First National Flag. When the brigade was organized, only one battle

flag for each regiment was needed, so the company colors were sent home or stored. The soldiers placed the superfluous flags that had not been sent home in the brigade's Richmond repository, which they called the Texas Depot. Early in the war the volunteers had rented a three-story brick building on Thirteenth Street between Main and Cary Streets to serve as the brigade's headquarters, warehouse, and home away from home for visiting Texans. Each regiment was assigned a floor that a specially detailed enlisted man administered. According to one veteran, the Texas Depot was the repository for "keepsakes and valuables we did not wish to carry on the battle field, to remain there until our return home." Unfortunately, the warehouse did not escape the war's fury. Everything kept in the building went up in flames on the night of April 3, 1865, when the Texas Depot burned along with the surrounding section of the city.[25]

Beginning in late November, 1861, commanders of Confederate forces in northern Virginia began presenting regiments with the new Southern Cross battle flag. The Wigfall family at this time also provided regimental colors to the Fourth and Fifth Texas. These two finely crafted silk banners conformed to the new pattern while still retaining a representation of the lone star. Each was a square, yellow-bordered, ANV-style flag with twelve stars in the arms and a larger lone star representing Texas in the center. Some accounts claim that these colors were, like the Texian Flag of the First Texas, made from Mrs. Wigfall's wedding dress.[26] While it is unrecorded how copious a woman she was, it is doubtful her dress could have been large enough to supply the silk for two more flags. There would, however, probably have been sufficient material left over from making the white star and middle bar of the First Texas color to fabricate at least the lone stars for both the Fourth and Fifth Texas flags. Conservation analysis revealed that the colored silk of all three flags had not previously been part of any dress (see plate 12).

The colonels of the two regiments presented these new battle flags in Lula Wigfall's name at the army's Dumfries, Virginia, encampment in late November or early December. During the ceremony, one veteran recalled that John B. Hood, then colonel of the Fourth Texas, gave an appropriate speech. "Texans," he intoned, "let us stand or fall together beneath this silken flag."[27] Col. J. J.

Archer of the Fifth Texas no doubt shared similar sentiments with the men of his regiment. In January both commanders sent brief notes of appreciation addressed to young Lula. Archer's read, "In the name of as gallant a regiment that ever gathered . . . I thank you for the beautiful banner. . . . Be sure they will carry it where brave deeds are done."[28] The Fourth Texas also obtained a fine brass finial point to mount on its flagstaff. Engraved on the spear's point were the words "Fear not, I am with thee. Say to the North, give up, and to the South, keep not back." Also written is the dedication "Lula Wigfall, *fille de regiment*." It is not known if the flagstaff of the Fifth Texas mounted a similar ornament.[29]

In late spring and early summer of 1862, the Texas Brigade played a major role in the defeat of Union Gen. George B. McClellan's offensive against Richmond. The Peninsula Campaign brought Robert E. Lee into the command of the Confederate Army in Virginia and Hood's Texas Brigade its first glory. It fought its initial action at Eltham's Landing, where the Texans demonstrated a skill and bravery unusual for green troops. Other battles followed, but it was at Gaines Mill where they confirmed their emerging prowess. In this battle the Texans' wild charge breached, then broke, the well-fortified and defended Union line, giving Lee his most clear-cut victory of the Seven Days Battles. At Gaines Mill the Texian Flag of the First Texas was always conspicuous. When color-bearer George Branard reached the obstructions placed in front of the Union trenches, he threw the flag over and crawled under them to reach the artillery battery on the summit. As he emerged on top and began waving his flag, a great shout of victory greeted him.[30] To commemorate the campaign, General Hood ordered the brigade's battle flags to headquarters so they could be inscribed with the battle honors "Seven Pines," "Gaines Farm," "Eltham's Landing," and "Malvern Hill."[31]

The soldiers of the First Texas held great affection for their Texian battle flag, but the Confederate authorities were determined that each regiment should acquire an ANV color. In late spring the Richmond Depot sent one of the newly made twelve-star cotton-issue flags to the First Texas. The men, however, were unwilling to relinquish their lone-star flag. During the campaigning ahead, the regiment carried, then lost, both battle flags.

The most dramatic moment for the First Texas came at the bat-tle of Antietam. During the summer of 1862 Lee's army marched from victory to victory. After soundly whipping Union forces at Second Manassas, Lee led his battle-hardened and confident army into Maryland. Once across the Potomac, however, ill fortune assailed the Confederates. Union soldiers found a copy of the army's complete battle plan at an abandoned campsite. Armed with this incredible intelligence windfall, General McClellan forced the Confederates into a desperate withdrawal. By mid-September Lee's army had fallen back to a defensive perimeter around the little town of Sharpsburg, Maryland. Facing a force nearly twice its size and with backs against the Potomac, the Army of Northern Virginia would have to hold its lines or be destroyed.

Just before dawn on September 17, 1862, an entire Union corps fell on Lee's northern flank. Within the hour, two Confederate divisions had been thrown back, and the commander of that wing, Stonewall Jackson, ordered the Texas Brigade into the breach. The Texans were in terrible shape. The hard campaigning in Virginia and Maryland had taken its toll. Many of the men were barefoot and dressed in ragged uniforms. For the past twenty-four hours they had been without food and were exhausted from skirmishing the previous night. The Union assault made them angry because it had interrupted their breakfast, so the Texans formed lines to attack.

What awaited them was the most intense battle of the Civil War and, for the First Texas, the moment of truth. The fight centered on farmer David Miller's thirty-acre cornfield. Into the ripe stalks the Texas Brigade charged, and the first Union line broke. The Texans, seized by battle frenzy, continued forward. The First Texas was particularly aggressive and pressed more than 150 yards ahead of the rest of the brigade. A second Union line broke. At this point enemy reinforcements closed in on the flanks of the isolated First Texas. Assailed from three sides, the Texans began to fall by the score. The survivors withdrew in good order, "turning to fire on the enemy as rapidly as the pieces could be reloaded and fired."[32] For two hours the Texas Brigade, with the First Texas in advance, tenaciously held on to the cornfield as the battle ebbed and flowed across the cut and trampled corn stalks.[33]

The battle flags of the First Texas were the focus of much of the heaviest fighting. The Texian Flag was lost first. According to the

regiment's commander, Lt. Col. Philip A. Work, "When the order to retire was given, the colors began to move to the rear . . . the color bearer, after moving a few paces, was shot down." When the flag fell, "some half dozen" soldiers rushed to raise it, but each in turn was cut down. In all, eight Texans fell trying to bring the flag safely off the field.[34] Finally, the entire Ninth Pennsylvania Reserves Regiment delivered a devastating volley into the thin Texas ranks from a distance of less than thirty yards, and the remnants of the First Texas fell back for good.[35] S. T. Blessing, as he lay wounded, had seen the last color-bearer go down and Union troops rush to "gather the sacred silk from the burial pile."[36] At about the same time, W. D. Pritchard, the color-bearer of the regiment's cotton-issue ANV battle flag, fell, and his flag was taken.[37]

Pvt. Samuel Johnson of the Ninth Pennsylvania picked up both colors. A year later the U.S. War Department awarded him the Congressional Medal of Honor for this deed.[38] Johnson's regiment had also suffered severe punishment in the eye of the storm. The Ninth Pennsylvania itself had lost three color-bearers.[39] The lone-star flag of the First Texas proved a singular prize for its new owners. A Confederate prisoner reported that the enemy "rejoiced over it exceedingly — mounting it on a music wagon, and running up the Stars and Stripes over it, drove it through the camp to the tune of 'Yankee Doodle,' and then to McClellan's headquarters."[40] Nearly fifty years would elapse before Texans saw the flag again.

That night, after the fighting had ended on the bloodiest day of the war, Lee asked Hood what had happened to his "splendid division," to which the Texas general replied, "They are lying on the field." Such was indeed the case. In the cornfield at Antietam the First Texas lost 186 men out of 226, the highest percentage of casualties, 82.3 percent, of any regiment, North or South, in the entire war. The Texas Brigade as a whole suffered a casualty rate of over 64 percent. Including those of the First Texas, sixteen color-bearers had fallen.[41] Despite the heavy loss of their comrades, the captured flags caused the survivors of the First Texas considerable additional pain. Lieutenant Colonel Work wrote sorrowfully after the battle that "the loss of our flag will always remain a sore and deep regret."[42]

After Antietam the First Texas received a new flag. The Confederate quartermaster issued a third bunting ANV as the regimen-

tal color. Some veterans claimed that Mrs. Wigfall made a second flag for the regiment at this time. A late-nineteenth-century writer asserted, "It was a lone star flag like the one lost" in the cornfield and was "draped in mourning for the heroic dead of the brigade who fell at Sharpsburg."[43] According to this account, this new Texian Flag was carried alongside the regiment's official color at Gettysburg.[44] Nothing further is known of this possible second Wigfall Texian Flag.

One other First Texas flag, a late issue ANV bunting pattern, survived the war and is unusual because of its large size. This banner measures seventy inches on a side rather than the standard forty-eight.[45] Today it displays only twelve stars, rather than the thirteen customary for late-issue flags. The color might have been a special presentation flag whose central star was removed or lost at some point. In every other detail it conforms with the Richmond Depot fourth-bunting pattern. Because there are few signs of wear, it must have been issued near the end of the war and was probably not the regiment's primary battle flag during most of the last months of fighting. Union records reported that Lt. Martin A. Reed of the Eighth New York Cavalry, in what must have been one of the last actions fought by the Texas Brigade, captured the flag just outside Appomattox on the day before Lee's April 9 surrender (see plate 11).[46]

Mrs. Young's Largess

Houston's Maude Young was an extraordinary woman. A lady of great intelligence and patriotism, she was a writer, poet, and educator. Mrs. Young wrote a botany textbook, was a Houston public-school principal, and served as state botanist in 1873.[47] During the Civil War her special cause was providing support for the Texas Brigade, in which her son served. She raised over $30,000 in gold to build a hospital for the brigade in Richmond.[48] Notwithstanding her many achievements, Maude Young is best remembered for the battle flag she provided to the Fifth Texas Infantry.

When Confederate authorities formally organized the regiment on September 31, 1861, the Fifth Texas was without a flag. Its officers took up a collection and went into Richmond to have one made. They chose the Confederate First National pattern as the basic design but instructed the flag maker to place a single star for

it was just before the Seven Days Battles, and that it had been "badly soiled and considerably torn."[50]

During the campaign, more recruits soon arrived from Texas and carried with them a battle flag sent by Maude Young. The design conformed generally to the ANV flags for the army but was without borders or fimbriations. It was also slightly smaller than the regulation colors and had a prominent Texas lone star on the center of the crossed bars. Attached to the upper field was a rectangular white badge with "5^{th.} T^{xs.}" painted on it. An unusual feature of the flag was the blue fifty-seven-inch streamer attached to the staff. The obverse carried the embroidered motto *"vivere sat vincere,"* and the reverse displays *"5 REG VOL."* and a lone star with a small letter of the word *"TEXAS"* in each point. The new battle flag was presented to the Fifth Texas on June 14, 1862, and the damaged Wigfall color was sent back to the Richmond headquarters for safekeeping.[51] Two weeks later Mrs. Young's flag first faced the enemy at the battle of Gaines Mill, and served with the regiment for the rest of the Peninsula Campaign (see plate 14).[52]

Many of the soldiers, however, still preferred the "Lone Star and Bars" flag stored in Richmond. Back in camp, after the fighting on the peninsula had ended, the officers of the Fifth Texas petitioned Gen. James Longstreet, who commanded their wing of the Army of Northern Virginia, to permit them to carry their old flag in the coming campaign. Confederate authorities, however, had made great efforts to convert the army to the ANV pattern, and Longstreet refused to allow the substitution. This official refusal, however, did not deter some of the regiment's officers. In July General Hood had ordered that the flags of his division should be sent to headquarters so that battle honors could be inscribed on them. While Mrs. Young's flag was away being decorated, Capt. J. S. Cleveland and regimental adjutant Campbell Wood decided to reinstate the Lone Star and Bars. They agreed that when Mrs. Young's color was returned to regimental headquarters, Wood would conveniently absent himself for his office and Cleveland would remove it. In the meantime Wood went to Richmond and took the Lone Star and Bars flag out of storage and hid it in camp. The two conspirators pulled the "switch" the day before the brigade marched out for the fields of Second Manassas and Antietam.[53] By the time the brigade's commanders discovered the ruse it was too late to take

Texas in the canton rather than the familiar circle of eleven stars. The resulting banner, which the soldiers referred to as a "lone star" flag, was "made of silk, fringed with silver, and mounted on a handsome staff."[49] The design proved popular with the soldiers of the regiment but was superseded in January by the Wigfall family's ANV flag. For the time being, the "lone star" flag went into storage at the Texas Depot (see plate 13). Silk colors often proved too fragile for extensive use in the field, and such was the case with Fifth Texas Wigfall flag. One veteran recalled that the last time he saw

Figure 73. *Maude Young. Although she was a pioneer botanist, educator, and philanthropist, Houston's Maude Young is best known for the homemade battle flag she presented to the Fifth Texas Infantry. Courtesy of the Center for American History, the University of Texas at Austin.*

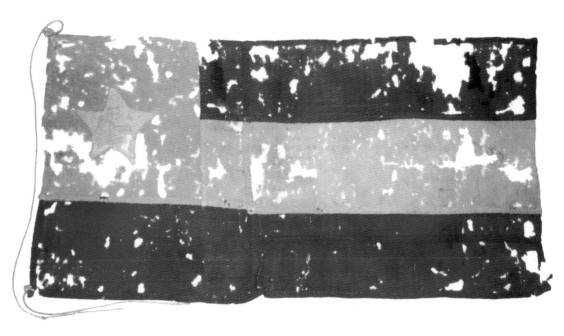

Figure 74. *Miniature Lone Star and Bars. The Lone Star and Bars was a common design among Texas troops in Virginia. After Antietam until the end of the war, First Texas standard-bearer George Branard attached a miniature version (2½″ × 4½″) to the pole above the regiment's Richmond-issue battle flags so the Texans could always fight under the lone star.*

action. At Hanover Junction a review took place and the brigade's battle flags were ordered displayed. The color-bearer of the Fifth Texas, not wishing to incur the wrath of the commanding general, kept his flag in its case. Soon General Hood rode down the line, halted, and ordered the color to be unfurled. Adjutant Wood later wrote, "When its beautiful folds were given to the breeze a cheer broke lose despite the fact that the officers did all they could to restrain it." Hood then stared Wood in the face and snarled, "Adjutant, why do you not have your battle flag, sir?" Wood brazenly maintained he had not seen the ANV flag since it went to division headquarters, and "having no other I brought along the Lone Star flag of Texas." Hood, wise to soldiers' ways, would have none of it. "I believe you know more of this than you are willing to tell," he said, and rode off.[54] The machinations of the two officers meant that the Lone Star and Bars would lead in two of the regiment's most famous battles.

The flag soon won a place of honor. At the battle of Second Manassas, the soldiers of Fifth Texas found themselves up against the crack Fifth New York Zouave Regiment. As the Confederates formed their ranks for the attack, Captain Cleveland took the flag

from the color bearer and "grandly" waved it before his massed troops. "Cling to it boys," he shouted as he pointed to the flag, "as you would your sweethearts." In the hard fight that followed, the sight of this lone-star flag led the Fifth Texas to victory. As the regiment fought through three heavily defended Union lines, several color-bearers were shot down with the flag in their hands.[55] The last to die was Lt. Col. J. C. Upton, who, snatching up the lone-star flag while on horseback, was heard to exclaim, "Come on Boys, follow me," just before he was killed.[56]

Following Antietam and after one last appearance at a military review, the Fifth Texas Lone Star and Bars and the Fourth Texas Wigfall ANV were sent home so they could, in the words of Chaplain Nicholas A. Davis, "report our conduct in the hour of our country's struggles, and be deposited in the archives of the State."[57] The two flags were displayed in the capitol building in Austin until the end of the war.[58] All three regiments already possessed, or were soon issued, Richmond Depot third-bunting ANV battle flags. The First and Fourth Texas used theirs as their principle colors. It is not known if the soldiers added a lone star to each, but the flags likely had battle honors inscribed. The Fifth Texas was fortunate to have Mrs. Young's flag in reserve, and the regiment chose to carry it at the battle of Chickamauga and through most of the rest of the war.

In 1864 Gen. Ulysses S. Grant became commander of Union forces and was determined to fight a war of attrition against Lee's army. Heedless of his own horrific loses, in a series of tremendous battles throughout the late spring and summer his Army of the Potomac repeatedly hammered the Confederates. Union losses could be replaced, but Lee's could not. The relentless onslaught eventually forced the Army of Northern Virginia into entrenchments around the city of Petersburg, just south of Richmond. Ten months passed before Lee's army was rooted out and forced to surrender at Appomattox.

In the beginning of Grant's campaign, during the Battle of the Wilderness, the most famous incident involving Mrs. Young's flag took place. On May 6, 1864, the Army of Northern Virginia faced its worst crisis since Antietam. Early that morning a federal attack near the Orange Plank Road had nearly driven A. P. Hill's corps from the field, and the Confederate line was in danger of being

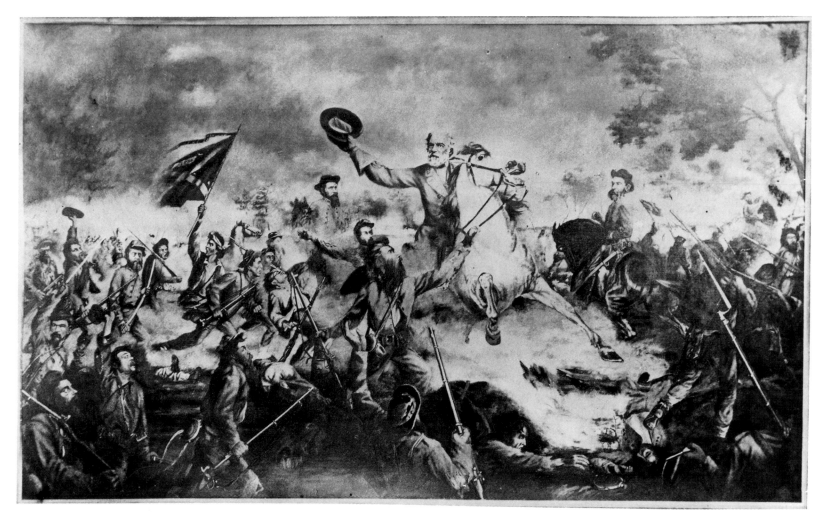

Figure 75. Lee at the Wilderness. *Henry Arthur McArdle's hyperkinetic rendition of the "Lee to the Rear" episode contains a detailed image of Mrs. Young's flag. Courtesy of the Harold B. Simpson Hill College Research Center, Hillsboro, Texas.*

routed. Lee, on the scene, prepared to order a general retreat. At that point the first elements of Longstreet's corps appeared, and at their head was the Texas Brigade. Lee, perhaps noticing the lone star on the Fifth Texas battle flag, was elated and, waving his hat, shouted, "Hurrah for Texas." [59] As they passed the batteries where the great general had stationed himself, and formed for the attack, the Texans "gave a rousing cheer for 'Marsh Robert.'" [60] Lee ordered the brigade forward. Its then-commander, Gen. John Gregg, shouted, "Attention Texas Brigade! The eyes of General Lee are upon you! Forward!" Lee remarked to an aid, "Texans always move them," and spurred his horse forward to personally lead the attack. When the soldiers saw what Lee intended they shouted for him to go back. Lee's battle blood was up, however, and with eyes wild and fixed on the enemy lines, he ignored their entreaties. [61] The men continued to shout "Lee to the rear" and "We won't go in unless you go back." According to a soldier who witnessed the incident, "twenty or thirty" Texans "sprang forward and made an effort to lead or push his horse to the rear." [62] At last a member

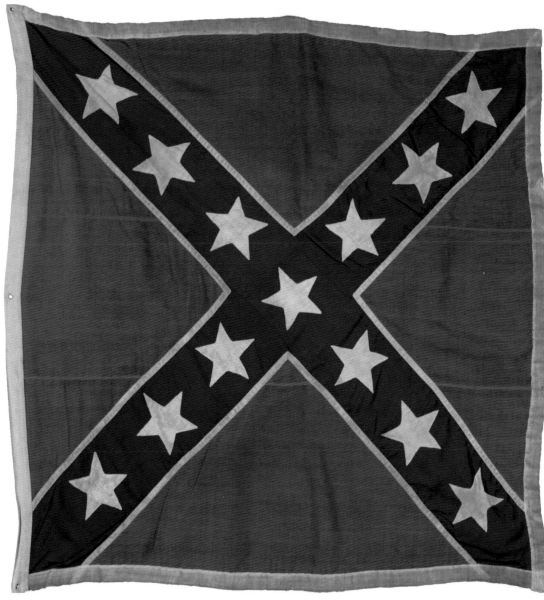

Figure 76. *Fourth Bunting ANV Battle Flag of the Third Arkansas. In the fall, 1864, the regiments of Hood's Texas Brigade, which then included the Third Arkansas, received battle flags of this pattern. The Museum of the Confederacy, Richmond, Virginia. Photography by Katherine Wetzel.*

of the general's staff came forward and shouted in his ear that he must continue to direct the battle. "With evident disappointment General Lee turned off and joined General Longstreet."[63] With Mrs. Young's flag on the right, the brigade moved forward, and the eight hundred Texans, "regardless of number, flanks or support, dashed directly" on the oncoming federals. A Confederate general later recalled, "There was a terrific crash, mingled with wild yells, which settled into the steady roar of musketry." In less than fifteen minutes the Texans had broken the Union advance and saved the army from a major defeat, but after the action "one-half of the devoted eight hundred were lying upon the field dead or wounded."[64]

Mrs. Young's flag continued to lead the Fifth Texas until the fall. On October 7, 1864, again under the eyes of General Lee, the brigade advanced out of the Petersburg trenches against a strongly fortified federal position along the Darbytown Road. The assault was a disastrous failure. Two hundred out of the 450 remaining men of the brigade fell, and General Gregg died at the head of his troops.[65] It was also the last battle for Mrs. Young's flag. When it came off the field at Darbytown "the flag had become simply a bunch of faded shot and shell-torn bunting, totally unfit for use as a flag any longer." After the brigade went into winter quarters, a meeting of the regiment was held and the men decided to return the flag to Mrs. Young. Three officers, who had been detailed to return to Houston for recruits, took it back to her.[66]

All of the regiments of the Texas Brigade again received new battle flags in the fall of 1864, when they were part of Gen. Charles W. Field's division. These were of the fourth-bunting issue, which were slightly larger then the previous Richmond Depot flags but otherwise of the same pattern. In late November, 1862, the Third Arkansas Infantry had become the fourth regiment of Hood's old brigade and shared the perils of the battle line with the Texans for the rest of the war. It also received a new fourth-bunting ANV battle flag.

For Hood's Texas Brigade, the end came on April 9, 1865, when Lee's starving and exhausted Army of Northern Virginia surrendered at Appomattox. Late in life veterans asserted that none of the three Texas regiments turned over their flags to the conquerors. Val C. Giles, one of the color-bearers of the Fourth Texas, wrote

in 1907, "The truth is the boys deliberately cut up their flags into little pieces and divided them among themselves, and those little fragments of silk were all they got for four years of devoted service." [67] The old soldier can certainly not be faulted for remembering the unpleasant moment imperfectly. The last flag of his own regiment, which was wool bunting and not silk, had not been destroyed but was relinquished at the surrender ceremony. John David Murray, color sergeant of the Fourth Texas, recalled that "the moment he laid the flag on the stack of rifles in front of the regiment was the saddest of his life." [68] What happened to the flag after that is unknown.

There is no record that the First or Fifth Texas surrendered any flags at Appomattox. Federal horsemen had captured the First Texas' oversized color on April 8, but nothing is known of the fate of either regiment's fourth-bunting ANV flags. They could have been lost or damaged beyond repair at any point during the siege of Petersburg. But if they had survived the retreat to Appomattox, the soldiers might have sacrificed them in the manner Giles describes.

The flag of the Third Arkansas, like that of the Fourth Texas, was surrendered. Before placing it on the heap of fallen colors, the regiment's standard bearer could not resist one last sneer at the enemy. He pasted a wry note to the staff that read, "Mr. Yankee, you will please return this flag staff and shoulder belt over to the 9th Maine, was captured at . . . [Ft.] Gilmore on the 29th October 1864 by the . . . 3rd [Arks] Regt. Vols. [Signed] "Big Rebel." [69] This last regimental color of the Third Arkansas survived the war. It was placed, along with hundreds of other Confederate battle flags, in the confines of the War Department's storerooms in Washington, D.C.

Just as the exploits of Lee's Army of Northern Virginia overshadowed the reputations of all the other Confederate field armies, Hood's Texas Brigade became the most renowned of the Lone Star State's Civil War units. It was not that the brigade's soldiers fought any more bravely or with greater skill than other Texans. They had been fortunate to have served under the South's finest general and in a well-supplied and usually victorious army. But that was far away in Virginia. Most of the state's soldiers fought under worse conditions and under less-expert commanders to defend the Confederate heartland and to keep the invader away from Texas. They enjoyed mixed success. The Union juggernaut finally swept into the heartland, but other than superficial forays along the coast, Texas remained unconquered. For Texans, the surviving flags of Hood's Brigade may have become the most important icons of the Civil War, but the diverse banners of the western Confederacy told their own story of courage, honor, and sacrifice.

(6)
**Stars of
Heartland
and Home**

Several Confederate armies defended the vast territory between the Blue Ridge Mountains and the Mississippi River. The largest and most important of these was the Army of Tennessee. Its task was the defense of what historian Thomas Connelly called the "Heartland." This vast region of more than 150,000 square miles included the entire state of Tennessee, large portions of Alabama and Mississippi, and the richest sections of Georgia. For four years almost constant fighting raged on a large scale here. In the Heartland Confederates not only faced the best troops and generals the North could field, but also had to battle with vast distances and an inadequate supply system. Some of Texas' most famous regiments and brigades fought in defense of this vital core.[1]

The Army of Tennessee never received the material support that Lee's army in Virginia enjoyed, and this was reflected in the flags its regiments flew. The Richmond Depot consistently provided the Army of Northern Virginia with standardized battle flags, but the supply network of the Heartland was never as well organized. Not until 1863 did army quartermasters achieve much success in providing uniform patterns for the Army of Tennessee.[2] For the first two years of fighting, western commanders were left to decide for themselves which flag their troops would carry. When the Stars and Bars proved inadequate, some generals issued versions of the ANV pattern, while others developed their own unique designs.

"A Battle Flag So Distinctive"

The Hardee pattern became the best known of the nonstandard Confederate battle flags. The design apparently originated with Gen. Simon Bolivar Buckner, who commanded a division in central Kentucky early in the war. He designed, and his wife sewed, for each regiment of his division "a battle flag so distinctive in character that it could not be mistaken."[3] The flag Buckner devised displayed an elliptical white disk that the men referred to as a "full moon" or "silver moon" in the center of a blue cotton- or wool-bunting field edged with a white border.[4] Soldiers often painted their unit designations on the central disk and battle honors on the field or border. In 1862 most of the regiments of Buckner's command became part of Gen. William Hardee's corps. These troops continued to carry the distinctive blue flag, and other regiments in

the corps adopted it.[5] Although Buckner designed it, the soldiers called their new colors "Hardee flags."

In time, however, only Gen. Patrick R. Cleburne's division bore the Hardee battle flag. Fighting under it, his men had acquired a reputation for being fierce and resourceful soldiers. Union forces learned to dread the sight of the blue flag on the Confederate battle line. In late December of 1863, however, commanders of the Army of Tennessee directed that new regimental colors similar to the ANV pattern be issued to all its divisions. When the men of Cleburne's command learned of this edict, "a hurricane of protest was heard," and they demanded to be allowed to retain their old distinctive flags. In recognition of their fighting qualities, the generals relented and allowed the men to keep their familiar regimental colors. For the rest of the war, Cleburne's Division was the only organization in Confederate service authorized to carry a distinctive battle flag.[6]

Granbury's Texas Brigade, after an unpromising start, became the most famous unit in Cleburne's command. In the fall of 1862, Confederate commanders in the Trans-Mississippi ordered six Texas regiments, five of cavalry and one infantry, to join the garrison of the earthen fort at Arkansas Post that defended the mouth of the Arkansas River.[7] On January 19, 1863, a massive Union division forced the Confederates to surrender after a brief and half-hearted fight. Disgraced, the men were conveyed to prison camps in Ohio and Illinois, where disease and mistreatment claimed the lives of 30 percent of the Texans. After months of captivity the survivors were exchanged. Instead of being returned to fight in the Trans-Mississippi, the Texans instead were assigned to the Army of Tennessee.[8]

The ordeal of surrender and imprisonment did not break the Texans' spirits; it strengthened their resolve. Questions, however, lingered about their actions at Arkansas Post, and few commanders or their troops would trust the Texans to serve beside them in battle. Fortunately, Maj. Gen. Pat Cleburne recognizing the potential of the Texans as fighting men, recruited them to his division as a new brigade, and personally undertook their retraining.[9] Captivity had so depleted their numbers that the Texas regiments had to be consolidated and supernumerary officers transferred to the Trans-Mississippi.[10] The Texans proved a good fit with Cleburne's division, which already possessed a hard-earned reputation for valiance and steadiness. In their first battle, at Chickamauga, more than 400 of the 1,783 Texans who went into battle became casualties. To make up the brigade's losses, the Seventh Texas Infantry was added, and its colonel, Waco lawyer Hiram Granbury, was promoted to brigadier general and given command. Henceforth, the Texans would be known as Granbury's Brigade.

The brigade soon evolved into one of the finest fighting units of the Civil War. During the Army of Tennessee's debacle at Missionary Ridge outside Chattanooga and just after, Granbury's Brigade made its reputation. As Confederate forces collapsed in disorder, Cleburne's division, with the Texas Brigade foremost, held off the federal army at Ringgold Gap and allowed the Army of Tennessee to escape annihilation. During the campaign for Atlanta in the summer of 1864, Granbury's Brigade continued its distinguished service, inflicting terrible punishment on Gen. William T. Sherman's Union troops, especially on the Marietta Line and in the fierce battles around Atlanta.

After the defeat at Chattanooga, Gen. Joseph E. Johnston took over command of the Army of Tennessee. As part of an effort to restore morale, Johnston ordered the distribution of new battle flags. In 1861, while commanding troops in Virginia, Johnston himself had authorized the first issue of the ANV pattern. The flags he ordered for the Army of Tennessee were rectangular versions of that same Southern Cross design.[11] Johnston also instructed Cleburne to obtain new Hardee flags for each regiment in his command.

One of these was issued to the Seventeenth and Eighteenth Texas Cavalry. The soldiers of the consolidated regiment were justifiably proud of their new blue battle flag. Though crude and poorly made, its decorations cataloged the regiment's already extensive record. The battle honors of their previous service, "Arkansas Post," "Chickamauga," "Tunnel Hill, Tenn.," and "Ringgold Gap," were painted in white across the blue field. White twin curved arrows and scrollwork highlighted the center "moon," which displayed the unit designation, "17th & 18th Texas." Although none has survived, the other regiments of Granbury's Brigade must have acquired similar flags at this time (see plate 16).[12]

The flag of the Seventeenth and Eighteenth Texas served the regiment until the August 22, 1864, battle of Atlanta, where, under unusual circumstances, Union forces captured it. Joseph McClure, the regiment's color-bearer, recounted the grim scene. "In the very beginning of the battle our captain . . . was shot down," he wrote. "Then I was shot down under the flag, and in less than two hours, our entire company, with the exception of two men were either killed or wounded." As for the flag, "I am of the opinion that [it] remained on the field until it was picked up by a member of the 15th Michigan."[13] Here was the scene as McClure liked to remember it: the revered battle flag was lost only when no man remained to defend it. The actual events were far less heroic; they well illustrate the confusion of Civil War combat.

An exchange of letters between aged veterans tells the real story. At the height of the battle, the Seventeenth and Eighteen Texas was part of a battle line that was fighting off a Union counterattack from behind captured breastworks. Sgt. Maj. Andrew LaForge of the Fifteenth Michigan Infantry, momentarily pinned down by Rebel fire, spied through the heavy gray smoke what he took to be a surrender flag in the Confederate line. He dashed up the slope expecting to take prisoners into custody. "Imagine my surprise," he wrote, "when I found the supposed signal of surrender to be a regimental flag." Too exposed to turn back, LaForge charged ahead. Pistol in hand, he leaped into the breastwork, grabbed the flag, and brazenly demanded its surrender. McClure, the color-bearer, snatched it back, and a scuffle ensued between the two men. Texan R. H. Hopkins, "seeing the Federal was about to get the best of our ensign," ran to his assistance and took hold of the flagstaff while exhorting McClure not to give up the color. LaForge admonished the two Confederates to stop struggling because, he insisted, "You have surrendered!" While the defenders were distracted by the tussle over the regimental flag, the rest of the Yankee regiment had come up and surrounded the Rebel position. According to Hopkins, "Looking up and down our line, I saw that our men had thrown down their arms to my astonishment."[14] The Michiganders led away nearly two hundred dumbfounded prisoners along with the flag of the Seventeenth and Eighteen Texas.[15]

The hundred days of fighting that had led to the fall of Atlanta had been hard on the army's flags. The colors of the Sixth Texas Infantry and Fifteenth Texas Cavalry Regiment, for instance, were "unrecognizable from being shot to pieces and covered with blood."[16] Cleburne again ordered a new set for his division. The soldiers of the Sixth and Fifteenth elected to send their old flag back to Austin for display in the capitol. They placed it in a trunk and entrusted it to a captain who was to take it to Texas. Unfortunately, while crossing a river in Alabama, high water swept the trunk away, and the flag was lost.[17] The Sixth and Fifteenth Texas' new color was a standard-issue Hardee pattern that the men altered to reflect their Texas heritage. They overlaid a red lone star with point downward onto the round white "moon" and embellished it by embroidering the word "TEXAS," placing a letter between each point. In the same manner, battlefield tailors sewed the unit designation, "6th & 15th," across the face of the star (see plate 15).

After the fall of Atlanta, General Sherman turned his mighty army eastward in the terrible campaign history remembers as the march to the sea. Although defeated, the Army of Tennessee still remained a formidable force of veteran soldiers. A few months earlier Gen. John B. Hood, who had once led the Texas Brigade in Virginia, became commander of the Army of Tennessee. Instead of pursuing Sherman, Hood decided the best way to strike back was to march northwest to recapture Middle Tennessee and take Nashville. Hood's dream died, along with a large portion of his army, on a warm late-autumn afternoon in front of Franklin, Tennessee. There, on November 30, 1864, Gen. John Schofield and 28,000 Union soldiers, many armed with repeating rifles, waited behind an impregnable series of trenchworks. At 4:00 P.M. Hood hurled forward his valiant veteran Confederates. What ensued was the grandest and most suicidal attack in North American history, more impressive even than Pickett's Charge. All who witnessed it were awestruck by the pageantry and ultimate horror. A South Carolina colonel described the event: "We beheld the magnificent spectacle . . . bands were playing, general and staff officers and gallant couriers were riding in front of and between the lines, 100 battle-flags were waving in the smoke of battle, and bursting shells were wreathing the air with great circles of smoke, while 20,000 brave men were marching in perfect order against the foe."[18] Of the "hundred battle flags," those at the spearhead of the Rebel attack were blue.

The charging Confederates met a hurricane of fire and steel. According to one who survived the day, "Never on earth did men fight against such terrible odds. It seemed that the very elements of heaven and earth were in an uproar."[19] During the rush over the broad, level ground, Granbury was killed at the head of the Texans, then Cleburne himself fell, pierced through the heart by a musket ball. Four other Confederate generals died that day. Nevertheless, even after taking terrible losses, Cleburne's leaderless regiments broke through two lines of Union fortifications before being flung back by a massive counterattack. By nightfall more than six thousand soldiers of the Army of Tennessee had fallen. In the words of Sam Watkins, "It was a great holocaust of death."[20] Unlike many who had followed it into battle, the flag of the Sixth and Fifteenth Texas survived to bear witness to the cataclysm.

After Franklin, the Army of Tennessee was a shadow of its former self. Schofield retreated to the fortifications around Nashville, and Hood limped after with what remained of his forces. On December 15 and 16, the vastly superior federal army, attacking out of its trenches, crushed the Rebels and eventually drove them across Tennessee and into Mississippi. In March, 1865, Granbury's Brigade and the Army of Tennessee faced Union forces one last time near Bentonville, North Carolina. But when Lee's army in Virginia capitulated, all hope of continuing the fight evaporated. In late April, Gen. Joseph E. Johnston, who had resumed command, negotiated the surrender. No dramatic surrender ceremony, as the nation had witnessed at Appomattox, awaited the survivors of Granbury's Brigade. The men simply presented themselves for parole, handed over their tattered banners, and quietly started for home.[21] Even so, the moment was bitter. Mark Kelton, captain in the Sixth and Fifteenth Texas, could not bear the thought of surrendering the battle flag that was all that remained of the regiment's pride. Reverently, he removed it from its staff and wrapped it around his body beneath his ragged uniform. In this manner Kelton brought the precious battle flag safely home to Texas.[22]

Horsemen's Stars

It is almost axiomatic that Civil War Texans preferred to serve in the cavalry. The Lone Star State contributed more regiments of horse soldiers to the Confederacy than any other. Whether true or

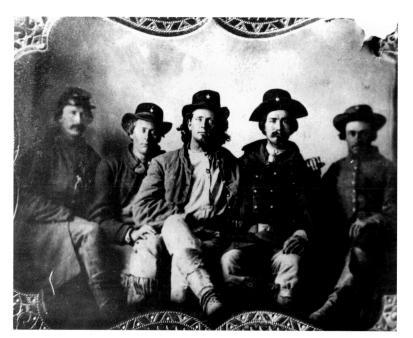

Figure 77. *Terry's Texas Rangers Troopers. Lone-star badges on hats and clothing were common among Texas soldiers. Courtesy of the Texas State Library and Archives Commission.*

not, many a Texan fancied himself an expert horseman, who never "walks a yard if he can help it." By December, 1861, the number of Texans who had enlisted in the cavalry was two and a half times the number who had volunteered as infantry. Unfortunately, maintaining mounted troops was expensive, and horses and fodder often scarce. Moreover, generals, especially in the Army of Tennessee, needed infantry to win battles. It soon became clear that the Confederacy did not need all those Texas horsemen.[23] Of the fourteen lone-star cavalry regiments assigned to the Heartland, eight would be dismounted. Yet the six that did serve on horseback more than upheld the state's reputation for equestrian daring.

The most famous of these was the Eighth Texas Cavalry, best known as Terry's Texas Rangers. Benjamin Franklin Terry, a large slaveholder from Brazoria County, formed the regiment in August, 1861, for service in Virginia. Its compliment of ten companies drawn from the state's central and southern counties was a microcosm of 1861 Texas. In the ranks were professional men and wealthy planters as well as poor farmers and stockmen.

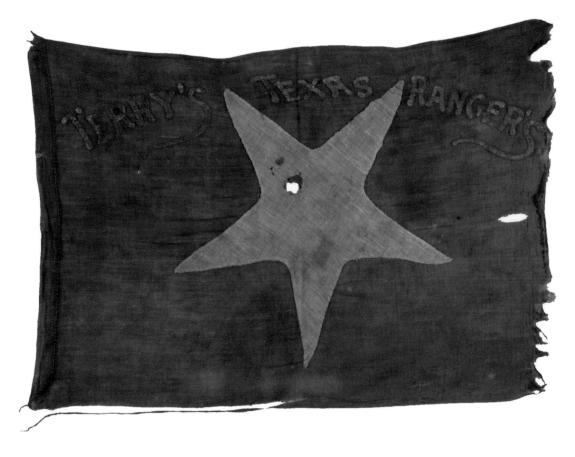

Figure 78. *Terry's Texas Rangers Bonny Blue Flag. After witnessing Harry McCarthy performing his stirring song "The Bonny Blue Flag" in New Orleans, the men of the regiment were inspired to make this flag.*

1861, it did not yet possess a battle flag. At that time the Crescent City was a hotbed of southern patriotism and military activity, as large numbers of volunteers gathered there. One evening some of Terry's Texans attended a concert at the Academy of Music, and young soldiers packed the house to the rafters. Harry McCarthy, a famous minstrel performer, appeared on stage to introduce a new song that he called "The Bonnie Blue Flag." With him was a young female assistant bearing "a flag of dark blue silk with a white star in the center." The words McCarthy had set to music created a sensation. By the second verse the audience had joined in "and sang it over and over again, amid the most intense excitement. It was wafted to the streets, and in twenty-four hours it was all over the Southern army."[27] The experience inspired the design of the Eighth Texas Cavalry's first battle flag. After the performance, the soldiers fashioned their own version of the Bonny Blue Flag out of coarse wool cloth. The large white star they placed in the center had its point downward in the manner Texans preferred. Above it they painted "Terry's Texas Rangers" in yellow. It was probably the only true Bonny Blue Flag any Texas regiment ever carried.

The Eighth Texas proved their mettle in the early fighting but did not keep their original flag for long. Although promised assignment in Virginia, Gen. Albert Sidney Johnston diverted the regiment to his own army, which was assembling at Bowling Green, Kentucky. This force would eventually become the Army of Tennessee. On December 17, 1861, near Woodsonville, Kentucky, the rangers fought their first battle. Compared to later fights, it was a minor affair, but Terry himself was killed leading a charge. Despite his early death, for the rest of the war friend and foe would best know the Eighth Texas by its first commander's name. Sometime during the early skirmishes, the regiment's Bonny Blue Flag was lost or captured.[28] Contemporary accounts report that the regiments of Johnston's army mostly carried the Stars and Bars, so it is likely Terry's rangers obtained one as well.[29] In February, 1862, the fall of Fort Donelson on the Cumberland River forced the Confederates to retreat to northern Mississippi. On April 6, the Rebel army counterattacked at Shiloh. In the bloody two-day battle in which Johnston fell, the Eighth Texas distinguished itself.

That summer, while the army reorganized, Terry's Texas Rangers received a new regimental color from home. Two young ladies,

Among this humbler category were the volunteers who gave the regiment its special character. Several companies came from the great cattle-raising counties of Fort Bend, Goliad, and Gonzales. Here, on the vast coastal plain, southern traditions of open-range herding melded with the brilliant horsemanship of the Mexican vaquero.[24] Thus, many of the cowboys in Terry's ranks possessed dazzling riding skills. While in Nashville early in the war, Terry's Texas Rangers enhanced their reputation by staging "Wild West shows" for the entertainment of the local ladies.[25] The men also made sure they looked the part of wild and exotic Texans. Terry's men customarily added elements of Mexican dress to their gray uniforms. Sombreros, serapes, and large Mexican spurs could not fail to make a dramatic impression east of the Mississippi. Lone-star badges worn on hats and vests completed the picture.[26]

When the regiment assembled in New Orleans in September,

Eliza E. Groce and Annie Jefferson, both of Hempstead, Texas, sewed a red rectangular Southern Cross–style flag out of French merino wool and sent it to the rangers. The blue crosses were silk and displayed thirteen stars. In the center was an oversized lone star characteristic of most homemade Texas Confederate flags. The entire flag was "ornamented with a neat and tasteful border." The ladies also provided a "graceful blue silk streamer" to decorate the flagstaff. On one side an inscription read, "We conquer or Die." Between the words "Terry's" and "Rangers" on the other side was a five-point star with a letter of "TEXAS" between each point.[30] The new battle flag served the regiment through two years of heavy fighting. The Rangers followed it through the invasion of Kentucky in late 1862, and it led during the dozens of battles, skirmishes, scouts, and raids of 1863. The flag was a talisman for the Texas horsemen and a tangible remembrance of home. Sometime in the summer of 1863, one of the young cavalrymen, George Turner, spoke for his comrades when he penned the following lines of a song about their flag:

Through the blinding smoke of battle, like a red hot glare of flame,
Our star-crossed banner flashes, bearing our Terry's name,
Leading us to our first battle, at Woodsonville he fell,
But since on many a battlefield we have avenged him well.
That banner is our glory, 'tis sacred in our eyes,
And we guard it like an amulet on every field it flies,
Like a light from home 'twas sent to us by our noble Texas girls,
And we seem to feel their eyes on us when Count its stars unfurls.[31]

By the fall of 1864, hard service had all but ruined the treasured banner, so after Atlanta fell, the Eighth Texas, like most of the Army of Tennessee's regiments, obtained a new regimental color. Much of the rangers' service had consisted of fighting and raiding in Tennessee, where the Texans had become friendly with many of that state's inhabitants. In gratitude, two Nashville women, Mary McIver and Robbie Woodruff, made a flag for them.[32] Perhaps to indicate solidarity with the Texans of Granbury's Brigade, they chose the Hardee pattern as its basic design. The hand-sewn silk flag displayed the usual white circle in the center of the blue field. On the obverse, in the middle of the circle, they placed a red Latin

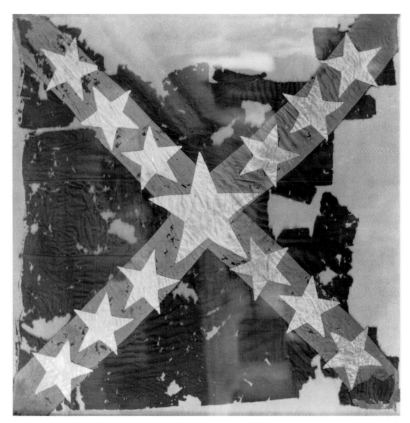

Figure 79. *Terry's Texas Rangers Southern Cross Flag. This unidentified flag in the Texas State Archives may be the Terry's Texas Rangers flag made by two young ladies from Hempstead that served the regiment until the fall of 1864. Hatzenbuehler Photography © 2000 Dan Hatzenbuehler.*

cross embroidered with eleven equal-sized gold stars. Just within the borders of the circle and above the cross are the words *"Ducit amor patriae"* (roughly translated as "love of country motivates us"), and below, "TERRY'S TEXAS RANGERS." The reverse is identical, except the motto "God defend the right" replaced the Latin phrase. In a September 20, 1864, ceremony held at the regiment's camp near Tuscumbia, Alabama, John S. McIver, brother of one of the seamstresses, presented the new flag to Col. Gustave Cook and the assembled regiment. The officers folded the revered Southern Cross flag and sent it back to Texas (see plate 17).[33]

The war would last until late the following April, but the Rangers were able to keep their finely wrought Hardee flag for only a few weeks. On October 13, 1864, the Eighth Texas, as part of Harri-

son's Brigade, was scouting near Rome, Georgia. After skirmishing for hours, the brigade was unexpectedly attacked "from every direction" by John T. Wilder's Lightning Brigade, a crack mounted infantry outfit. In an episode remembered as the "Rome Races," it was every man for himself as the Texans dashed hell-for-leather through the woods to escape encirclement. In the "general stampede" that ensued, Count Jones, the standard-bearer, got entangled in some trees, and the flag, still furled in its waterproof case, was wrenched from the pole. At the time Jones did not notice the loss, but when the Texans reassembled he was astonished to discover the flag gone.[34] The next day a major of the Seventeenth Indiana found the flag still in the rubber sleeve.[35]

Not all Confederates mourned the Texans' loss. Some of the Tennesseans that served with them had been harboring resentment toward the Eighth Texas and its flag. They had voiced displeasure that the Tennessee ladies had made a flag for Texans instead of for soldiers from their own state. According to a Fourth Tennessee Cavalry trooper who had fought alongside the Rangers that day, "It was always a sore reflection for the Tennessee boys to see this flag, as they thought it should have been given to them." The Texans relished their envy and had great fun taunting their fellow soldiers. When the Tennessee cavalrymen discovered the blue flag had been lost, they thought it a great joke. "Look here boys," one of them remarked to the somber Rangers, "what did you do with the flag our gals gave you?"[36] There is no record of what flag Terry's Texas Rangers flew for the rest of the war.

Although the war ended before it could be sent, people in Texas had procured a new flag for the regiment. Hearing of the loss of the Rangers' flag at Rome, the citizens of Houston took up a collection to purchase for them "the best flag that could be made." For the princely sum of $150, they ordered a flag from Cuba, where there was no shortage of silk. The magnificent banner arrived by way of a Galveston blockade-runner in March or April of 1865. As described by a local newspaper, it was "the finest flag we ever saw. . . . 48 inches square of heavy red silk, having the blue bars of the same material six inches wide. The white border of the bars and the stars are heavy silk embroidery."[37] Before it could be sent, the Army of Tennessee had surrendered, and the survivors of Terry's Texas Rangers no longer had need for battle flags.

Ross's Brigade

Ross's Texas Cavalry Brigade was another distinguished fighting force of the western Confederacy. The brigade, which included the Third, Sixth, Ninth, and Twenty-seventh Texas Cavalry regiments, participated in the hotly contested campaigns of the Mississippi Valley region, with the Army of Tennessee in defense of Atlanta, and in Hood's incursion into middle Tennessee. At Wilson's Creek in August, 1861, the Third Texas became the first regiment from the Lone Star State to fight in a major battle. All four regiments participated in early fighting in the Indian Territory against a Unionist faction of the Creek tribe under the old chief Opothleyahola.[38]

After fighting in the March, 1862, battle of Pea Ridge as part of Gen. Earl Van Dorn's Army of the West, the four regiments were dismounted and transferred across the Mississippi River to begin their service in the Confederate Heartland. At the battle of Iuka in September, 1862, the Third and Twenty-seventh Cavalries each lost nearly one-third of their men when they captured an enemy artillery battery. In October of the same year, the Texans fought in the bloody battle of Corinth, where the Sixth and Ninth took heavy casualties.

By November the army's need for cavalry had increased, so the four regiments were remounted and organized as a brigade under the command of Gen. John Whitfield. A few weeks later, as part of a large force of Rebel cavalry, the Texas Brigade helped destroy the Union depot at Holly Springs, Mississippi, thus foiling Gen. Ulysses S. Grant's first advance on Vicksburg. Raids into Tennessee and a stubborn fight at Thompson's Station followed. The Texas horsemen spent most of 1863 fighting on the fringes of the Union army in Mississippi. In December of 1863, John Whitfield passed command of the brigade to Brig. Gen. Lawrence "Sul" Ross of the Sixth Texas. The former Texas Ranger and future governor led it with distinction for the rest of the war. The number and variety of battle flags the regiments of Ross's Brigade carried during the war reflected the chaotic conditions of the western Confederacy. All four regiments probably began service in the Trans-Mississippi with variants of the Stars and Bars.

The Third Texas Cavalry was organized in Dallas from independent companies raised in ten East Texas counties. Many of the volunteers had been members of the Knights of the Golden Circle.[39]

In the summer of 1861, Union pressure in Missouri and the Indian Territory threatened the security of Texas. The Third Texas Cavalry was already mounted and ready, thus becoming the first Texas regiment to go to war. Each company brought its own flag to Dallas, but before the regiment could obtain its color, Gen. Ben McCulloch summoned it to his Arkansas command, which was assembling to meet an immediate threat there from Union troops. On its way, as the regiment passed through the Indian Territory, this omission was remedied. At Boggy Depot, a town just north of the Red River in the Choctaw Nation, the women there presented the Third Texas with a battle flag. A few days later, in the Cherokee Nation settlement of Blue Ball, the enthusiastic tribesmen awarded the Texans a second color.[40] For an undisclosed reason the men chose the Boggy Depot flag to lead the regiment. While no record exists that describes either flag, it seems all but assured that both were Stars and Bars.

The Third Texas fought under the Choctaw-made flag until it was lost at the battle of Thompson's Station in early March, 1863. In this action, Confederate cavalry, including the Texas brigade, had surrounded a substantial Yankee infantry force near Spring Hill, Tennessee, and after a sharp fight forced its surrender. While the Third Texas was on the battle line, a bullet severed the staff that held the regimental color. When the standard-bearer retrieved it, he was forced to escape through a "plum thicket," where the flag was "torn to ribbons," and there it remained, hopelessly tangled among the branches.[41]

The original flag of the Sixth Texas Cavalry was lost a month later. In the summer of 1861, ten mounted companies, whose numbers included many frontiersmen and Indian fighters, had assembled south of Dallas to organize as a regiment and drill. On September 7, when the regiment formally mustered into Confederate service, part of the ceremony consisted of the presentation by the ladies of nearby Lancaster of a splendid Stars and Bars. The flag survived dozens of hard battles and skirmishes as it led the regiment through the first year and a half of the war. According to one of the Sixth Texas standard-bearers, it was "one of the most bullet-riddled Battle-flags that Freedom ever followed."[42] Its demise, however, did not come in glory on the battlefield but in a Mississippi hotel. By the late spring of 1863, the Sixth Texas' Stars and Bars was worn out. The soldiers agreed it should be sent home to Austin so that "patriots from every land might view" the retired banner. However, Sul Ross, then colonel of the regiment, decided the flag should first be repaired and inscribed with the names of the battles in which the Sixth Texas had engaged. John Miller, the standard-bearer, took the flag to Mobile, where the Sisters of Charity sewed up the rents and embroidered the battle honors. An aide to the general, a Captain Simpson, was returning with it to camp when he checked into a Jackson, Mississippi, hotel. That night Simpson was showing the flag to some ladies when dinner was announced. He folded it, left it on a table in the lobby, and carelessly set his valise on top before going into the dining room for supper. While he ate, the hotel caught fire. Simpson rushed into the burning lobby, snatched up the valise, and made a narrow escape. In his haste, he left the flag on the table, and the fire consumed it along with the hotel.[43]

In February, 1862, Gen. Earl Van Dorn, commander of the Army of the West, had provided his solution to the flag problem that other Confederate commanders in the field had faced. "So many mistakes have occurred during this war," he wrote to Gen. Sterling Price, "by the similarity of flags that I have had a battle-flag made, one of which I send you for our army. Please have one made for each regiment . . . to be carried in battle."[44] Even though while serving in Virginia Van Dorn had received one of the three original ANV flags, he decided on a completely unique design for his western forces. The Van Dorn battle flag, as it came to be called, was a red rectangle bordered in yellow on three sides. Thirteen stars were scattered across the field, and in the upper left was a white crescent symbolizing Missouri. Historians believe the first of these flags was issued to regiments of the Army of the West in June, 1862, after its transfer to Mississippi. Examples continued to be used by some Confederate units until the Vicksburg campaign in the summer of 1863.[45]

The Texans apparently did not share Van Dorn's concern about "the similarity of flags." The Third and Sixth Texas continued to fly their original Stars and Bars, and it is unknown which flag the Twenty-seventh carried before 1863. Only the Ninth Texas is known to have used and developed an attachment to the Van Dorn flag. A. W. Sparks recalled that until after the battle of Pea Ridge,

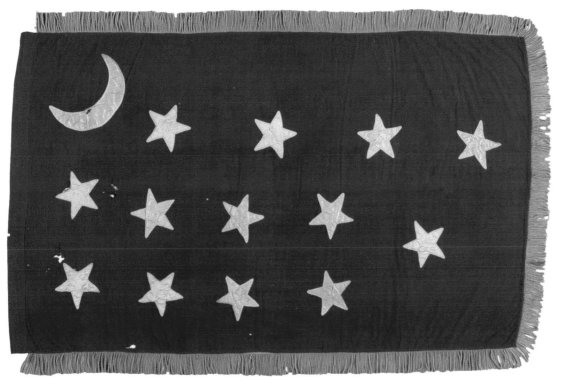

Figure 80. *Van Dorn Flag. Confusion on the battlefield made it necessary for some Confederate commanders to design unique battle flags for their troops. The flag pictured, that of a Missouri infantry regiment, is one of those Gen. Earl Van Dorn issued to his Army of the West. It is the same pattern as the regimental color that led the Ninth Texas Cavalry at the battle of Corinth. The Museum of the Confederacy, Richmond, Virginia. Photography by Katherine Wetzel.*

the Ninth Texas Cavalry had not possessed an official regimental battle color but had made do with various company flags. Thus, having developed no great attachment to any of these flags, the regiment was pleased to receive the new Van Dorn. Sparks described the new color as "a small brownish red silk flag, in the center of which was a crescent moon and thirteen five-point silver stars. It was trimmed with silk fringe and attached to a dark mahogany colored staff with a gilded spear head at the top."[46] In later years veterans recalled with pride following this flag in the bloody battle of Corinth. The severe damage inflected upon it bore witness to the terrible fire the Ninth Texas endured. Our flag "is torn, tattered and faded," wrote one of the Texans shortly after the battle. "In three days of fighting . . . about eighteen inches was torn off and lost, there are fifteen bullet holes through the flag and three through the staff . . . [and a] large rent made by a piece of bomb. Three color bearers were shot down & a fourth now carries it."[47] After the battle the flag was retired.

In November, 1863, Gen. "Red" Jackson's cavalry division,

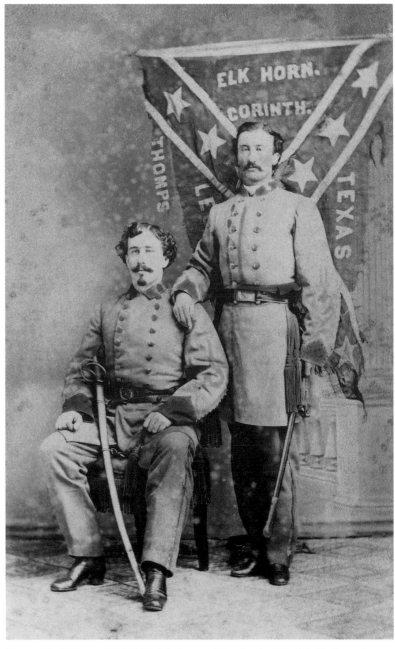

Figure 81. *Officers with Whitfield's Legion Flag. In the fall of 1863, the regiments of Ross's Brigade, including the Twenty-seventh Cavalry, also known as Whitfield's Legion, each received a handsome twelve-star battle flag emblazoned with battle honors. Courtesy of the Houston Metropolitan Research Center, Houston Public Library.*

which included Ross's Brigade, received a new set of battle flags. These were rectangular bunting twelve-star variants of the ANV battle flag, which had been made by private contractors in Mobile, Alabama. Sewn on each flag in handsome white letters were the regimental designation and the names of the battles in which each had fought.[48]

Three of the Texas regiments took quickly to the impressive new battle flags, but the Sixth Texas apparently never used theirs regularly. After the original flag had been lost in the Jackson hotel fire, the ladies of Richland, Mississippi, presented the regiment with a replacement constructed from a "fine silk dress." In pattern it resembled the Texas secession banner. The sky-blue "flag was one solid color, without the bars; the stars clustered in the middle." The Sixth Texas bore this flag for the rest of the war. In time, however, the sun and rain took a toll on the delicate fabric, and its color faded to a "very light blue." John Miller, the regiment's standard-bearer, reported that the flag's washed-out appearance provoked ribbing from fellow Confederates. "While campaigning around Atlanta," he recalled, "we passed by a Georgia regiment, [and] someone called out in a derisive voice: 'That's a mighty pale flag you carry!'" Miller replied in a funereal voice, "Yes! But like the 'Pale Horse' of the Apocalypse, 'Hell follows after it!'"[49]

The Ninth and Twenty-seventh Texas bore their twelve-star

flags until the end of the war, but the Third Texas lost theirs while repelling a Yankee cavalry raid near Atlanta in August, 1864. The incident occurred when most of the Confederate cavalry was away fighting in Tennessee, while Red Jackson's Division remained behind to screen the main army. A large Union cavalry force under Brig. Gen. H. J. Kilpatrick approached Atlanta from the west, aiming to wreck Confederate supply lines and create as much chaos as possible. As the raiders were ripping up railroad tracks and burning the little town of Jonesboro, three Rebel brigades, including Ross's, closed in. Near Lovejoy's Station they cornered Kilpatrick and his Yankee horsemen. As one of the Texas troopers saw things, "We had him surrounded, and in a 'Very tight fix.' But [Kilpatrick's] Celtic sagacity soon discovered our weakest point, which happened to be our brigade."[50] Three Union regiments with sabers drawn crashed into the Rebel line in a desperate bid to make their escape. The Confederates were unprepared for this audacity, which caught the Third Texas dismounted in an open field. The Texans got off a single volley before the blue-coated horsemen rode over them. With the fleeing federals went thirty prisoners and the flag of the Third Texas.[51]

The end of the war came as an anticlimax for the men of Ross's Brigade. They had endured the horrors of Hood's Middle Tennessee campaign with the rest of the Army of Tennessee, but the spring of 1865 found them bivouacked in central Mississippi, awaiting the inevitable. On May 15, after the major armies of the Confederacy had surrendered, the brigade's officers went to Union headquarters in nearby Jackson, obtained parole documents, and brought them back to camp for the men to sign. No surrender ceremony occurred and no northern soldiers entered the Rebel camp. The veteran cavalrymen simply parked the artillery, stacked their rifles and carbines, and began preparing for the journey back to Texas. The victors had neglected to demand the surrender of the battle flags, so the Texans removed them from their staffs and started home with them.[52]

The flag of the Ninth Texas, however, would resist federal authority one last time. As part of the surrender terms, Union forces were to provide the Texans transportation home. Soon after receiving their paroles, a contingent of the Ninth Texas boarded the steamer *Fairchild* at Vicksburg for the trip downriver. After getting

Figure 82. *Sixth Texas Blue Regimental Flag. The women of Richland, Mississippi, made this starry blue flag for the Sixth Texas out of dress silk. Drawing by Anne McLaughlin, Blue Lake Design, Dickinson, Texas.*

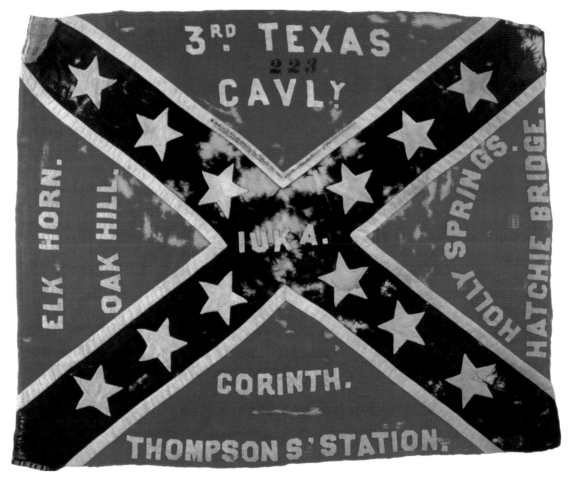

Figure 83. *Third Texas Cavalry Twelve-Star Southern Cross Battle Flag. The Third Texas lost this flag during a Union cavalry raid. Courtesy of the Texas State Library and Archives Commission.*

underway, the soldiers, in an act of defiance, unfurled their twelve-star Rebel battle flag that was inscribed with the names of so many hard-fought battles and hoisted it on the stern. For a time the ship steamed down the broad river with the Stars and Stripes on the bow and the Southern Cross on the fantail. The appearance of Union gunboats nearby prompted the Texans to haul down their flag for the last time.[53]

Ector's Brigade

Another distinguished Texas unit that fought in the Heartland was Ector's Brigade. The Rebel withdrawal from Kentucky in the spring of 1862 had signaled a crisis for the western Confederacy. By the end of March powerful Union armies were descending through

Tennessee and threatened to cut the South in two. To aid in the defense all available Confederate units in Arkansas were ordered to join Gen. Albert Sidney Johnston's beleaguered army in northern Mississippi. Among the troops summoned were the Tenth, Eleventh, Fourteenth, and Thirty-second Texas Cavalry regiments. As usual, the army already had all the mounted troops it needed, so the four regiments were dismounted and sent east. They were organized into an all-Texas brigade that was placed under the command of Henderson attorney Mathew D. Ector. During the next three years, Ector's Brigade would fight as infantry and became one of the western Confederacy's finest commands.

In addition to the Tenth Texas Cavalry's First National pattern with stars representing the Indian nations (see chapter 4), one other original regimental flag of Ector's Brigade survived. The Eleventh Texas, known in 1861 as Young's Regiment, began its service with an unusual variant of the Confederate First National pattern. It was the handiwork of the women of two North Texas towns. The ladies of Gainesville sewed one side, the ladies of Sherman the other, then joined them together. Each face displays four bars in a blue, red, white, blue pattern — rather than the three conventional in a red, white, red pattern. Each canton is white and contains eleven stars. On the obverse ten red stars orbit a large Texas lone star of the same color. On the reverse the stars are blue, but only nine circle the central lone star. Almost as an afterthought, an eleventh blue star was added to the lower staff quadrant, as if the makers had miscounted or not initially known how many stars should be included. No record exists of where are for how long the flag served.

The newly formed Texas brigade joined Gen. Evander McNair's Arkansas brigade to form a small division commanded by Gen. John P. McCown. In July, 1862, McCown's division was sent to reinforce Confederate forces near Chattanooga. During the Confederate offensive into Kentucky, this Arkansas and Texas division was closely associated with the troops of Gen. Patrick Cleburne and Gen. Preston Smith, both of which flew blue battle flags. Cleburne's carried the Hardee and Smith's the so-called Polk pattern. Before the war, Leonidas Polk had been the Episcopalian bishop of Louisiana. As a corps commander in the western Confederacy, he had issued his own battle flag. It was blue with a red St. George's

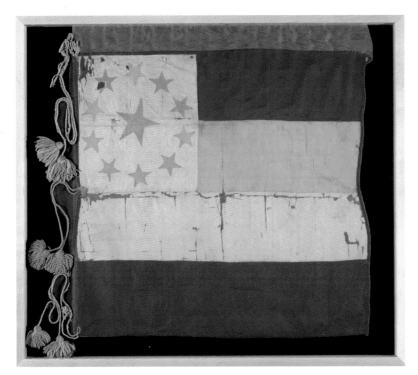

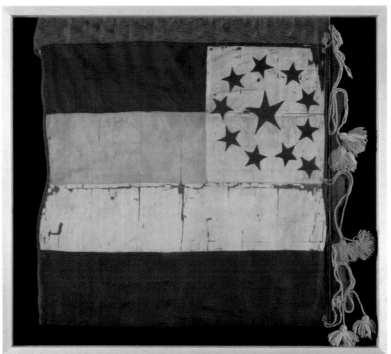

Figure 84. *Eleventh Texas Cavalry Stars and Bars Variant. The women of Sherman and Gainesville each made a side of this unique Stars and Bars. Note the misplaced star on the reverse. Hatzenbuehler Photography © 2000 Dan Hatzenbuehler.*

Figure 85. *Ninth Texas Infantry Polk-Pattern Battle Flag. Before the war, Confederate general Leonidas Polk had been Episcopal bishop of Louisiana. He ordered troops under his command to fly colors that displayed a design that was consonant with the former bishop's ecclesiastical background. Drawing by Anne McLaughlin, Blue Lake Design, Dickinson, Texas.*

Cross that displayed eleven stars in the arms. Before it joined Ector's Brigade after the battle of Murfreesboro, the Ninth Texas Infantry probably flew a Polk-pattern battle flag.[54] In solidarity with these units, McCown issued his own distinctive blue battle flag to the two brigades of his division. The design he chose was a blue field with a plain white St. Andrew's cross, bordered on four sides in white. Consciously or not, McCown had recreated the traditional flag of Scotland.[55]

During the hard campaigning of the next eighteen months, Ector's Brigade followed the blue flag. The Texans' first real battle came at Richmond, Kentucky, where their ferocious charges helped bag more than five thousand Yankee prisoners. On December 31, 1862, at the battle of Murfreesboro, Ector's Brigade took part in the first day's assault that nearly wrecked Union Gen. William S. Rosecrans's army's right flank. In desperate fighting, the Texans and their Arkansas comrades drove the enemy back more than

Figure 86. *Tenth Texas Cavalry McCown-Pattern Battle Flag. Regiments serving under Gen. John P. McCown were issued colors that resembled the national flag of Scotland. Drawing by Anne McLaughlin, Blue Lake Design, Dickinson, Texas.*

1864, orders came for the brigade to rejoin the Army of Tennessee for the defense of Atlanta. New battle flags were called for, and they would come from an unlikely source.

The regiments of the brigade had never given up hope that they would be remounted and transferred back to Texas. The men had some reason to expect this, because in January, 1863, the Eleventh Texas had been detached and reconverted to cavalry.[59] When acting brigade commander Col. William H. Young departed for Richmond on March 31, 1864, the soldiers assumed he was going in order to attempt to convince Confederate authorities to remount the three former cavalry regiments.[60] If this had indeed been his mission, it ended in failure; the brigade would finish out the war as infantry. Young, however, did not return empty-handed. With him were four new standard-issue fourth-bunting Richmond Depot ANV battle flags identical to those issued to Lee's army.[61] When it fought in the Atlanta Campaign, the bloody battle of Allatoona Pass, and Hood's ill-fated Middle Tennessee offensive, Ector's Brigade had the distinction of carrying the same flag as its brother Texas brigade in Lee's Army.

These Texans' last service was the defense of Mobile in March and April of 1865. As part of a 3,500-man Confederate garrison at Spanish Fort, Ector's Brigade withstood a thirteen-day siege by 30,000 Union troops. The odds, however, were clearly hopeless. On the afternoon of April 8, with fifty-three heavy-siege cannon and thirty-seven field guns pounding the defenders, federal forces began an all-out assault. After holding off the initial attack, the Rebel commander ordered his forces to evacuate. The Spanish Fort garrison spiked their guns and abandoned all the equipment they could not carry. To reduce the chance that Union troops would detect their flight, the soldiers removed their shoes and padded quietly across an eighteen-inch-wide causeway to safety.[62]

Among the gear left behind were three of the four battle flags of Ector's Texans. When Union soldiers later found them in the abandoned fort, true to form, Congressional Medals of Honor were awarded to the lucky scavengers.[63] Charlie Matthews, color-bearer of the Ninth Texas, however, refused to abandon his regiment's flag and escaped with it. A few weeks later, when the brigade finally surrendered near Meridian, Mississippi, Matthews again saved the

four miles, seizing large numbers of prisoners and fourteen pieces of artillery.[56] The Tenth Texas by itself captured three Union battle flags.[57] A Confederate officer noted that during the action "the color bearers along the whole line more than once elicited my admiration by the steadiness with which the Bonnie Blue Flag was constantly borne in the front line."[58] Ector's Brigade spent most of 1863 in Mississippi in often futile opposition to various Union incursions. In September, the Brigade shared in the Confederate victory at Chickamauga but lost more than five hundred men in the process. After so much marching and fighting, Ector's blue flags must have been in various states of deterioration. In the spring of

Figure 87. *Charlie Matthews with Ninth Texas Flag. Just before the 1864 Atlanta Campaign, the commander of Ector's Brigade obtained flags that were identical to those being used by Lee's Army of Northern Virginia. Charlie Matthews, who had saved his regiment's flag from capture, posed with it outside his Paris, Texas, home in 1910. Courtesy of the Lawrence T. Jones III Collection.*

flag. To keep it out of Union hands, he cut it from its staff, crammed it in his shirt, and brought it home to Paris, Texas, with him.[64] For the rest of his life the flag remained his proudest possession.

The Trans-Mississippi

To the residents of the Rebel states west of the Mississippi, it seemed the Confederate government was always on the verge of abandoning them. Richmond, in fact, could not afford to share many of the South's scarce resources in an area that was so far from the strategic axis of the war. Even the small stream of supplies the government could provide slowed to a trickle. The captures of Memphis and New Orleans in 1862 and the fall of Vicksburg in July, 1863, all but isolated the Trans-Mississippi from the rest of the Confederacy. For much of the war the people of western Louisiana, Arkansas, Missouri, and Texas had to provide for themselves.

More Texas regiments saw service in the Trans-Mississippi than in any other region. The fighting in this vast area was widespread but sporadic. Early in the war, Texas forces unsuccessfully invaded New Mexico and for four years battled Union forces in the Indian Territory, Arkansas, and Missouri. Federal efforts to choke off the Mississippi River beginning in 1862 led to bitter fighting in western Louisiana. Texans, however, devoted most of their energies to defending their own state. Throughout most of the war lone-star forces guarded the Rio Grande, the Texas coast, and the western frontier. Most of this service was unglamorous and routine. Texas soldiers spent much of their time riding monotonous patrols against Indians, deserters, and Union sympathizers, and watching the horizon for Yankee ships.

Sometimes the enemy came. In late 1863 and early 1864, a Union amphibious force briefly occupied the Texas coast from Brownsville to Matagorda. A few months later a federal army under Gen. Nathaniel Banks traveled up the Red River in an attempt to conquer the rich East Texas cotton lands. Texans, along with troops from the other Trans-Mississippi states, gathered to repel the invaders. In a series of battles beginning near the Louisiana communities of Mansfield and Pleasant Hill, Confederate troops drove back the intruders and thus spared Texas from the sort of physical devastation other southern states endured.

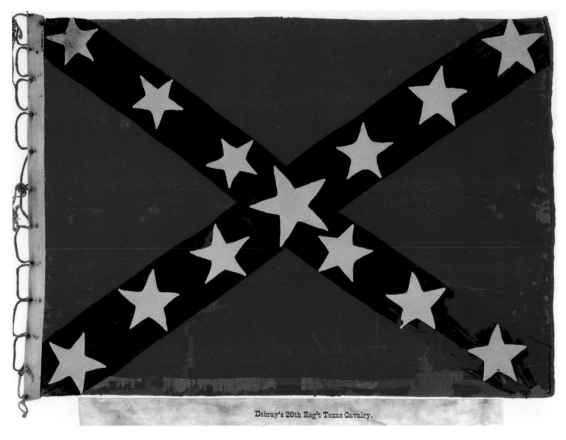

Debray's 26th Reg't Texas Cavalry.

Figure 88. *Debray's (Twenty-sixth) Texas Cavalry "Texas Pattern" Battle Flag. The pattern of this unit's flag was typical of the design Texans in the Trans-Mississippi preferred. Hatzenbuehler Photography © 2000 Dan Hatzenbuehler.*

Scarcity characterized the conditions in Texas during the war. Cotton and cattle were the state's chief prewar products, but the federal blockade severely limited trade in these commodities. A dependable industrial base had yet to develop; thus manufactured goods such as cloth and weapons could be obtained only with the greatest difficulty. The designs of surviving Texas battle flags from the Trans-Mississippi reflect the confusion and supply problems of this often isolated theater of war. An efficient supply network never developed in the region, and Confederate commanders rarely made attempts to provide flags of any particular design. For the most part, individuals and communities, not quartermasters, supplied colors to each Texas regiment, battalion, and company.[65]

As with other war materials, the manufacture and design of battle flags had a makeshift quality. Most were homemade out of whatever material was immediately available. Instead of bunt-

ing and silk, which after the first weeks of the war were all but unobtainable in Texas, many flags were made out of flannel and cotton. As elsewhere, in the early part of the war the Stars and Bars was the most common pattern, but in time rectangular versions of the ANV flag predominated. A few Confederate Second National Flags appeared in late 1863, but several surviving flags do not conform to any known Confederate pattern. Yet, true to the state's tradition, the makers of the majority of Trans-Mississippi Texas flags incorporated the lone star in their designs. So scarce were raw materials that some units did not obtain flags until years into the war. The Eleventh Texas Battery, which was raised in December, 1861, did not receive its first Confederate flag until 1864, when the women of Bonham, Texas, finally obtained some bunting from Mexico.[66] The Third Texas Infantry formed in the summer of 1861 but did not obtain a regimental color until the fall of 1863, when one was sent from Cuba.

Once a Trans-Mississippi Texas unit received a flag, the soldiers tended to keep it in service regardless of changes in regulations and styles in other theaters of war. Much of the fighting and campaigning in the region was limited, and despite the harsh weather battle flags did not wear out as readily as those carried in battle after battle in the east. Less fighting also meant fewer captures. Even if a flag became damaged or worn-out, repair was often the only option. This was the case with the color of the Sixth Texas Cavalry Battalion. In 1862 prominent Leon County lawyer Robert S. Gould organized five companies into a battalion with himself as major. Early in its service, Gould's Battalion was dismounted and served the rest of the war as infantry. The unit saw combat only during the Red River campaign, where it fought with some distinction at the battles of Mansfield and Pleasant Hill, and then at Jenkins Ferry.[67]

When Gould's Battalion formed, the women of Crockett, Texas, presented to the unit a battle flag remarkable in its elaborate design and crudeness of fabrication. The canton of this unusual Stars and Bars variant contains a huge red star within which are ten smaller stars and a larger lone star. A clumsily rendered shield bearing the word "Texas" and another lone star adorns the white center bar. The homespun cotton with which the flag was made did not wear well, and in the course of the battalion's service pieces from the fly end were cut off to repair damaged sections nearer

to the staff. Nevertheless, the color remained in service probably until after the Red River campaign. By the time of its retirement, Gould's battalion's flag was twenty inches shorter than when it was made and parti-colored with mismatched patches (see plate 22).[68]

Texans in the Trans-Mississippi began to adopt the Southern Cross battle flag in 1862, but they preferred a rectangular shape to the square characteristic of the flag of Lee's army. These flags had no border, and the blue cross was plain, without the white fimbriations that characterized the ANV pattern and the Army of Tennessee version. Referred to as the "Confederate battle flag, Texas pattern," these displayed a prominent lone star in the cross's center.[69] One of the most impressive of these was that presented to the Fourth Texas Cavalry. This unit had established one of the most impressive combat records of any Texas Trans-Mississippi regiment, as the flag's battle honors attest. Embroidered across its crimson field were the names of its fights in New Mexico, "VAL VERDE" "GLORIETA," "PERALTA," and the more recent "GALVESTON" and "GALVESTON BAY." In a Houston ceremony held in late January, 1863, Maude Young, of Hood's Brigade fame, and Charlotte Allen, sister of the city's founders, presented the flag to honor the regiment for its role in driving Union troops out of Galveston a few weeks earlier.[70]

A battle flag, Texas pattern that still exists is the flag of Debray's Twenty-sixth Texas Cavalry. It is a fifty-two-by-thirty-six-inch borderless red flannel regimental color that displays a lone star in the center of its cross. It was plain compared to the Fourth Texas Cavalry flag but apparently impressive enough to uphold regiment's dashing image. Although the regiment did not participate in any major battles until 1864, the Twenty-sixth Texas early on developed a reputation for daring and good discipline. When stationed near towns, the regiment often drew large audiences with its elaborate mounted drill and dress parades. These events, accompanied by bands and other entertainment, were so impressive that citizens noted that the proceedings resembled a circus. Thus, they took to calling Debray's Regiment the "Menagerie," a nickname that delighted the soldiers.[71]

The designs of some flags of Texas Trans-Mississippi units would not have been recognized on eastern battlefields. The battle flag of Woods's Thirty-second Cavalry is a case in point. It is a blue forty-

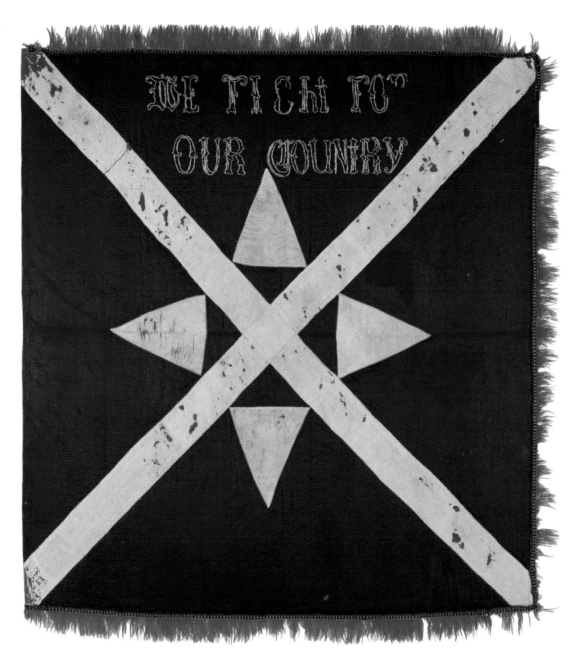

Figure 89. *Woods's (Thirty-second) Texas Cavalry Regimental Color. Many of the flags flown by Texans in the Trans-Mississippi were unique. The blue flag of the Thirty-second Cavalry, known as Woods's Regiment, displayed a St. Andrew's Cross and an unusual four-point version of the lone star. Hatzenbuehler Photography © 2000 Dan Hatzenbuehler.*

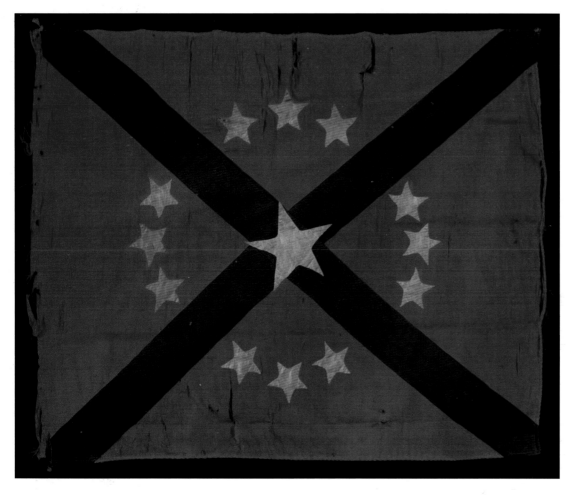

years of the war, Wood's regiment saw no action, its service limited to patrolling the frontier and Texas coast. When Union forces marched up the Red River, the Thirty-second Cavalry joined Confederate forces in Louisiana. In the course of the campaign, Woods's regiment, which had never been in battle, fought with great distinction — and loss of life.

Another unique flag was flown by Maltby's company, a unit that was officially part of the Eighth Texas Infantry. In 1861 William Maltby, a Corpus Christi newspaperman, raised an eighty-man company to defend Mustang Island and Aransas Pass. The unit, composed of about two-thirds Anglo and German recruits and one-third Mexican, was unable to cope with the bold Union landing parties that continually raided the Texas coast. At some point during their dreary service, Maltby's company procured an interesting and unique battle flag. It was constructed from two layers of light red wool cloth displaying a blue St. Andrew's cross. Twelve white cotton stars formed a twenty-two-inch circle in the middle of the flag. A large tilted lone star in the center of the cross proclaimed it a Texas flag. In mid-1863 Confederate authorities assigned Maltby's company the unenviable task of defending a primitive earthen fortification on the north end of Mustang Island, known as Fort Semmes. A few months later a massive Union amphibious invasion force made its way from Brownsville up the Texas coast. More than two thousand well-equipped Yankee troops, supported by a powerful fleet, attacked the fort's hundred hapless defenders. Faced by such overwhelming odds, Maltby and his men surrendered without a fight. One of the Union regiments, the Fifteenth Maine, captured the unusual red flag that flew over the fort and returned it to their home state, where it remained until 1927.[74]

Lt. Gen. Richard Taylor, son of former president Zachary Taylor and in charge of the district of West Louisiana, tried to bring some semblance of uniformity to the flags his units carried. His command included many soldiers from the Lone Star State, most notably Walker's Division, the largest body of Texas troops to fight as a single formation during the war. Sometime in 1863, Taylor began ordering his forces to obtain flags of a design essentially the same as that of the Army of Northern Virginia, with the notable exception that the colors of the field and the cross were reversed.[75] There is no written record of his orders, and only three of the blue

Figure 90. *Fort Semmes Flag. Union forces captured this unusual Confederate Flag on Mustang Island in late 1863. The state of Maine returned it to Texas in 1927. Hatzenbuehler Photography © 2000 Dan Hatzenbuehler.*

four-inch silk square with a white St. Andrew's cross, edged with a red wool fringe. In the center is a white four-point star, above which is embroidered the straightforward patriotic motto — "WE FIGHT FOR OUR COUNTRY." The makeup of the regiment was as diverse as its flag's symbols. Seguin physician Peter C. Woods raised the Thirty-second Texas in March, 1862. Among its complement was a large contingent of German immigrants.[72] For the most part German-born Texans were cool toward the Confederate cause, but those of Wood's regiment proved an exception. Even though their Anglo compatriots sometimes doubted their loyalty, these Germans worked hard to prove that they were patriotic Texans and generally performed well as Rebel soldiers.[73] For the first two

flags with the red St. Andrew's cross survive, one of which is of a Louisiana unit, so there is no way to know how many Texas units carried this pattern. The earliest known surviving example of a Taylor battle flag was one presented to the Third Texas Infantry (see plate 21).

This regiment more than any other represented the diversity of Civil War Texas. It was a polyglot unit raised in San Antonio and South Texas composed of equal portions of Germans, Mexicans, and Anglos.[76] For the first two years of the war, the Third Texas patrolled the Rio Grande. Col. Arthur Fremantle, an English soldier who visited Brownsville in 1863, wrote that even though many of its soldiers could speak little or no English, the Third Texas was the best-drilled and -equipped Texas regiment he ever saw. He noted that a number of the men wore Mexican sombreros while the rest sported all manner of military and frontier headgear.[77] The regiment moved to Galveston in the summer of 1863, where its personnel, suffering from homesickness, intense heat, and wretched living conditions, staged a brief mutiny.[78] Under its steady officers, the morale of the regiment quickly recovered, and the Third Texas was back in fighting trim when it was called on to join the defense of East Texas. Despite its long service, the Third Texas Infantry did not have a battle flag.

In Cuba at that time was a colony of exiles who had fled New Orleans when northern troops occupied the city in 1862. In Havana, where silk and other costly materials were abundant, some of these expatriates began making flags for the Confederacy. In August, 1863, a woman named Mrs. Phelps constructed a fine Taylor flag for the Third Texas and dispatched it to Galveston by blockade-runner. A newspaper described it as being "all of heavy silk, with bullion stars and heavy bullion cords and tassels."[79] The magnificent battle flag was presented to the regiment in Houston as it departed to join Walker's Texas Division in Louisiana. The Third Texas arrived after Banks's army had been turned back at the battle of Mansfield, but marched north with a large Confederate force that was ordered to meet the second wing of the Union threat, which was moving south from Arkansas. The Third Texas fought its only battle at Jenkins Ferry in southern Arkansas. Here, in the rain and mud and across flooded ground with their new flag in the van, the regiment charged like veterans into the teeth of the Union defenses, taking heavy casualties.[80]

One other Taylor battle flag that may have belonged to a Texas unit still exists. It is a huge, approximately seventy-two inches square, deep-blue silk flag with a wide red cross. In the upper quadrant the battle honor "Mansfield" arches over the date of the battle, "April 8th 1864." The lower quadrant similarly displays "Pleasant Hill" and "April 9th 1864." The flag exhibits no unit designation, and it is not known to which regiment it belonged. The enlarged star in the center of the cross, however, strongly suggests this was a flag presented to a Texas unit, possibly of Walker's division. Because the flag is so luxurious, it is probable that, like that of the Third Texas, it too originated in Havana.

When in May, 1865, Texans learned of the surrenders of the Confederate armies east of the Mississippi, the will to continue resisting drained away. Civil government collapsed; plundering and other lawlessness broke out in some areas. Throughout the region, soldiers simply packed up their belongings and headed for home. To keep them from being dishonored by capture, and as souvenirs of the years of privation and futile struggle, they took their battle flags with them. On June 19, Maj. Gen. Gordon Granger landed in Galveston with the first contingent of what would swell to over forty thousand blue-clad occupation troops and announced that slavery in Texas was ended. The people expected military trials of former Confederates and the confiscation of property. Some fled to Mexico and South America.[81] Dark days loomed for the former Rebels, and, for the foreseeable future, the flags under which they had so recently served would have to stay hidden.

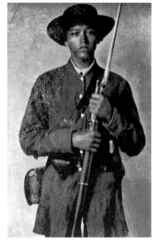

Figure 91. *Hispanic Confederate Soldier. The young Rebel pictured here was one of hundreds of Hispanics who served in Texas Confederate regiments, such as the Third Texas Infantry. Courtesy of Chrysalis Books Limited.*

(7)
Lost
Cause
and
Lone
Star

The end of the War Between the States did not bring reconciliation to North and South, and Texans did not immediately regain their affection for the Stars and Stripes. Almost as soon as the cannon ceased their roar, both sides began a debate over what the war had been about. Northerners proclaimed that theirs had been a victory over treason, plain and simple. Southerners bridled under this effrontery, but with the former states of the Confederacy under military occupation and their governments controlled by outsiders, they could do little to counter the assertion. The end of Reconstruction a decade later did little to reunite the nation. On the contrary, the South again found its voice and did not hesitate to aggressively present its case in this continuing national argument.

From Reconstruction until the early days of the twentieth century, opposing groups of veterans and their allies in the two regions engaged in a propaganda war for the soul of the nation that was sometimes as ardent as the fighting had been on the sanguine fields of Shiloh and Gettysburg. Northern watchdog groups surveyed textbooks and school curricula to be sure children learned that federal armies had fought to destroy treason and save the Union. Decoration days and civic celebrations were established that excluded participation of former Rebels. Patriotic groups in the North self-consciously promoted a "Cult of the Stars and Stripes." They urged acceptance of the U.S. flag as an icon of patriotism, which would be placed in every classroom where young Americans would daily intone a "Pledge of Allegiance" to it.[1]

Southerners responded by promoting the tenets of the "Lost Cause." The Civil War had not been about secession or slavery, they argued, but had been fought over honorable constitutional principles. Confederate arms had failed not from lack of determination or honor but because the South's armies had been overwhelmed by superior resources and numbers. Southern organizations, like their northern counterpoints, encouraged the teaching of their version of history. Not surprisingly, Southerners refused to embrace the Stars and Stripes, but established a cult of their own — that of the Confederate Flag.[2]

In Texas, as in the rest of the South, the Lost Cause guided nearly every aspect of public life in the late nineteenth and early twentieth centuries. Confederate veterans were venerated and elected to po-

litical office. Patriotic organizations exerted considerable influence over the state's affairs, and monuments to southern arms were erected throughout Texas. The Confederate Flag was more important than either the Stars and Stripes or the lone-star flag of the Republic. As time passed, however, the United States began to assume a greater role in the world at large. Imperialism abroad brought with it contact with potentially hostile foreign powers. The possibility of outside threats helped engender a new age of patriotism in the United States. The outbreak of the Spanish-American War in 1898 marked the beginning of a sectional truce that brought full reconciliation to North and South (see chapter 8). Southerners became satisfied that the entire nation had come to accept the Lost Cause version of the war, and in return they fully embraced the Stars and Stripes. From that time forward the people of the former Confederacy became some of the most patriotic of all Americans. A corollary to this reunion was the rediscovery by Texans of their own unique heritage and a renewed veneration for the old Flag of the Republic. The inscription on the Texas Confederate Memorial on the state capitol grounds is a succinct statement of the Lost Cause:

<div align="center">

DIED

FOR STATE RIGHTS

GUARANTEED UNDER THE CONSTITUTION

The people of the South, animated by the spirit of 1776, to preserve their rights,

withdrew from the federal compact in 1861. The North resorted to coersion.

The South, against overwhelming numbers and resources, fought until exhausted.

During the war, there were twenty two hundred and fifty seven engagements;

In eighteen hundred and eighty two of these, at least one regiment took part.

Number of men enlisted:

Confederate armies, 600,000; Federal armies, 2,859,132.

Losses from all causes:

Confederate, 437,000; Federal, 485,216.

</div>

Return of the Stars and Stripes

For more than four years, Austin physician William Stiles had veiled his loyalties. The Massachusetts-born physician and his family, like a small but significant minority of their fellow Texans, were Unionists. They had endured the same hardships as their neighbors, but faith that the North ultimately would triumph sustained them. The collapse of Confederate arms and the arrival of federal troops at Galveston on June 19, 1865, proved their vindication. The Stiles family determined to celebrate the new era's first Fourth of July by restoring the symbol of the Union — the Stars and Stripes — to Austin.[3]

In March, 1861, secessionists had removed the last U.S. flag from the city, so these loyalists would have to make their own. With the same diligence Confederate women had shown in sewing homespun Rebel flags, on the day before the holiday Stiles's wife and her cousin set to work. They rummaged through family possessions to find materials for the task. The two women cut up a blue riding skirt for the canton and clipped small fabric circles, affixing to each a shiny spangle to represent the stars. They made thirty-six of these "moons" and sewed them onto the blue square to form the outline of a six-point star. The sacrifice of some precious red and white dress fabric contributed the stripes. The work went on late into the night, but the flag was ready for the celebration the following morning.[4] At 9:00 A.M. on July 4, 1865, the family assembled near their home with some friends, and Dr. Stiles ran up the first Stars and Stripes to be displayed in Austin for over four years. Those gathered fired off a homemade "saluting gun" to proclaim to their sullen neighbors the return of federal hegemony. The crude little flag still flew a few weeks later when provisional governor A. J. Hamilton arrived and took control of Texas in the name of the restored Union (see plate 23).[5]

Even though Hamilton had been an important Texas politician before the war, he had nevertheless strongly opposed secession. After he was forced to flee the state in 1862, Hamilton accepted President Abraham Lincoln's appointment as brigadier general and proceeded to recruit like-minded volunteers to fight for the Union. Lincoln's successor, Andrew Johnson, chose Hamilton as provisional governor of Texas and charged him with the task of reestab-

lishing the state's civil government.[6] The new governor's impending arrival in Austin was cause for rejoicing among Texas Unionists, and they planned an appropriate celebration. One of the first orders of business was to officially restore the U.S. flag. On August 2, 1865, a committee of thirty prominent citizens along with scores of Unionists and former slaves met Hamilton and his cavalry escort on the outskirts of the capital. Together they formed a procession that wound its way toward the capitol. As the festive parade passed Hancock's Store, which had been the last place in the area the U.S. flag had flown before the war, the marchers cheered as a more resplendent Stars and Stripes was run up.[7] Notwithstanding the exultation of the Unionists, most Texans in the summer of 1865 were not yet prepared to applaud the return of the national flag.

The defeat of the Confederacy had come as a terrible blow to Texas and the South. No other region of the United States had dealt with continuous invasion, defeat, and prolonged occupation by a military power. Texans believed their cause had been honorable, but the harsh reality was that they were now at the mercy of their most implacable enemies. For Texans who had supported the Confederacy, the restored Stars and Stripes was the embodiment of their defeat. A verse from the contemporary song "The Good Old Rebel" drips with the bitterness and resentment many of the former Rebels harbored:

> I hates the Yankee nation,
> And everything they do;
> I hates the Declaration
> Of Independence, too;
> I hates the glorious Union,
> 'Tis dripping with our blood;
> And I hates the stripéd banner —
> I fit it all I could.[8]

Some believed their honor was still linked with the Confederate colors they had recently fought under and determined to deprive the victors possession of those that remained. Sometime before Hamilton and his entourage triumphantly entered Austin, two Hood's Brigade veterans, W. C. Walsh and Randolph Robertson,

went to the capitol building and removed the battle flags of the Fourth and Fifth Texas that had been enshrined there since after the battle of Antietam. Walsh took the Fourth Texas color the Wigfall family had made, wrapped it in oilcloth, and buried it in a pecan grove behind his house on Barton Creek. The former soldiers dispatched the Fifth Texas Lone Star and Bars to a comrade in Brenham, who, for protection, passed it on several times. Soon a rumor spread that the flag had been lost in a fire, but in reality the old color had come finally into the possession of W. A. George, a long-serving veteran of the Fifth Texas. He kept the flag safe — and unseen — for the next forty years.[9]

Soldiers who had survived the war trickled back to the state over the summer of 1865. A few had brought their old regimental colors home with them, but these would have to remain hidden for the foreseeable future. The former Rebels were embittered and unrepentant, but most were willing to put the past behind them and make a fresh start. Confederate-era flags disappeared from public view. For the next nine years the state wrestled with the displacements and turmoil of Reconstruction.

White Texans at first struggled to maintain the status quo. Like other Southerners, in order for their state to be readmitted to the Union they grudgingly accepted the Thirteenth Amendment, which abolished slavery, and were willing to swear a loyalty oath, but would concede little else. In 1866, in Texas as in the rest of the former Confederacy, conservatives, including many former secessionists, resumed control of the state government. They promulgated a new constitution consonant with minimal compliance to the new social order, passed "Black Codes" designed to limit the rights of the freedmen, and elected former Confederates to important offices. Many Northerners began to suspect that the South still harbored treason. In Texas, actions by the new conservative governor, James W. Throckmorton, a Unionist who had served in the Confederate Army, and other elected officials were often in conflict with federal military leaders and President Johnson himself.

The U.S. Congress, however, was dominated by radical Republican politicians who were unwilling to allow the fruits of the Union victory to be eroded by the recalcitrance of southern conservatives. In 1867 it seized control of Reconstruction from the president and passed a series of laws aimed at forcing permanent social,

political, and economic change in the region. The First Reconstruction Act placed the states of the former Confederacy under military rule and allowed the disenfranchisement of those who could not swear the "ironclad oath." [10] Within months military authorities in Texas had removed Governor Throckmorton and hundreds of lesser officials from office as "obstacles to reconstruction." Large numbers of African Americans joined the voter rolls as former Confederates exited them. This allowed the state's Republicans, whose numbers including many recently arrived Northerners, to dominate elective office, and they wrote their own constitution, which concentrated power in the hands of the executive branch.

Yet Republican power proved ephemeral; within a few years, conservative Texans, who were mostly Democrats, had regained control of the state. Almost as soon as their new constitution was ratified, the grip of the radical Republicans began to loosen. In the election of 1871, Democrats captured all four congressional seats and the following year regained control of the state's house of representatives. Moderate Republicans began joining Democrats in undoing many of the laws the Reconstruction legislature had passed. In December, 1873, Democrat Richard Coke defeated radical governor Edmund J. Davis in the general election, and Reconstruction ended in the Lone Star State. With its end, psychological reconstruction got underway. For Texas, as for the rest of the South, this entailed a sympathetic — and sanitized — reappraisal of the recent past. The core of assertions that collectively embodied the so-called myth of the Lost Cause served the interests of the Democratic Party, supported the doctrine of state's rights, and rationalized white supremacy. Most visibly, in the words of a modern historian, it "bestowed cultural authority on Confederate symbols." [11] No symbols were more venerated than the old Confederate battle flags.

As the political climate improved, Texas veterans began resurrecting their flags as remembrances for lost comrades and to remind others of their sacrifices. On June 27, 1871, the ninth anniversary of the battle of Gaines Mill, Captain Walsh and a few survivors of his old company dug up the Fourth Texas battle flag and raised it again in a solemn ceremony that memorialized their dead. [12] So moved were the participants that they resolved to hold annual reunions of Hood's Texas Brigade veterans for mutual support and reminiscence. [13] This association and others like it would provide the early impetus for the preservation of the state's Civil War flags.

The Hood's Texas Brigade Association formally organized in Houston at a meeting held during the Texas State Fair on May 14, 1872. Sixty-one survivors and Gen. John B. Hood himself attended the proceedings. [14] The high point of the affair, however, was not the address by the former commander but a visit from Maude Young, the brigade's wartime benefactor. She received an ovation equal to that given Hood, and the applause and cheering continued for several minutes while the veterans crowded around to shake her hand. The final resolution of the assembly named Mrs. Young the "Mother of Hood's Brigade." [15]

No flags were present at the meeting, but they were in the thoughts of the participants. Sometime during the proceedings, W. A. George pulled General Hood aside and asked him if he should turn over the Lone Star and Bars of the Fifth Texas to the new brigade association. Hood, misapprehending the role flags would play in the new South, advised him, "No man is more entitled to it than you are, keep it as long as you live and leave it to your family." [16] George took the advice to heart, and the Fifth Texas battle flag would not be publicly displayed until 1910.

Despite the turmoil of the times, this first meeting of the association was apparently free from political undertones. [17] The meeting even adjourned early so the former soldiers could attend public speeches given at a nearby hotel by two men the veterans had every reason to revile. They listened politely with a thousand other onlookers as Gen. Philip Sheridan and radical Republican governor A. J. Davis gave addresses. General Hood himself rose to the speaker's platform and made a few remarks, to the applause of those gathered below. [18]

Not until the third annual reunion at Galveston in 1874 was one of the former battle flags displayed. That year, Maude Young's son, Dr. S. O. Young, brought the tattered flag his mother had made for the Fifth Texas, which had been in the family's possession since the soldiers returned it to Houston in 1864. Dr. Young, himself a veteran of the brigade, reiterated that the flag was not to be seen as a political symbol. He announced to the gathering, "I appear before you today to unfurl this flag (applause). . . . It is our guiding star. It is our greatest earthly treasure. . . . I do not unfurl it . . . to kindle

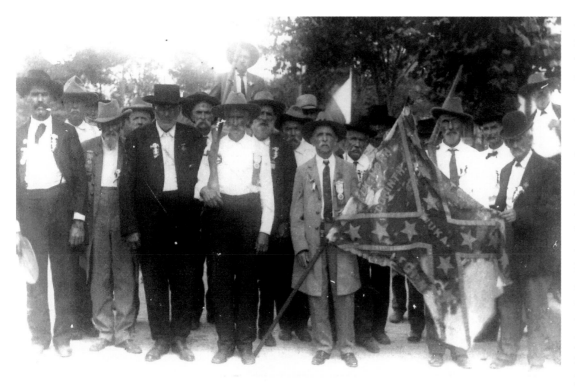

Figure 92. *Veterans with Whitfield's Legion Flag. Many years after the war ended, former members of Whitfield's Legion still honored their old twelve-star battle flag (see fig. 81). Courtesy of Jasper County Historical Commission Collection, Sam Houston Regional Library and Research Center.*

any unpeaceful feelings . . . this flag is the sacred talisman." Its presentation caused a considerable stir, as one speaker after another came forward to testify to the valor of the brigade.[19] From then until the last reunion in 1916, the presentation of battle flags became an important element in association proceedings.[20]

Other alliances of Confederate veterans sprang up in the years after Reconstruction. The Terry's Texas Rangers Association had been organized in Houston on the same day the Hood's Brigade veterans had first met. In 1880 Ross's Brigade Association was founded. By the 1890s the survivors of Ector's Brigade, Granbury's Brigade, and Parson's Brigade also had their own organizations and held annual reunions. These yearly meetings soon grew beyond assemblages of ever-decreasing numbers of reminiscing graybeards into major celebrations of civic solidarity. At the 1900 combined reunion of the survivors of Ross's, Ector's, and Granbury's Brigades, for instance, less than a hundred veterans were able to make the trip to Lancaster, Texas, where the meeting was held. Nevertheless, more than seven thousand of their fellow Tex-

ans took part in the two days of speeches, entertainments, and picnics in honor of the Lost Cause. Typically, the presence of one of the old banners at these gatherings evoked the wildest enthusiasm, which, when coupled with the playing of "Dixie," set off waves of Rebel yells, extemporaneous oratory, mass foot stomping, and not a few tears.[21]

Umbrella organizations formed that served to concentrate the energies of the veterans and their supporters. The United Confederate Veterans was chartered 1889, and the organization's camps soon flourished in Texas and throughout the South. Five years later its more militant distaff counterpart, the United Daughters of the Confederacy, or UDC, whose unabashed purpose was to be an advocate for the sentiments of the Lost Cause, came into being. In Texas, the Confederate veterans' organizations and their allies were as strong as anywhere in the South, and their influence was widespread. This was chiefly because the state had more than its share of former Rebels. Texas itself had suffered little physical damage during the fighting, and considerable land remained available for settlement after the war. Thus thousands of young ex-Confederates from other parts of the South returned to their homes, surveyed the devastation campaigning armies had wrought, packed up, and moved to Texas. With the advantage of shear numbers and with the admiring support of the majority of Texans, Confederate veterans wielded great influence and became the political and business leaders of the state. While the old soldiers lived, the Confederate Flag remained a symbol as dear to most Texans as the lone star itself.

The former Confederates realized that preserving the old flags for posterity would be an important part of their legacy. As long as the colors existed and were available for viewing, some interpretation of their story would have to be addressed. As the years passed, the veterans redoubled efforts to find safe and appropriate repositories for their battle flags and to seek the return of those lost during the war. Putting them in public hands by giving them to the state of Texas seemed for some to offer the best solution for long-term preservation.

In 1885 the Hardee battle flag of the Sixth and Tenth Texas became the first Confederate banner in what would one day become a significant state flag collection. Capt. Mark Kelton had rescued

his regiment's flag from capture and brought it to back Austin following the 1865 surrender of the Army of Tennessee (see chapter 6). Since the war the flag had been in the safekeeping of a number of Granbury's Brigade veterans. Austin businessman William J. Oliphant was in many ways typical of the former soldiers. He had had been wounded eight times and captured twice in four years of service with the Sixth Texas Infantry. In the years since the war, he had become one of the state's most skillful commercial photographers and an influential civic leader. Oliphant and his surviving comrades decided the flag should have a permanent home with the state. They determined that the most secure place for such a valuable was with the Office of the Commissioner of Insurance, Statistics, and History. In a letter to the commissioner of that agency, Oliphant wrote, "Many splendid specimens of Texas youth and manhood have gone down beneath its folds, and it is the wish of those who have preserved it, that this flag should become the property of the state."[22] There was no controversy about granting the request; the commissioner of insurance, statistics, and history was Hamilton P. Bee, a former Confederate general.[23]

Not only did Texas veterans wish to save the flags already in hand, they also searched for those lost during the war so they could be brought home for preservation. In the course of the fighting each side had captured hundreds of flags. Most of the captured Union flags had been turned over to federal authorities when the South surrendered, but Confederate flags remained trophies of war. In the 1880s, with the wartime animosity dissipating, there seemed little reason for Northerners to hold on to their old adversaries' flags.

When Union soldiers captured a flag, it technically became the property of the U.S. government. War Department regulations required that individuals who had seized a Confederate color should forward it through proper military channels to the adjutant general's office in Washington. There a clerk would list each flag in a registry book, describe it, and record the known facts of its capture. He then assigned each entry a number and stenciled it on the flag. If all the procedures were followed, the government usually rewarded the flag's original captor with a Congressional Medal of Honor. In all, U.S. forces deposited 544 Confederate flags with the War Department.[24] Many flags, however, did not make it through proper channels to Washington. Often captors kept them as souvenirs. Sometimes officers of volunteer units dispatched captured Confederate flags to their home states, knowing the publicity surrounding them could be beneficial to potential political careers or future commercial interests.[25]

These trophies of federal victory, so coveted during the war, were largely forgotten by the government afterward. In 1867 the superintendent of War Department buildings removed the flags without authorization from the sparse attic room in the adjutant general's office and moved them to his own office. There he hung a few on the walls and placed the rest on shelves and in cubbyholes. In 1882 the secretary of war directed that the flags be boxed and stored in a subbasement of the State, War, and Navy Building. There, seeping water, dust, and extremes in temperature accelerated the flags' deterioration. With the hundreds of tightly stacked boxes, access was impossible.[26] This hardly mattered, however, because there seemed to be little public interest in the flags in the North, and storing the old war relics had become a nuisance. In 1887 the adjutant general proposed that rather than continue to be stored, the Confederate battle flags should be returned to the proper authorities of the states whose military units had flown them. He sent the recommendation to President Grover Cleveland, who approved it.[27] Southern veterans were delighted that the flags would be coming home. Unfortunately, this practical and magnanimous proposal ran afoul of national politics and residual sectional ill will.

The Grand Army of the Republic, or GAR, was a powerful organization of northern Civil War veterans originally founded in 1866 as a fraternal order. For a decade afterward, it was foundering and on the verge of dissolution when its members began to sponsor efforts to secure federal pensions for former Union soldiers. Self-interest proved a potent membership inducement, and by the 1890s almost half a million former northern soldiers had joined. The organization's lobbying efforts proved highly effective, and the GAR helped secure pensions for more than a million veterans.[28] Many reformers, among them President Cleveland, believed this liberal federal largess had been overly generous and threatened the fiscal well-being of the nation. When the president endorsed the return of the Confederate battle flags, the GAR leadership saw an oppor-

tunity to wreak political damage on him and his administration and at the same time demonstrate its disdain for the Lost Cause.

In an orchestrated howl of outrage, the GAR loudly and publicly condemned Cleveland's action. "May God palsy the hand that wrote that order! May God palsy the tongue that dictated it!" raged the organization's commander. The governor of Ohio, a close political ally, announced, "No rebel flag will be surrendered while I am governor." A bombastic resolution from the St. Louis GAR camp, reminiscent of modern Confederate flag controversies, declared, "These flags can have no other meaning than a representation of treason. There ought to be in this land to-day no one who would own them."[29] The attacks had the desired effect. Stung by the virulence of the onslaught, Cleveland backed down and issued the face-saving statement that upon further consideration "the return of these flags in the manner contemplated is not authorized by existing law."[30] For nearly two more decades, the flags would continue to molder in government storage, and Southerners would seethe in anger.

Finally, in 1905, long after the pension issue had become moot, President Theodore Roosevelt, who had made reconciliation between North and South a hallmark of his administration, again proposed that the Confederate battle flags be returned. This time there was no major objection. Many fewer Union veterans were around to resist, and younger generations of Northerners had come to accept the tenets of the Lost Cause. The bill, which was almost identical to Cleveland's proposal, unanimously passed both houses of Congress without the need for a formal vote.[31] Among the returned battle flags were four from Texas units. Included in the March, 1905, shipment from the War Department was the Wigfall Texian Flag of the First Texas, captured at Antietam, two other colors of Hood's Brigade, and the elaborate Third Texas Cavalry flag lost at Lovejoy's Station in 1864.[32] These were entrusted to the state library, and several hung there for years on its east wall.[33] Up until the late 1920s, the Wigfall flag was displayed in the chamber of the house of representatives.[34]

Despite hard feelings generated by the GAR's 1887 attack on President Cleveland, the quest by individuals for the return of Texas Civil War flags often became a means of reconciliation between North and South. Such was the case with the recovery of the Terry's Texas Rangers flag in 1899. Because the regiment had been one of the best known in the Confederate Army, its Hardee-pattern battle flag had made a particularly attractive trophy to Northerners. A soldier of the Seventeenth Indiana had picked it up in a field near Rome, Georgia, in 1864, and sent the flag not to the War Department but to the governor of Indiana (see chapter 6). After the war, surviving Terry's Texas Rangers veterans learned that promoters had been parading it through a series of fairs and expositions in the North with a label that read, "Captured from Terry's Texas Rangers . . . by the Seventeenth Indiana Mounted Infantry." Galled by what one veteran referred to as the "public exhibition of our misfortune," the Texans resolved to get it back. When Indiana elected a Democratic governor in 1876, they requested the flag be returned. Unfortunately, the governor referred the request to the state librarian, who, according to former ranger Henry Graber, "happened to be a vindictive, howling Republican" and in a "very insulting" letter decreed that the flag would remain in Indiana.[35] The matter was dropped.

The patriotic afterglow of the Spanish-American War proved a propitious time to try again. J. A. Mount, then the governor of Indiana, had served as a private in the Seventeenth Indiana. In 1898 the Terry's Texas Rangers Association addressed a letter to him requesting their flag's return. As they had expected, Mount was sympathetic, and within a month the Indiana state legislature passed a unanimous resolution to return the flag. To celebrate the occasion, Governor Mount decided to bring the old color back to Texas personally and present it in a ceremony to be held at the 1899 state fair in Dallas. The governor arrived by special train with an entourage of fifty-two people during the first week of the fair. An elaborate formal ceremony attended by a number of high-ranking state officials took place, complete with music, patriotic oratory, and soaring bonhomie. At the climax of the proceedings, Governor Mount presented the flag to Texas governor Joseph D. Sayers, to the cheers of all present. According to Graber, it "was one of the greatest occasions ever since the Civil War and its salutary effect on sectional feeling cannot be overestimated."[36]

The Hardee-pattern battle flag of the Seventeenth and Eighteenth Texas endured a more circuitous odyssey before its return to Texas. Sgt. Maj. Andrew LaForge of the Fifteenth Michigan had

captured it during the battle of Atlanta on July 22, 1864 (see chapter 6). He dutifully turned it over to his regimental commander, Lt. Col. F. S. Hutchinson, who forwarded it through proper channels to army headquarters. There, Gen. James B. McPherson's adjutant, Lt. Col. William T. Clark, received it.[37] Contrary to army directives, he kept the flag himself, intending, as it turned out, to employ it for political and financial gain. After the war Clark came to Texas to make his fortune and became one of the state's most notorious carpetbaggers. Following his discharge from the army with a general's rank, Clark settled in Galveston, becoming active in Republican politics, and was instrumental in the founding of several chapters of the Union League. In 1869, with many ex-Confederates banned from the polls, he won election to Congress from Texas' Third District. While in office Clark attempted to induce the federal government to buy vast tracts of West Texas lands where he allegedly had financial interests. He lost a bid for reelection in 1872, but Governor Davis, reluctant to lose such a staunch Union man, attempted unsuccessfully to manipulate the results and reinstate him. When this scheme failed, Republicans compensated Clark by appointing him postmaster of Galveston, a position he held for two years. The display of the captured flag of the Seventeenth and Eighteenth Texas, which was still in his possession, no doubt increased his stature in the eyes of his radical allies. In 1874, Clark secured a post with the Bureau of the Internal Revenue and left the state for good.[38] Back East the flag would be of no particular use to him, so he deposited it at last with the War Department. Thirteen years later Clark changed his mind and convinced the secretary of war to loan it back to him for use in a "panorama." He had promised in writing to return it to the War Department but never did so.[39] As early as 1900 former members of the Seventeenth and Eighteenth Texas, unaware of Clark's continued interest in the flag, began posting letters to veterans' groups and newspapers throughout the country trying to locate their old color.[40] For more than a decade the quest was unsuccessful. Clark, in the meantime, had died without returning the flag, and it remained in his widow's possession. In 1914 representatives of the United Confederate Veterans finally located the flag and convinced Mrs. Clark to return it to Texas.[41]

By the turn of the century and just after, the civic religion in Texas that was the Lost Cause reached its height. The old soldiers,

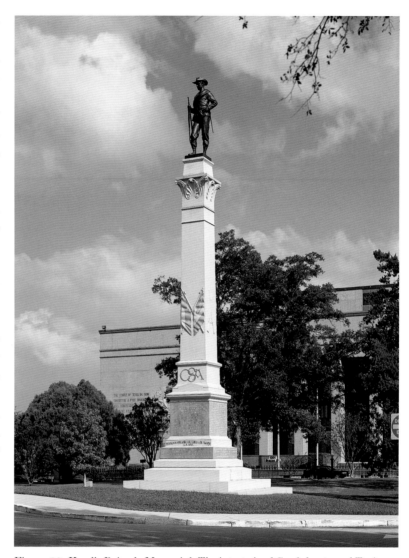

Figure 93. *Hood's Brigade Memorial. The intertwined Confederate and Texian Flags are a visual demonstration of the symbiosis between the Lost Cause and the Texas-heritage movement in the early twentieth century. Hatzenbuehler Photography © 2000 Dan Hatzenbuehler.*

however, were passing rapidly from the scene. The last great hurrah for living Texas Confederates came on October 26 and 27, 1910, when the Hood's Texas Brigade monument was dedicated on the state capitol grounds. Participating were 126 surviving veterans of the brigade, the governor, former governor, and a host of other dignitaries. The high point of the first day's events was the presenta-

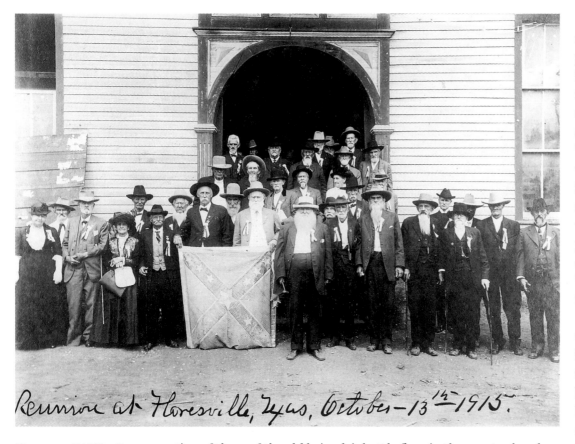

Reunion at Floresville, Txas, October-13th-1915.

Figure 94. *1915 Hood's Brigade Reunion. The Fourth Texas Wigfall flag became a fixture at Hood's Brigade reunions. Courtesy of the Harold B. Simpson Hill College Research Center, Hillsboro, Texas.*

tion of three of the old brigade's battle flags in the senate chamber. Val C. Giles, standard-bearer for the Fourth Texas, had kept the regiment's silk Wigfall ANV color in his care. In 1905 he became too sick to continue this task and donated it to the UDC for display in their Confederate museum in Austin. The ladies were more than happy to bring out the flag for the festivities. For the first time since it had been removed from the old capitol, the Lone Star and Bars battle flag of the Fifth Texas made a public appearance. In honor of the occasion, W. A. George, who had kept it for so long, had finally donated it to the brigade association. Also present was the First Texas' lone-star flag that had been lost in the cornfield at Antietam and recently redeemed from the War Department. When the tattered and faded banners were brought out, they made such an impression that the official proceedings had to be halted so that the aged veterans could come forward to "touch and kiss the old relics."[42]

The next day a parade up Congress Avenue preceded the monument's formal unveiling. Local fire companies led the impressive procession, followed by prominent citizens and dignitaries riding in automobiles. Behind these the University of Texas band and a troop of U.S. Cavalry and units of the state guard led a mile-long column of five thousand school children and their teachers. The students of the Bickler School had the honor of carrying the First Texas' Texian Flag. Along the parade route, which was festooned with U.S. and Confederate flags, thousands cheered. A large Texian Flag draped the monument, which was a tall granite shaft surmounted by a bronze statue of a Confederate soldier. As the cord was pulled and the structure revealed, artillery crashed and Rebel yells erupted. When the last speech ended, cannon fire and the cheering thousands drowned out the band as it played "Dixie."[43] The event marked the last decisive Confederate victory in Texas — the victory of the Lost Cause.

As the veterans aged and died, they made decisions about what to do with their flags. Some old soldiers bequeathed them to their immediate families, who disposed of them in various ways. A few insisted that the precious banners they had carried in their youth be buried with them. For years the Hood's Brigade Association had bickered over how the battle flags should be preserved. This conundrum was brought to a head when Val Giles had donated the Wigfall ANV in 1905. Some offered a resolution to place it in the Museum of the Confederacy in Richmond, Virginia. Tearful entreaties by members of the United Daughters of the Confederacy, however, convinced the majority to vote for giving them charge of the flag and thus keep it in Texas.[44]

Most veterans and their families who had flags would eventually entrust them to the UDC or to the state library. When the state of Texas built its new capitol building in 1885, three Confederate veterans donated the red granite for the structure. In return the state granted to them the use of a room in the building for the rest of their lifetimes. In 1903 the men designated their room as a Confederate museum to house flags and other artifacts held in trust by the UDC. Over the next few years donations flowed in and the museum soon ran short of space. In 1920 the Texas Confederate Museum collection moved to the Old Land Office building on the southeast corner of the capitol grounds, where the artifacts remained until

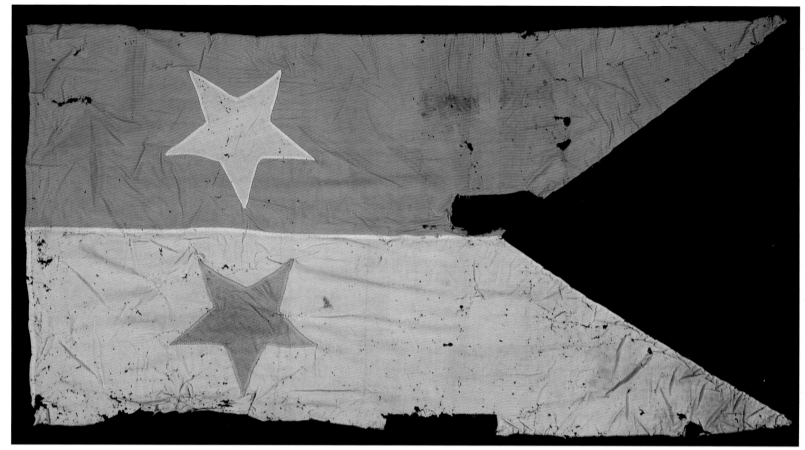

Figure 95. *Union general Phillip Sheridan's Headquarters Flag. By the twentieth century Americans assumed any flag with a prominent lone star must be a Texas flag. Ironically, this flag that the state of Maine identified as a "Texas Rangers" flag was in reality Sheridan's headquarters flag. Hatzenbuehler Photography © 2000 Dan Hatzenbuehler.*

1989. Meanwhile, other donated flags joined those already in the care of the state. By 1920 the state library had possession of the collection and periodically displayed the most significant flags.[45]

A problem common to all repositories was that donated flags could not always be identified. Donors often gave flags without written documentation and curators were frequently careless in keeping records. Fortunately, during the war it was often the practice to inscribe in some manner the unit name directly on the flag. When this was not done, the flag's identity was often lost. The last flags Northerners returned to Texas reflected this problem. In 1927 the state of Maine decided to return the last seven captured Confed-

erate flags still in its possession. Two of them displayed stars prominently, so Maine officials assumed they must be Texas flags. One, the unusual red Southern Cross variant that the Fifteenth Maine had captured on Mustang Island in 1863, had indeed belonged to a Texas unit (see chapter 6).[46] The other, a swallow-tailed red-and-white cavalry guidon with two stars, turned out not even to have been Confederate. Ironically, historians later determined the guidon had been a headquarters flag of Gen. Philip Sheridan, an officer whom Texans had reason to dislike. Nevertheless, on December 12, 1927, in a ceremony held on the steps of the national capitol in Washington, D.C., and attended by President Calvin Coolidge,

Figure 96. *1927 Flag Return Ceremony. President Calvin Coolidge, flanked by politicians and wizened veterans, presides over the return of Confederate battle flags from the state of Maine in 1927. © CORBIS.*

gion's dominant political philosophy. Confederate veterans had become the leaders of postwar Texas. These former soldiers became governors, senators, congressmen, as well as the business leaders who began the transformation of the state's economy into the powerhouse it would become in the twentieth century. Throughout this period, the Confederate flag remained as important and as meaningful to Texans as it had been during the war.[48]

Ignored by these equations were the aspirations of the state's African Americans. While white Texans recaptured the social and economic power they had enjoyed during the antebellum period, blacks, freed from bondage, struggled to establish a dignified place in a hostile society. After Reconstruction, they soon discovered that conventional paths to success in business and government were closed to them. Blacks had little reason to join their fellow Texans in the celebrating the Lost Cause. The resumed settlement of the West, however, offered some African Americans at least a limited opportunity to show their mettle — if not as politicians and businessmen, then perhaps as soldiers. On isolated posts in a desolate and unforgiving land, they would battle another class of outsider, the Indians, as well as the harsh elements, to make West Texas safe for whites. In the process they helped bring back the Stars and Stripes.

The Lone Star Flag

After annexation the Texian Flag had continued, technically, to be the legal flag of the state of Texas. Yet with the Stars and Stripes now flying in the position of sovereignty, Texans discarded the Flag of the Republic as a relic of the past. Secessionists had briefly revived it in 1861, but it again faded to insignificance during Reconstruction. When conservative rule returned, lawmakers saw no reason for Texas to have its own official flag. The sixteenth legislature issued the Revised Civil Statues of 1879, which superseded all previous state law. The revised statutes contained no reference to a state flag and thus had the effect of repealing the 1839 flag act. Until 1933 Texas had no legal flag.[49] Throughout this period, only the U.S. flag legitimately flew over the capitol and other state buildings.

Before the Civil War the Stars and Stripes had played little role in the lives of average Americans. On land the flag flew almost exclusively on federal buildings and military installations. Display

Governor Brewster of Maine presented the seven flags to representatives of their respective states and various veterans' organizations. Sen. John M. Sheppard received the two flags on behalf of Texas. At the end of the ceremony, the U.S. Marine band struck up "Dixie," and "shrill 'yip-yips,' burst from the lips of gaunt grayhaired men who had insisted on removing their overcoats so their gray uniforms would show." The Maine governor opined, "the return of these flags marks an end of all ill-feeling growing out of the war, and a new era where North and South will stand side by side for the preservation of the Union."[47]

The Confederates may have lost the Civil War, but in Texas the veterans had won their fellow citizens over to their view of the conflict. They had convinced subsequent generations that the cause for which they had fought had been a noble one. In the latter part of the nineteenth century, even Northerners had come to sympathize with the sacrifices of the Confederate soldier and to romanticize the Old South. The doctrine of states' rights, which seemingly had been repudiated by force of arms, emerged again as the re-

at private residences and in schools was virtually unknown. Not even the army carried the Stars and Stripes until the 1840s.[50] The South's attack on Fort Sumter changed this. The war for the Union transformed the American flag into "a genuinely popular, and frequently displayed, symbol of the nation, or more precisely, of the North." After the war, organizations of Union veterans and patriotic hereditary groups exerted themselves to "deliberately and systematically create a 'Cult of the Flag'" that the entire nation would embrace. The peak of this movement, some of whose objectives consisted of introducing the flag into classrooms, instituting a pledge of allegiance, and encouraging laws against flag desecration, was from 1895 to 1910.[51]

Southerners rejected exhortations that they venerate the banner of their erstwhile enemies. For them "the American flag represented not freedom, independence, and political liberty, but oppression, occupation, and political manipulation."[52] Their response was instead a revitalized Confederate movement and a "cult" of Confederate symbols, whose apogees coincided precisely with the most influential days of the Stars and Stripes enthusiasts. To the honoring of Confederate symbols, Texans added the veneration of their own flag. A modern historian has recently written that throughout the nineteenth century, "Texans acted as southerners and gave short shrift to proponents of Texas nationalism and Texas exceptionalism." Frequent celebrations of the state's past and its icons separate from the rest of the nation has been a fairly recent development.[53]

Ironically, the modern predilection for Texans to glorify their history and symbols was at least partly a byproduct of the movement to sanctify the Lost Cause. The two movements went hand in hand. The Daughters of the Republic of Texas organized in 1891, at about the same time foundations were laid for the United Daughters of the Confederacy. Many Texas women belonged to both organizations. Nowhere was this symbiosis better illustrated than in the sight of a Texian Flag draped over the Hood's Brigade monument during the 1910 unveiling ceremony. The monument itself displays the Texian Flag crossed with the Confederate flag. In 1897, during the height of the Confederate revival, the first formal ceremonies to commemorate the fall of the Alamo were held in San Antonio.[54] Newly constructed monuments and buildings began to display not just the emblems of the Lost Cause and the Old South but ranch scenes and representations of the Texas Revolution.

Aside from the awakening interest in things Texan, an impetus to revive the official use of a state flag was the drive, just before and after the turn of the century, by other states to establish their own flags. The dueling between advocates of the Stars and Stripes and Stars and Bars had made the whole country flag-conscious. By the end of the century most of the former Confederate states had adopted distinctive flags that underscored their desire to remain aloof from the rest of the nation. Some emphasized the position the Confederacy had taken to preserve the Constitution. Thus, the new state flags of North Carolina, South Carolina, Louisiana, and Virginia were based on their secession banners. Most of the rest adopted flags that displayed conspicuous elements lifted whole or in part from the Stars and Bars and the Confederate battle flag. Not to be outdone by this outburst of flagsmithing, northern and western states began to adopt their own flags. Between 1900 and 1920 nearly all the nonsouthern states chose designs for state flags. Most of these emphasized their ties to the Union. During much of the nineteenth century, U.S. Army troops had carried regimental flags of blue and sometimes white, which displayed the nation's arms. Similarly, most of these states adopted flags that were blue or white banners emblazoned with the state's seal or coat of arms.

About the time the southern states began adopting their flags, interest in the Texas flag increased. After Reconstruction the Texian Flag had become a common sight. By at least 1880 it began appearing regularly at gatherings honoring veterans of the Texas Revolution and other "old-timers." Newspaper and almanac articles appeared that described the flag and traced some of the history of the lone star. By the turn of the century, the Flag of the Republic, along with the Confederate Flag and, less commonly, the Stars and Stripes, were flown at most public events. The display of the Texian Flag assumed a semiofficial status not apparent since the days of the Republic. The governor's personal bodyguard began carrying a Texian-pattern flag. Just prior to World War I, women presented Texian Flags to their local state guard companies. After the Civil War the banner of the former Republic had been the only remaining lone-star flag in Texas, and thus it became *the* Lone Star Flag.

Yet its ultimate triumph came as the result of the statewide ob-

Figure 97. *San Jacinto Day, 1906. Texas Revolution veterans with Texian Flag at Goliad. The UT Institute of Texan Cultures at San Antonio, No. 72-769.*

servance of the Texas Centennial in 1936. For this milestone Texans planned an elaborate celebration of the state's heroic past. Pageants in the major cities not only commemorated the Texas Revolution, but, like the celebration in Fort Worth, also recalled "the winning of the West." The state allocated millions of dollars to construct museums, monuments, historical markers, and statues lauding Texas heroism. Millions of Texans attended the central celebration in Dallas, whose theme promoted "history and progress."

In preparation for the centennial, the state legislature passed a bill in 1933 that enshrined the Texian Flag as the Lone Star Flag of Texas. Texans are used to being told that their state flag is the oldest in the nation. This is true for the design, but *legally*, Texas was among the last states to adopt an official flag. In addition to establishing the Lone Star Flag as the de jure flag of Texas, the new statute also standardized its design.

Throughout the state's history, very few Texian Flags had looked exactly like Krag's 1839 illustration. Texas flag makers were not particular about the size of the star and preferred giving it a rakish slant. Proportions of the stripes and canton were rarely uniform. With the great celebration of both history and modernity on the horizon, some Texans resolved to regularize the flag's design. Led by Wylie A. Parker, the principal of Forest Avenue High School in Dallas, schoolteachers lobbied for a law that would "clarify the description of the Texas flag," and especially would "standardize the star in the blue field." This was essential and needed, so the bill's advocates argued, "so pupils in the lower grades of elementary school will be able to draw or make the flag." Gov. Miriam Ferguson signed the bill, which passed easily into law on April 19, 1933. It prescribed in great detail, complete with complex geometric formulae, the exact dimensions of the Lone Star Flag. Henceforth, one point of the star would be pointed straight up and proportionally every flag would look alike.[55]

Today the Lone Star Flag remains the supreme symbol of Texas. Fortunately, its display has so far escaped the controversy that in recent years has assailed the state's Confederate flags, even though the usage of the modern Lone Star flag developed from the same cultural and political substrate. Once-firm convictions about the Lost Cause are today in as much jeopardy as during Reconstruction. Nevertheless, the icons of the Confederacy are now and will likely remain powerful and controversial symbols.

(8)
Patriots'
Stars

During the period from the end of the Civil War to the First World War, an extraordinary transformation occurred in Texas and the South. The states of the Confederacy, which had revered states' rights to the point of rebellion and fervently followed the Lost Cause, became perhaps the most patriotic section of the United States. In the region where the Confederate battle flag was and is regarded with fierce devotion, the Stars and Stripes nevertheless emerged as a sacred symbol. This change had not always come easily.

The presence of the U.S. Army on the Texas frontier after the war did not endear the federal government to the people of the state. Resentment growing out of Reconstruction and especially the presence of African American bluecoats in Texas fueled their distrust. Yet, by the twentieth century, the military became the vessel through which Texans expressed their reborn patriotism. U.S. Army flags became Texas flags.

Army Colors

After peace with Mexico in 1848, the U.S. Army had assumed the role of defending Texas. The chief enemies were the wide-ranging plains tribes and the Apache bands for whom warfare was a central cultural element. As white settlement advanced westward, contact assured continued conflict. Between 1848 and 1851 the army established a line of forts through the state's western settlements, from Fort Duncan on the Rio Grande to Fort Worth in North Texas. When these posts proved inadequate to quell the Indians' frequent incursions, a second line was established a hundred miles farther to the west. Infantry companies manned this outer perimeter and scouted the known Indian and buffalo trails. When the foot soldiers detected movement toward the settlements, their orders were to relay the news to the inner forts, which were manned by cavalry. It was the function of these mounted soldiers, or dragoons, to take up the pursuit. Unfortunately, this system left the initiative with the Indians and did little to stem the tide of costly and deadly raids on settlements.[1]

For most of the nineteenth century, the U.S. Army followed flag practices inherited from the British army. During the Revolutionary War, each Redcoat infantry regiment carried two flags: a king's color, roughly equivalent to a national flag, and a regimental color,

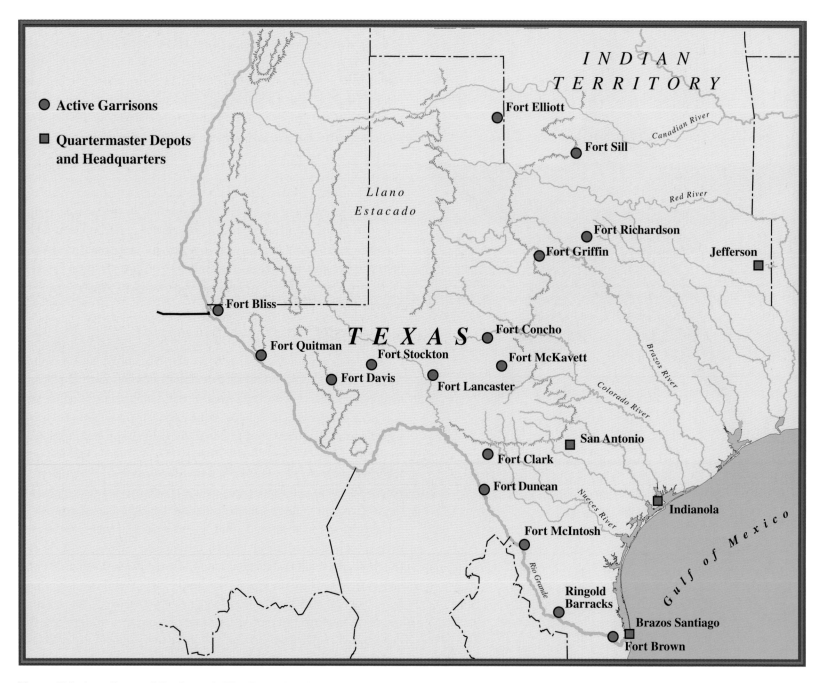

Active Garrisons

Quartermaster Depots and Headquarters

INDIAN TERRITORY

Canadian River

Fort Elliott

Fort Sill

Llano Estacado

Red River

Fort Richardson

Fort Griffin

Jefferson

Fort Bliss

TEXAS

Fort Concho

Fort Quitman

Fort Stockton

Fort McKavett

Brazos River

Fort Davis

Fort Lancaster

Colorado River

San Antonio

Fort Clark

Fort Duncan

Nueces River

Indianola

Gulf of Mexico

Fort McIntosh

Rio Grande

Ringold Barracks

Brazos Santiago

Fort Brown

Map 4. *U.S. Army Posts and Battles on the West Texas Frontier, 1875. Courtesy Don Frazier.*

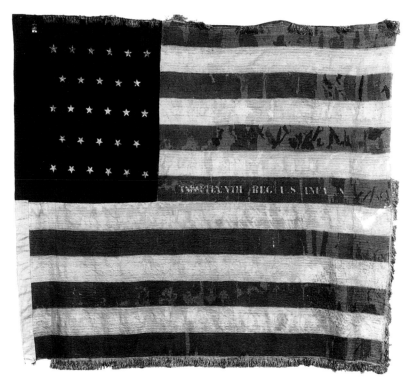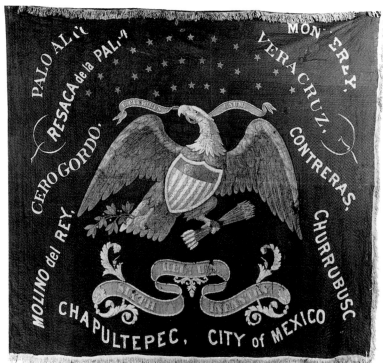

Figure 98. *Early U.S. Army Regimental Colors. Pictured from the Mexican War is,* left, *a national color and,* right, *a regimental color. Courtesy of the United States Military Academy, West Point Museum.*

representing the unit itself. Both flags were large — six feet on the staff by six feet, six inches on the fly.[2] Americans adopted these conventions. Beginning in 1796, regulations stipulated that U.S. infantry regiments also carry two flags: a national color and a regimental color. The national color was a blue flag displaying the arms of the United States, an eagle and shield in the center above which were stars in various numbers and patterns, and below a scroll with the regimental name and number. The regimental color was usually white, displaying the regimental designation on a scroll in the center. U.S. Army infantry flags were the same size as their British counterparts.[3]

Not until 1841 did American regiments begin carrying the Stars and Stripes.[4] Regulations of that year demoted the blue standard to the position of regimental color.[5] The Stars and Stripes became the national color, but it did not look quite like its modern counterpart. The blue canton was a tall, thin, vertical rectangle, twenty-seven inches wide and stretching down through the seventh stripe. With few exceptions, cantons on regimental flags did not assume their present-day shape until the 1880s. The flags' dimensions gave them a square appearance that markedly contrasts to the long rectangle of the modern flag. U.S. troops in the Mexican War were the first to carry the Stars and Stripes during wartime. These battle flags, reflecting Texas' entry in the Union, displayed twenty-eight stars in five staggered rows alternating between six and five stars each.[6]

Regulations for cavalry flags only partly followed British tradition. Beginning in 1808, U.S. mounted regiments carried one flag, the regimental color. This small flag, measuring two feet, three inches by two feet, five inches, was similar in design to the infantry's regimental color and was identical in size to the British cavalry standard.[7] Also beginning in 1808, each troop or company of a regiment was issued a second type of flag, which differed from that of their English counterparts. Known as a company flag, it was of

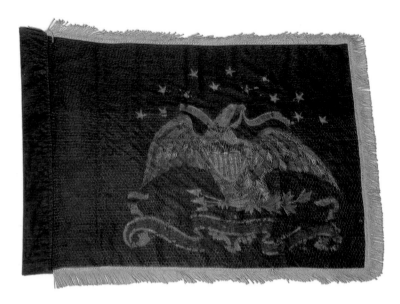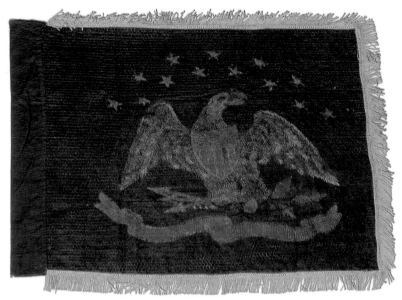

Figure 99. *Blue Cavalry Standards. For most of the nineteenth century, U.S. Cavalry regiments each carried a single blue color inscribed with the national arms. Courtesy of the U.S. Army Center of Military History.*

yellow silk and displayed an image of a horse's head in the canton. Army regulations in 1834 replaced the yellow company flag with a guidon that was a red-and-white swallow-tail flag measuring two feet, three inches by three feet, five inches. The letters "US" were inscribed in white on the red upper half and the company designation in red on the lower half.[8] American Cavalry regiments did not fly the Stars and Stripes until the Civil War.

Frontier Colors

The particular nature of service on the Texas frontier dictated that an infantry regiment's Stars and Stripes was seldom seen. Most duty required that regiments be broken up into companies and assigned to separate posts. Because army regulations proscribed the display of the two regimental flags unless five or more companies were gathered, the Stars and Stripes often remained in storage at the headquarters post or supply depot.[9] However, most forts before and after the Civil War possessed a Stars and Stripes garrison flag that played a significant role in the soldiers' everyday routine.

This large banner was one of the first things the troops of the post saw in the morning and one of the last things they saw at night. Just after reveille sounded, weather permitting, a detail raised the flag from a pole on the parade ground and fired a round in salute from a garrison cannon. The sleepy men then formed ranks around the pole for roll call. At sunset the garrison assembled for retreat. In this ritual, buglers and drummers called the soldiers to ranks and sergeants paced their charges through the manual of arms before taking roll again. Then, with the files at attention, a color detail lowered the flag, ending another day.[10] During the time the army served on the Texas frontier, there were two patterns of Stars and Stripes garrison flags. Until 1857 regulations required that these large post colors be made of bunting, twenty feet on the hoist and thirty-six feet on the fly. The stars were to be cotton, equal in number to the states, and sewn in a diamond pattern. After 1857 new directives ordered the stars placed in horizontal rows.[11]

During the Civil War the secessionists forced the U.S. Army out of Texas, and state troops assumed the task of defending the

frontier. Despite some success in this endeavor, by 1865 the line of settlement had retreated eastward a hundred miles. In the process the Stars and Bars replaced the Stars and Stripes on the frontier. Disorganization and a general lack of resources, however, characterized the Confederate effort. There were no official flag regulations for the few posts the Rebels tenuously held during those dark years, and no colors identified with specific service on the frontier have survived.

Buffalo Soldiers

The Confederate surrender brought federal soldiers back to Texas, but for nearly two years conditions remained chaotic. A force of nearly forty thousand Union volunteer troops occupied the state in the summer of 1865. These citizen soldiers had expected to be discharged with the rest of the Union Army, and were angry when ordered to extended service in Texas. This led to insubordination and even mutiny in some regiments. Army commanders hastened to replace the unhappy volunteers with units of the regular army, but the process was very inefficient, and it was not until 1867 that the frontier fort line was substantially reestablished.[12] At that time a new type of soldier made his appearance in the ranks.

African Americans had been given their first chance to fight in substantial numbers for the United States during the Civil War. In all, 180,000 blacks, most former slaves, served, and 33,000 died. In 1866, out of gratitude, Congress authorized six regiments of black troops, four infantry and two cavalry, to serve in the regular army. Two of the regiments, the Thirty-ninth and the Fortieth Infantry, received assignments related to Reconstruction in the South. The Forty-first Infantry was stationed on the Rio Grande and the Thirty-eighth saw action against Indians at its first postings in Kansas and New Mexico.[13] The two black cavalry regiments were designated the Ninth and Tenth and began preparing for mounted warfare on the western plains.

It was clear from the beginning that black regiments would face special problems. All the officers were to be white, but finding those who would serve with black troops proved difficult. Many whites did not believe blacks would make good soldiers, while others calculated service with African American units would permanently mar their records. Even ambitious officers like George A. Custer, who had declined the offer of a lieutenant colonelcy in a black regiment, were willing to accept lower rank to serve in all-white units.[14] Finding places to station black troops also presented a dilemma. Service in the former Confederate states was strongly resisted. The obvious solution was to send them to the parched and arid regions of Texas. This seemed only proper; conventional wisdom held that blacks physiologically could tolerate heat better than whites. There was also the added advantage that in the desolate wilds of West Texas, there would be minimal contact with white civilians.[15] Thus, for the next twenty years the brunt of the protection of the Texas frontier fell to black soldiers.[16]

In 1869 Congress again reorganized the army and reduced the number of black infantry regiments to two. The War Department consolidated the Thirty-ninth and the Fortieth and redesignated them as the Twenty-fifth Infantry. The following year the new regiment was ordered to the Texas frontier. The Thirty-eighth and Forty-first combined to make the Twenty-fourth Infantry, whose headquarters was designated as Fort McKavett, Texas.[17] For two decades, detached companies of these two regiments would do garrison duty at most of the military posts in West Texas and along the Rio Grande.[18]

Although they were seldom displayed in the West, regimental colors remained central to the identity of the unit. The consolidated African American infantry regiments each received the two regulation flags. During the Civil War the U.S. government had contracted for more battle flags than were needed. When the fighting ended, quartermaster warehouses overflowed with never-issued Stars and Stripes and cavalry guidons. Each black infantry regiment was issued flags from the surplus. The government, frugal when it came to military expenditures in peacetime, would not change U.S. Army flag regulations until all the leftover colors had been used. This would not occur until the 1880s.[19]

Infantry service in West Texas was far from glamorous for the black soldiers. The typical military post there was an aggregate of buildings arranged in a square around a central parade ground without protective walls. Most had been built before the Civil War

and were in various states of decay. Located in isolated and forbidding terrain and lacking in the simplest of human comforts, they could be grim places.[20] Military duties for the foot soldiers proved arduous and monotonous. Because of the nature of plains warfare, the cavalry assumed most of the fighting, so the routine labor on and around the frontier forts devolved to the infantry. Even so, in addition to guard and fatigue assignments, these troops performed scouting missions and escort duty. Off-post assignments could entail trudging hundreds of miles with supply trains and survey parties or being detailed as camp and wagon guards for major scouting expeditions. Black infantry also undertook the hard physical labor of building and repairing roads. Stringing the telegraph lines that connected towns and military posts became an important duty. Such assignments could keep the soldiers in the field for months at a time.[21] Only occasionally did their labors include combat.

The two black cavalry regiments that served in Texas had more opportunity to prove themselves in battle. The Ninth Cavalry, commanded by Col. Edward Hatch, was organized under less than ideal conditions in Greenville, Louisiana. The regiment came to Texas in 1867 but initially performed poorly. A mutiny by the men in San Antonio was put down with considerable difficulty. As the troopers became better trained under more competent officers, however, their record began to improve. They initially demonstrated their soldierly qualities by keeping the San Antonio–to–El Paso road open and safe from Indians, rustlers, and Mexican bandits. After leaving San Antonio, the regiment made its new headquarters at Fort Davis, and detached companies operated from a variety of posts in the area. Along with the Tenth Cavalry, the Ninth played a key role in the 1874 Red River War, which suppressed the Comanches. In 1875 the army transferred the regiment to New Mexico to fight the stubborn Apaches.[22] Even more than the Ninth, the Tenth Cavalry is identified with its Texas frontier service. Benjamin Grierson, a renowned Civil War cavalry commander, came out of retirement to assume command of the regiment, which was formed at Fort Leavenworth, Kansas. Grierson avoided the early problems faced by officers of the Ninth Cavalry by insisting his new recruits be of the highest quality.[23]

While defending the Kansas-Pacific Railroad in 1867, the Tenth Cavalry first came in contact with the Cheyenne Indians, who be-

gan referring to the black troopers as "buffalo soldiers." The best-known explanation for the term is that the Indians noted the similarity between the hair of the buffalo and that of the black soldier. According to historian William H. Leckie, the buffalo was a sacred animal to the Cheyenne, who would certainly have meant the title as a sign of respect. The men of the Tenth accepted the new label, and soon it was applied to all African American soldiers.[24]

The Tenth Cavalry went on to give exemplary service in a variety of roles. During the Red River War, the regiment, along with elements of the Ninth Cavalry, destroyed more Indian property, captured more tribesmen, and scouted more miles than any of the other

participating white regiments. For the next decade the Tenth Cavalry headquartered at Fort Concho, near present-day San Angelo, and was the most prominent military force in West Texas. In 1881 the regiment moved to Fort Davis and four years later was transferred to Arizona to deal with the last hostile Apache bands.[25]

While their small blue regimental flag was undoubtedly a source of pride and inspiration for the black cavalrymen, company guidons led them through most of their duties on the Texas frontier. Over those years the cavalry used two patterns. In recognition of the growing importance of the national flag to the Union morale, in 1862 the government replaced the red-over-white guidons used by U.S. cavalry since 1834 with a new issue patterned on the Stars and Stripes. Two Philadelphia contractors modified large numbers of old red-and-white guidons into the new design, and other firms manufactured thousands more. By 1865 almost eight thousand had been made. These numbers proved sufficient to supply the ten postwar U.S. Cavalry regiments for the next twenty years.[26] When this inventory ran out in 1885, the army issued new sets of guidons similar to the old red-over-white swallow tails (see plate 26).[27]

In the final analysis, the buffalo soldiers had rendered great service to the state of Texas and had been exemplary soldiers. In clearing the state of hostile Indians, they had fought more battles than their white counterparts and proved immeasurably useful in bringing civilization to a vast wilderness. Colonel Grierson, commander of the Twenty-fourth Infantry, summed up the contributions the black soldiers had made when he wrote in 1880, "In addition to work at posts and subposts on barrack and quarters and in guarding mails and other public property . . . over one thousand miles of wagon roads and three hundred miles of telegraph lines have been constructed and kept in repair by the labor of the troops, a vast region scouted over, minutely explored, its resources made known and wonderfully exploited. . . . A settled feeling of security, heretofore, unknown prevails throughout western Texas, causing a rapid increase in population and wealth of the state."[28] For these labors and sacrifices, nineteenth-century white Texans were eternally ungrateful.

The frontier army had been unsuccessful in bringing back respect for the Stars and Stripes in Texas. While many whites in the West appreciated the efforts of the federal military, most remained embittered by memories of the late war and by the perceived excesses of Reconstruction. The army often bore the brunt of this distrust and resentment. When Reconstruction ended, the new Democratic government of Texas determined not to rely on the bluecoats for frontier protection but opted to undertake the defense of the frontier on its own. In 1873, the legislature passed a bill authorizing six companies of rangers to protect the settlers. The Frontier Battalion, as it was called, rarely cooperated with the army.[29]

Clashes between civilians and soldiers in West Texas were all too frequent, but special onus fell on the buffalo soldiers. As the Indian Wars wound down, black troops suffered from increasing racial prejudice. They were mistreated in segregated towns near their posts and often harassed and assaulted by white citizens and law-enforcement officers alike.[30] But it must have been the lack of recognition for the decades of diligent service that stung the most.

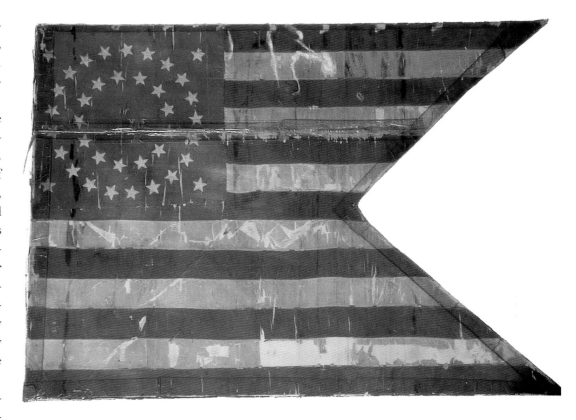

Figure 101. *Stars and Stripes Guidon. Swallow-tail company flags like this one were the first Stars and Stripes carried by the U.S. Cavalry. They were superceded by red-over-white guidons in 1885, when the Civil War surplus had been exhausted. Courtesy of the U.S. Army Center of Military History.*

Almost a century would pass before Texans began to acknowledge the great debt the state owed to the buffalo soldier.

Stars and Stripes Triumphant

It seemed as though Americans had always had their eyes on Cuba. In the nineteenth century, the Spanish colony just south of Florida had presented a tempting target for annexation, especially for antebellum Southerners. Bowing to pressure from proslavery expansionists, the Franklin Pierce administration in 1854 had offered to buy Cuba for $130 million. When the Spanish government indignantly refused the offer, a group of U.S. diplomats issued the so-called Ostend Manifesto, which declared that the United States reserved the right to annex Cuba if it saw fit. The South's defeat quelled American interest in the island for a while. In the later part of the nineteenth century, however, Spanish rule there seemed to be withering as a series of revolts, imaginatively reported in American newspapers, caught the public's attention. On the night of February 16, 1898, the battleship USS *Maine* exploded in Havana's harbor, and after weeks of pointless diplomatic maneuvering, the United States declared war against Spain on April 25.

Military leaders believed that in order to undertake an invasion of Cuba, the United States needed an army far larger than the small professional force it had on hand. To augment its numbers, the generals proposed to expand the existing regular army regiments. President William McKinley, however, insisted on a more traditional path. He ordered the states to muster volunteer regiments, much as they had during the War Between the States.[31] The War Department assigned Texas' contribution to be one regiment of cavalry and four of infantry to be drawn from existing units of state troops. But the Texas Volunteer Guard, as the state militia was officially called, numbered less than two thousand men, far short of the five thousand needed to fill the ranks of the five regiments. To make matters worse, state officials soon discovered that many of the available guard members refused induction. Some Texans were willing to fight but wanted no connection with the U.S. Army. Several units volunteered but reconsidered and withdrew, in time-honored militia tradition, when they found out they could not select their own commanding officers.[32] One company, the Houston Light Guard, which had been one of the most proficient of the

state's military units, refused even to volunteer because they had "sworn only to defend their city, county, and state."[33] The shortfall in manpower forced the state's adjutant general to fill the ranks with inexperienced volunteers, a commodity of which there was no shortage. The additional time required to outfit and train the new recruits assured that no Texas state volunteer units would see action in what turned out to be a very short war.

Four of the five Texas regiments mustered into federal service in Austin in mid-May, 1898. The First Texas Infantry, United States Volunteers, would be the only unit to actually travel to Cuba, but it arrived in Havana in late December, long after the fighting had ended. Its volunteers served as occupation troops until late March, 1899. The Second Texas Infantry was also assigned to duty in Cuba but had reached only Jacksonville, Florida, at war's end. Various companies of the Third Texas Infantry spent the war on garrison duty along the Rio Grande, and on the Gulf Coast as far east as Key West. The Fourth Texas Infantry did not muster until July but remained on duty in San Antonio until its March, 1899, demobilization.[34]

The service of the First Texas Cavalry resembled that of its sister regiments. The unit mustered into federal service on May 14 and 15, 1898, with a complement of 47 officers and 1,025 enlisted men. In June detached troops of the regiment dispersed to military posts along the Rio Grande. Troop I remained at Fort Sam Houston in San Antonio, where its most arduous duty seems to have been to ride in the city's Fourth of July parade. Active service for the First Texas lasted only until late September. Its casualty list reveals the humdrum character of these citizen soldiers' uneventful time in uniform: three dead from disease, one killed in an accident, one murdered, and eighteen desertions.[35] Today, one of the few tangible reminders that state-guard volunteers had participated in the War with Spain is the tattered National Color of the First Texas Cavalry.

For the first conflict since the Mexican War, troops raised under Texas' official aegis flew the Stars and Stripes. When the volunteers entered federal service, units discarded company flags and received U.S. colors along with other equipment. Infantry flags had changed little since the 1840s, but in 1887 regulations for cavalry had been modified, and the regimental standard was changed from

"swells." The largest contingent from any one state or territory were the 127 men from Texas.[37] Their presence particularly pleased Roosevelt, who wrote, "We drew a great many recruits from Texas: and from no where did we get a higher average, for many of them had served in that famous body of frontier fighters, The Texas Rangers. Of course the rangers needed no teaching. They were already trained to obey and take responsibility. They were splendid shots, horsemen, and trailers. They were accustomed to living in the open, to enduring great fatigue and hardship, and to encountering all kinds of danger."[38] The Rough Riders found San Antonio a felicitous location for training. The goodwill of the citizens, the pleasant surroundings, and the echoes of history all around reinforced the soldiers' patriotic resolve. "We . . . were glad," wrote Roosevelt, "that our regiment had been organized in the city where the Alamo commemorates the death fight of Crockett, Bowie, and their famous band of frontier heroes."[39]

When the Rough Riders departed San Antonio they carried at least three regimental flags. During official reviews and other functions, the soldiers displayed their regulation Stars and Stripes and yellow regimental color (see plate 28). Roosevelt's men, however, were rarely conventional, and the flag most in evidence in photographs and in action was a Stars and Stripes provided by the people of Arizona. When the contingent from that territory had gathered in Prescott just before departing for Texas, a typical presentation ceremony had taken place. The territory's governor presented the volunteers with a U.S. flag the ladies of the Women's Relief Corps of Phoenix had made.[40] The large ninety-one-by-fifty-inch silk standard with its forty-five stars was visually impressive and no doubt appealed to Roosevelt's sense of theater more than the smaller, official regimental colors.[41]

In tangible ways the planning for the war with Spain signaled the North's acquiescence to the Lost Cause. President McKinley made powerful efforts to engage the states of the former Confederacy in the war effort. He called on the South to provide a substantial levy of recruits and actively sought former Rebel military leaders for high command in the volunteer forces. The president appointed sixty-one-year-old Joseph "Fightin' Joe" Wheeler, onetime cavalry leader of the Army of Tennessee, major general in charge of all mounted forces of the Fifth Corps. This was a partic-

blue to yellow. In 1895 new regulations required that cavalry, like infantry, carry two colors. One flag, the national color, was a three-by-four-foot Stars and Stripes with the unit's name and number inscribed in gold along the center white stripe (see plate 27). The second was the regimental color, which displayed the same arms as the venerable blue standard, now fabricated in yellow silk.[36]

The most famous regiment of the Spanish-American War had strong Texas connections. Part of McKinley's request for volunteers had been a call for three regiments of cavalry to be composed of cowboys and other outdoorsmen from the West. The first of these to assemble and the only one to see action was designated the First Regiment United States Volunteer Cavalry. History would know them as the Rough Riders. Taking advantage of political connections, the bumptious assistant secretary of the navy, Theodore Roosevelt, secured the position of lieutenant colonel in the new regiment. Its commanding officer, Col. Leonard Wood, a Harvard-schooled physician and former Indian fighter, chose San Antonio as assembly point and camp of instruction.

The volunteers who journeyed to the Alamo City that spring were not only a colorful amalgam of former Indian fighters and cowboys, but also boasted a sizeable complement of Ivy League

Figure 103. *Joe Wheeler as Confederate general* (left) *and Joe Wheeler as U.S. general* (right). *President McKinley took special care to include former Confederates in important positions in the war effort against Spain. U.S. Army Military History Institute, courtesy of the National Archives, photo no. 111-SC-90118.*

ularly important post because the command had been tapped as the expeditionary force that would land in Cuba. The president also appointed Fitzhugh Lee, son of the venerable Robert E. Lee, to command the Seventh Corps, and awarded brigadier general's stars to a number of other former Confederate officers.[42] In return, Southerners joined the patriotic frenzy that had engulfed the nation after the sinking of the *Maine*. The mobilization was a milestone in the reunion of North and South.

This became crystal clear to the delighted commanders of the Rough Riders as the regiment traveled from San Antonio to the embarkation port at Tampa, Florida. Roosevelt recalled, "Everywhere we saw the Stars and Stripes, and everywhere we were told, half laughing, by grizzled ex-Confederates that they never dreamed in the bygone days of bitterness to greet the old flag as they now were greeting it, and to send their sons, as they were now sending them to fight and die under it."[43] Colonel Wood witnessed this en-

thusiasm demonstrated by the people of New Orleans. "The streets are full of people," he wrote, "and best of all an American flag in the hands of all. The cost of the war is amply repaid by seeing the old flag as one sees it today in the South. We are indeed once more a united country."[44]

Assigned to Wheeler's division, the Rough Riders became one of the first American regiments to land in Cuba. Unfortunately, a lack of transports made it necessary to leave their horses behind, forcing these "wild horsemen" of the West to fight the entire campaign on foot. But at least one traditional trapping of the American cavalryman remained with them. Each troop would continue to mark its presence in camp, on the march, and in action with its red-and-white guidon.

The Stars and Stripes the Phoenix ladies had made became the first U.S. flag raised in Cuba. While landing his men at Daiquiri, thirteen miles east of Santiago, General Wheeler noticed a flagpole on an abandoned Spanish blockhouse that crested a nearby hill. The Rough Riders were already ashore, so he ordered Colonel Wood to dispatch some of his men to place their colors there. Three Rough Riders hiked up to the blockhouse and hoisted the regiment's Arizona-made Stars and Stripes. The sight of the flag electrified the landing force below. In the words of an eyewitness, "Thousands of voices, scores of stream whistles, and dozens of brass bands joined in a great outburst of noise that made no secret of the fact that the men of the United States were landing."[45] After a sharp fight four miles inland, near the village of Las Guásimas, on June 24, the Rough Riders were poised for a central role in the most famous battle of the war. In the meantime, Wood had been promoted to brigadier general, and Roosevelt was in full command of the First United States Volunteer Cavalry. He would make the most of the opportunity.

The July 1 battle at San Juan Hill was a very confused affair. A series of well-defended hills guarded the western approaches to Santiago. American commanders identified a blockhouse at the crest of San Juan Hill as the key to the defenses. Before it could be taken, however, a position just to its front, Kettle Hill, would have to be overrun. The troops assigned to the assault included, along with the Rough Riders, several buffalo soldier regiments that had served on the Texas frontier. Roosevelt on horseback in effect led

Figure 104. *Unity Tableau of North and South. This less-than subtle allegorical image depicts the reconciliation between North and South brought about by the war in Cuba. Courtesy of the Library of Congress, LC-USZ62-63679.*

Figure 105. *Rough Rider Standard-Bearer and Regimental Flags. The six-foot-six standard-bearer of the Rough Riders with the national color the ladies of Arizona had made. In the background are other regimental flags, including the regulation Stars and Stripes. Theodore Roosevelt Collection, Harvard College Library.*

Figure 106. *Rough Riders atop San Juan Hill. Theodore Roosevelt well knew the drama flags added to a scene. This famous photograph was made on July 1, 1898, on San Juan Hill. Courtesy of the Library of Congress, LC-USZ62-7626.*

the charge, which was not nearly as picturesque as contemporary illustrations depict. The soldiers went forward in small, bunched-up groups that "spread out like a fan." The attackers soon became disorganized and intermingled, but the advance was inexorable.[46]

This may have been the last battle in American history where flags led a major attack. The sight must have been dramatic. During the advance the standard-bearer of the Third Cavalry was shot. Near the head of the advancing Americans was George Berry, the black color sergeant and thirty-year veteran of the Tenth Cavalry. Shouting, "Dress on the colors, boys, dress on the colors," he picked up the fallen flag and bore it, along with his own regimental color, across the enemy trenches. As the surviving Spaniards fled, Berry planted both flags on the crest of the hill. Fittingly, the colors of the African American Tenth Cavalry and the white Third Cavalry to-

gether became the first flags atop Kettle Hill.[47] The Rough Riders were close behind Sergeant Berry, and the guidons of three New Mexico troops became the first of Roosevelt's flags on the summit.[48] From their position, many of the troops who had just taken Kettle Hill provided covering fire for the infantry force that stormed the actual San Juan Hill position.

The battle had provided a brief interlude when old prejudices were set aside and all Americans fought as equals under the same flag. John J. Pershing, who was at that time lieutenant in the Tenth Cavalry, observed, "White regiments, black regiments, regulars and Rough Riders, representing the young manhood of North and South, fought shoulder to shoulder, unmindful of race or color, unmindful of whether commanded by ex-Confederate or not, and mindful only of their common duty as Americans."[49] A little over a month later, after the Spanish had capitulated, the Rough Riders departed Cuba along with the rest of the Fifth Corps. The instant

fame Roosevelt had achieved helped propel him into the White House.

Texans in France

In Texas as elsewhere the militia had rarely constituted an effective military force. Citizen soldiers could be effective in responding to local threats, such as Indian raids, but raising forces for protracted or arduous service was difficult. "The individual's right to refuse to volunteer," wrote a modern scholar, "was implicit in the ethos of the nineteenth-century citizen soldier."[50] After Reconstruction the Texas Volunteer Guard, as the militia was called after 1879, acted more as a constabulary than a trained fighting force. In the more than fifty activations in the later part of the century, a third were to prevent lynchings.[51]

Since the Civil War the tendency has been for the federal government to assume many of the traditional functions of the states. Nowhere has this been more manifest than in the raising and control of military forces. The Spanish-American War had demonstrated to the army's generals that the states were not capable of providing the mass of well-trained and equipped troops that contemporary European nations could raise. In a series of reforms after 1900, the government in Washington federalized state troops. The army assumed most of the responsibility for training and equipping them and in so doing transformed state forces into the secondary arm of the U.S. Army for national defense.[52] Even this national guard, however, would prove insufficient when the U.S. became embroiled in a general conflict with the world's great powers.

The turmoil of revolution in Mexico led to the United States' largest military action since the Spanish-American War. On March 16, 1916, revolutionary general Francisco "Pancho" Villa led a raid against Columbus, New Mexico, that took the lives of several Americans. The incursion prompted President Woodrow Wilson to order Gen. John J. Pershing to lead an army expeditionary force into Mexico in pursuit. Villa's band was not the only threat from the south, but the army lacked the manpower to protect the entire border. To meet the crisis, Wilson mobilized five thousand national guardsmen from Texas, New Mexico, and Arizona. When these numbers proved insufficient, the president activated troops from the rest of the states a few months later.[53]

Texas guardsmen were still in service along the Rio Grande when the United States declared war against Germany and its allies on April 2, 1917.

With that declaration, the U.S. Army began its largest mobilization up to that time. Troops would come from three sources: the regular army, the national guard, and conscription. The basic tactical unit of American infantry in World War I was the division. Each numbered about 28,000 officers and men. The typical division underwent six months' training in a camp, then two months' additional drill after arriving in France. Another month in a quiet sector followed before a division was hurled into battle.[54] The majority of Texans who saw action in Europe served in either the state's national guard division, the Thirty-sixth, or the conscript (national army) division, the Ninetieth.[55] The War Department, in the interest of forging a true national army, minimized the traditional military ties between citizen soldiers and their home states. Thus the generals assigned numbers without reference to state origins to the new divisions, brigades, regiments, and battalions. Men recruited from the same regions, however, tended to be assigned to the same units.[56]

World War I was the first American conflict where battle flags played no tactical part on the battlefield. In an environment that spanned enormous distances and where lethal new weapons dealt death from afar, flags could have served only to draw unwanted attention to their bearers. The War Department continued to issue regimental colors, but their function became purely ceremonial. Flag regulations for infantry regiments had changed little since the Mexican War. Each unit was still issued the Stars and Stripes and a blue regimental color. In 1895, however, new directives had reduced their size from six feet by six feet, six inches—measurements in use since the eighteenth century—to four feet, four inches on the staff by five feet, six inches on the fly.[57] The national arms on the regimental flag retained their shield-and-eagle design but were now handsomely embroidered in silk thread. Because contractors mass-produced the flags to precise specifications, there were no variants. With the exception of the unit designation, each flag for a particular branch of the service was a virtual clone of the next. Despite the federalization of the army, the time-honored tradition of the flag presentation often persisted. For example, in January,

Figure 107. *Thirty-sixth Division Panther's Logo. In 1917 Fort Worth was nicknamed "Panther City." The Thirty-sixth Division, which trained there, was originally known as the Panther Division. Hatzenbuehler Photography © 2000 Dan Hatzenbuehler.*

"We'll conquer (or, we shall win) even though hell opposes."

Earlier Division Insignia

1918, the Women's Patriotic League of Waco and McLennon Counties presented the Thirty-sixth Division in Fort Worth with a Stars and Stripes to take to France.[58] It seems unlikely, however, that the division commanders would have ignored regulations, as Roosevelt had done in 1898, to display such a flag on official occasions (see plate 29).

In July, 1917, units of the Texas and Oklahoma national guards assembled at Camp Bowie just west of Fort Worth and formed the Thirty-sixth Division.[59] Fort Worth, today widely know by its nickname, "Cowtown," was in 1917 usually called "Panther City." The soldiers took a liking to the sobriquet and began referring to the Thirty-sixth as the "Panther Division." The officers and men designed an appropriate logo and even composed a marching song, "The Panthers Are Coming," sung to the tune of "The Campbells Are Coming."[60] The men who became "panthers" represented a cross-section of the societies of these two unique states. Farmers, stockmen, as well as businessmen all lost their distinctive appearances when they donned doughboy khaki. For some of the Texans, service in the army also meant an introduction to the modern world. One engineers' battalion, for instance, contained some four hundred West Texas cowboys. They were keenly disappointed when they discovered their mounts would be trucks and not horses.[61]

Among the recruits from Oklahoma was the largest contingent of Native Americans ever to bear arms for the United States up to that time. Most were in the 142d Infantry Regiment. One company was completely Indian and contained members from fourteen different tribes.[62] Many of these came from areas where oil had been discovered, and some tribesmen had become relatively wealthy as a result. Texas soldiers often dropped by the campsite of the "millionaires company," as they came to call it, just to gaze at the royalty checks the Indians received.[63]

Contrary to the expectations of some Texans, Indian soldiers did not demonstrate any special skills in tracking and ambushing nor show any tendencies toward "savageness." They did, however, possess one unique quality that proved invaluable in the fighting. When the Thirty-sixth Division arrived on the battle line in France, the Panthers quickly learned that brutal small-scale raids and patrols between trench lines characterized daily life. Trying to gain an advantage over the Americans, German infiltrators sometimes tapped into telephone lines, and English-speaking listeners frequently gained valuable intelligence from this eavesdropping. To counter the problem, division commanders assigned Native American doughboys who were fluent in traditional languages to communication posts and relayed orders through them. The Germans, understandably baffled by the unexpected sonorities of Choctaw, Cherokee, and Creek, lost an important intelligence advantage. The lesson was not lost on later American generals. In World War II, Native American "wire-talkers" would be common.[64]

Many Mexican Americans also served in the Thirty-sixth Division. Most came from the counties along the Rio Grande, and some

Figure 108. *Thirty-sixth Infantry Division T-patch Emblem. Pictured is the original 1918 design for the famous T-patch. Hatzenbuehler Photography © 2000 Dan Hatzenbuehler.*

perimposed on a khaki disk.[66] In the period between the world wars, the War Department would reassign the Oklahoma national guard to another division, but the T-Patch remained the emblem of the all-Texas guard unit (see plate 31).

The service of the Ninetieth Division, in some ways, paralleled that of the Thirty-sixth. The division, composed of Texas and Oklahoma draftees, came into being in August, 1917, at Camp Travis, a new facility erected adjacent to San Antonio's Fort Sam Houston. Despite the army's preference for sublimating state identity, even in this new division unit organization closely followed geographic lines. The 179th Brigade was designated the Oklahoma Brigade and contained the 357th Infantry Regiment, which was composed of men drafted from the western part of that state, and the 358th Infantry Regiment, with men from eastern sections. The 180th Brigade was known as the Texas Brigade. Its 359th Infantry Regiment came from North and West Texas.[67] With more Texans than any other unit, the 360th Infantry was called the "Texas Regiment"; most of its recruits were residents of the southern and eastern portions of the state (see plate 30).[68]

The ethnic makeup of the Ninetieth was similar to the Thirty-sixth, with a significant exception. While most of the division was white, about 10 percent was Mexican, and more than a thousand Native Americans served. Unlike the Thirty-sixth, the Ninetieth received a contingent of black draftees. The mistreatment of African Americans in the army, which had worsened after the war with Spain, continued during the Great War. Black Texans who had been drafted into the Ninetieth Division were placed in segregated units that would not be sent overseas. In November, 1917, three thousand African Americans arrived at Camp Travis and were assigned to a segregated battalion of the 165th Depot Brigade for manual and menial labor.[69]

When the Ninetieth Division was in San Antonio it was known as the Alamo Division, in honor of the nearby shrine of Texas liberty. Many of the officers and men wanted to make the name the official designation, but some of the Oklahomans objected. In the end the commanding general, Henry T. Allen, in keeping with the army's policy of limiting regional identity, rejected the imposition of an official nickname. This, of course, did not discourage newspapers and the general public from continuing to refer to the

companies were completely Hispanic. Their presence, like that of the Native Americans, represented a continuity of Texas tradition. One of the captains in the 143d Infantry was Augustine de Zavala, grandson of the Texas Revolution hero Lorenzo de Zavala.[65]

In July and August, 1918, after nearly a year of organization and training, the Thirty-sixth Division departed for France. In the closing months of the war, the Texans and Oklahomans, alongside the French Fourth Army, engaged in heavy fighting in the Champagne region. After the Armistice, the division did occupation duty before its return to Fort Worth, where it was demobilized in June, 1919. Just before the fighting ended, the Thirty-sixth Division received the emblem that would identify it in the future. In order to help sort out troops who had become intermixed in combat and to help increase esprit de corps in the army, American commanders ordered each division to design its own emblem. A committee of the Thirty-sixth rejected the Panther symbol in favor of a new design, the T-Patch. It consisted of a khaki "T" symbolizing Texas on a cobalt arrowhead representing Oklahoma, su-

The conscript division saw more fighting and suffered more casualties than the Thirty-sixth. Arriving in France in July, 1918, the Ninetieth fought in the first major American offensive at St.-Mihiel and played a pivotal role in the Meuse-Argonne offensive that led to the end of the war. As the Armistice was being negotiated, the division was heavily engaged along the Meuse River and its last soldier was killed fifteen minutes before the cease-fire. The Ninetieth Division took part in the occupation of Germany before returning to the United States by June, 1919.

The First World War marked the completion of the sea change in Texans' attitudes toward the United States and their place in it. The state's citizens took great pride in their two Texas divisions, and they relished the parts they played in the great national effort. No longer did Texans "hate the stripéd banner" but embraced it with unprecedented patriotic fervor, even in preference to the beloved Lost Cause. Nowhere was this better illustrated than when the Ninetieth Division paraded through the streets of San Antonio on Washington's birthday in 1918. As the color guard marched past with the Stars and Stripes, an aged Confederate veteran in the crowd failed to remove his hat. Seeing this, spectators hustled the old man off to the nearby federal building and upbraided him for not showing enough respect to the American flag.[71] When Texas troops returned home from Europe, their colors were treated with the same respect earlier generations had accorded to the Rebel Flag. After demobilization the colors of the Thirty-sixth and Ninetieth Divisions were presented to the state for display in specially constructed cases in the adjutant general's headquarters.[72]

The First World War began what amounts to a love affair between Texans and the American military. Any resentment or ambivalence Texans had felt for the post-Reconstruction army had faded by 1917. For economic reasons as much as patriotic, the sight of the Stars and Stripes fluttering over the dozens of army, air force, and navy installations in the state brought twentieth-century Texans as much delight as those of the late nineteenth century would have felt had the Stars and Bars been installed in Washington, D.C. Despite the affection for the Stars and Stripes the war brought out, residents of the Lone Star State still prided themselves as a people apart — and had symbols to prove it. All the

Ninetieth as the Alamo Division and adding equally colorful monikers, such as the Rattlesnake Division and the Outlaw Division. In France, when the order came down to select an emblem, Allen opted for a design with "T-O" superimposed in red for Texas and Oklahoma in such a way that neither dominated the other. This configuration suggested yet another unofficial nickname for the division, the "Tough 'Ombres."[70]

icons we recognize today as representing Texas were already in place and well understood by the time of the First World War. This can be seen in the 1918 coat of arms of the 359th Infantry Regiment of the Ninetieth Division. The design displayed prominently the lone star, the Six Flags over Texas, the head of a longhorn steer, and a wreath of bluebonnets.[73]

"The whole flag is historic," proclaimed a newspaper item in 1836, referring to an early lone-star banner. And so it is with the Lone Star Flag Texans honor today. The red-white-and-blue standard with its single five-point star is much more than simply the state flag of Texas. It is the avatar of all the flags that the people who built Texas flew. Anglo-Celtic settlers, Confederates, Unionists, Mexicans, African Americans, Native Americans, and others all played their parts in this great saga and had flags to lead them. The Lone Star Flag is a tricolor like the Mexican flag. It is red, white, and blue like the Stars and Stripes and the Stars and Bars. These were hues that also tinted the guidons and regimental colors of buffalo soldiers and Native American doughboys. For Texans it was the lone star that was the common charge in most of their flags and the icon they most revered. Despite our forebears' very human failure to produce anything resembling a utopia, they did, nevertheless, achieve great things, and always looked to the lone star as the symbol of their noblest aspirations. As time passes it will no doubt be the embodiment of new myths as it is for old. All modern Texans should fly the Lone Star Flag proudly and without reservation. To do so is not chauvinism, but a reaffirmation of community.

Appendix Existing Flags Pictured in Text

Figure 1. Spanish Viceroy's Flag 57″ × 59″ silk
 Colección de Banderas, Museo Nacional de Historia, Mexico City
Figure 3. Death's Head Flag 25.5″ × 28″ wool
 Colección de Banderas, Museo Nacional de Historia, Mexico City
Figure 4. Morelos's Flag 57″ × 74″ silk
 Colección de Banderas, Museo Nacional de Historia, Mexico City
Figure 8. Puebla Infantry *bandera trigarante* 50″ × 52″ silk
 Colección de Banderas, Museo Nacional de Historia, Mexico City
Figure 14. Mexican Cavalry Guidon 24″ × 28″ silk
 Dallas Historical Society
Figure 23. New Orleans Grays Flag 35.5″ × 45.5″ silk
 Colección de Banderas, Museo Nacional de Historia, Mexico City
Figure 41. Texian Flag of Ross's Regiment 24″ × 48″ wool
 Star of the Republic Museum, Washington-on-the-Brazos, Texas
Figure 42. *(top)* Texian Flag of the Santa Fe Expedition
 34.5″ × 59″ wool
 Colección de Banderas, Museo Nacional de Historia, Mexico City
 (middle) Lipantitlán Texian Garrison Flag 58″ × 129″ wool
 Colección de Banderas, Museo Nacional de Historia, Mexico City
 (bottom) Texian Flag of the San Antonio garrison 70″ × 215″ wool
 Colección de Banderas, Museo Nacional de Historia, Mexico City
Figure 43. Galveston Invincibles Flag 49″ × 53.5″ silk
 Colección de Banderas, Museo Nacional de Historia, Mexico City
Figure 44. Georgia Militia Flag 36″ × 44.5″ silk
 Colección de Banderas, Museo Nacional de Historia, Mexico City
Figure 45. Texian Flag, Dawson's Fayette County Volunteers 36″ × 56″
 cotton
 Colección de Banderas, Museo Nacional de Historia, Mexico City
Figure 50. Tyler Guards Flag 24″ × 84″ silk
 Smith County Historical Society, Tyler, Texas
Figure 59. Alamo City Guards Flag 48″ × 72″ (estimated) silk
 The Alamo, San Antonio, Texas
Figure 61. Confederate First National Flag 102″ × 156″ bunting
 Texas State Library and Archives Commission, Austin, Texas

Figure 62. Stars and Bars Co. F, 17th Texas 46″ × 67″ silk
 United Daughters of the Confederacy, Texas Division, Texas
 Confederate Museum Collection
Figure 63. Corpus Christi Light Infantry Stars and Bars 52″ × 72″
 silk (?)
 United Daughters of the Confederacy, Texas Division, Texas
 Confederate Museum Collection
Figure 64. Confederate Second National Flag 74″ × 112″ bunting
 Texas State Library and Archives Commission, Austin, Texas
Figure 65. Waul's Legion Confederate Second National Flag 2″ × 84″
 bunting
 United Daughters of the Confederacy, Texas Division, Texas
 Confederate Museum Collection
Figure 66. Confederate Third National Flag 35″ × 55″ bunting (?)
 United Daughters of the Confederacy, Texas Division, Texas
 Confederate Museum Collection
Figure 68. Army of Northern Virginia Battle Flag, Prototype
 35″ × 37″ silk
 Museum of the Confederacy, Richmond, Virginia
Figure 74. Miniature Lone Star and Bars 6.75″ × 13.5″ silk
 Museum of the Confederacy, Richmond, Virginia
Figure 76. Fourth Bunting ANV Battle Flag of the Third Arkansas
 50″ × 51″ bunting
 Museum of the Confederacy, Richmond, Virginia
Figure 78. Terry's Texas Rangers Bonny Blue Flag 22″ × 33″ wool
 Decorative and Industrial Arts Collection, Chicago Historical
 Society
Figure 79. Terry's Texas Rangers Southern Cross Flag 36″ × 36″ silk
 Texas State Library and Archives Commission, Austin, Texas
Figure 80. Van Dorn Flag 47″ × 76″ silk
 Museum of the Confederacy, Richmond, Virginia
Figure 83. Third Texas Twelve Star Southern Cross Battle Flag
 42.5″ × 52″ bunting
 Texas State Library and Archives Commission, Austin, Texas

Figure 84. Eleventh Texas Cavalry Stars and Bars Variant
 23″ × 25.25″ silk
 United Daughters of the Confederacy, Texas Division, Texas
 Confederate Museum Collection
Figure 88. DeBray's (Twenty-sixth) Cavalry ″Texas Pattern″ Battle Flag
 35.5″ × 52″ cotton
 United Daughters of the Confederacy, Texas Division, Texas
 Confederate Museum Collection

Figure 89. Wood's (Thirty-second) Cavalry Regimental Color
 44.75″ × 46″ silk
 United Daughters of the Confederacy, Texas Division, Texas
 Confederate Museum Collection
Figure 90. Fort Semmes Flag 35″ × 42″ cotton
 United Daughters of the Confederacy, Texas Division, Texas
 Confederate Museum Collection
Figure 105. Rough Riders Arizona Stars and Stripes 50″ × 91″ silk
 State Capitol Museum, Phoenix, Arizona

Plate 1. Sidney Sherman's Company San Jacinto Battle Flag

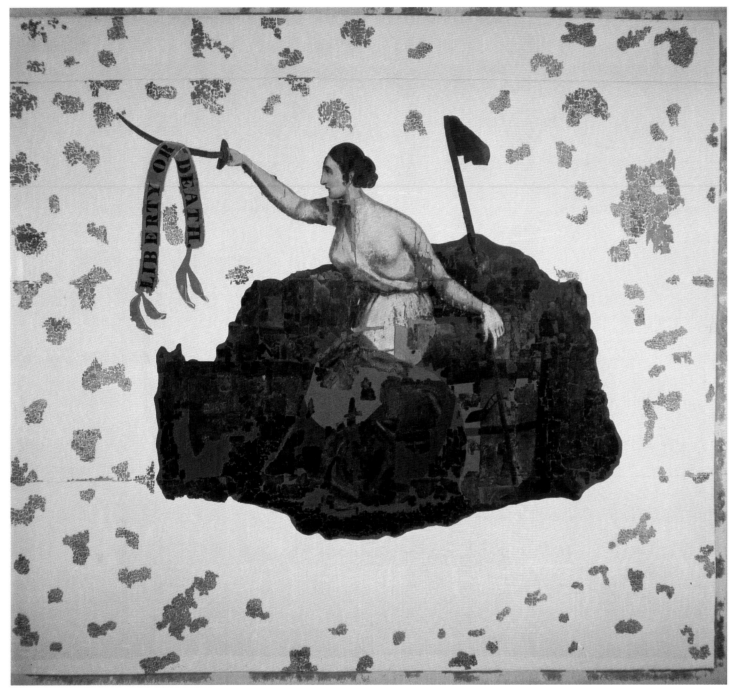

Dimensions: Fly: unknown
Leading Edge: unknown
Material: silk
Border: yellow silk fringe
Attachment: possibly pole sleeve
Repository: State Preservation Board,
 Austin, Texas

Very little remains of this flag that the Texian army carried at the Battle of San Jacinto. Time and the abuses of a well-meaning but misguided restoration in the 1930s have taken a heavy toll on the fragile silk banner. Today, only about 10 percent of the original silk fabric of the field remains, and it is impossible to determine with any assurance what the original central image looked like. The flag was handmade by the ladies of Newport, Kentucky, who presented it to Sidney Sherman's volunteer company as it departed for Texas to fight for independence from Mexico. The banner, probably blue originally, was constructed of three pieces of silk seamed horizontally. Artist Charles Beard painted a liberty figure in its center. Today the image is 40 percent complete and only the head and torso are intact. As best as can be determined, the figure is a bare-breasted, seated female image meant to personify Liberty. In her raised arm is a sword over which hangs a streamer that proclaims "Liberty or Death." Beneath the upraised arm upon a green background that encircles the lower portions of the figure are a plow and two stacks of wheat. Behind the lowered shoulder is a staff surmounted by a Phrygian-style red liberty cap. A red cloth drapes the figure's lap and legs. Members of the victorious Texian army presented the flag to Mrs. Sidney Sherman in August, 1836, and it remained with that family until 1896, when heirs donated it to the state. By that time the flag was nothing more than fragments.

Plate 2. Toluca Battalion / Mexican Tricolor Battle Flag

Dimensions: Fly: 55″ (present day)
Leading edge: 67″ (present day)
Material: silk
Border: none
Attachment: sleeve
Repository: Texas State Library and
 Archives Commission, Austin, Texas

This Mexican tricolor variant was originally inscribed with the words "Batallon Activo de Toluca," which were sewn in black across the vertical white bar. The national arms in the center panel is less elaborate than on other Mexican army battle flags of the period. Displayed above the unit designation is an embroidered eagle with wings spread, holding a snake in its beak, done in various shades of brown, gold, and black. The flag was constructed from three separate sections of single-layered silk. Battle damage inflicted during the assault on the Alamo and at San Jacinto, and from previous preservation attempts, make it impossible to determine the flag's original dimensions.

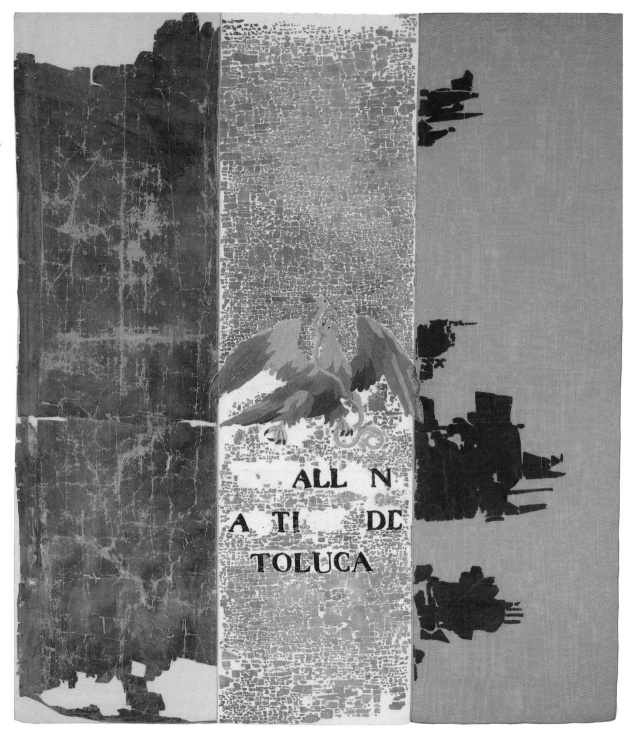

Plate 3. Guerrero Battalion / Mexican Tricolor Battle Flag

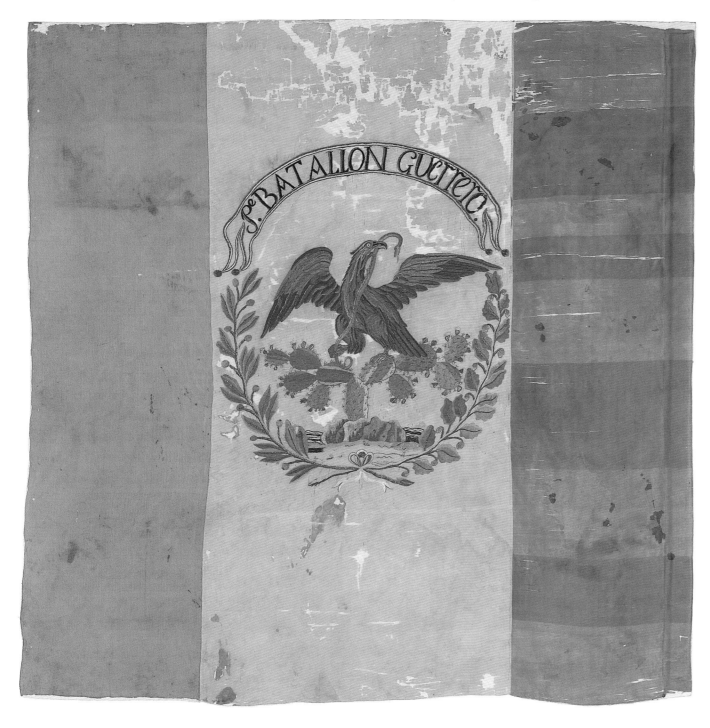

Dimensions: Fly: 60″
Leading Edge: 58″
Material: silk
Border: none
Attachment: sleeve
Repository: Texas State Library and
 Archives Commission, Austin, Texas

The flag of the Guerrero Battalion consists of three lengths of silk, joined vertically to form a Mexican tricolor. A variant of the national arms is embroidered on the central vertical stripe. This consists of the traditional wings-spread eagle with snake, perched on a cactus. The cactus grows out of a rock protruding from water in which are several waterfowl. Above the eagle is embroidered "P. BATTALON GUERRERO," with a wreath below. The embroidery was finished on the reverse side, while the lettering is finished only on the obverse. This is the only battle flag captured at San Jacinto that depicts the cactus fronds usually associated with the federalist political faction. Forensic tests revealed that the flag was extensively blood-stained.

Plate 4. Matamoros Battalion / Mexican Tricolor Battle Flag

Dimensions: Fly: 67″
Leading edge: 57″
Material: silk
Border: none
Attachment: double layer of green silk
 wrapped around staff and tacked into place
Repository: Texas State Library and
 Archives Commission, Austin, Texas

The field of this Mexican tricolor consists of three vertical bars: green, white, and red. On the white middle bar, embroidered in brown, blue, and gold silk thread, is a variant of the national arms of Mexico, an eagle holding a snake. Embroidered above the snake's head in cursive letters is "Batallon." Beneath the eagle, written similarly, is "Matamoros," under which is the word "Permanente." The flag suffered considerable damage during the Texas campaign before its capture at San Jacinto.

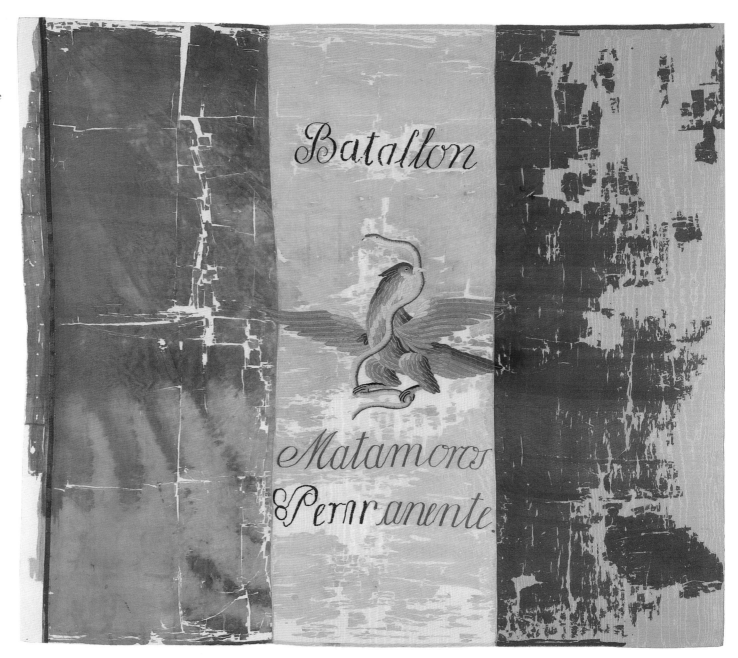

Plate 5. Texian Flag / Republic of Texas Era

Dimensions: Fly: 64″
Leading edge: 36″
Material: wool
Border: missing
Attachment: unknown
Repository: The Heritage Society, Houston, Texas

In January, 1839, the Texas Congress adopted a flag for the three-year-old Republic that displayed a lone star and was essentially a simplified version of the U.S. Stars and Stripes. A short time later that same body agreed that the permanent capital of Texas would be located on the Colorado River in Travis County. That spring and summer, surveyors laid out the town of Austin, and workmen began constructing the capitol and other public buildings to house the government. The site, however, was on Texas' western frontier, and there was constant danger of attack by Indians and Mexican troops. For protection congress raised three companies of troops, totaling just over one hundred soldiers. Documents associated with this flag suggest it was carried by these Texian troops and thus was probably the first lone-star flag to fly over Austin. Its proportions are much closer to government specifications than other Texian Flags that still exist from the period. The flag was made from machine-made wool, and the sections were hand-sewn with linen thread. The star on each side was skillfully attached with a row of red silk chain-stitched thread. The red and blue panels were poorly tinted with locally produced vegetable dyes. Despite the skill the flag makers demonstrated in their handiwork and the use of commercially obtained fabric, this Texian Flag is unmistakably the product of an unsophisticated frontier society.

Dimensions: Fly: 50¼″
Leading edge: 30½″
Material: cotton
Border: none
Attachment: tacks around entire perimeter
Repository: Dallas Historical Society

This Stars and Stripes variant 1844 campaign flag was made from one width of printed cotton fabric. The decoration is relief-printed in two colors, red and blue. In the blue canton are twenty-six stars representing the states of the Union in 1844. They circle a portrait of

Democratic presidential candidate James K. Polk, which is in turn is surrounded by a wreath of oak leaves. This cameo is a black lithograph. Outside the field is a lone blue star representing Texas. The flag's field is printed with seven red stripes, leaving the white fabric

plain to form the white stripes. On two of the white stripes of the field are the names "POLK" and "DALLAS."

Plate 7. **Twenty-eight Star Stars and Stripes**

Dimensions: Fly: 168″
Leading edge: 120″
Material: wool bunting
Border: none
Attachment: metal grommet at top and
 bottom

Repository: Texas State Library and
 Archives Commission, Austin, Texas

*Pictured is a rare U.S. flag that reflected the
number of states of the Union after Texas was
annexed. Its dimensions and the configuration
of the stars in the canton suggest the flag was
not made for the army or navy but served some
civil function, such as flying over a U.S.
customs house or other government building
or facility. Its construction is typical for the
period. The body of the flag was assembled from
machine-made English wool bunting and
hand-sewn with linen thread. The stars are
cotton. The flag was current for only one year,
from December 29, 1845, to December 28, 1846,
the date the twenty-ninth state, Iowa, joined the
Union.*

Plate 8. Alamo Secessionist Flag / Texian Flag

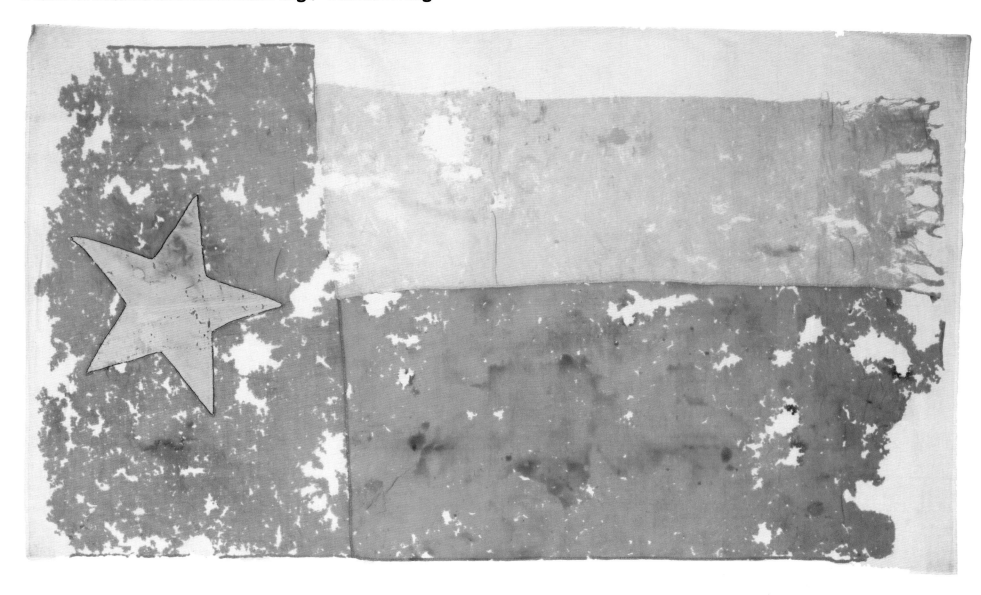

Dimensions: Fly: 67"
Leading edge: 36¼"
Material: homespun cotton
Border: none
Attachment: unknown
Repository: Texas Memorial Museum,
 University of Texas at Austin

As the Civil War approached, most Texas flags were still homespun and hand-sewn. Such is the case with this Texian Flag that the women of Seguin made for a local military company. It is constructed of wool challis and pieced together with hand stitching. Appliquéd to the blue bar is a large five-point white wool tilted star. There is a one-eighth-inch red trim around the star. After state forces compelled the surrender of U.S. troops in San Antonio in February, 1861, the flag flew over the Alamo for a week, "representing the state of Texas." The flag was later presented to a Seguin company that became part of the Fourth Texas Infantry.

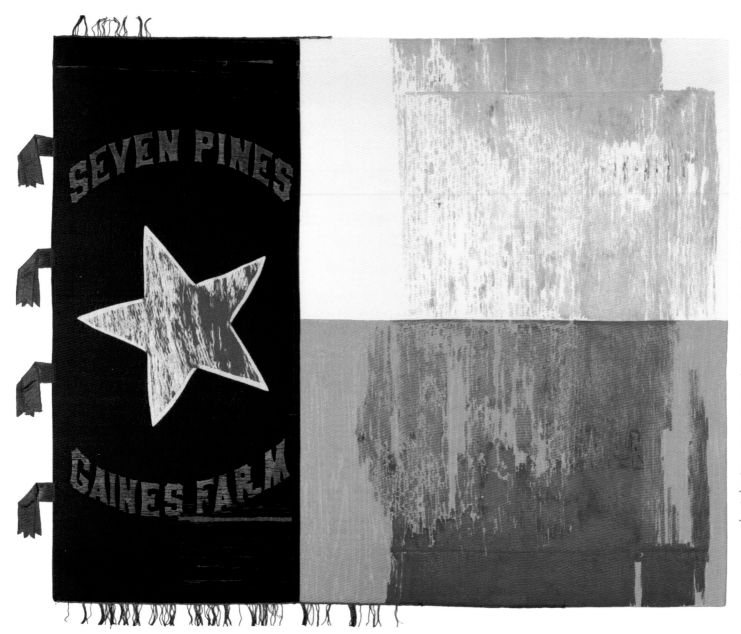

Dimensions: Fly: 81½″ (present day)
Leading edge: 65″
Material: silk
Fringe: gold metallic
Colors: red, white, and blue
Attachment: six pairs of dark blue silk ties
Repository: Texas State Library and
 Archives Commission, Austin, Texas

The family of Louis T. Wigfall presented this Texian Flag variant to the Texas Battalion in July, 1861. Tradition maintains that Mrs. Wigfall made it out of her wedding dress. This is probably not literally true, but it is possible the star was once part of the nuptial gown. Nevertheless, the flag was handmade by a skilled seamstress with dress fabrics and construction methods not typical of most flags issued during the Civil War. The entire flag, with its red, white, and blue sections, was assembled with two layers of silk throughout. Each side of the blue bar displays a white silk tilted lone star. The blue section on the obverse also shows two battle honors applied with white paint. Above the star and in a slight arch is "SEVEN PINES," and below, "GAINES FARM." On the white bar are the remnants of gold and red lettering, which at one time read "ELTHAM'S LANDING." The red bar has the remains of gold and green lettering, including a nearly intact "LL" that once spelled "MALVERN HILL." Sections of a two-and-a-half-inch metallic fringe are still present along the top and bottom edge. Originally the flag measured at least six feet in length.

Dimensions: Fly: 42″
Leading edge: 42″
Material: cotton/wool blend
Border: orange cotton
Attachment: tacked (thirty-seven nail holes
 on fly edge)
Repository: Texas State Library and
 Archives Commission, Austin, Texas

*When the silk supply in Richmond ran short in
early 1862, quartermasters began substituting
other types of available cloth to make Army of
Northern Virginia battle flags. One of these
variants incorporated a wool/cotton blend
commonly used in work clothes. The tradition
of calling these flags "cotton issue" had more
to do with their appearance, which did not
resemble wool bunting and had a tight weave,
than with the composition of the cloth. These
flags, which mounted half-inch orange cotton
borders, displayed twelve cotton stars on a wide
Southern Cross of blue wool.*

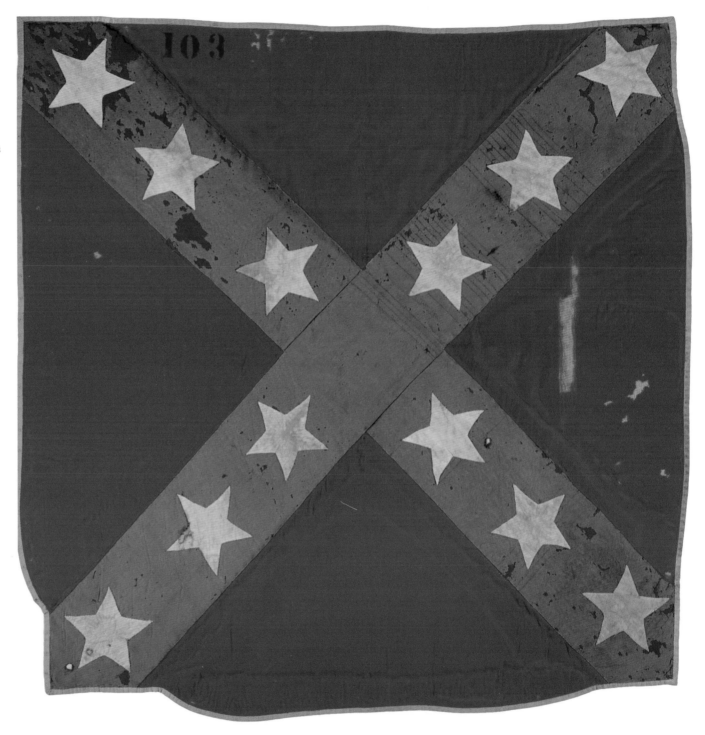

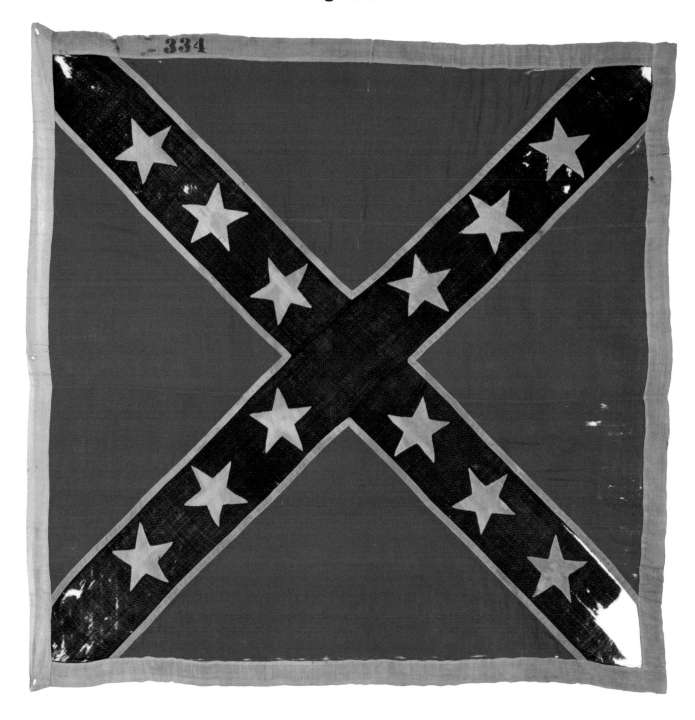

Dimensions: Fly: 67″
Leading edge: 67″
Material: wool bunting
Border: 2½″ white wool bunting
Attachment: three equally spaced eyelets on fly
Repository: Texas State Library and Archives
 Commission, Austin, Texas

*The design of this flag corresponds with the Richmond
Depot's fourth-bunting issue Army of Northern Virginia
battle flags, with the notable exception that it measures
sixty-seven inches on a side rather than the customary
forty-eight. This suggests that this particular regimental
color may have been a special presentation flag. The
central star, which may have been oversized as well, is
missing. The flag was issued late in the war and shows
few signs of wear or battle damage.*

Plate 12. Fourth Texas Infantry / Hood's Texas Brigade / Army of Northern Virginia Battle Flag / Silk-Pattern Variant / "Wigfall Presentation Flag"

Dimensions: Fly: 47″
Hoist: 47″
Material: silk
Colors: red, white, and blue
Border: 2⅜″ yellow silk fringe
Attachment: possibly sleeve
Repository: United Daughters of the
　　Confederacy, Texas Division, Texas
　　Confederate Museum Collection

The family of Louis T. Wigfall, original commander of the Texas Brigade, presented this flag to the Fourth Texas and a similar one to the Fifth Texas. The Fourth Texas color is an impressive handmade variant of the Army of Northern Virginia silk-issue flags of late 1861. It is similar to the official flag but with a large central star representing Texas. The flag is constructed of red silk with a two-and-a-half-inch cotton heading. The white fimbriation is half-inch silk ribbon. The heading appears to have been folded and tacked for attachment. There is a nine-inch star in the center of the cross with twelve four-inch stars evenly divided on each arm. Across the top of the flag was attached a three-inch silk ribbon on which is printed "FREEMAN'S FORD, AUG 22ND, 1862," "MANASSAS PLAINS, AUG 29&30TH 1862" on the obverse, and "ELTHAM'S LANDING, MAY 7, 1862, —N PINES, MAY 31ST & JUNE 1ST, 1862." Contemporary Texans believed, as with the First Texas regimental color, that Mrs. Wigfall incorporated sections of her wedding dress in its construction.

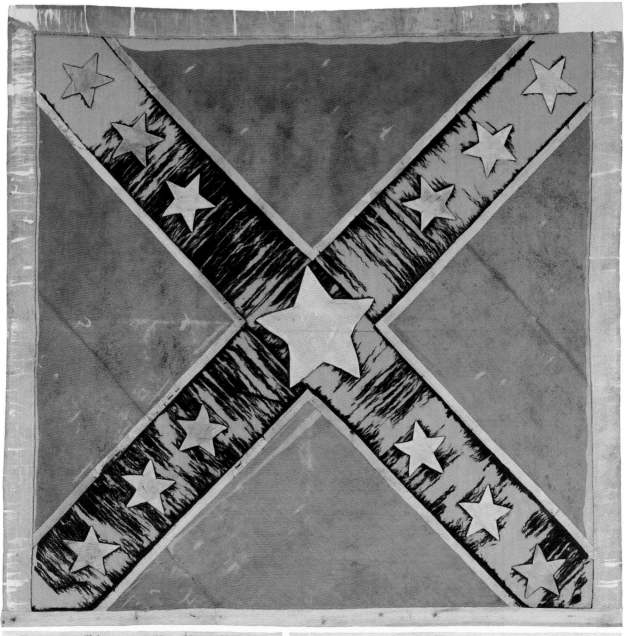

Eltham's Landing, May 7, 1862.
" Pines, May 31st & June 1st, 1862.

Freeman's Ford, August 22nd, 1862.
Manassas Plains, Aug. 29th & 30th, 1862.

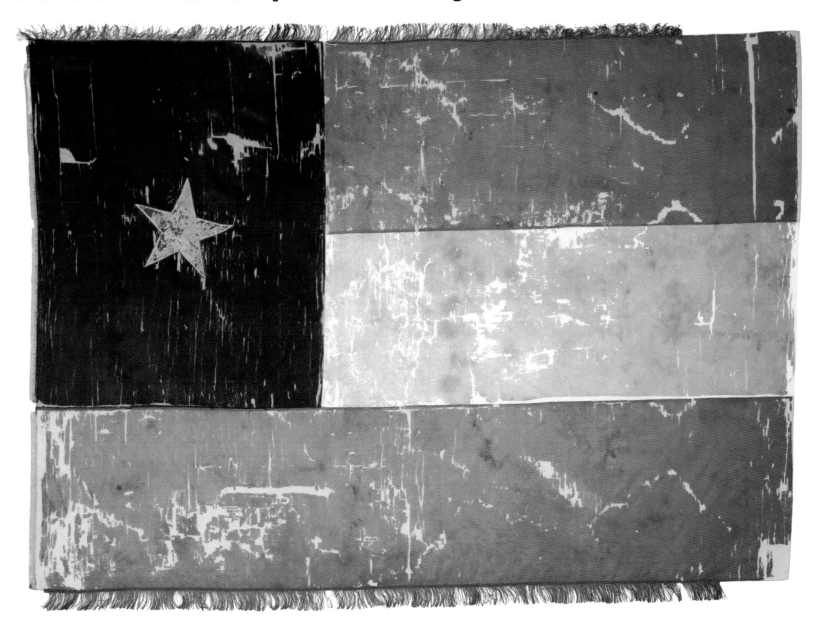

Texans during the Civil War preferred battle flags that displayed a prominent lone star. In the fall of 1861, the officers of the Fifth Texas had this flag made in Richmond. By this time the eastern Confederacy's supply of scarlet silk had been exhausted, and the Texans' new regimental color had to be constructed using fabric dyed to a purplish hue. Today the color has faded somewhat, and the formerly purple sections appear red. The flag was professionally made in two-ply sections. Its design is a variant of the Confederate First National Flag but with a single five-point star appliquéd on each side, replacing the familiar circle of stars of the canton. Flags of this pattern were not unusual; a number of Virginia units carried similar colors during the early months of the war. Nevertheless, the volunteers of the Fifth Texas developed great affection for it and referred to it as their "lone-star flag."

Dimensions: Fly: 84⅓″
 (including 2½″ fringe)
Leading edge: 60½″
Material: silk

Border: metallic wire fringe
Attachment: silk ties
Repository: Texas State Library and
 Archives Commission, Austin, Texas

Plate 14. Fifth Texas Infantry / Hood's Texas Brigade / Army of Northern Virginia Battle Flag Variant / "Mrs. Young's Flag"

Dimensions: Fly: 46″
Leading edge: 38″
Streamer: 57″ x 4″
Material: flag, wool bunting; streamer, blue wool with white embroidered letters
Border: none; streamer, ¼″ white silk
Attachment: ten whipped eyelets on leading edge
Repository: Texas State Library and Archives Commission, Austin, Texas

Flag: In the spring of 1862 Mrs. Maude Young of Houston produced this Army of Northern Virginia battle flag variant that displays a large Texas lone star in the center of the cross. It is without fimbriations and conforms to the "battle flag, Texas pattern" common in the Trans-Mississippi. The flag's ornaments include a rectangular white cotton badge in the upper quadrant with the words "5ᵗʰ Tˣˢ." Three battle honors appear in each quadrant (except that closest to the staff), reading "Elthams Landing," "Gaines Farm," and "Malvern Hill," respectively. The inner quadrant at one time displayed "Seven Pines." The flag was homemade; the cloth and decoration are typical garment fabrics and not the usual materials used for the construction of military-issue flags. Streamer: The obverse of the long blue streamer carries the motto "VIVERE SAT VINCERE" embroidered in white silk chain stitch. The reverse carries the unit designation, "5 REG VOL" in two rows of chain stitch, one white and one red. Between the "REG" and the "VOL" is a white star with a letter of "TEXAS" in red chain stitching in each point.

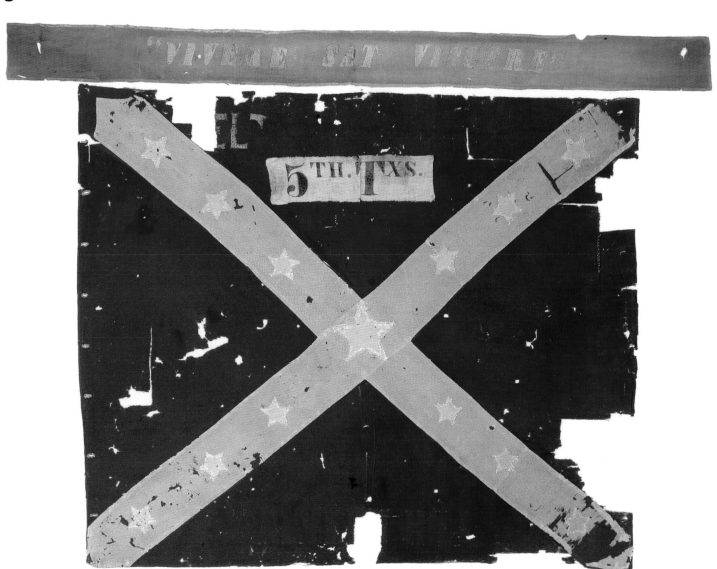

Plate 15. Sixth Texas Infantry and Fifteenth Texas Cavalry (consolidated) / Granbury's Texas Brigade / Hardee Battle Flag

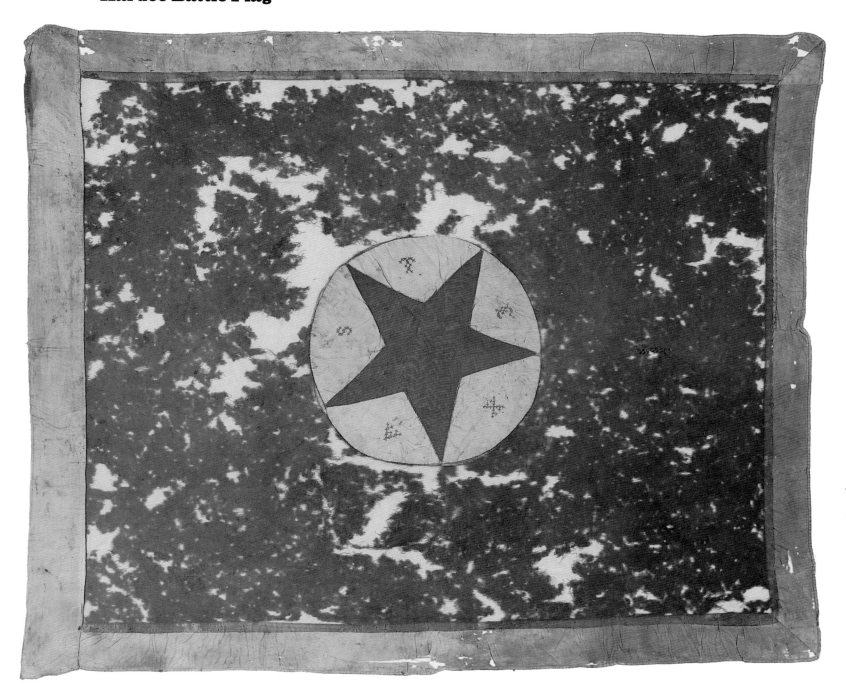

Dimensions: Fly: 38″
Leading edge: 30″
Material: wool with
 cotton disc
Border: 2⅜″ white cotton
Attachment: sleeve
Repository: Texas State
 Library and Archives
 Commission, Austin,
 Texas

This regimental color of the Sixth and Fifteenth Texas is a well-worn Hardee-pattern battle flag. The field was blue wool, now faded to gray. On both obverse and reverse is a white cotton disc, each appliquéd with a five-point lone star. The stars, which originally were red, have "16ᵗʰ & 15ᵗʰ" embroidered across the center. "Texas" is cross-stitched in red on both discs by placing one letter between each point of the star. A single layer of white cotton forms the border and pole sleeve. The flag was hand-assembled in the field out of machine-sewn materials.

Plate 16. Seventeenth Texas Cavalry and Eighteenth Texas Cavalry (consolidated) / Granbury's Texas Brigade / Hardee Battle Flag

Dimensions: Fly: 40″
Leading edge: 33″
Material: cotton/wool flannel
Border: 2″ white cotton
Attachment: sleeve
Repository: Texas State Library and
 Archives Commission, Austin, Texas

The regimental color of the Seventeenth and Eighteenth Texas represents one of the most elaborate Hardee-pattern battle flags still in existence. Its central device is a white oblong "new moon" containing the unit designation "17th & 18th Texas." The letters are outlined in black, then filled in with crosshatching, using black ink at the top and red at the bottom. The battle honors are printed with white pigment and read, "Arkansas Post," "Chickamauga," "Tunnel Hill Tenn," and "Ringgold Gap." Twin arrows of white pigment decorate the field just below the uppermost battle honors.

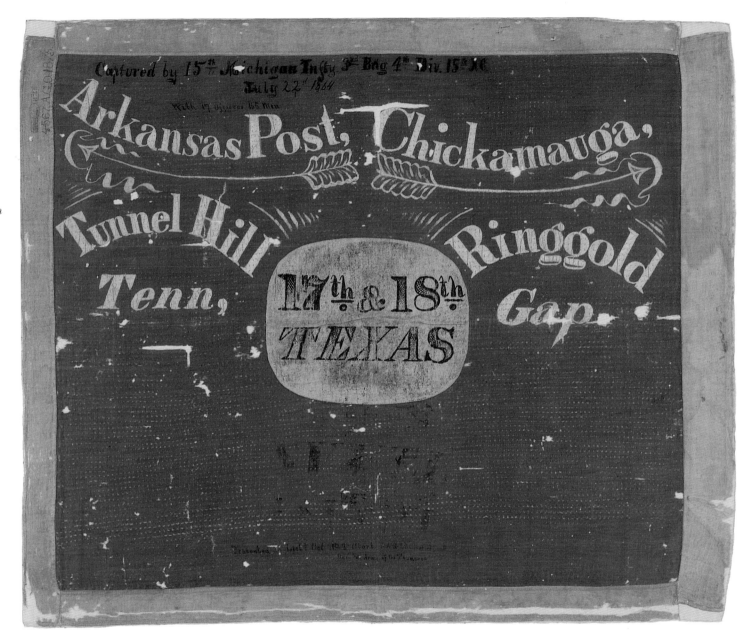

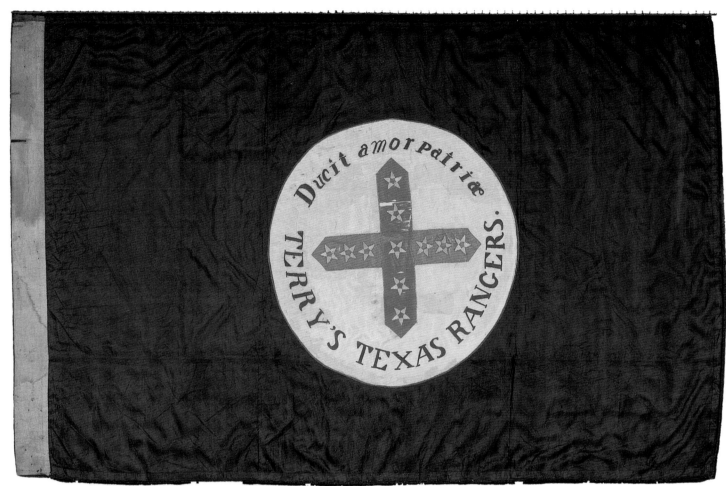

Dimensions: Fly: 46″
Leading edge: 28½″
Material: silk
Border: none
Attachment: 2″ white cotton heading
Repository: United Daughters of the
 Confederacy, Texas Division, Texas
 Confederate Museum Collection

This Terry's Texas Ranger flag is a finely crafted, hand-sewn silk variant of the Hardee pattern. Constructed from a single layer of blue silk, each side is appliquéd with a sixteen-inch beige satin circle. Within each circle is an eleven-inch cross of red silk ribbon decorated with eleven one-and-three-sixteenth-inch stars. The points of the stars are embroidered in gold silk thread. On the obverse, embroidered in blue silk thread above the cross and following the arch of the circle, is the Latin inscription "Ducit amor patriae." Beneath the cross are the words "TERRY'S TEXAS RANGERS" rendered in the same manner. The reverse is identical, except the motto "God defend the right" replaces the Latin inscription.

Plate 18. **Tenth Texas Cavalry** / **Stars and Bars Variant**

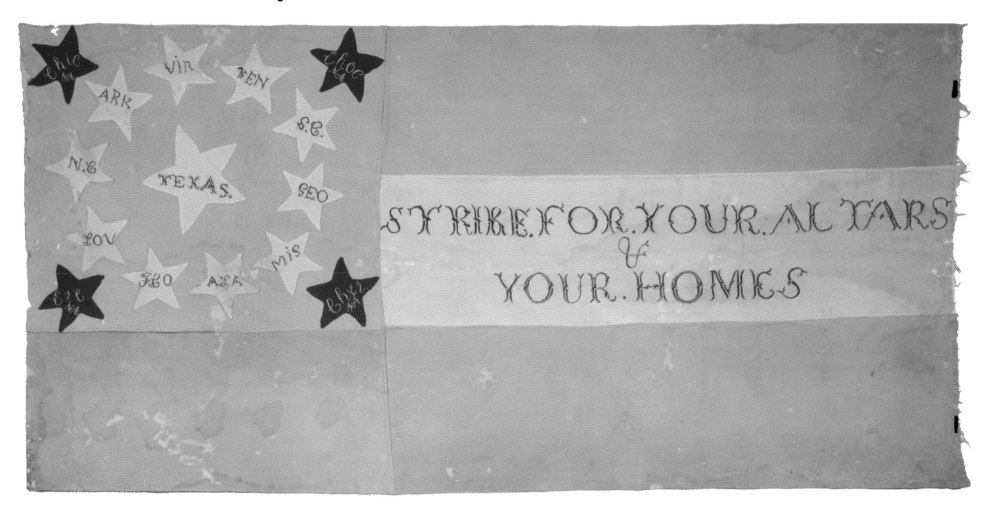

Dimensions: Fly: 81″
Leading edge: 39½″
Material: wool
Border: none
Attachment: blue silk ties
Repository: Texas Military Forces Museum,
 Camp Mabry, Austin, Texas

This homemade variant of the Confederate First National Flag is very similar to the quilts of the day in design and execution. In the canton are a total of fifteen stars. In the center is a crudely cut-out, nine-inch, leaning white lone star with "TEXAS" embroidered in red and white thread. Orbiting the lone star are ten six-inch white stars, each embroidered with the abbreviated name of a Confederate state, likewise in white and red thread. In each corner of the canton is a red star representing four

"civilized" nations of the Indian Territory (modern-day Oklahoma), which were allied by treaty to the Confederacy. In the horizontal white bar of the field, the motto "STRIKE. FOR. YOUR. ALTARS & YOUR. HOMES" is embroidered in elaborate but crude letters of red and white thread. The construction of the flag was probably a community effort. One flag maker first drew the outline of the letters in pencil, but the embroiderer did not follow the design.

Plate 19. Twentieth Texas Infantry / Stars and Bars Variant

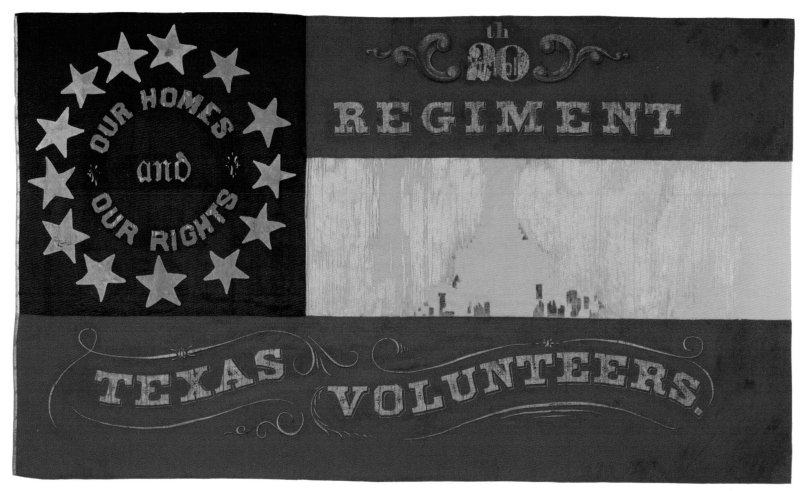

Dimensions: Fly: 92″
Leading edge: 53″
Material: silk
Border: none
Attachment: unknown
Repository: United Daughters of the Confederacy, Texas Division, Texas Confederate Museum Collection

This is the most spectacular surviving flag of Confederate Texas, more a work of art than a battle flag. The flag of the Twentieth Texas is an enormous Confederate First National variant swathed in elaborate decoration. Thirteen white silk stars are appliquéd to both sides of the canton. Within the circling stars the motto "OUR HOMES and OUR RIGHTS" is painted in gold pigment. On the top red bar, in two lines, is painted "20th REGIMENT," in gold outlined in black. There is a scrolled decoration in brown and gold on either side of "20th." The flag was originally made for Nichols's Regiment, a short-term volunteer unit. On the upper red bar of the field, a gold painted "20th" is superimposed over "Nichols." On the lower red bar "Texas Volunteers" is painted in gold undulating letters, which are surrounded in scrollwork. On the white bar, now mostly lost, can be seen the remnants of an unrecognizable painting of what appears to have been some sort of pastoral or patriotic scene. The flag of the Twentieth Texas was unusual among Texas Civil War flags in that, though hand-sewn, it was commercially made. Barely visible on one of the lower scrolled lines is the name of the flag maker, "Rice & Baulard. Ptrs."

Plate 20. **Unidentified Confederate Texas Unit / Taylor Battle Flag**

Dimensions: Fly: 74½″
Leading edge: 72½″
Material: silk
Border: gold metallic tape
Attachment: sleeve
Repository: Texas State Library and
 Archives Commission, Austin, Texas

This is a so-called Taylor battle flag of an unidentified Texas unit. The Taylor-pattern flags reversed the colors of the common Confederate battle flag. This very large flag is an intense dark blue and its red Southern Cross displays large white silk stars. A leaning lone star somewhat bigger than the others adorns the center of the cross. In the upper quadrant is the battle honor "Mansfield," which is embroidered in gold metallic thread. Directly beneath is the date of the battle, "April 8th 1864," rendered in white thread. In the lower quadrant the battle honor "Pleasant Hill" arches over that battle's date, "April 9th 1864," both embroidered with white thread.

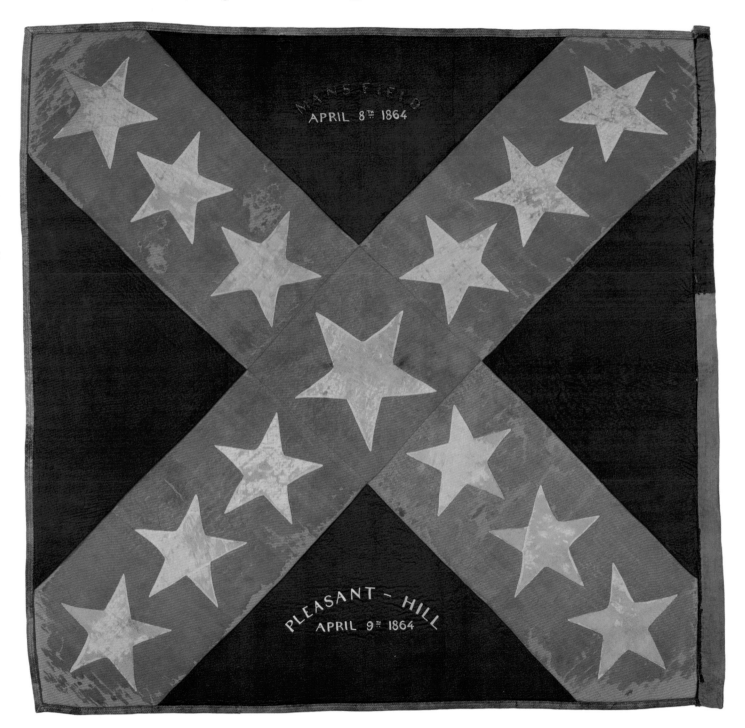

Plate 21. **Third Texas Infantry / Taylor Battle Flag**

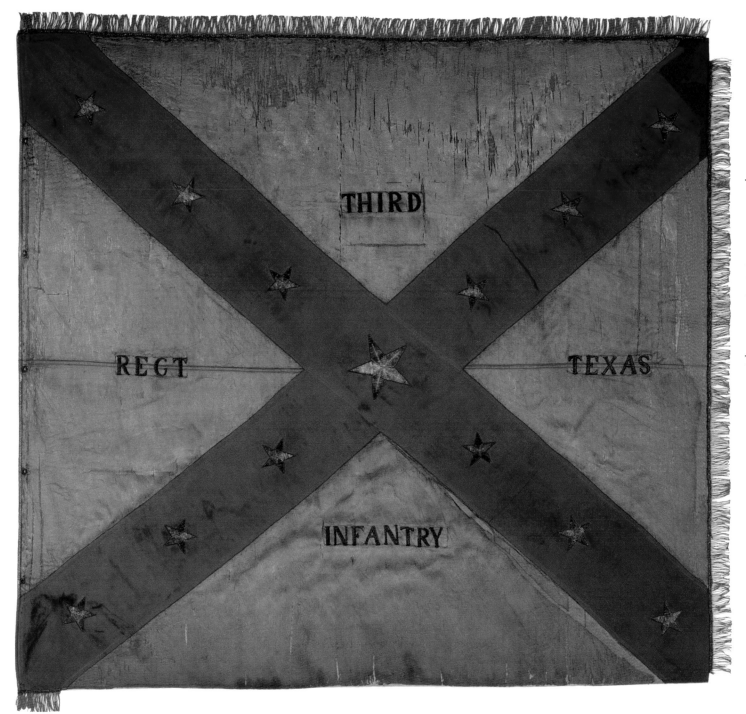

Dimensions: Fly: 50″
Leading edge: 48″
Material: silk
Border: 1½″ gold metallic fringe
Attachment: seven eyelets
Repository: United Daughters of the
 Confederacy, Texas Division, Texas
 Confederate Museum Collection

The regimental color of the Third Texas Infantry is a magnificent Taylor-pattern silk flag with a red cross on a blue field. In the summer of 1863 it was constructed in Cuba, where silk was plentiful, and sent to Texas by a blockade-runner. There are twelve two-and-a-half-inch silver stars in the arms of the cross and a four-and-a-half-inch leaning Texas lone star in the center. These are applied with silver metallic thread embroidered over cardboard. Embroidered on the obverse in silver metallic thread is the unit designation "THIRD REGT TEXAS INFANTRY," one word in each quadrant. The field, which originally was blue, has now faded to nearly white and is edged on three sides with gold metallic fringe.

Dimensions: Fly: 76″ (present day)
Hoist: 57″
Material: cotton
Border: none
Attachment: missing
Repository: Texas State Library and
 Archives Commission, Austin, Texas

This is a unique Confederate flag epitomizing the homespun, makeshift conditions of the Trans-Mississippi Confederacy. The imaginative variation on the Confederate First National pattern is hand-sewn cotton pieced together like a quilt. The canton contains an enormous red lone star within which are painted eleven smaller white stars. One of these is a central lone star that is larger then the ten others, which are arranged two to each point of the larger red star. The white bar of the field is painted with an elaborate but primitively executed badge in the form of a shield. Within the shield, below some scrollwork, is painted "TEXAS." Beneath these letters is a bold yellow star with radiating lines. The upper right quadrant of the canton has been repaired with a piece of the white bar from the fly.

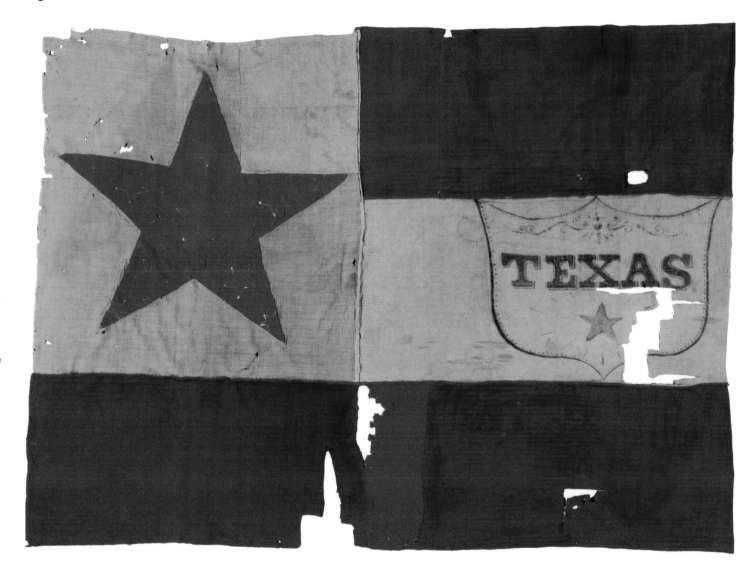

Plate 23. Stiles Family / Stars and Stripes

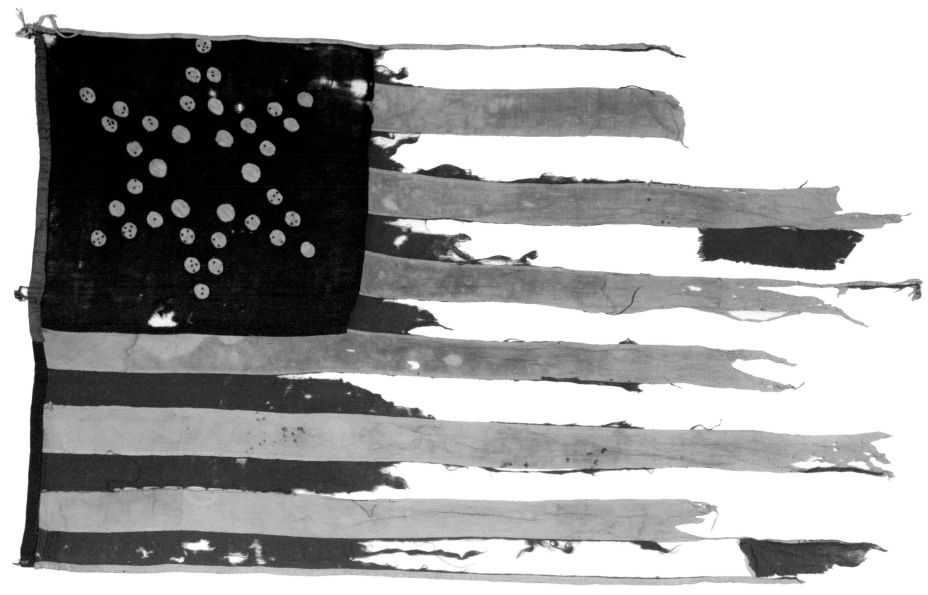

Dimensions: Fly: 75″
Leading edge: 43″
Material: cotton, wool
Border: white cotton strips
Attachment: blue cotton and wool with
 leather tabs at top and bottom

Repository: United Daughters of the
 Confederacy, Texas Division, Texas
 Confederate Museum Collection

*This U.S. Stars and Stripes variant was made
by hand mostly out of materials available in a*
typical 1865 middle-class Austin household.
The red stripes and blue canton are constructed
of wool; the white stripes are cotton. In the
place of stars, the canton of the flag contains
thirty-six decorative cotton circles, each with
five to seven metallic sequins attached. The
"moons"—as the makers referred to the
circles—were arranged to form a six-point star.

Plate 24. Twenty-fourth U.S. Infantry / "Buffalo Soldiers" / National Color

Dimensions: Fly: 80″
Hoist: 76″
Material: silk
Border: knotted gold silk fringe
Attachment: sleeve
Repository: U.S. Army Center of Military
 History, Washington, D.C.

*When the Civil War ended, the federal
government possessed a large number of flags
that were never issued to Union regiments.
The Twenty-fourth Infantry, as a newly
formed regiment, received this surplus Stars
and Stripes, which had been manufactured
no later than 1865. The pattern of stars and
shape of the canton suggests the flag had
been made late in the war by independent
contractors associated with the New York
quartermaster's depot. When the flag was
issued, the unit designation "24th U.S.
Infantry" was painted in gold on the
seventh stripe. During its service with
this black regiment on the Texas frontier,
two more stars were added to the flag's canton
representing the admission of Nevada and
Nebraska to the Union.*

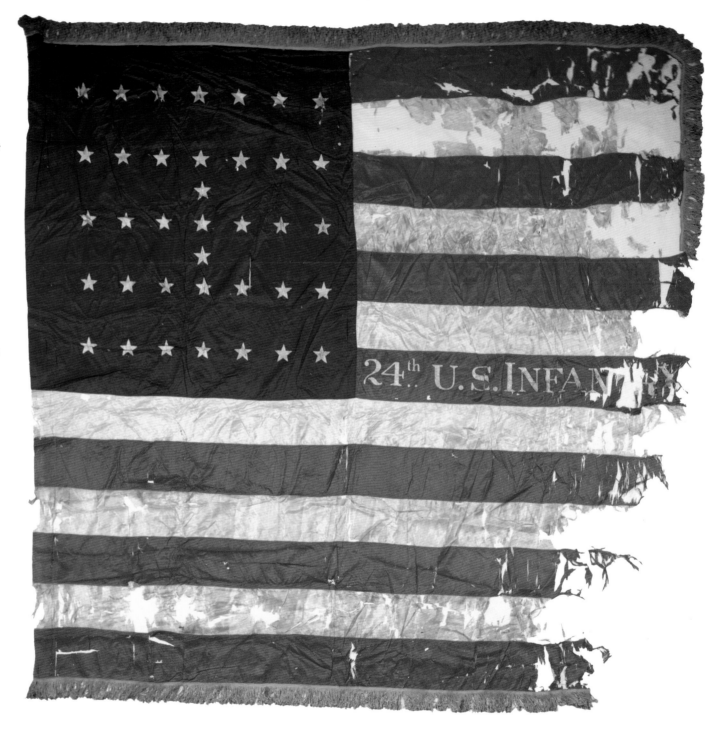

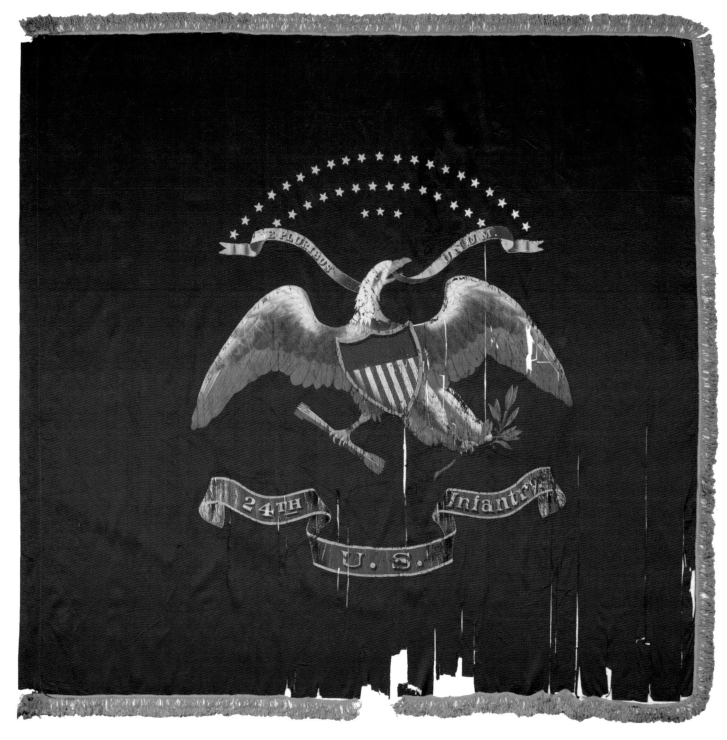

Dimensions: Fly: 76"
Hoist: 76"
Material: silk
Border: knotted gold silk fringe
Attachment: sleeve
Repository: U.S. Army Center of Military
 History, Washington, D.C.

The Twenty-fourth Infantry also received a war-surplus regimental color. It displayed the national arms of the United States, a painted eagle and shield in the center, framed above by a pattern of stars and below a scroll with the unit designation, which had been in use for most of the century. This particular example was probably made late in the war by contractors working for the Cincinnati quartermaster's depot, who provided "generic" regimental flags to the Union's western forces. When it was issued to the Twenty-fourth, the regimental designation was painted on the blank red scroll beneath the eagle.

Plate 26. Tenth U.S. Cavalry / "Buffalo Soldiers" / Guidon, Company G

Dimensions: Fly: 41″
Leading edge: 27″
Material: silk
Border: none
Attachment: sleeve
Repository: Fort Davis National
 Historical Site

American cavalry regiments, along with their regimental colors, carried a second type of flag known as a guidon. These were small banners issued to each troop or company; 1834 regulations specified the guidon as a red-and-white swallow-tail flag measuring three feet, five inches by two feet, three inches. In recognition of the growing importance of the Stars and Stripes to Union morale, in 1862 the federal government replaced the red-and-white guidon with one patterned on the national flag. These continued in use until the war surplus ran out more than twenty years later. In 1885 the army issued new sets of the red-and-white swallow tails. The guidon pictured was that of Company G, Tenth Cavalry, one of the most renowned of the buffalo soldier units. The company carried this small flag during its service at Fort Davis in West Texas. Capt. Mason Marion Maxon, a dedicated white officer, spent his entire army career, from 1869 to 1891, with the Tenth Cavalry. He commanded Company G for his final two years in uniform. When he retired Captain Maxon kept his company's guidon as a token of respect for the men with whom he had served.

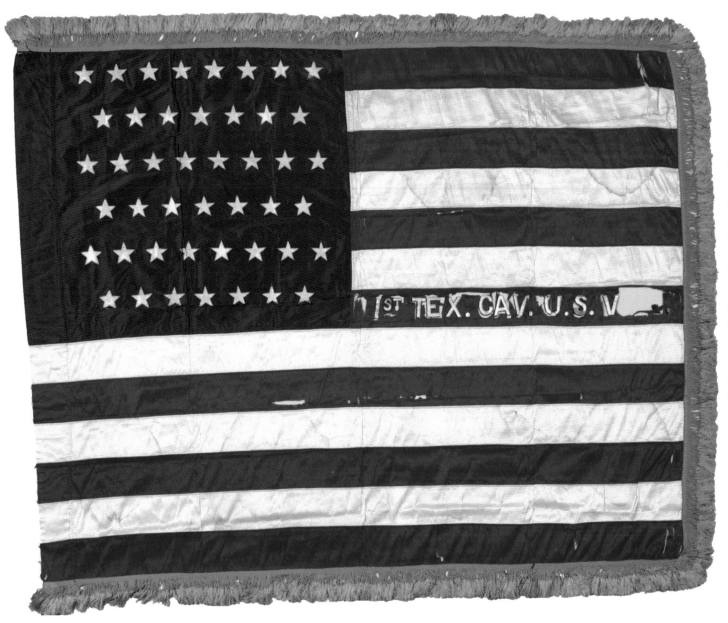

Dimensions: Fly: 51″
Leading edge: 42″
Material: silk
Border: knotted gold silk fringe
Attachment: sleeve
Repository: Texas Military Forces
 Museum, Camp Mabry, Austin, Texas

For most of the nineteenth century, U.S. Cavalry regiments did not fly the Stars and Stripes. Regulations stipulated that there be only one flag, the blue regimental standard. In 1895, however, the War Department ordered mounted troops to fly two flags: one, the regimental color, and the other, the national color, which was the Stars and Stripes. The national color was to be three by four feet in size and carry the unit's name and number, inscribed in gold along the center stripe. The Stars and Stripes of the First Texas Cavalry was typical of those issued to U.S. troops during the Spanish-American War. While the Texas volunteer regiments played little part in defeating the Spanish, the war proved to be the first conflict since the Mexican War where troops raised by the state served under the Stars and Stripes.

Dimensions: Fly: 52″
Leading edge: 41″
Material: silk
Border: knotted gold silk fringe
Attachment: sleeve
Repository: Sagamore Hill National
 Historic Site, Oyster Bay, New York

Beginning early in the nineteenth century, each U.S. Army Cavalry regiment carried a blue silk flag measuring three feet, three inches by two feet, five inches, similar in design to the regimental color the army flew. Under these venerable blue standards, U.S. Cavalry regiments served on the Texas frontier. Regulations in the 1890s ordered that new flags be issued to mounted troops but be made of yellow silk while continuing to display the national arms of the United States. The regimental color of Theodore Roosevelt's Rough Riders, which formed in the spring of 1898, followed this pattern. On a single layer of yellow silk was painted an eagle with outstretched wings and a shield on its chest grasping a sheaf of six arrows in the right talon and two olive branches in the left. The eagle holds a scroll inscribed with the nation's motto in its beak, while below is a scroll upon which is painted the Rough Riders' official unit designation, "1ˢᵗ REGIMENT. U.S. VOLUNTEER CAVALRY."

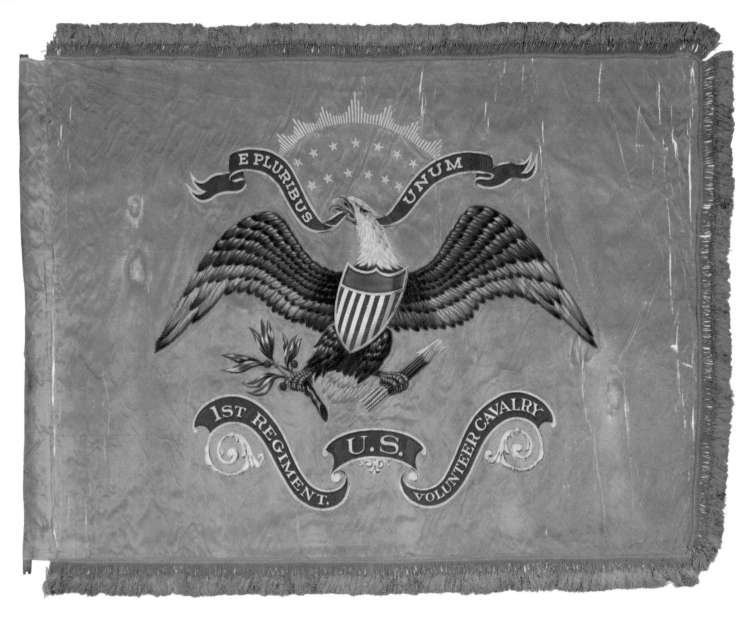

Plate 29. 143rd Infantry, Thirty-sixth Division / American Expeditionary Forces / World War I / Regimental Color

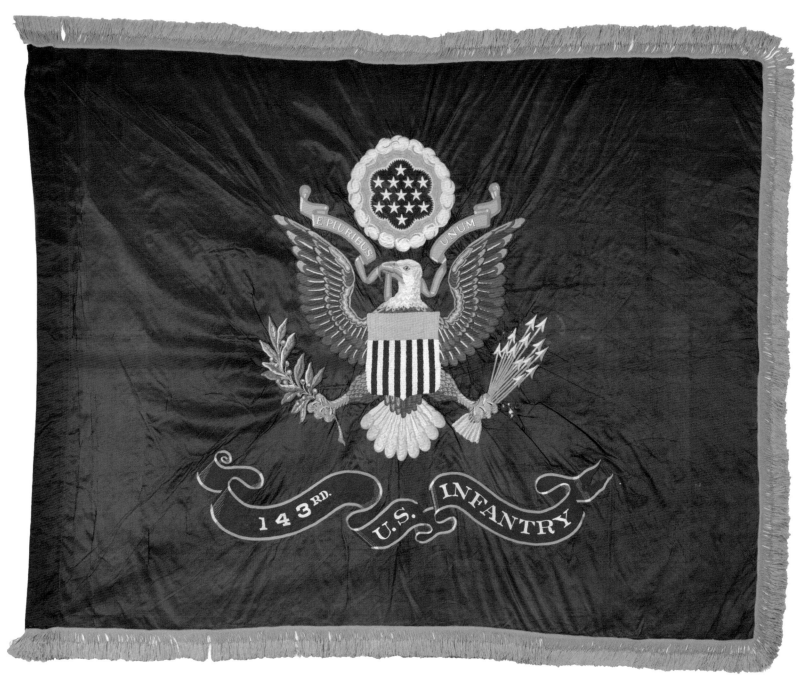

Dimensions: Fly: 68½″
Leading edge: 57½″
Material: silk
Border: knotted gold silk
 fringe
Attachment: sleeve
Repository: Texas Military
 Forces Museum, Camp
 Mabry, Austin, Texas

In 1895, army regulations reduced the size of regimental flags. The regimental color retained the traditional national arms with its eagle and shield, but the standardized design was now rendered not in paint but in handsome and colorful embroidery. The regimental colors of the 143rd Infantry of the Texas National Guard was typical of such flags used by U.S. forces in France.

Dimensions: Fly: 67″
Leading edge: 57″
Material: silk
Border: knotted gold silk fringe
Attachment: sleeve
Repository: Texas Military Forces
 Museum, Camp Mabry, Austin, Texas

Standardization was the goal of the U.S. military during the First World War, and regimental flags reflected this. Gone were the days when Texans asserted their heritage by adding a lone star to their battle flags. The 360th Infantry of the Ninetieth Division, known as the "Texas Regiment," was issued a flag that was essentially a clone of every other U.S. infantry regimental color.

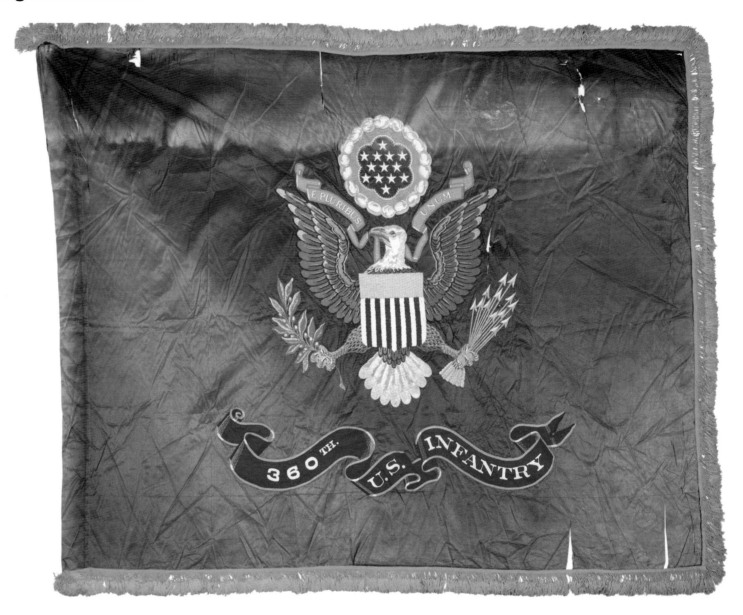

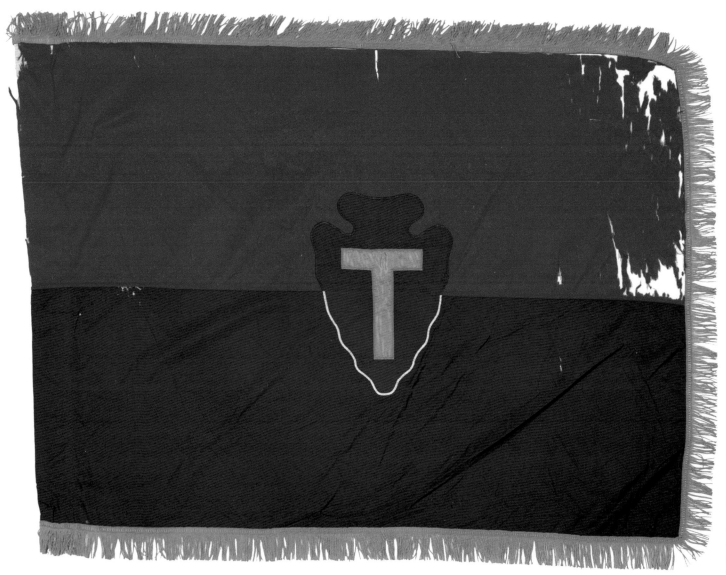

Dimensions: Fly: 51″
Leading edge: 40″
Material: silk
Border: twisted gold silk fringe
Attachment: sleeve
Repository: Texas Military Forces Museum,
 Camp Mabry, Austin, Texas

This is a headquarters flag of the Thirty-sixth Division. The field of this silk banner is divided into a red upper half and blue lower half. The famous T-patch, which consists of a blue arrowhead overlaid with a cream-colored "T," adorns the center. After World War I its Oklahoma National Guard troops were reassigned, and the Thirty-sixth Division was reorganized as an all-Texas national guard division. In November, 1940, the division was called to active duty at Camp Bowie, Brownwood, Texas, and shipped overseas in 1943. The Thirty-sixth served briefly in North Africa, and in September at Salerno, Italy, became the first U.S. combat division to land on the European continent. For the next year the division, as part of the U.S. Fifth Army, fought its way up the Italian Peninsula. The Thirty-sixth, ordered to force a crossing at the Rapido River against well-entrenched German forces, lost the better part of two of its three infantry regiments. In May, 1944, the division landed at Anzio and spearheaded the breakout that led to the capture of Rome. Late that summer, the Thirty-sixth pulled out of Italy and became part of the Allied invasion of southern France. The T-patchers were pounding the southern sections of the Siegfried line when the war ended. In all, the hard-fighting division had endured more than four hundred days of combat and lost upwards of 27,000 men. In the course of the carnage of the Italian campaign, the Thirty-sixth Division ceased being a Texas unit. Extremely heavy casualties, upwards of 200 to 300 percent in some units, coupled with the U.S. Army practice of providing replacements from a general pool of soldiers from all over the United States, transformed the Thirty-sixth Division from a force of Texans into an "all-American" command.

Plate 32. USS *Texas* / Battle Ensign / World War II

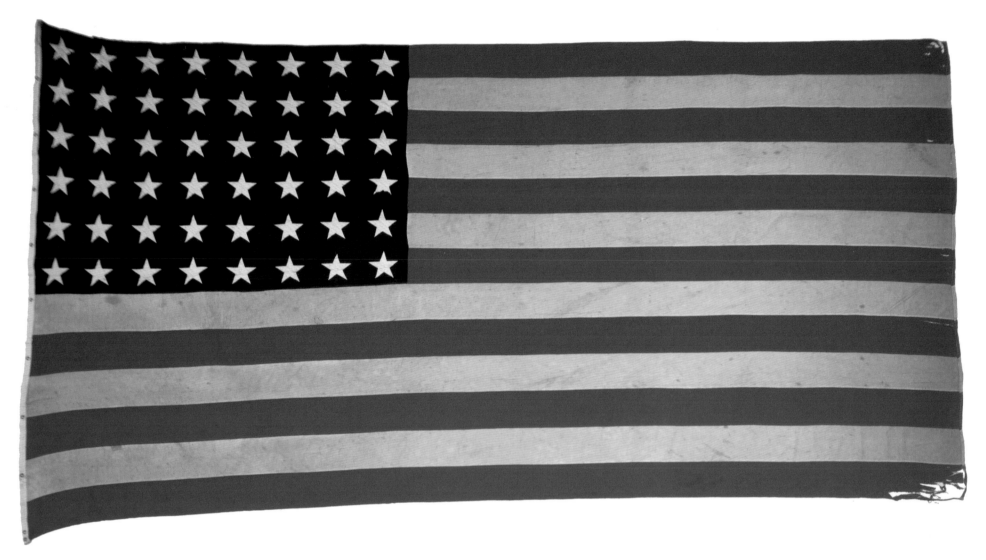

Dimensions: Fly: 194″
Leading edge: 110″
Material: cotton
Border: none
Attachment: eleven ¾″ grommets
Repository: Battleship Texas Foundation

This large Stars and Stripes naval ensign with its forty-eight stars was a World War II battle flag of the USS Texas. It flew from the

masthead during the D-Day invasion, where the Texas served as flagship of the bombardment group in support of allied landings on Omaha Beach. The battleship also displayed this flag on June 25, 1944, when the Texas engaged German shore batteries off Cherbourg. The Texas suffered two direct hits, one in the conning tower that killed the helmsman, and another in the main hull below the officers' ward room. On the obverse of the

canton, the first two stars on the top row and the first star on the second record the flag's service with hand-scribed battle honors in blue ink. The first star reads, "This ensign flew from USS Texas in France for Second Front June 6, 1944 to June 14, 1944 Normandy Beach." The second star reads, "Cherbourg France 2 enemy hits just below bridge." The third star reads, "Southern France August 15 1944 St Tropez, France." After the war, the USS Texas became

the nation's first battleship memorial and a Texas icon in its own right. Today, historic Texas flags have become unofficial battle ensigns for some U.S. Navy ships. The missile cruiser USS San Jacinto often flies a Lone Star and Stripes flag just as its Texas navy namesake did in 1839. Other ships named for Texas cities display the Lone Star Flag on special occasions.

Notes

Preface

1. *New Larousse Encyclopedia of Mythology*, v.

2. Whitney Smith, *Flags through the Ages and Across the World*, 30.

3. Huntsville *Democrat*, February 6, 1861, quoted in G. Ward Hubbs, "Lone Star Flags and Nameless Rags," 271.

4. Mark E. Nackerman, *Nation within a Nation: The Rise and Fall of Texas Nationalism*, n. 150.

5. *Texas Almanac 1857*, 176.

6. For more on this question, see Stephen L Hardin, *Texian Iliad: A Military History of the Texas Revolution*, n. 252

7. Definitions compiled from Howard Michael Madaus and Robert D. Needham, *The Battle Flags of the Confederate Army of Tennessee*, 17–19; Richard A. Sauers, *Advance the Colors: Pennsylvania Civil War Battle Flags*, 1: xv–xvi; Smith, *Flags through the Ages*, 13–31; Alfred Znamierowski, *The World Encyclopedia of Flags*, 24–49.

8. Gordon Campbell, *The Book of Flags*, 3.

Chapter 1. Tricolor y Tejas

1. For the most recent scholarship concerning Austin's intentions and feelings toward Mexico see Gregg Cantrell, *Stephen F. Austin: Empresario of Texas*.

2. See Grady McWhiney, *Cracker Culture: Celtic Ways in the Old South* and Grady McWhiney and Perry Jamieson, *Attack and Die: Civil War Military Tactics and the Southern Heritage* for an explanation of the influence of Celtic culture in the southern United States.

3. Paul D. Lack, *The Texas Revolutionary Experience: A Political and Social History, 1835–1836*, 137.

4. The viceregal banner of Mexico that royalists flew was white with a red Burgundy cross. This was the flag of the Spanish Bourbon monarchs and was common to Spain's Latin American colonies. Whitney Smith, *Flags through the Ages and Across the World*, 126.

5. Jesús Romero Flores, *Banderas Históricas Mexicanas*, 22.

6. Jesús de León Toral, et al., *El Ejército Mexicano*, 560; Smith, *Flags through the Ages*, 74.

7. *Banderas: Catálogo de la Colección de Banderas*, 37.

8. Toral et al., *El Ejército Mexicano*, 560. *Anáhuac* is the Indian name for the Valley of Mexico.

9. Michael C. Meyer and William L. Sherman, *The Course of Mexican History*, 148.

10. Kurt Ross, *Codex Mendoza*, 18–19.

11. Manuel Carrera Stampa, *El Escudo Nacional*, 94–111.

12. Meyer and Sherman, *The Course of Mexican History*, 287–88, 292

13. Carman G. Basurto, *Mexico y Son Simbols*, 61.

14. Ibid., 62.

15. Toral, et al., *El Ejército Mexicano*, 562.

16. *Banderas*, 44.

17. Toral et al., *El Ejército Mexicano*, 562–63.

18. Flores, *Banderas Históricas Mexicanas*, 13–14.

19. Virginia Doggett, "Constitution of 1824," in *The United States and Mexico at War: Nineteenth-Century Expansionism and Conflict*, ed. Donald S. Frazier, 108.

20. During most of the nineteenth century, the eagle on the Mexican tricolor is depicted with widespread wings. The eagle in profile, sometimes called the "Aztec eagle," that decorates Mexico's flag today was instituted in 1916. Smith, *Flags through the Ages*, 150.

21. Laws Passed By the Legislature of the State of Coahuila and Texas, Militia Law, 1, 4. One infantry battalion was to be from San Felipe and the other from Nacogdoches. One cavalry unit is referred to as a squadron and was to be from Béxar, while the other, from Goliad, is called a "separate company." Before the revolution various Texas militia units carried on their rolls about six hundred men. These were employed in such mundane duties as catching horse thieves and guarding prisoners. When the war with Santa Anna began, insurrectionist colonists bypassed the Mexican state militia system, which was only casually organized, and instead appealed directly to the people for volunteers. Some advocated the creation of a new militia system. Allan Robert Purcell, "The History of the Texas Militia, 1835–1903," 71.

22. Herman Ehrenberg, *The Fight for Freedom in Texas in the Year 1836*, 90.

23. Eugene C. Barker, ed. *The Austin Papers, Volume III*, 214.

24. Ehrenburg, *Fight for Freedom*, 97.

25. Ibid., 109.

26. Charles A. Spain, "The Flags and Seals of Texas," 231–32.

27. Quoted in James Atkins Shackford, *David Crockett: The Man and the Legend*, 281.

28. Amelia Williams, "A Critical Study of the Siege of the Alamo," n. 27.

29. Walter Lord, *A Time to Stand*, 210–11. Even modern publications continue to propagate the myth of the "1824z" flag. See front cover of Ron Jackson, *Alamo Legacy: Alamo Descendents Remember the Alamo*.

30. Thomas Lindley, "Alamo Strays," 463.

31. Charles M. Yates, "The Alamo Flag."

32. Juan Nepomuceno Almonte, "The Private Journal of Juan Nepomuceno Almonte, February 1–April 16, 1836," 16–17.

33. Miguel A. Sanchez Lamego, *The Siege and Taking of the Alamo*, 45.

34. Tim J. Todish and Terry S. Todish, *Alamo Sourcebook 1836: A Comprehensive Guide to the Alamo and the Texas Revolution*, 184.

35. Lord, *A Time to Stand*, 211. Juan Seguín was a prominent resident of San Antonio. A liberal who opposed the policies of Santa Anna, he joined the Texian forces and raised Tejano troops for the struggle. He would have died at the Alamo with nine of his Tejano followers had not Travis ordered him to ride to Gonzales for help.

36. José Enrique De La Peña, *With Santa Anna in Texas: A Personal Narrative of the Revolution*, 8.

37. T. R. Fehrenbach, *Fire and Blood: A Bold and Definitive Modern Chronicle of Mexico*, 365–66.

38. William A. DePalo, *The Mexican National Army, 1822–1852*, 41. In 1833 the statutory strength of regular and reserve troops was approximately sixty thousand, but only some fifteen thousand were actually under arms (DePalo, *Mexican National Army*, 41).

39. Richard G. Santos, *Santa Anna's Campaign Against Texas, 1835–1836*, 2.

40. Antonio López de Santa Anna, *Manifesto*, in *The Mexican Side of the Texas Revolution*, trans. Carlos E. Casteñeda, 50–51.

41. Ibid., 11.

42. Hardin, *Texian Iliad*, 99.

43. DePalo, *Mexican National Army*, 30.

44. Mexican troops were armed with weapons similar to those used in the Napoleonic Wars. In the 1830s Great Britain was Mexico's most important trading partner and was able to unload surplus arms on the Mexicans. The center and grenadier companies carried the British East India Pattern Brown Bess musket, and many *cazadores* were armed with the Baker .61 rifle. Hardin, *Texian Iliad*, 99.

45. H. C. B. Rogers, *Napoleon's Army*, 65–68.

46. Another flag of Santa Anna's Army of Operations that still exists is that of the *Battalón de las Tres Villas*. It displays an eagle with spread wings, and is without snake, cactus, and wreaths. *Banderas*, 50.

47. Santos, *Campaign in Texas*, 1–2.

48. Ibid., 14–17.

49. Ibid., 62.

50. Almonte, "Private Journal," 17–18.

51. The *Zapadores*, or sappers, composed a small battalion and were the very cream of Santa Anna's army. Hardin, *Texian Iliad*, 101.

52. Santos, *Campaign in Texas*, 69–71; Almonte, "Private Journal," 20; Peña, *With Santa Anna in Texas*, 37.

53. Peña, *With Santa Anna in Texas*, 47–48; D. Ramon Martinez Caro, *A True Account of the First Texas Campaign and the Events Subsequent to the Battle of San Jacinto*, 105.

54. Almonte, "Private Journal," 23.

55. Caro, *A True Account*, 105.

56. Peña, *With Santa Anna in Texas*, 52. Joseph Hefter, a distinguished authority on the Mexican army, believes that the battalion battle flags were not carried by the attacking columns. Jerry J. Gaddy and J. Hefter, *Texans in Revolt: Contemporary Newspaper Account of the Texas Revolution*, 58.

57. "Three hundred were left dead on the field and more than a hundred of the wounded died afterward as a result of the lack of proper medical attention." Caro, *A True Account*, 105.

58. Almonte, "Private Journal," 24; Peña, *With Santa Anna in Texas*, 65.

59. Almonte, "Private Journal," 31.

60. Pedro Delgado and Sam Houston, *The Battle of San Jacinto: Viewed From Both An American and Mexican Standpoint*, 35.

61. Ibid., 34.

62. Ibid., 35. In addition to the Guerrero Battalion, Cos's reinforcements included the remaining companies of the Toluca Activo and "the remnants" of the Aldama Permenente, as well as two companies of the Guadalajara Activo. Peña, *With Santa Anna in Texas*, 113.

63. Santa Anna, *Manifesto*, 76.

64. Delgado and Houston, *The Battle of San Jacinto*, 35.

65. Ibid.

66. Santa Anna, *Manifesto*, 77–78; Delgado and Houston, *The Battle of San Jacinto*, 35.

67. Delgado and Houston, *The Battle of San Jacinto*, 36.

68. Santa Anna, *Manifesto*, 78; "Sam Houston's Report of the Battle of San Jacinto, April 25, 1836" in John J. Linn, *Reminiscences of Fifty Years in Texas*, 207.

69. Delgado and Houston, *Battle of San Jacinto*, 36.

70. According to one account, Colonel Almonte collected a large body of men from the Guerrero Battalion and surrendered them in a group. Frank X. Tolbert, *The Day of San Jacinto*, 160. Whatever Almonte's role might have been, given the distribution of Santa Anna's battalions, it makes sense that the Guerreros being to the rear of the camp and away from the breastworks would have had the greatest chance for survival. Colonel Peña lists the Mexican units lost at San Jacinto as the Toluca Battalion, the Matamoros Battalion, the Guerrero Battalion, the Aldama Battalion, two companies of the Guadalajara Battalion, and one rifle company of the Mexico City Battalion. Peña, *With Santa Anna in Texas*, 123.

71. J. W. Gilmore to Joseph Gilmore, June 23, 1836, Sam H. Acheson Collection, Dallas Historical Society, Dallas, Texas.

72. "Houston's Report," 207–208.

73. Ibid., 207.

74. Guerrero Battalion Flag, Analysis Report, Textile Preservation Associates, Sharpsburg, Maryland, in author's possession.

75. Mexican Flag File, Dallas Historical Society, Dallas, Texas.

76. *New Orleans Picayune*, March 3, 1846.

77. Michael R. Green to Chris LaPlante, July 26, 1991, Flag Accession File, Texas State Library and Archives Commission, Austin, Texas.

Chapter 2. Lone Stars and Stripes

1. Henry David Pope, *A Lady and A Lone Star Flag: The Story of Joanna Troutman*, 10.

2. "And a Star is Born," Ross W. Anderson Papers, Daughters of the Republic of Texas Library, The Alamo, San Antonio, Texas.

3. Michel Pastoureau, *Heraldry: An Introduction to a Noble Tradition*, 53.

4. Smith, *Flags through the Ages*, 194.

5. Ibid., 190.

6. Two recent articles document the use of the U.S. flag as a medium for political action and social protest. See Carita M. Culmer, "Trial by Jury in the Court of Public opinion: Phoenix Reacts to the Flag Art Exhibition Phoenix Art Museum, March 16–June 16, 1996," 5–15; and Rosalind Urbach Moss, "'Yes, There's a Reason I Salute the Flag': Flag use and the Civil Rights Movement," 16–37.

7. Milo Quaife, Melvin J. Weig, and Roy E. Appleman, *The History of the United States Flag: From the Revolution to the Present, Including a Guide to Its Use and Display*, 29. Some early U.S. flags had stars with six, seven, and even eight points. For instance, the famous Bennington Stars and Stripes had a blue canton upon which seven-pointed stars arched over the numeral "76." Milo Milton Quaife, *The Flag of the United States*, 75.

8. Smith, *Flags through the Ages*, 194–96. Historians of the U.S. flag cannot say with certainty who suggested the addition of stars or what inspired this symbol. As with the Texas Lone Star, some suggest celestial origin. One story has the Star of Bethlehem as the source, while another asserts that Harvard astronomy professor John Winthrop recommended the use of stars on the national flag. Quaife, *History of the United States Flag*, 36; Smith, *Flags through the Ages*, 193.

9. Thomas P. Abernathy, *The South in the New Nation 1789–1819*, 351.

10. "The Lone Star flag was unfurled within the present limits of Louisiana, as the standard of those 'gallant filibusters' who, in 1810, rescued the Florida parishes in this state from the Spanish dominion. Regardless of neutrality laws . . . the citizens of Louisiana and Mississippi cooperated together for the purpose of driving the Spanish out of the territory. . . . On these grounds, a gallant group of Americans, mostly residing outside the Spanish territory, attacked the fort at Baton Rouge, drove out the Spaniards and raised the Lone Star flag in place of the showy banner of old Spain." *Texas Almanac 1861*, 75.

11. Hubbs "Lone Star Flags and Nameless Rags," 273–75.

12. James Long had fled to Natchez but was unable to overcome the temptation of other annexation schemes. He returned to Texas in 1820, where, near Galveston, he hoped to raise another force. In October, 1821, Mexican troops captured Long and sent him as a prisoner to Mexico City, where a guard murdered him six months later. His long-suffering wife, Jane Long, accompanied him on the second trip to Texas and has been memorialized as the "Mother of Texas." Harris Gaylord Warren, "Long Expedition," in Ron Tyler, ed., *The New Handbook of Texas* 4: 278, 274 (hereafter cited as *NHOT*).

13. Mamie Wynn Cox, *The Romantic Flags of Texas*, 138.

14. Eli Harris to M. B. Lamar, January 18, 1841, in Charles Adams Glick Jr., ed., *The Papers of Mirabeau Buonaparte Lamar* 3: 483. "The flag you now use" probably refers to the Lone Star and Stripes that served as the de facto flag of the Revolution and the early Republic of Texas, which was almost identical to Long's flag.

15. Hardin, *Texian Iliad*, 12.

16. James T. DeShields, comp., *Tall Men and Long Rifles: Set Down and Written Out by James T. DeShields as Told to Him by Creed Taylor*, 28.

17. Thomas Ricks Lindley, "Gonzales 'Come and Take It' Cannon," *NHOT*, 3: 230.

18. Noah Smithwick, *Evolution of a State; or, Recollections of Old Texas Days*, 72. According to Texas vexillologist Charles Spain, Cynthia Burns, daughter of Evalina DeWitt, made the Gonzales flag. DeWitt's husband, Charles Mason, who took part in the skirmish, does not mention the lone star in his description of it. Charles Spain, "Flags of the Texas Revolution," *NHOT* 6: 1022.

19. DeShields, comp., *Tall Men and Long Rifles*, 31–32.

20. Ibid., 47–48.

21. James S. McGahey, letter printed in undated *Galveston News* (written sometime between 1870 and 1885), quoted in Adele B. Looscan, "Harris County, 1822–1845," 272. Some historians assert that Scott himself, not McGahey, suggested the flag design. Spain, "Flags of the Texas Revolution," *NHOT* 2: 1022.

22. McGahey letter, 272

23. Ibid.

24. Mrs. M. Looscan, "The History and Evolution of the Texas Flag," in Dudley Wooten, ed. *A Comprehensive History of Texas 1685 to 1897* 1: 694.

25. Hobart Huson, *Captain Phillip Dimmitt's Commandancy of Goliad October 15, 1835–January 17, 1836*, 218.

26. A. B. Dodson to Mrs. M. Looscan, July 22, 1894, Sarah Brady Dodson Papers, Center for American History, University of Texas at Austin.

27. A. Looscan, "Harris County," 273–74.

28. A. B. Dodson to M. Looscan, July 17, 1896, Sarah Brady Dodson Papers, Center for American History, University of Texas at Austin.

29. "The Dodson Flag," 4.

30. *Southern Historical Society Papers* 9: 221. In 1855 the state of Georgia asked Texas to reimburse it for the arms issued to the Georgia battalion, maintaining that these had been a loan. Two years later, the Georgia legislature agreed to waive the debt if Texas would erect a monument to the fallen

Georgians. No monument was built, however, until the town of Albany, in Shackleford County, Texas, built one in 1976. Craig H. Roell, "The Georgia Battalion," *NHOT* 3: 136. Dr. Jack Shackleford, for whom the county is named, commanded the Alabama Red Rovers, a unit in Fannin's forces.

31. Hugh McLeod to Joanna Troutman, November 23, 1835, in John H. Jenkins, ed. *Papers of the Texas Revolution* 2: 494. The Latin translates as, "Where liberty dwells, there is my country." Pope, *A Lady and A Lone Star Flag*, 11.

32. J. C. Kidd, *Texas, Her Flags*, 5.

33. M. Looscan, "History and Evolution of the Texas Flag," Wooten, 1: 694–95. January 8 is the anniversary of the battle of New Orleans and was widely celebrated in the southern states.

34. *Southern Historical Society Papers* 9: 223.

35. Looscan, "History and Evolution of the Texas Flag," Wooten, 1: 694–95.

36. Ehrenberg, *The Fight for Freedom*, 89.

37. Jenkins, ed., *Papers of the Texas Revolution* 3: 268

38. Huson, *Captain Phillip Dimmitt's Commandancy of Goliad*, 218.

39. Many Texian settlers were of Celtic origin, and legends of the Bloody Hand of Ulster and other tales must have been well known to them. See Huson, *Captain Phillip Dimmitt's Commandancy of Goliad*, 254–56. The "Arm of God" smiting the wicked has been an element of flags used in Poland, England, Hungary, Algeria, Bosnia, Sweden, and the Netherlands. Smith, *Flags through the Ages*, 73. The Bedford flag of the American Revolution displays an armored arm with sword, and Massachusetts militia companies carried flags with a similar design, which was part of that state's coat of arms. Philip Katcher, Rick Scollins, and Gerry Embleton, *Flags of the American Civil War 3: State & Volunteer*, 6, 7.

40. Santa Anna, *Manifesto*, 17.

41. Kathryn Stoner O'Connor, *The Presidio La Bahía del Espíritu Santo de Zuniga*, 114.

42. Eduard Harkort, "Journal of Col. Eduard Harkort, Captain of Engineers, Texas Army, February 8–July 17, 1836," 355.

43. Delgado and Houston, *Battle of San Jacinto*, 35.

44. J. Hefter, "Flags of the Alamo," in Miguel A. Sanchez Lamego, *The Siege and Taking of the Alamo*, 48.

45. Bill of lading, Tourne & Beckworth Company, February 18, 1834, Alexander Dienst Papers, The Center for American History, University of Texas at Austin.

46. S. W. Cushing, *Wild Oats Sowings*, excerpted in S. W. Cushing, *Adventures in the Texas Navy and at the Battle of San Jacinto*, 37. It seems likely that Brown added the blood-arm symbol after seeing Dimmitt's flag in Goliad in late December, 1835. It is impossible to say when the word "Independence" was added.

47. Ibid.

48. M. Looscan, "The History and Evolution of the Texas Flag," Wooten, 1: 694. Traditionally Texas flag chroniclers have assumed it was Brown's Goliad flag that flew in Velasco on January 8, but Brown was in New Orleans on that day, and his subsequent actions aboard ship suggest he had the flag with him. See Kidd, *Texas: Her Flags*, 5; M. Looscan, "History and Evolution of the Texas Flags," Wooten, 1: 694–95.

49. *Cincinnati Daily Whig and Commercial Intelligencer*, March 24, 1836.

50. Gaddy and Hefter, *Texans in Revolt*, 59.

51. Travis to the Public, February 24, 1836, in Jenkins, ed., *The Papers of the Texas Revolution* 4: 423 .

52. Gaddy and Hefter, *Texans in Revolt*, 59.

53. Shackford, *David Crockett*, 273–81.

54. Ibid.

55. Contrast "The Mexicans [were] about 1,600 strong," *Davy Crockett's Own Story: As Written by Himself*, 363, with "For the attack on the Alamo, Santa Anna committed five battalions, about 4,000 men," T. R. Fehrenbach, *Lone Star: A History of Texas and the Texans*, 212.

56. *Davy Crockett's Own Story*, 364.

57. William Barret Travis himself may have brought the flag from San Felipe. Records show that he had purchased a flag there for five dollars just before departing to assume command of the Alamo in late January. William C. Davis, *Three Roads to the Alamo: The Lives and Fortunes of David Crockett, James Bowie, and William Barret Travis*, 510.

58. *The General Convention at Washington, March 1–17 1836*, 890.

59. F. W. Johnson to John Forbes, December 8, 1874, Texas Veterans Association Papers, Center for American History, University of Texas at Austin.

60. Winfield Scott Downs, ed., *Encyclopedia of American Biography*, 411; *Dallas Morning News*, April 21, 1938. Moore's descendants donated a flag to an Ardmore, Oklahoma, museum that they claimed was the one carried at San Jacinto. A recent photograph shows a handsome U.S. Stars and Stripes whose canton contains a large lone star surrounded by other stars. Unfortunately for the family's claim, the canton contains a total of thirty-one stars, which places the date of the flag no earlier than 1851.

61. Charles E. Gilbert, *Flags of Texas*, 58; attachment to text of an address by Guy Bryan, Texas Veteran's Association, 1873, Sam Acheson Papers, Dallas Historical Society, Dallas, Texas. Sherman commanded the Second Regiment; his old company, the Newport Rifles, along with their flag, served in Burleson's First Regiment. It makes sense that each regiment would have its own flag.

62. Barker, ed., *The Austin Papers*, 306, 307.

63. George P. Garrison, "Another Texas Flag," 171–73.

64. Ibid., 173–74.

65. At least one example of the flag was made. Mary Holly, Austin's cousin, wrote on June 1, 1836, from Lexington, Kentucky, that "Miss James has painted your flag on silk — sun Washington and all." Barker, ed., *The Austin Papers*, 361.

66. Cox, *The Romantic Flags of Texas*, 230.

67. See also Spain, "The Flags and Seals of Texas," 217–21.

68. *The General Convention at Washington;* H. P. N. Gammel, *The Laws of Texas, 1822–1897*, 841.

69. *The General Convention at Washington*, 69. "TEXAS" intertwined with the five-point star conforms with the design attributed to the Alamo flag reported in the Crockett *Exploits*.

70. Cushing, *Wild Oats Sowings*, 6.

71. Ibid., 25–26.

72. *Laws of the Republic of Texas* 1: 72.

73. Spain, "The Flags and Seals of Texas," 227.

74. Ibid., 224.

75. Ibid., 245.

76. Ibid., 223.

77. *1869 Texas Almanac* in *Texas: Her Flags*, 7.

78. Republic of Texas Senate Committee Report, 3rd Congress, January 4, 1839, 87.

79. *Flags of the Principal Nations of the Earth*. The author is greatly indebted to Sam Lanham of Fredricksburg, Texas, for calling this flag chart to his attention.

Chapter 3. Republic of the Lone Star

1. Republic of Texas Senate Committee report, 3rd Congress, January 4, 1839, Texas State Library and Archives Commission, Austin, Texas.

2. For an excellent discussion of this question, see Charles A. Spain, Jr., "Who Designed the Lone Star Flag?" 16–21. Tradition credits Dr. Charles Stewart with designing the flag, but Spain makes clear that there is little evidence for this assertion.

3. Act approved January 25, 1839, 3rd Congress, Republic of Texas Laws, in Gammel, *The Laws of Texas* 2: 87–88.

4. L. W. Kemp, "Official Flags of the Republic of Texas," 490.

5. Section 1 of the act also modified the state seal: "The National Great Seal of this Republic shall consist of a single star of five points, with olive and oak branches encircled, and with the letters 'Republic of Texas.'" Quoted in Ross W. Anderson Papers, Daughters of the Republic of Texas Library, San Antonio, Texas. The original seal consisted of a single five-point star surrounded by "Republic of Texas" circular. Act approved December 10, 1836, 1st Congress, 1836–1837, Republic of Texas Laws, in Gammel, *The Laws of Texas* 1: 132.

6. Spain, "The Flags and Seals of Texas," 234. In this and subsequent chapters, any flag of this design will be referred to as the Texian Flag to differentiate it from the legion of lone-star flags that Texans flew in the nineteenth century. In 1933 the exact dimensions of the state flag were codified. Any flag conforming to this law after this date is referred to as the Lone Star Flag.

7. Republic of Texas Senate Committee report, 3rd Congress, January 4, 1839, Texas State Library and Archives Commission, Austin, Texas. Charles Spain speculates that the design may have evolved from the tricolor lone-star banner Sarah Dodson made in 1835. Spain, "Who designed the Lone Star Flag?" 17.

8. Ibid., 223. Pioneer vexillologist Whitney Smith defines a war flag as being "the national flag flown over camps and other military establishments on land." Smith, *Flags through the Ages*, 31.

9. Spain, "The Flags and Seals of Texas," 234. The Flag of the Republic superseded the Lone Star and Stripes as naval flag.

10. General Order no. 5, "Uniforms of the Army of the Republic of Texas," May 23, 1836, in Bruce Marshall, *Uniforms of the Republic of Texas, and the Men that Wore Them, 1836–1846*, 73.

11. The first Texian Flag flown on foreign soil, other than in Mexico, was probably unfurled in New Orleans. A letter dated March 4, 1840, states that the Texas consul paid seventy-nine dollars for the manufacture of a lone-star flag to be flown at the consulate. Seymour Connor, ed., *Texas Treasury Papers: Letters Received in the Treasury Department of the Republic of Texas, 1836–1846* 2: 403–404.

12. M. A. Sanchez Lamego, *The Second Mexican-Texas War, 1841–43*, 1–7.

13. H. Yoakum, *History of Texas from Its First Settlement in 1685 to Its Annexation to the United States in 1846*, 2: 274.

14. Joseph Milton Nance, *After San Jacinto: The Texas-Mexican Frontier, 1836–1841*, 213.

15. See Glick, ed., *The Papers of Mirabeau Buonapart Lamar* 6: 136.

16. Nance, *After San Jacinto*, 240. Other bands of Texians fought with the federalists in 1839 and 1840, some with Ross and some after he had departed. These included companies commanded by William S. Fisher, Samuel W. Jordan, and Juan Seguín. Historian Joseph Nance assumes that each unit carried its own flag into northern Mexico. Nance, "Was There a Mier Expedition Flag?" 556.

17. According to Yoakum, the Battle of Alcantra, as the action came to be called, cost the Texans fourteen killed and wounded. The Mexican centralist forces suffered 150 casualties and 350 taken prisoner. Yoakum, *History of Texas* 2: 276.

18. Ibid.; Nance, *After San Jacinto*, 229. The ultimate fate of this flag is unknown.

19. Yoakum, *History of Texas* 2: 277.

20. Nance, *After San Jacinto*, 240.

21. Nance, "Was There A Mier Expedition Flag?" 555. L. Cletus Brown of Brookshire, Texas, subsequently purchased the flag from a Houston relic dealer. In 1972 Brown placed the flag with the Star of the Republic Museum at Washington-on-the-Brazos; Ibid., 552.

22. George Wilkins Kendall, *Narrative of the Santa Fe Expedition*, 64.

23. Gerald S. Pierce, "The Army of the Republic of Texas, 1836–1845," 226, 227; Noel M. Loomis, *The Texan–Santa Fe Pioneers*, 11; Kendall, *Narrative of the Santa Fe Expedition*, 71–72.

24. Sam W. Haynes, "Santa Fe Expedition," in *The United States and Mexico at War: Nineteenth-Century Expansionism and Conflict*, Donald S. Frazier, ed., 379.

25. Report of Brevet General, Colonel Manuel Armijo to the Secretary of War and the Navy, October 22, 1841, in Lamego, *The Second Mexican-Texas War*, 72.

26. No description of either flag has survived. The author had concluded these were Texian Flags because of the official nature of the expedition and the presence of several unidentified flags of this well-known pattern in the collections of the Mexican government.

27. Yoakum, *History of Texas* 2: 354.

28. In early June there had been six companies of volunteers at Lipantitlán. In addition to the Galveston Invincibles were companies from New Orleans, Mobile, Memphis, Mississippi, and Georgia. Pierce, "The Army of the Republic of Texas," 234.

29. Joseph Milton Nance, *Attack and Counter-Attack: The Texas-Mexican Frontier, 1842*, 246.

30. Ibid., 250.

31. Report of Colonel Antonio Canales of the Battle of Lipantitlán to General Isidro Reyes, July 17, 1842, in Lamego, *The Second Mexican-Texas War*, 98.

32. *Telegraph and Texas Register*, August 31, 1842.

33. John R. Gebhart, *Your State Flag*, 17.

34. *Banderas*, 28. Twentieth-century Mexican museum curators did not know quite what to make of this flag displaying a design with which they were clearly unfamiliar. In a recent publication curators misidentified it as the flag of a seventeenth-century English filibuster named Cromwell and claim it was captured in Baja California (*Banderas*, 28).

35. Canales's Report, 98.

36. *Telegraph and Texas Register*, August 31, 1842.

37. Ibid., 251.

38. Yoakum, *History of Texas* 2: 363.

39. Report of General Adrian Woll to the Secretary of War and Navy, September 20, 1842 in Lamego, *The Second Mexican-Texas War*, 103.

40. Nance, *Attack and Counter-Attack*, 413.

41. Ibid., 412.

42. Yoakum, *History of Texas* 2: 365.

43. So far U.S. historians have been unable to examine this flag, which remains the property of the Mexican government. A recent photograph and a late-nineteenth-century painting seems to show that this particular Texian Flag was made with the red stripe on the top.

44. John S. Jenkins, ed., *Recollection of Early Texas: The Memoirs of John Holland Jenkins*, 132; Joseph D. McCutchan, *Mier Expedition Diary*, Joseph Milton Nance, ed., 62.

45. Nance, *Attack and Counter-Attack*, 559

46. McCutchan, *Mier Expedition Diary*, 62.

47. See Nance, "Was There a Mier Expedition Flag?" for a discussion of other possible flags present.

48. During the trek to Mexico City, 176 of the Texians escaped but were soon recaptured. As punishment, the Mexican colonel in charge ordered the decimation — the execution of every tenth man — of the unfortunate prisoners. To determine the victims, each Texian was forced to draw from an earthen pot that contained 176 beans. Those who chose one of the seventeen black beans were taken out and shot.

49. Nance, *Attack and Counter-Attack*, 289.

50. Arthur M. Schlesinger, Jr., ed., *Running for President: The Candidates and Their Images* 1: 154.

51. Ibid., 1: 175.

52. *New York Tribune*, November 18, 1844.

53. Justin Smith, *The Annexation of Texas*, 298.

54. *New Orleans Daily Picayune*, March 3, 1846.

55. Smithwick, *Evolution of a State*, 211; "End of the Republic," Annexation File, Center for United States History, University of Texas at Austin.

56. Smithwick, *Evolution of a State*, 211.

57. Ibid., 212.

Chapter 4. Secession's Lone Star

1. Charles D. Spurlin, *Texas Volunteers in the Mexican War*, 24.

2. Anton Adams, *The War with Mexico*, 177.

3. Ron Field, *Mexican-American War, 1847–1848*, 96–97. Texas volunteers sometimes wore "surplus" military jackets of the Republic of Texas Army that had buttons inscribed with the word "Texas"; Field *Mexican-American War*, 97; Pierce, "The Army of the Republic of Texas," 43.

4. Robert Maberry, Jr., "Texans in the Defense of the Confederate Northwest, April 1861–April 1862: A Social and Military History," 102.

5. See Roy Sylvan Dunn, "The KGC in Texas, 1860–1861," 543–73.

6. Douglas Hale, *The Third Texas Cavalry in the Civil War*, 47. The nineteen stripes probably refer to the fifteen slave states, plus the countries of the "golden circle" the KGC had its sights on.

7. Alan K. Sumerall, *Battle Flags of Texans in the Confederacy*, 23.

8. Maberry, "Texans in the Defense of the Confederate Northwest," 10–11.

9. Dunn, "The KCG in Texas," 559.

10. Hubbs, "Lone Star Flags and Nameless Rags," 282.

11. The first known lone-star flag used as a symbol for southern rights was one captured from proslavery immigrants in Kansas in 1856. It was a four-foot-by-six-foot red cotton flag with a white cotton star sewed on it. In crude

cotton letters across the top is inscribed "Southern Rights"; George Henry Preble, *Origin and History of the American Flag,* 497.

12. For a discussion of this position see Marshall DeRosa, *The Confederate Constitution: An Inquiry into American Constitutionalism,* 44.

13. Glenn Dedmont, *The Flags of Civil War South Carolina,* 13

14. Devereaux D. Cannon, Jr., *The Flags of the Confederacy: An Illustrated History,* 40.

15. *Austin State Gazette,* January 26, 1861; Hubbs, "Lone Star Flags and Nameless Rags," 280. A former mayor of Augusta, B. E. Allen, Jr., donated this flag to the Augusta/Richmond County Museum in 1945. It is a 40.5-inch-by-68-inch red cotton flag with a 26-inch white star painted on it. "Secessionist Flag of Augusta, Georgia," Howard Madaus Flag Files, report in author's possession.

16. Two weeks after its introduction, the Bonny Blue design became an element in the official Mississippi state flag. The new flag displayed a white star in a blue canton, but the white field, decorated by an image of a magnolia tree and surrounded by a red border, dominated the viewer's attention. Hubbs, "Lone Star Flags and Nameless Rags," 278–79.

17. *Southern Historical Society Papers* 38: 248.

18. After southern volunteers attacked Fort Sumter in April, 1861, Lincoln called for troops to put down the rebellion in South Carolina. Because of his action, four states of the upper South — Virginia, Arkansas, North Carolina, and Tennessee — seceded. By the time this occurred, the Confederate government had been formed, and the Stars and Bars was already in use. Each state received a star in the new national flag. Tennessee was the last state to successfully secede. On June 17, 1861, a ceremony took place in Nashville in which the Stars and Bars, displaying for the first time the eleventh star for Tennessee, was raised over the state capitol; Devereaux D. Cannon, *Flags of Tennessee,* 59. Nevertheless, citizens of the upper South understood the symbolism of the lone five-point star. For instance, in December, 1860, students at Washington College in Lexington, Virginia, in defiance of the school's unionist president, George Junkin, raised a secession flag over the main building. It was described as "blue with a blood red star in the middle and 'DISUNION' painted in large letters above it"; Ollinger Crenshaw, *General Lee's College: The Rise and Growth of Washington and Lee University,* 119–24. Although Virginia's newly adopted state flag did not display a star, its military forces flew a number of Confederate First National variants that had lone stars in their cantons. North Carolina soldiers also sometimes carried Confederate flags with lone stars, and the state chose an official flag that displayed a lone star and closely resembled the Texian Flag; Joseph H. Crute, *Emblems of Southern Valor: The Battle Flags of the Confederacy,* 14–15, 18–19.

19. *Southern Historical Society Papers* 38: 247.

20. Ibid. For a detailed contemporary description of the Louisiana secession flag, see the *Dallas Herald,* March 13, 1861.

21. William Winkler, ed., *Journal of the Secession Convention of Texas 1861,* 105.

22. In a letter to Louisiana officials, Forshey wrote, "My object is to call your attention . . . to the striking resemblance of the colors and designs you have adopted to the national flag of Texas" (Winkler, ed., *Journal of the Secession Convention,* 103).

23. Ibid., 105.

24. *Houston Telegraph,* November 21, 1860.

25. *Dallas Herald,* December 26, 1860.

26. *Turner's Southern Star,* December 26, 1860.

27. *Galveston News,* December 12, 1860.

28. *Houston Telegraph,* November 28, 1860. Also, "The Lone Star Flag that was raised at Houston on Friday was in the thickest fighting at San Jacinto," *Galveston News,* December 12, 1860.

29. *Dallas Herald,* March 6, 1861. The date this Lone Star and Stripes flag had been unfurled was December 18, 1860.

30. *Austin State Gazette,* December 22, 1860.

31. Ibid.

32. *Dallas Herald,* March 20, 1861.

33. Ibid., December 28, 1860.

34. Ibid.; *Austin State Gazette,* December 29, 1860.

35. *Austin State Gazette,* March 9, 1861.

36. Ibid., March 2, 1861.

37. Winkler, ed., *Journal of the Secession Convention,* 105; Frank Wilson Kiel, "A Fifteen-Star Texas Flag: A Banner Used at the Time of Secession — February 1861 and March 1861," 360.

38. See Boleslaw and Marie-Louise D'Ortange Mastai, *The Stars and Stripes: The Evolution of the American Flag,* 47.

39. *Dallas Morning News,* October 3, 1897.

40. Flag in possession of the Harrison County Historical Museum, Marshall, Texas.

41. *Dallas Herald,* November 21, 1860. The number of stars that orbited the central lone star in Texas flags varied from thirteen to fifteen.

42. *Austin State Gazette,* December 29, 1860; January 5, 1861; January 10, 1861; January 12, 1861.

43. Kiel, "A Fifteen-Star Texas Flag," 358–59.

44. *Austin Gazette,* March 9, 1861.

45. Winkler, ed., *Journal of the Secession Convention,* 247.

46. Clement A. Evans, ed., *Confederate Military History* 11: 20–21.

47. Robert U. Johnson and Clarence C. Buel, eds., *Battles and Leaders of the Civil War* 1: 35.

48. *San Antonio Light,* January 14, 1936; handwritten statement of William M. Edgar, Flag files, Daughters of the Republic of Texas Library, the Alamo, San Antonio, Texas.

49. See James Patrick McGuire, *Iwonski in Texas: Painter and Citizen,*

75–76. In Iwonski's drawing, Edgar's lone-star flag appears as a small Bonny Blue–type banner. It is possible the artist never saw the flag himself — hence the lack of detail — or employed artistic license.

50. Johnson and Buel, eds., *Battles and Leaders* 1: 35.

51. Ben McCulloch to John R. Jefferson, February 21, 1861; Ben McCulloch to John R. Jefferson, February 28, 1861, both in Flag Accession Files, Texas Memorial Museum, University of Texas at Austin.

52. Historians have been puzzled by the orientation of the Texas flag in this depiction. The most likely explanation is that the Seguin flag, like most Texian Flags, has a tilted star. The author has observed that similar flags were often displayed upside down by those unfamiliar with the design so that the star would appear upright, even though this places the red stripe on top. Sometimes Texans were simply careless about the orientation of their flag. Based on the dreadful but imaginative façade the artist added to the Alamo's front in his drawing and the improper attitude of the flag, the artist was most likely not an eyewitness to the events. See above, 103.

53. James M. Day, ed. *The Texas Almanac 1857–1873: A Compendium of History*, 485.

54. *Dallas Herald*, November 28, 1861.

55. Ibid.

56. *Houston Weekly Telegraph*, March 12, 1861.

57. *Austin State Gazette*, August 27, 1862.

58. Robert Hodges to Robert Hodges Sr., February 22, 1861, Robert Hodges Letters, The Texas Collection, Baylor University, Waco, Texas; Winkler, ed. *Journal of the Secession Convention*, 403; see also John Salmon Ford, *Rip Ford's Texas*, ed. Stephen B. Oats, 319–21.

59. *Dallas Herald*, March 13, 1861.

60. Cannon, *Flags of the Confederacy*, 7.

61. Winkler, ed., *Journal of the Secession Convention*, 104.

62. *Southern Historical Society Papers* 38: 255. The committee decided not to adopt a design with stripes because when the members examined the flags of the world, they realized such a design would be similar not just to the U.S. flag but also to those of Liberia and the Sandwich Islands. According to Miles, the committee "felt no inclination to borrow, at second hand, what had been pilfered and appropriated by a free negro community and a race of savages." *Austin State Gazette*, March 23, 1861.

63. *Southern Historical Society Papers* 38: 256.

64. William C. Davis, *"A Government of Our Own": The Making of the Confederacy*, 243; Cannon, *Flags of the Confederacy*, 9.

65. The first seven states to join the Confederacy were South Carolina, Georgia, Florida, Mississippi, Alabama, Louisiana, and Texas. The Confederate flag used in representations of the Six Flags of Texas is a seven-star First National. This flag was only current until April, when Virginia seceded. More appropriately, generalized representations of the Stars and Bars should display eleven stars for the eleven states of the Confederacy.

66. Cannon, *Flags of the Confederacy*, 9–10.

67. *Galveston News*, April 3, 1861.

68. During the war the number of stars on most Confederate flags varied between eleven, twelve, and thirteen. Prosouthern citizens of both Missouri and Kentucky organized Confederate state governments in exile, and the use of twelve and thirteen stars signified their recognition by Richmond. Note that many secession flags and some company flags had displayed fifteen stars, representing all the slave states.

69. A. B. Blocker, "The Boy-Bugler of the Third Texas Cavalry: The A. B. Blocker Narrative," 73.

70. Sam R. Watkins, *"Co. Aytch," A Side Show of the Big Show*, 48.

71. Eugenia Reynolds Briscoe, "A Narrative History of Corpus Christi, Texas — 1519–1875," 373; *Corpus Christi Ranchero*, June 15, 1861. Unlike the vast majority of Confederate flags given to Texas units, the Stars and Bars presented that day in Corpus Christi had not been locally made but was manufactured and purchased from L. Levy of New Orleans "at a greatly reduced price"; *Corpus Christi Ranchero*, June 15, 1861.

72. *Austin State Gazette*, June 29, 1861.

73. Khleber Van Zandt to his wife, October 16, 1861, Seventh Texas Infantry Files, Harold B. Simpson Research Center, Hill College, Hillsboro, Texas.

74. *Fort Smith Times*, August 19, 1861.

75. Members of every tribe except the Seminoles held slaves, and many Indians were fierce anti-abolitionists. Census documents for 1860 reveal that in the Indian territory as a whole there was approximately one slave for every eight Indians. *Preliminary Report of the Eighth Census 1860*, 11.

76. Samuel B. Barron, *The Lone Star Defenders: A Chronicle of the Third Texas Cavalry Regiment in the Civil War*, 32–33.

77. *Dallas Herald*, August 7, 1861.

78. Victor M. Rose, *Ross' Texas Brigade*, 19.

79. For a discussion of the cultural and political affinities between the Indian nations and the Confederacy, see Maberry, "Texans in the Defense of the Confederate Northwest," 189–211.

80. Congress of the Confederate States of America, Minutes of the Third Session of the First Congress, May 1, 1863, *Southern Historical Society Papers* 49: 271–73; Cannon, *Flags of the Confederacy*, 19.

81. Quoted in the *Dallas Herald*, August 26, 1863.

82. Cannon, *Flags of the Confederacy*, 19. Another sobriquet for the Confederate Second National was the "white man's flag."

83. *Dallas Herald*, August 26, 1863.

84. *Houston Telegram*, June 24, 1863.

85. The Galveston garrison flag is in the collections of the Texas State Library and Archives Commission.

86. *Dallas Herald*, April 6, 1865.

87. "The flag of the Confederate States of America shall be as follows: The

width two-thirds of its length, with the union (now used in the battle flag) to be in width two thirds of the width of the flag. . . . The field to be white, except the outer half from the union to be a red bar extended the width of the flag." Congress of the Confederate States of America, Minutes of the Second Session of the Second Congress, December 13, 1864, *Southern Historical Society Papers* 51: 461. The few Third Nationals produced were most likely made by shortening the white field of a Second National and adding a red band. Cannon, *Flags of the Confederacy*, 24.

88. Texas newspapers were reporting that Confederate military leaders approved of the new design as early as January, 1865. *Dallas Herald*, January 26, 1865. The collections of the United Daughters of the Confederacy's Texas Confederate Museum do contain a full-size example of the flag, but its history is unknown. A smaller version in the same collection attributed as the handiwork of Eliza Pledger may have been a demonstration model of Civil War–era provenance.

Chapter 5. Texas Star in Virginia

1. Madaus and Needham, *The Battle Flags of the Confederate Army of Tennessee*, 11–16.

2. For a discussion of the cultural, social, and military significance of the Civil War Confederate battle flag see Richard Rollins, *"The Damned Red Flags of the Rebellion": The Confederate Flag at Gettysburg*, xii–xxxii, 1–54.

3. Sauers, *Advance the Colors!*, 1: 18.

4. Ibid., 1: 18–19.

5. *The Southern Historical Society Papers* 8: 497–98. This account is based on a December 6, 1878, speech by General Beauregard.

6. Cannon, *Flags of the Confederacy*, 8.

7. *The Southern Historical Society Papers* 8: 489–99.

8. At the time of the new battle flag's adoption, Johnston's forces were called the Army of the Potomac. When Gen. Robert E. Lee assumed command in June, 1862, the name was changed to the Army of Northern Virginia. Thus, technically, there could be no ANV flag until that time. For the sake of clarity, however, the term "ANV" is used throughout.

9. Howard Madaus, Greg Biggs, and Devereaux Cannon, "Battle Flags of the Army of Northern Virginia," Flags of the Confederacy Web site, http://home.att.net/~dcannon.tenn/FOTCanv.html, 2–5.

10. Ibid., 5.

11. Kathy Sawyer, "Capture the Flag," *Washington Post*, April 23, 2000. Wool from the long-coated sheep of the British Isles was best for making this cloth (Sawyer, "Capture the Flag").

12. Madaus, et al., "Battle Flags of the Army of Northern Virginia," 6

13. Ibid.

14. Harold Simpson estimates that with the inclusion of the Third Ar-

kansas Infantry, which served with the Texas Brigade during the final years of the war, 5,300 men had enlisted. At the surrender, 617 men remained. Harold B. Simpson, *Hood's Texas Brigade: Lee's Grenadier Guard*, 468.

15. Dudley Wooten, ed., *Comprehensive History of Texas* 2: 651.

16. Cannon, *Flags of the Confederacy*, 52.

17. Dr. John O. Scott, "The Battle Flags of Texas," *Dallas Morning News*, October 3, 1897, typescript version, First Texas Flag File, Harold B. Simpson Research Center, Hill College, Hillsboro, Texas. The original version of the October 3, 1897, article does not include "It was made from her wedding dress, as was also the white stripe." Mrs. D. Giraud Wright, *A Southern Girl in '61: The War-Time Memories of a Confederate Senator's Daughter*, 66; *Dallas Herald*, September 18, 1861.

18. First Texas flag, Analysis Report, Textile Preservation Associates, Sharpsburg, Maryland, in author's possession.

19. *Dallas Herald*, September, 18, 1861.

20. Robert H. Gaston to his sister, August 1, 1861, in Robert W. Glover, ed., *Tyler to Sharpsburg: Robert H. and William H. Gaston, Their Civil War Letters, 1861–1862*, 9.

21. Wooten, *Comprehensive History of Texas* 2: 651.

22. *Dallas Herald*, September 18, 1861.

23. Willia Mae Weinert, *An Authentic History of Guadalupe County*, 64.

24. The Lone Star Rifles became Company L of the First Texas. Harold B. Simpson, *Hood's Texas Brigade: A Compendium*, 103, 77.

25. Campbell Wood, adjutant of the Fifth Texas Regiment of Hood's Brigade, "Flags of the Fifth Texas C.S.A." prepared by J. B. Polley in "Historical Reminiscences," Flag Files, Daughters of the Republic of Texas Library, The Alamo, San Antonio Texas; O. T. Hanks. *History of Captain B. F. Benton's Company, Hood's Texas Brigade, 1861–1865*, 9.

26. *Austin Statesman*, October 15, 1905.

27. F. B. Chilton, *Unveiling and Dedication of the Monument to Hood's Texas Brigade*, 315.

28. John Bell Hood to Miss Louise Wigfall, January 26, 1862, Pearce Civil War Collection, Navarro College; J. J. Archer to Miss Wigfall, January 23, 1862, Fifth Texas flag Files, Texas Confederate Museum Collection, United Daughters of the Confederacy, Texas Division.

29. "Confederate Battle Flag of the Fourth Volunteer Regiment Hood's Texas Brigade," Fourth Texas Flag File, Harold B. Simpson Research Center, Hill College, Hillsboro, Texas.

30. *Dallas Morning News*, October 3, 1897.

31. Wood, "Flags of the Fifth Texas." Battle honors are marks applied to military unit flags that memorialize service. During the Civil War these were usually the names of battles in which the units honorably participated. Whitney Smith, *Flags through the Ages*, 13. When army commanders ordered the application of battle honors, it did not necessarily mean the unit had played an important part. Hood's Brigade, for instance, had barely partici-

pated in the battles of Seven Pines and Malvern Hill. There is no explanation why Gaines Mill is written as Gaines Farm.

32. U.S. War Department, *The War of the Rebellion; A Compilation of the Official Records of the Union and Confederate Armies*, series 1, vol. 19, pt. 1, 933 (hereafter cited as *O.R.*; unless otherwise indicated, all references are to series 1).

33. Simpson, *Hood's Texas Brigade*, 174.

34. *O.R.* 19, pt. 1, 933.

35. *O.R.* 51, pt. 1, 151.

36. *Dallas Morning News*, October 3, 1897.

37. Ibid. ; Simpson states that the Texas Brigade lost sixteen color-bearers in all. Simpson, *Hood's Texas Brigade*, 177.

38. *O.R.* 19, p. 2, 729.

39. Sauers, *Advance the Colors!* 1: 104–105. There is confusion regarding the unit designations of some Pennsylvania regiments. In addition to its volunteer force, the state raised thirteen "reserve" infantry regiments. Each received a reserve regiment number as well as a line regiment designation. Private Johnson's regiment was one of these. To the Army of the Potomac his unit was the Thirty-eighth Regiment Pennsylvania Volunteers, but state officials listed it as the Ninth Regiment Pennsylvania Reserve Volunteer Corps. Its battle flag carried both designations; ibid., 80, 105.

40. Reverend Nicholas A. Davis, *The Campaign from Texas to Maryland with the Battle of Fredericksburg*, 99.

41. Simpson, *Hood's Texas Brigade*, 176–77. The Texas Brigade went into action with 854 men. Their losses in killed, wounded, and missing were 560. *O.R.* 19, pt. 1, 929.

42. *O.R.* 19, pt. 1, 933.

43. *Dallas Morning News*, October 3, 1897.

44. "The Lone Star Flag at Gettysburg," First Texas Flag File, Harold B. Simpson Research Center, Hill College, Hillsboro, Texas.

45. The regiments of Hood's Brigade apparently received standard fourth bunting issue ANV flags at this time. The oversized flag may have been a special presentation version.

46. Richard Rollins, ed., *The Returned Battle Flags*, 30.

47. *Texas: Biographical Dictionary*, 391–92. Maude Jeannie Fuller Young (1826–82) was born in South Carolina, and her family settled in Houston in 1837, where her father, Nathan Fuller, was mayor from 1853 to 1854. She married Dr. S. O. Young but became a widow within the year. After this tragic event she embarked on her intellectual and public-service career; ibid.

48. Harold B. Simpson, *Hood's Texas Brigade: In Reunion and Memory*, n. 141.

49. Wood, "Flags of the Fifth Texas."

50. Ibid.

51. The damaged Wigfall ANV flag was probably destroyed when the Texas Depot burned in 1865.

52. "The Flag of the Fifth Regiment Infantry Hood's Brigade — Army of Northern Virginia," Fifth Texas Flag File, Harold B. Simpson Research Center, Hill College, Hillsboro, Texas; Wood, "Flags of the Fifth Texas."

53. Wood, "Flags of the Fifth Texas." The First Texas Regiment's Texian Flag and the colors of the Fifth Texas received battle honors, but the field of the Fourth Texas' Wigfall ANV remained undecorated. It is likely that the Fourth Texas also possessed a Richmond-issue third bunting ANV, now lost, that was sent to headquarters for inscription while the Wigfall flag remained in service. Mrs. Young's flag received the same battle honors as the First Texas flag but in different colors to better harmonize with its design. Artisans painted "Eltham's Landing," "Gaines Farm," "Malvern Hill," and "Seven Pines(?)" in gold letters in the quadrants of the field.

54. Ibid.

55. Harold B. Simpson, *Hood's Texas Brigade*, 154; *Dallas Morning News*, October 8, 1887.

56. *Dallas Morning News*, October 8, 1887.

57. Davis, *The Campaign from Texas to Maryland*, 97–98.

58. It was probably after the flag of the Fourth Texas arrived in Austin that a three-inch-wide silk ribbon was sewn to its upper edge that proclaimed the regiment's battle honors. On one side was printed "ELTHAMS LANDING, MAY 7, 1862" and "SEVEN PINES MAY 31st & JUNE 1st, 1862," and on the reverse, "FREEMANS FORD, AUG 22nd, 1862" and "MANASSAS PLAINS, AUG 29th & 30th."

59. Grady McWhiney, *Battle in the Wilderness: Grant Meets Lee*, 70.

60. Johnson and Buel, eds., *Battles and Leaders* 4: 124.

61. Simpson, *Hood's Texas Brigade*, 396; McWhiney, *Battle in the Wilderness*, 70.

62. J. B. Polley, *Hood's Texas Brigade; Its Marches, Its Battles, Its Achievements*, 231.

63. Johnson and Buel, eds., *Battles and Leaders*, 4: 125.

64. Ibid. Nearly every account of the "Lee to the rear" incident varies in one detail or another, but the core facts remain. Lee, in a moment of excitement or perhaps frustration, attempted to lead the charge of the Texas Brigade, and the soldiers out of love and fear for his life prevented the general from doing so.

65. Simpson, *Hood's Texas Brigade*, 439–42.

66. "The Flags of the Fifth Regiment Infantry, Hood's Brigade," Fifth Texas Flag File, Harold B. Simpson Research Center, Hill College, Hillsboro, Texas.

67. Val C. Giles, "The Flag of the First Texas, A.N. Virginia," *Confederate Veteran*, 417.

68. Thomas Fletcher Harwell, *Eighty Years under the Stars and Bars*, 101.

69. Rollins, ed., *Returned Battle Flags*, 36.

Chapter 6. Stars of the Heartland and Home

1. Thomas Lawrence Connelly, *Army of the Heartland: The Army of Tennessee, 1861–1862,* 3–10.

2. Howard Michael Madaus and Robert D. Needham, "Unit Colors of the Trans-Mississippi Confederates, Part 1," *Military Collector & Historian,* 123.

3. M. B. Morton, "General Simon Bolivar Buckner Tells Story of Fall of Fort Donelson — Part II," *Nashville Banner,* December 11, 1909, 17.

4. A blue flag with some sort of seal in the center was the most common militia flag pattern in antebellum America. The white circle on blue field was a common pattern for prewar militia and volunteer flags in the regions around the Ohio Valley. Note the Mexican War flag of the Menard Volunteers (Fourth Illinois) in Adams, *The War in Mexico,* 184.

5. Buckner claimed the Hardee flag was first used at Fort Donelson; Morton, "Fall of Fort Donelson," 17. Flag historian Greg Biggs has speculated that during the war there were six basic patterns of the flag, each varying in minor details. These were at least partially fabricated in the field by soldiers who had tailoring skills, and as a result the quality of construction varied greatly. Surviving examples have a combination of machine and hand stitching. The blue dye was generally of poor quality and thus some of the flags tended to fade to a greenish color; Howard Michael Madaus, "Battle Flags of the Army of Mississippi/Army of Tennessee (1861–Late 1863)," Flags of the Confederacy Web site, http://home.att.net~dcannon.tenn/FOTCaotm .html#hardee; Madaus, "Battle Flags of the Army of Tennessee (Late 1863– 1865)," http://home.att.net~cannon.tenn/FOTCaot.html#cleburne.

6. Irving A. Buck, *Cleburne and His Command,* 130.

7. By the end of the war, eight regiments composed Granbury's Brigade. They were the Sixth, Seventh, and Tenth Texas Infantry Regiments, and the Fifteenth, Seventeenth, Eighteenth, Twenty-fourth, and Twenty-fifth Cavalry Regiments. All of the cavalry regiments were dismounted for service in the Army of Tennessee.

8. Robert Maberry, Jr., "Texans and the Defense of the Confederate Northwest," 370–71.

9. Samuel T. Foster, *One of Cleburne's Command: The Civil War Reminiscences and Diary of Capt. Samuel T. Foster, Granbury's Brigade, CSA,* ed. Norman D. Brown, 43–44.

10. By the time of the Atlanta Campaign, Granbury's Brigade contained five regiments: the Sixth Infantry and Fifteenth Cavalry (dismounted) consolidated, the Seventh Texas Infantry, the Tenth Texas Infantry, the Seventeenth and Eighteenth Texas Cavalry (dismounted) consolidated, and the Twenty-fourth and Twenty-fifth Texas Cavalry (dismounted) consolidated. William R. Scaife, *The Campaign for Atlanta,* 176

11. Madaus and Needham, *The Battle Flags of the Army of Tennessee,* 63.

12. The new Hardee flags issued before the 1864 campaign were the second set the Texas troops had carried. No examples of the first issue survives or is documented. Madaus and Needham, *Battle Flags of the Army of Tennessee,* 96–97

13. "Return of a Confederate Flag," *Confederate Veteran,* 302.

14. Joseph McClure to John T. Callahan, April 30, 1914; Andrew LaForge to John F. Callahan, May 25, 1914; R. H. Hopkins to Andrew LaForge, August 2, 1914, all in Flag Accession File, Texas State Library and Archives Commission, Austin, Texas.

15. "Return of a Confederate Flag," 302. Some of those captured were soldiers of the Fifth Confederate Regiment that also had lost its Hardee battle flag. Just prior to the loss of its flag, the Seventeenth and Eighteenth Texas had struck a grievous blow against Sherman's army. In the course of their headlong advance, the Texans had come upon Maj. Gen. James B. McPherson, one of the Union's ablest commanders. When he turned to escape, two Rebel privates, "both good shots," gunned him down. Foster, *One of Cleburne's Command,* n. 112.

16. Lou Guthrie affidavit, Flag of the Sixth and Fifteenth Texas file, Texas Confederate Museum Collection, United Daughters of the Confederacy, Texas Division.

17. Ibid.

18. *O.R.* 45, pt. 1, 737.

19. Sam R. Watkins, *"Co. Aytch," A Side Show of the Big Show,* 219.

20. Ibid., 220.

21. For an account of the last days and surrender of the Army of Tennessee, see Bromfield L. Ridley, *Battle and Sketches of the Army of Tennessee,* 453–89.

22. Affidavit of W. J. Oliphant, July 25, 1885, Flag Accession File, Texas State Archives and Library Commission, Austin, Texas.

23. Anne J. Bailey, *Texans in the Confederate Cavalry,* 13–21.

24. Based on author's statistical compilation.

25. L. B. Giles, *Terry's Texas Rangers,* 12.

26. H. W. Graber, *A Terry Texas Ranger: The Life Record of H. W. Graber, Sixty-two Years in Texas,* 70; Robert Frank Bunting to the *Houston Tri-Weekly Telegraph,* February 2, 1863.

27. "Presentation of Bonnie Blue Flag," *Confederate Veteran,* 216.

28. There is no documentary evidence for the first Terry's Texas Ranger flag, and thus its history has been surmised. By the twentieth century it had turned up in the collections of the Chicago Historical Society.

29. Bunting to the *San Antonio Herald,* November 13, 1861.

30. Bunting to the *Houston Tri-Weekly Telegraph,* February 2, 1863.

31. Two stanzas of a song composed by George Quincy Turner in the field sometime around June, 1863, and sung to the tune of the *Bonny Blue Flag.* Benjamin Franklin Batchelor and George Q. Turner, *Batchelor-Turner Letters, Written by Two of Terry's Texas Rangers,* annot. H. J. H. Rugeley (unpaginated frontmatter). Count Jones was the regiment's standard bearer.

32. In 1897 Miss McIver maintained that the flag had been made from a

blue silk dress and was lined with a satin wedding dress. "The Texas Ranger's Flag," *Confederate Veteran*, 159.

33. Bunting to the *Houston Tri-Weekly Telegram*, September 21, 1864. Bunting wrote that the flag was to be placed in the state archives.

34. Graber, *A Terry Texas Ranger*, 202–203; Glen W. Sunderland, *Lightning at Hoover's Gap: The Story of Wilder's Brigade*, 184–85; "The Texas Ranger's Flag," *Confederate Veteran*, 159.

35. Graber, *A Terry Texas Ranger*, 403–404.

36. *Nashville American*, n.d. Civil War Scrapbook File, Tennessee State Library, Nashville, Tennessee.

37. *Houston Telegram*, April 6, 1865.

38. For a description of this campaign see Maberry, "Texans in the Defense of the Confederate Northwest," 212–40.

39. The original colonel, Elkanah Greer, was the state commander of the KGC. Hale, *The Third Texas Cavalry*, 27.

40. Maberry, "Texans in the Defense of the Confederate Northwest," 193–94.

41. Samuel B. Barron, *The Lone Star Defenders*, 150–51

42. John A. Miller, "A Memoir of the Days of '61," unpublished manuscript, Sixth Texas File, Harold B. Simpson Research Center, Hill College, Hillsboro, Texas, 39.

43. Ibid. Miller bitterly reproached himself for not fetching the flag personally, and his account rationalizes the aide's negligence by explaining that Simpson was "not a Texan." In later years General Ross recalled that fourteen or fifteen flags "were burned by accident in Jackson, Mississippi." Besides the Sixth Texas regimental color, the others were probably Union flags the brigade had captured; *Minutes of the Proceedings of the Association of the Survivors of Ross', Ector's, and Granberry's Brigades, U.C.V. Held at Garland, Texas August 8 and 9, 1899*, 9.

44. *O.R.* 8, 749.

45. Madaus and Needham, "Unit Colors of the Trans-Mississippi Confederacy, pt. 2," 175. These flags were probably fabricated in the field by soldiers skilled in needlecraft, and the patterns varied according to their talents and preferences. The dyes used were poor, so the colors of the flags varied from red to orange to brown.

46. A. W. Sparks, *The War between the States as I Saw It*, 53–54. Sparks stated that the company flags were sent to Austin so they would be "in the safe-keeping of the governor." No such flags have yet been identified. He also claims that the Van Dorn flag used by the regiment had originally been the flag of Company K and that it had led the regiment during the Battle of Pea Ridge. In light of Van Dorn's letter to Price quoted above, this assertion is unlikely. Most flag historians agree with Howard Madaus that the first Van Dorn flags were not issued until well after the battle.

47. James M. Bates to his mother, October 12, 1862, in Richard Lowe, ed., *A Texas Cavalry Officer's Civil War: Diary and Letters of James C. Bates*, 190.

The colonel of the Twenty-seventh Ohio that defended Battery Robinett during the Confederate onslaught claimed his troops captured the flag of the Ninth Texas. *O.R.* 17, pt.1, 186–187. Contemporary Confederate sources, however, contradict the assertion. The flag that Sparks claimed the Ninth Texas carried at Corinth was returned to Texas and was displayed and photographed often after the war. Seen Martha L. Crabb, *All Afire to Fight: The Untold Story of the Civil War's Ninth Texas Cavalry*, n. 361.

48. Madaus and Needham, *Battle Flags of the Army of Tennessee*, 77–78. Necessity made Mobile, Alabama, an important manufacturing center for the Confederacy, and many of the flags of the western armies were fabricated there. Two contractors made the twelve-star flags issued to the department of Alabama, Mississippi, and East Louisiana in late 1863, including those Ross's Brigade received. They were Jackson Belknap, who had been a painter, along with his wife Sarah, and James Cameron, a Memphis flag and tent maker, who had fled to the gulf city in 1862. Civil War–flag historian Greg Biggs has speculated that the Cameron/Belknap flags only displayed twelve stars because the contractors used the twelve-star flag of New Orleans's Washington Artillery as their model. Gregg Biggs, "Battle Flags of the Army of Tennessee," 11.

49. Miller, "A Memoir of the Days of '61," 39–40.

50. Ibid., 49–50.

51. Hale, *The Third Texas Cavalry*, 241.

52. Crabb, *All Afire to Fight*, 292–93.

53. Sparks, *The War between the States*, 121.

54. Madaus and Needham, *Battle Flags of the Army of Tennessee*, 23–24.

55. Ibid., 30. When the flag order was issued, McCown was post commander of Chattanooga, Tennessee. In his absence, Gen. Thomas J. Churchill commanded the division. Churchill may have been responsible for selecting the flag's design.

56. *O.R.* 20, pt. 1, 945.

57. Ibid., 929.

58. Ibid., 947. Contemporary accounts frequently identify any blue confederate color as a "bonny blue flag."

59. The Ninth Texas Infantry, known as Maxey's Regiment, joined Ector's Brigade in February, 1863, as the Eleventh Cavalry's replacement.

60. Charles D. Douglas Diary, March 31, 1964, Tennessee State Library.

61. Ibid., May 12, 1864.

62. *O.R.* 49, pt. 1, 317.

63. Ibid., 103.

64. "Flag of the Ninth Texas Infantry," *Confederate Veteran*, 455.

65. Madaus and Needham, "Unit Colors of the Trans-Mississippi, pt. 1," 123.

66. Carl Moneyhon and Bobby Roberts, *Portraits of Conflict: A Photographic History of the Civil War*, 339.

67. W. D. Wood, *A Partial Roster of the Officers and Men Raised in Leon County, Texas, for Service of the Confederate States in the War between the States*

with Short Biographical Sketches of Some of the Officers, and a Brief History of Maj. Gould's Battalion, 4–8.

68. The flag had originally been made as a company flag, probably in 1861. Tom Nixon, a veteran of Gould's Battalion, claimed that the original flag of Gould's Battalion had been converted into an ANV type-pattern. Archival records contradict this statement, which was written thirty years after the fact; Statement of Tom Nixon, January 5, 1893, Flag Accession File, Texas State Library and Archives Commission, Austin, Texas; Fonda Ghiardi Thomsen, "A Flag's Story," *Heritage Magazine,* 27.

69. *Houston Tri-Weekly Telegraph,* January 23, 1863.

70. Ibid.

71. X. B. Debray, *A Sketch of the History of Debray's (26th) Regiment of Texas Cavalry,* 6 .

72. Carl L. Duaine, *The Dead Men Wore Boots: An Account of the 32nd Texas Volunteer Cavalry, CSA, 1862–1865,* 24–25.

73. To learn more about the Germans who served in Wood's Regiment, see Minetta A. Goyne, ed. *Lone Star and Double Eagle: Civil War Letters of a German-American Family.*

74. *O.R.* 26, pt.1, 409, 426–27; *Corpus Christi Ranchero,* December 17, 1863; C. Barney, *Recollections of Field Service with the Twentieth Iowa Infantry Volunteers,* 247–48.

75. Madaus and Needham, "Unit Colors of the Trans-Mississippi, pt. 2," 180.

76. Compiled service records of Confederate Soldiers Who Served in Organizations from the State of Texas, Washington, D.C.: National Archives and Records Service, roll 273.

77. James Arthur Lyon Fremantle, *The Fremantle Diary,* ed. Walter Lord, 16.

78. *O.R.* 21., pt.1, 241–48.

79. *Houston Telegram,* September 16, 1863; A. Q. Clements to his sister, Prenia, September 15, 1863, Adam Quincy Clements letter, Third Texas Infantry File, Harold B. Simpson Research Center, Hill College, Hillsboro, Texas.

80. *Fredericksburg Zeitung,* August 28, 1864, Oscar Haas Papers, Texas State Library and Archives Commission, Austin, Texas.

81. Ralph A. Wooster, *Texas and Texans in the Civil War,* 183.

Chapter 7. Lost Cause and Lone Star

1. Cecilia Elizabeth O'Leary, *To Die For: The Paradox of American Patriotism,* 49; Nina Silber, *The Romance of Reunion: Northerners and the South, 1865–1900,* 163.

2. O'Leary, *To Die For,* 130–33; Fred Arthur Bailey, "Free Speech and the 'Lost Cause' in Texas: A Study of Social Control in the New South," *Southwestern Historical Quarterly,* 476–77.

3. Stiles Family Flag File, Texas Confederate Museum Collection, United Daughters of the Confederacy, Texas Division.

4. Ibid.

5. Ibid.

6. William L. Richter, *The Army in Texas during Reconstruction, 1865–1870,* 21.

7. Ibid., 22; Stiles Family Flag File.

8. Innes Randolph, "The Good Old Rebel," *Annals of America,* 19 vols. (Chicago: Encyclopedia Britannica, Inc., 1974), 10:17.

9. *Austin American Statesman,* April, 1903[?], Flags and Emblems Vertical File, Texas State Library and Archives Commission, Austin, Texas; W. A. George to Captain [?], April 11, 1910, Flag Accession File, Texas State Library and Archives Commission, Austin, Texas.

10. The "test oath" or "ironclad oath" reads in part, "I, do solemnly swear that I have never voluntarily borne arms against the United States . . . that I have voluntarily given no aid, countenance, counsel, or encouragement to persons engaged in armed hostility thereto; that I have neither sought nor accepted nor attempted to exercise the functions of any office whatever, under any authority in hostility to the United States; and that I have not yielded a voluntary support to any pretended government." Charles William Ramsdell, *Reconstruction in Texas,* n. 116.

11. Charles Reagan Wilson and William Ferris, eds., *Encyclopedia of Southern Culture,* 1134.

12. *Austin American Statesman,* April, 1903 [?].

13. Simpson, *In Reunion and Memory,* 15.

14. Ibid., 16–17.

15. "The Flag of the Fifth Texas Regiment Hood's Brigade — Army of Northern Virginia," Fifth Texas Flag File, Harold B. Simpson Research Center, Hill College, Hillsboro, Texas. At the same time, a few blocks from where the veterans of Hood's Brigade met, the survivors of Terry's Texas Rangers were organizing their own association. Simpson, *In Reunion and Memory,* 20.

16. W. A. George to Captain [?], April 11, 1910, Flag Accession File, Texas State Library and Archives Commission, Austin, Texas.

17. The stated purpose of the brigade association, like that of other similar Texas Civil War veterans' groups, was apolitical. "The object of this Corporation shall be to collect and preserve materials for the history of said Brigade and to collect and maintain a permanent fund for the assistance and maintenance of members of said regiments, their children and lineal descendents." Charter of Hood's Texas Brigade Association, June 5, 1874, in Simpson, *In Reunion and Memory,* 319.

18. *Houston Daily Telegraph,* May 15, 1872.

19. Chilton, *Unveiling and Dedication,* 226.

20. At most reunions the veterans brought out the Fourth Texas flag and Mrs. Young's flag for display. In 1885, however, a battle flag of the Third Arkansas, a regiment that had served in the brigade, was also shown; Ibid., 142.

21. *Minutes of the Proceedings of the Association of the U.C.V Held at Lancaster, Texas, August 14 & 15, 1900,* 10, 11, 142. Veterans' attendance at the

1900 meeting breaks down as seventy from Ross's Brigade, thirty-six from Granbury's, and six from Ector's.

22. W. J. Oliphant to H. P. Bee, November 25, 1885, Flag Accession File, Texas State Library and Archives Commission, Austin, Texas.

23. H. P. Bee to W. J. Oliphant, December 3, 1885, Flag Accession File, Texas State Library and Archives Commission, Austin, Texas. The Mexican flags captured at San Jacinto were at this time apparently in possession of the Frontier Regiment. The Office of the Commissioner of Insurance, Statistics, and History had charge of the state's historical documents.

24. U.S. Congress, House, "Captured Battle Flags: Letter From the Secretary of War," Federal Resolutions, Fiftieth Congress, First Session, House of Representatives, Executive Document 163, 3.

25. Madaus and Needham, *Battle Flags of the Army of Tennessee*, 39–40.

26. "Captured Battle Flags," 3.

27. Ibid., 4.

28. Simpson, *In Reunion and Memory*, 3–4.

29. Robert McElroy, *Grover Cleveland: The Man and the Statesman: An Authorized Biography*, 208, 206, 212–13. Substitute the word "racism" for "treason" in this last statement and it fits well into today's controversies.

30. "Captured Battle Flags," 4.

31. McElroy, *Grover Cleveland*, 217.

32. Secretary of War to the Governor of Texas, March 25, 1905, Flag Accession File, Texas State Library and Archives Commission, Austin, Texas.

33. Unidentified document signed by C.W.R. [Cadwell W. Raines], Flag Accession File, Texas State Archives and Library Commission, Austin, Texas.

34. Fannie M. Wilcox to Mrs. Forest B. Farley, June 22, 1929, Flag Accession File, Texas State Library and Archives Commission, Austin, Texas.

35. Graber, *A Terry Texas Ranger*, 401–402.

36. Ibid., 419–22. A major blemish on the affair was the fact that only twenty-four of the regiment's veterans were present. Many, including George Littlefield, who was one of the state's most prominent former Terry's Texas Ranger, refused to attend because they were angry that the ceremony was being held in Dallas and not Austin; Ibid., 420.

37. William T. Clark to F. S. Hutchinson, August 6, 1864, Flag Accession File, Texas State Library and Archives Commission, Austin, Texas.

38. Thomas W. Cutrer, "William Thomas Clark," in Ron Tyler, ed., *NHOT* 2: 139.

39. "Captured Battle Flags," 4.

40. R. H. Hopkins to Andrew LaForge, August 2, 1900. Flag Accession File, Texas State Library and Archives Commission, Austin, Texas.

41. John T. Callahan to Adjutant General Hutchings [Texas Confederate Veterans], July 8, 1914. Flag Accession File, Texas State Library and Archives Commission, Austin, Texas.

42. Chilton, *Unveiling and Dedication*, 315, 14–15, 27. Mrs. Young's flag was probably too fragile for display. Two other Hood's Brigade flags had been re-

turned to the state in 1905 — the cotton issue ANV of the First Texas, lost at Antietam, and the oversized Fourth Bunting ANV captured just before Appomattox. A close reading of the postwar sources indicates still-living veterans had no recollection of these two flags, both of which had served with the First Texas for short intervals.

43. Ibid., 31–32.

44. Simpson, *In Memory and Reunion*, 144.

45. Robert Maberry, Jr., "Conservation of the Flags of Confederate Texas."

46. "Coming Home Again," *Confederate Veteran*, 50.

47. Unidentified newspaper article, Fort Semmes Flag File, Texas Confederate Museum Collection, United Daughters of the Confederacy, Texas Division.

48. Silber, *The Romance of Reunion*, 40, 96, 54.

49. Charles A. Spain, "The Flags and Seals of Texas," 228–29.

50. Robert Justin Goldstein, *Saving "Old Glory": The History of the American Flag Desecration Controversy*, 1.

51. Ibid., 13.

52. Ibid., 44.

53. Walter L. Buenger, "Texas and the South," *Southwestern Historical Quarterly*, 315.

54. Edward Tabor Linenthal, "'A Reservoir of Spiritual Power': Patriotic Faith at the Alamo in the Twentieth Century," *Southwestern Historical Quarterly*, 513.

55. Wylie A. Parker, *The Texas Flag and Texas Week*, 8.

Chapter 8. Patriots' Stars

1. Thomas T. Smith, *The Old Army in Texas: A Research Guide to the U.S. Army in Nineteenth-Century Texas*, 15–16.

2. Keith Over, *Flags and Standards of the Napoleonic Wars*, 18.

3. Quaife, *The Flag of the United States*, 139–40, 142. From 1812 through 1887, as a general rule, U.S. Army flags were made of silk and designs on them were painted. Stars were always of five points and usually arranged in horizontal rows. During the Civil War and just after, however, flag makers placed the canton's stars in oval patterns. Gherardi Davis, *The Colors of the United States Army, 1789–1912*, 47.

4. G. Davis, *The Colors of the United States Army*, 7.

5. The white regimental color had been discontinued in 1835, and from then until 1841, U.S. infantry regiments carried only the blue standard. The blue regimental color became influential in its own turn. By 1942 it was the basic design of nearly half of America's state flags. Quaife, *The Flag of the United States*, 146; G. Davis, *The Colors of the United States Army*, 47.

6. Howard Madaus, "The United States Flag in the American West: The Evolution of United States Flags Produced by U.S. Government Entities During the Westward Movement," in Raven, *A Journal of Vexillology*, 68–69.

7. G. Davis, *Colors of the United States Army*, 19, 30; Over, *Flags and Standards of the Napoleonic Wars*, 21.

8. Quaife, *The Flag of the United States*, 143; Over, *Flags and Standards of the Napoleonic Wars*, 21.

9. Madaus, "The U.S. Flag in the American West," 70.

10. Robert Wooster, *Soldiers, Sutlers, and Settlers: Garrison Life on the Texas Frontier*, 83, 98.

11. Madaus, "The U.S. Flag in the American West," 65–68.

12. William L. Richter, *The Army in Texas during Reconstruction*, 27–30.

13. Arlen Fowler, *The Black Infantry in the West, 1869–1891*, 17–18.

14. Ibid., 115–16.

15. Marcos E. Kinevan, *Frontier Cavalryman: Lieutenant John Bigelow with the Buffalo Soldiers in Texas*, 29.

16. From 1866 to 1881, of the four infantry and three cavalry regiments typically serving in Texas, two infantry and two cavalry were black. Smith, *The Old Army in Texas*, 19.

17. Paul H. Carlson, *"Pecos Bill": A Military Biography of William R. Shafter*, 45. The Twenty-fourth's colonel, Ranald S. MacKenzie, and lieutenant colonel, William R. Shafter, would achieve considerable fame during their frontier service.

18. Ibid., n. 15.

19. Madaus, "The U.S. Flag in the American West," 70; U.S. Army, *Heraldic Services Handbook*, 21.

20. Fowler, *Black Infantry in the West*, 23; Wooster, *Soldiers, Sutlers, and Settlers*, 8.

21. Fowler, *Black Infantry in the West*, 23–33.

22. William H. Leckie, "Ninth United States Cavalry," in Ron Tyler, ed., *NHOT* 4: 1018–19.

23. William H. Leckie, *The Buffalo Soldiers: A Narrative of Negro Cavalry in the West*, 13.

24. Ibid., n. 26.

25. William H. Leckie, "Tenth United States Cavalry," in *NHOT* 6: 255.

26. Madaus, "The U.S. Flag in the American West," 69.

27. Ibid., 32.

28. Quoted in Fowler, *Black Infantry in the West*, 38–39.

29. Stephen Hardin, *The Texas Rangers*, 24.

30. Wooster, *Soldiers, Sutlers, and Settlers*, 194; Mark Odintz, "Buffalo Soldiers," in *NHOT* 1: 815.

31. Charles Reginald Shrader, ed., *Reference Guide to United States Military History, 1865–1919*, 48–49.

32. Christian G. Nelson, "Texas Militia in the Spanish-American War," *Texas Military History*, 195.

33. Jerry Cooper, *The Rise of the National Guard: The Evolution of the American Militia, 1865–1920*, 106.

34. U.S. Army, *Correspondence Related to the War with Spain Including the Insurrection in the Philippine Islands and the China Relief Expedition April 15, 1898, to July 30, 1902*, 612–20.

35. Ibid., 620.

36. Quaife, *The Flag of the United States*, 149; G. Davis, *The Colors of the United States Army*, 26.

37. Stan Cohen, *Images of the Spanish-American War*, 120.

38. Theodore Roosevelt, *The Rough Riders*, 60.

39. Ibid., 74.

40. Virgil Carrington Jones, *Roosevelt's Rough Riders*, 24–25. The Women's Relief Corps was the ladies' auxiliary of the Grand Army of the Republic.

41. The citizens of the New Mexico Territory also presented a Stars and Stripes to their volunteers. It measured seventy-one and a half by sixty-one inches. The Arizona squadron, however, had arrived in San Antonio first, and its flag remained the regiment's choice; J. C. Stewart, *Cowboys in Uniform: Uniforms, Arms, and Equipment of the Rough Riders*, 64.

42. Party politics also played a significant role in the appointments. Most of the former Confederates were prominent leaders of the Democratic Party, and the president desired to augment his administration's southern support. Graham A. Cosmas, *An Army for Empire: The United States Army in the Spanish-American War*, 142.

43. Roosevelt, *The Rough Riders*, 77.

44. Jones, *Roosevelt's Rough Riders*, 48.

45. Walter Millis, *The Martial Spirit*, 267.

46. The famous July 1 charge up San Juan Hill was like a reunion of regiments from the days on the Texas frontier. Roosevelt personally led forward the Rough Riders, who were joined by the Ninth and Tenth Cavalry. Nearby was the Shafter's old Twenty-fourth Infantry. Two other regiments in the fight, the Third and Sixth Cavalry, had also served in Texas.

47. Miles V. Link, *The Black Trooper*, 42.

48. Dale L. Walker, *The Boys of '98*, 216; Roosevelt, *The Rough Riders*, 140. Photographic evidence suggests that all three Rough Rider flags were present at the battle but do not reveal which were carried to the summit of Kettle and San Juan Hills.

49. Cohen, *Images of the Spanish-American War*, 125.

50. Cooper, *Rise of the National Guard*, 106.

51. Ibid., 46–47.

52. Ibid., 122.

53. Ibid., 157.

54. U.S. Army, *The Official Record of the United States' Part in the Great War*, 22 (hereafter cited as *ORWWI*).

55. The U.S. Army in World War I consisted of twenty regular army divisions, seventeen national guard, eighteen conscript, and two conscripted black divisions; *ORWWI*, 25. During training and deployment there was considerable shuffling of personnel, so some Texas guardsmen served in the Ninetieth and some draftees in the Thirty-sixth.

56. Lonnie J. White, "The Formation of the 36th Division," *Military History of Texas and the Southwest*, 30, 35–36.

57. *Heraldic Services Handbook*, 21. As tactics evolved and the army became more specialized, the War Department ordered other types of flags for occasional usage. Regulations for artillery and engineering unit colors were issued. Guidons, each with its own color, were added for each branch of service. By 1913 there were guidons for everything from the air service to infantry to medical corps (*Heraldic Services Handbook*, 23–24).

58. Lonnie J. White, "Camp Bowie," *Military History of Texas and the Southwest*, 82.

59. By the time the division shipped overseas, the complement was about 60 percent Texas Guardsmen, 12.5 percent from Oklahoma, and the remaining 25 percent were conscripts; *ORWWI*, 24.

60. White, "Camp Bowie," 82; William E. Jary, Jr., ed., *Camp Bowie Fort Worth, 1917–18: An Illustrated History of the 36th Division in the First World War*, 102.

61. White, "The Formation of the 36th Division," 47.

62. Ben F. Chastaine, *The Story of the 36th: The Experiences of the 36th Division in the World War*, 17.

63. Lonnie White, "Indian Soldiers of the 36th Division," *Military History of Texas and the Southwest*, 1, 12.

64. *Biennial Report of the Adjutant General of Texas from January 1, 1919 to December 31, 1920*, 107–108.

65. White, "Formation of the 36th Division," 43.

66. Jary, ed., *Camp Bowie Fort Worth*, 60. Another proposed design, a lone star overlaid with the head of an Indian warrior, was not used because it had been granted to the regular army's Second Division (Jary, ed., *Camp Bowie Fort Worth*, 60).

67. George Wythe, *A History of the 90th Division*, 3–7.

68. Lonnie J. White, *The 90th Division in World War I: The Texas-Oklahoma Division in the Great War*, 204.

69. Ibid., 22.

70. White, *The 90th Division*, 162–63.

71. *San Antonio Light*, February 22, 1918. Attitudes had so changed that when command of the Texas Brigade in France was awarded to a Minnesotan improbably named Ulysses Grant McAlexander, who was son of a Union Civil War officer, this action provoked no unfavorable comments; White, *The 90th Division*, 89.

72. *Biennial Report of the Adjutant General of Texas*, 11. "21 units are represented by one or more flags"; ibid.

73. *A Short History and Photographic Record of the 359th Infantry Texas Brigade*, 4.

Selected Bibliography

Archival Collections

Center for American History, University of Texas at Austin
 Annexation File
 Sarah Brady Dodson Papers
 Alexander Dienst Papers
 Texas Veterans Association Papers
Dallas Historical Society, Dallas, Texas
 Sam H. Acheson Papers
 Mexican Flag Accession File
Daughters of the Republic of Texas Library, The Alamo, San Antonio
 Ross Anderson Papers
 Texas Flag Papers
Harold B. Simpson Research Center, Hill College, Hillsboro, Texas
 Fifth Texas Infantry File
 Fifth Texas Flag File
 First Texas Infantry File
 First Texas Flag File
 Fourth Texas Infantry File
 Fourth Texas Flag File
 Hood's Texas Brigade Association File
 Khleber Van Zandt Letters
 Sixth Texas Cavalry File
 Seventh Texas Infantry File
 Third Texas Infantry File
Navarro College Library, Corsicana, Texas
 Pearce Civil War Collection
Tennessee State Library, Nashville, Tennessee
 Charles D. Douglas Diary
The Texas Collection, Baylor University, Waco, Texas
 Robert Hodges Letters
 Lawrence Sullivan Ross Letters
Texas Confederate Museum Collection, United Daughters of the Confederacy
 Haley Library, Midland, Texas
 Flag Collection Papers
Texas Memorial Museum, University of Texas at Austin
 Flag Accession File
Texas State Library and Archives Commission, Austin, Texas
 Adjutant Generals' Papers
 Flag Accession File
 Flags and Emblems Vertical File
 Governor Clark's Correspondence
 Index to Captains of Texas Units in Confederate States Service
 Oscar Haas Papers

Government Documents

Mexico
Laws Passed by the Legislature of the State of Coahuila and Texas. Militia
 Law. 1828.

Texas
*Biennial Report of the Adjutant General of Texas From January 1, 1919 to
 December 31, 1920*. Austin, Tex.: Knape Printing Company, n.d.
Republic of Texas Senate Committee Report, 3rd Congress, January 4,
 1839, 87.

United States
Compiled Service Records of Confederate Soldiers Who Served in
 Organizations From the State of Texas. Washington, D.C.: National
 Archives and Record Service.
U.S. Army. *Correspondence Related to the War with Spain Including the
 Insurrection in the Philippine Islands and the China Relief Expedition
 April 15, 1898, to July 30, 1902*. Washington, D.C.: Center for Military
 History, 1993.
———. *Heraldic Services Handbook*. Ft. Belvoir, Va.: The Institute of
 Heraldry, n.d.
———. *The Official Record of the United States' Part in the Great War*.
 Washington, D.C.: Office of the Secretary of War, n.d.
U.S. Bureau of the Census. *Eighth Census of the United States*. 4 vols.
 Washington, D.C.: Government Printing Office, 1864.
———. *Preliminary Report of the Eighth Census 1860*. Washington, D.C.:
 Government Printing Office, 1862.
U.S. Congress, House. "Captured Battle Flags: Letter From the Secretary of
 War." Federal Resolutions, Fiftieth Congress, House of Representatives.
 Executive Document 163.
U.S. Navy. United States Atlantic Fleet, USS *Texas*, After Action Report,
 26 June 1944, File: BB 35/A9, Serial 084.
U.S. War Department. *The War of the Rebellion: A Compilation of the Official
 Records of Union and Confederate Armies*. Washington, D.C.: 1880–1901.

Primary Materials

Almonte, Juan Nepomuceno, "The Private Journal of Juan Nepomucen Almote, February 1–April 16, 1836." *Southwestern Historical Quarterly*, no. 48 (July, 1944–April, 1945): 10–32.

Barker, Eugene C., ed. *The Austin Papers, Volume III*. Austin: University of Texas, 1926.

Barney, C. *Recollections of Field Service with the Twentieth Iowa Infantry Volunteers*. Davenport, Iowa: n.p., 1865.

Barron, Samuel B. *The Lone Star Defenders: A Chronicle of the Third Texas Cavalry Regiment in the Civil War*. New York: Neal Publishing Company, 1881.

Batchelor, Benjamin Franklin, and George Q. Turner. *Batchelor-Turner Letters, Written by Two of Terry's Texas Rangers*. Annotated by H. J. H. Rugeley. Austin, Tex.: The Steck Company, 1961.

Blocker, A. B. "The Boy Bugler of the Third Texas Cavalry: The A. B. Blocker Narrative," pt. 1. edited by Max S. Lale. *Military History of Texas and the Southwest*, 14 (1978): 71–92.

Buck, Irving A. *Cleburne and His Command*. Dayton, Ohio: Morningside Bookshop, 1984.

Caro, Ramon Martinez. *A True Account of the First Texas Campaign and the Events Subsequent to the Battle of San Jacinto*. Translated by Carlos E. Castañeda. Mexico City: Imprenta de Santiago Perez, 1837.

Castañeda, Carlos E., ed. and trans. *The Mexican Side of the Texas Revolution*. Dallas: P. L. Turner Company, 1928.

Chastaine, Ben F. *The Story of the 36th: The Experiences of the 36th Division in the World War*. Oklahoma City: Harlow Publishers, 1920.

Chilton, F. B. *Unveiling and Dedication of the Monument to Hood's Texas Brigade*. Houston: F. B. Chilton, 1911.

"Coming Home Again." *Confederate Veteran* 36, no. 1 (January, 1928): 50–51.

Connor, Seymour, ed. *Texas Treasury Papers: Letters Received in the Treasury Department of the Republic of Texas, 1836–1846*. 4 vols. Austin: Texas State Library, 1955.

Cushing, S. W. *Adventures in the Texas Navy and at the Battle of San Jacinto*. Austin, Tex.: W. M. Morrison Books, 1985.

Davis, Reverend Nicholas A. *The Campaign from Texas to Maryland with the Battle of Fredricksburg*. Austin, Tex.: The Steck Company, 1961.

Davy Crockett's Own Story: As Written by Himself. New York: Citadel Press, 1955.

Day, James, ed. *The Texas Almanac 1857–1873: A Compendium of History*. Waco, Tex.: The Texian Press, 1967.

Debray, X. B. *A Sketch of the History of Debray's (26th) Regiment of Texas Cavalry*. Austin, Tex.: E. von Boeckman, 1884.

Delgado, Pedro, and Sam Houston. *The Battle of San Jacinto: Viewed from Both an American and Mexican Standpoint*. Austin, Tex.: Institution for the Deaf and Dumb, 1878.

DeShields, James T., comp. *Tall Men with Long Rifles: Set Down and Written Out by James T. DeShields as Told to Him by Creed Taylor*. San Antonio: The Naylor Company, 1935.

Ehrenberg, Herman. *The Fight for Freedom in Texas in the Year 1836*. Translated by Peter Mollenhauer. In Ornish, Natalie. *Ehrenberg: Goliad Survivor, Old West Explorer*. Dallas: Texas Heritage Press, 1993.

Evans, Clement A., ed. *Confederate Military History: Library of Confederate States History in Twelve Volumes Written by Distinguished Men of the South*. 12 vols. Atlanta: Confederate Publishing Co., 1899.

Filisola, Vincente. *Memoirs for the History of the War in Texas*. 2 vols. Austin, Tex.: Eakin Press, 1987.

Flags of the Principal Nations of the Earth. Philadelphia: Hinman & Dutton, 1837.

Ford, John Salmon. *Rip Ford's Texas*. Edited by Stephen B. Oats. Austin: University of Texas Press, 1987.

Foster, Samuel T. *One of Cleburne's Command: The Civil War Reminiscences and Diary of Samuel T. Foster, Granbury's Brigade, CSA*. Edited by Norman D. Brown. Austin: University of Texas Press, 1980.

Fremantle, James Arthur Lyon. *The Fremantle Diary*. Edited by Walter Lord. Boston: Little, Brown, 1954.

Gammel, H. P. N. *The Laws of Texas, 1822–1897*. 10 vols. Austin, Tex.: Gammel Book Co., 1898.

The General Convention at Washington, March 1–17, 1836. Houston: n.p., 1838.

Giles, L. B. *Terry's Texas Rangers*. Austin, Tex.: Von Boeckman-Jones, 1911.

Giles, Val C. "The Flag of the First Texas, A.N. Virginia." *Confederate Veteran* 15, no. 9 (September, 1907): 417

Glick, Charles Adams, Jr. *The Papers of Mirabeau Buonaparte Lamar*. 6 vols. Austin, Tex.: Boeckman-Jones Co., 1914.

Glover, Robert W., ed. *Tyler to Sharpsburg: Robert H. and Henry Gaston, Their Civil War Letters, 1861–1862*. Waco, Tex.: W. M. Morrison, 1960.

Goyne, Minetta A., ed. *Lone Star and Double Eagle: Civil War Letters of a German-American Family*. Fort Worth: Texas Christian University Press, 1982.

Graber, H. W. *A Terry Texas Ranger: The Life Record of H. W. Graber, Sixty-two Years in Texas*. N.p.: published by H. W. Graber, 1916.

Hanks, O. T. *History of Captain B. F. Benton's Company, Hood's Texas Brigade, 1861–1865*. Austin, Tex.: Morrison Books, 1984.

Harkort, Eduard. "Journal of Col. Eduard Harkort, Captain of Engineers, Texas Army, February 8–July 17, 1836." Translated and edited by Louis E. Brister. *Southwestern Historical Quarterly* 103, no. 3 (January, 1999): 345–79.

Harwell, Thomas Fletcher. *Eighty Years under the Stars and Bars*. Kyle, Tex.: n.p., 1947.

Jenkins, John H., ed. *Papers of the Texas Revolution*. 10 vols. Austin, Tex.: Presidial Press, 1973.

Jenkins, John Holland. *Recollections of Early Texas: The Memoirs of John Holland Jenkins*. Edited by John Holmes Jenkins, III. Austin: University of Texas Press, 1958.

Johnson, Robert U., and Clarence C. Buel, eds. *Battle and Leaders of the Civil War*. 4 vols. New York: Century Publishing, 1887.

Kendall, George Wilkins. *Narrative of the Santa Fe Expedition*. London: Wiley & Putnam, 1844.

Lane, Walter P. *The Adventures and Recollections of General Walter P. Lane*. Marshall, Tex.: News Messenger, 1928.

Laws of the Republic of Texas. 2 vols. Houston: n.p., 1838.

Lincecum, Gideon. *Gideon Lincecum's Sword: Civil War Letters from the Home Front*. Edited by Jerry Bryan Lincecum, Edward Hake Phillips, and Peggy A. Redshaw. Denton: University of North Texas Press, 2001.

Linn, John J. *Reminiscences of Fifty Years in Texas*. Austin, Tex.: The Steck Company, 1935.

Lowe, Richard, ed. *A Texas Cavalry Officer's Civil War: Diary and Letters of James C. Bates*. Baton Rouge: Louisiana State University Press, 1999.

Lozedon, Jack E. "Flag of the Ninth Texas Infantry." *Confederate Veteran* 17, no. 8 (August, 1909): 455.

McCutchan, Joseph D. *Mier Expedition Diary*. Edited by Joseph Milton Nance. Austin: University of Texas Press, 1978.

Minutes and Proceedings of the Association of the U.C.V. held at Lancaster, Texas, August 14 & 15, 1900. N.p.: privately printed, 1900.

Minutes of the Proceedings of the Association of the Survivors of Ross', Ector's, and Granberry's Brigades, U.C.V. Held at Garland, Texas, 8 and 9, 1899. N.p: privately printed, 1899.

Peña, José Enrique de la. *With Santa Anna in Texas: A Personal Narrative of the Revolution*. Translated by Carmen Perry. College Station: Texas A & M University Press, 1997.

Polley, J. B. *Hood's Texas Brigade; Its Marches, Its Battles, Its Achievements*. New York: Neale, 1910.

"Presentation of Bonnie Blue Flag." *Confederate Veteran* 3, no. 7 (July, 1895): 216.

"Return of a Confederate Battle Flag." *Confederate Veteran* 22, no. 7 (July, 1914): 302.

Ridley, Bromfield L. *Battles and Sketches of the Army of Tennessee*. Mexico, Mo.: Missouri Printing and Publishing Co., 1906.

Roosevelt, Theodore. *The Rough Riders*. Reprint, Dallas: Taylor Publishing, 1997.

Rose, Victor. *Ross' Texas Brigade*. Louisville, Ky.: Courier-Journal Book and Job Rooms, 1881.

Roundtree, Maude McIver. "The Texas Ranger's Flag." *Confederate Veteran* 10, no. 4 (1910): 159

Smithwick, Noah. *Evolution of a State; or, Recollections of Old Texas Days*. Compiled by Nanna Smithwick Donaldson. 1900; reprint, Austin: University of Texas Press, 1983.

Southern Historical Society Papers. 52 vols. Richmond, Va.: Southern Historical Society, 1910.

Sparks, A. W. *The War between the States as I Saw It*. Tyler, Tex.: Lee & Burnett, 1901.

Texas Almanac 1857. Galveston: B. D. Richardson & Co., 1857.

Texas Almanac 1861. Galveston: B. D. Richardson & Co., 1861.

Watkins, Sam R. *"Co. Aytch," A Side Show of the Big Show*. Nashville: Cumberland Presbyterian Publishing House, 1882.

Winkler, William, ed. *Journal of the Secession Convention of Texas 1861*. Austin, Tex.: Austin Printing Company, 1912.

Wood, Campbell. "Flags of the Fifth Texas, C.S.A." Prepared by J. B. Polley in "Historical Reminiscences." Daughters of the Republic of Texas Library, The Alamo, San Antonio, Texas.

Wood, W. D. *A Partial Roster of the Officers and Men Raised in Leon County, Texas, for Service of the Confederate States in the War between the States with Short Biographical Sketches of Some of the Officers, and a Brief History of Maj. Gould's Battalion*. N.p.: privately printed, 1899.

Wright, Mrs. D. Giraud. *A Southern Girl in '61: The War-Time Memories of a Confederate Senator's Daughter*. New York: Doubleday, Page & Company, 1905.

Secondary Materials

Abernathy, Thomas P. *The South in the New Nation, 1789–1819*. Baton Rouge: Louisiana State University Press, 1961.

Adams, Anton. *The War with Mexico*. Chicago: The Emperor's Press, 1998.

Annals of America. 19 Vols. Chicago: Encyclopedia Britannica, 1974.

Bailey, Anne J. *Texans in the Confederate Cavalry*. Abilene, Tex.: McWhiney Foundation Press, 1998.

Bailey, Fred Arthur. "Free Speech and the 'Lost Case' in Texas: A Study in Social Control in the New South." *Southwestern Historical Quarterly* 97, no. 3 (January, 1994): 453–77.

Banderas: Catálogo de la Colección de Banderas. México, D.F.: Secretaria de Gobernatión, 1990.

Barraclough, E. M. C., ed. *Flags of the World*. London: Fredrick Warne, 1953.

Basurto, Carman G. *Mexico y Son Simbols*. México, D.F.: n.p., n.d.

Belfliglio, Valentine J. *Honor, Pride, Duty: A History of the Texas State Guard.* Austin, Tex.: Eakin Press, 1995.

Buenger, Walter L. "Texas and the South." *Southwestern Historical Quarterly* 103, no. 3 (January, 2000): 309–26.

Campbell, Gordon. *The Book of Flags.* London: Oxford University Press, 1960.

Cannon, Devereaux D., Jr. *Flags of Tennessee.* Gretna, La.: The Pelican Press, 1990

———. *The Flags of the Confederacy: An Illustrated History.* Memphis: St. Luke's Press, 1988.

———. *The Flags of the Union: An Illustrated History.* Gretna, La.: The Pelican Press, 1994.

Cantrell, Gregg. *Stephen F. Austin: Empresario of Texas.* New Haven, Conn.: Yale University Press, 1999.

Carlson, Paul H. *"Pecos Bill": A Military Biography of William R. Shafter.* College Station: Texas A&M University Press, 1989.

Cohen, Stan. *Images of the Spanish-American War.* Missoula, Mont.: Pictorial Histories Publishing Co., 1997.

Connelly, Thomas Lawrence. *Army of the Heartland: The Army of Tennessee, 1861–1862.* Baton Rouge: Louisiana State University Press, 1967.

Cooper, Jerry. *The Rise of the National Guard: The Evolution of the American Militia, 1865–1920.* Lincoln: University of Nebraska Press, 1997.

Cosmas, Graham A. *An Army for Empire: The United States Army in the Spanish-American War.* College Station: Texas A&M University Press, 1994.

Cox, Mamie Wynn. *The Romantic Flags of Texas.* Dallas: Banks Upshaw and Company, 1936.

Crabb, Martha L. *All Afire to Fight: The Untold Story of the Civil War's Ninth Texas Cavalry.* New York: Post Road Press, 2000.

Crenshaw, Ollinger. *General Lee's College: The Rise and Growth of Washington and Lee University.* New York: Random House, 1969.

Crute, Joseph H. *Emblems of Southern Valor: The Battle Flags of the Confederacy.* Louisville, Ky.: Harmony House, 1990.

Culmer, Carita M. "Trial by Jury in the Court of Public Opinion: Phoenix Reacts to the Flag Art Exhibition, Phoenix Art Museum, March 16–June 16, 1996." *Raven: A Journal of Vexillology* 5 (1998): 5–15.

Davis, Gherardi. *Colors of the United States Army, 1789–1912.* New York: Gillis Press, 1912.

Davis, William C. *"A Government of Our Own": The Making of the Confederacy.* New York: The Free Press, 1994.

———. *Three Roads to the Alamo: The Lives and Fortunes of David Crockett, James Bowie, and William Barret Travis.* New York: Harper Collins, 1998.

Dedmont, Glenn. *The Flags of Civil War South Carolina.* Gretna, La.: The Pelican Press, 2000.

DePalo, William A. *The Mexican National Army, 1822–1852.* College Station: Texas A&M University Press, 1997.

DeRosa, Marshall. *The Confederate Constitution: An Inquiry into American Constitutionalism.* Columbia: University of Missouri Press.

"The Dodson Flag." *Military History of Texas and the Southwest* 15, no. 1: 4.

Downs, Winfield Scott, ed. *Encyclopedia of American Biography.* New York: The America Historical Society, 1935.

Duaine, Carl C. *The Dead Men Wore Boots: An Account of the 32nd Texas Volunteer Cavalry, CSA, 1862–1865.* Austin, Tex.: San Felipe Press, 1966.

Dunn, Roy Sylvan. "The KGC in Texas 1860–1861." *Southwestern Historical Quarterly* 70, no. 4 (April, 1967): 543–73.

Fehrenbach, T. R. *Fire and Blood: A Bold and Definitive Modern Chronicle of Mexico.* New York: Collier Books, 1973.

———. *Lone Star: A History of Texas and Texans* (New York: Macmillan, 1968.

Field, Ron. *Mexican-American War, 1847–1848.* London: Brassey's Ltd., 1997.

Finch, Karen, and Greta Putnam. *The Care and Preservation of Textiles.* Berkeley: LACIS, 1985.

Flores, Romero Jesús. *Banderas Históricas Mexicanas.* N.p.: Libro Mex, 1958.

Fowler, Arlen. *The Black Infantry in the West, 1869–1891.* Norman: University of Oklahoma Press, 1996.

Frazier, Donald S., ed. *The United States and Mexico at War: Nineteenth-Century Expansion and Conflict.* New York: Macmillan Reference USA, 1998.

Gaddy, Jerry J., and J. Hefter. *Texans in Revolt: Contemporary Newpaper Account of the Texas Revolution.* Fort Collins, Colo.: Old Army Press, 1973.

Garrison, George P. "Another Texas Flag." *Quarterly of the Texas State Historical Association* 3, no. 3 (January, 1900): 170–76.

Gebhart, John R. *Your State Flag.* Philadelphia: Franklin Publishing Company, 1973.

Gilbert, Charles E. *Flags of Texas.* Gretna, La.: Pelican Publishing Company, 1994.

Goldstein, Robert Justin. *Saving "Old Glory": The History of the American Flag Desecration Controversy.* Boulder, Colo.: Westview Press, 1995.

Hale, Douglas. *The Third Texas Cavalry in the Civil War.* Norman: University of Oklahoma Press, 1993.

Hardin, Stephen L. *The Texas Rangers.* London: Osprey, 1991.

———. *Texian Iliad: A Military History of the Texas Revolution.* Austin: University of Texas Press, 1994.

Harriman, Cynthia. "A Grassroots Effort to Preserve the Past." *Heritage Magazine* 18, no. 1 (winter, 2000): 22–25.

Hefter, Joseph. *El Soldado Mexicano.* México, D.F.: Edíciónes Nieto, Brown, Hefter, 1958.

Henry, David Pope. *A Lady and a Lone Star Flag: The Story of Joanna Troutman.* San Antonio: The Naylor Company, 1936.

Hubbs, G. Wars. "Lone Star Flags and Nameless Rags." *The Alabama Review* 34, no. 4 (October, 1986): 271–301.

Huff, Richard A., ed. *A Pictorial History of the 36th Division*. Austin, Tex.: The 36th Division Association, 1995.

Huson, Hobart. *Captain Phillip Dimmitt's Commandancy of Goliad October 15, 1835–January 17, 1836*. Austin, Tex.: Von Boeckman-Jones, 1974.

Jackson, Ron. *Alamo Legacy: Alamo Descendents Remember the Alamo*. Austin, Tex.: Eakin Press, 1997.

Jary, William E., Jr. *Camp Bowie Fort Worth, 1917–18: An Illustrated History of the 36th Division in the First World War*. Fort Worth, Tex.: B. B. Maxfield Foundation, 1975.

Jones, Virgil Carrington. *Roosevelt's Rough Riders*. New York: Doubleday & Company, 1971.

Katcher, Philip, Rick Scollins, and Gary Embleton. *Flags of the American Civil War 3: State and Volunteer*. London: Osprey, 1993.

Kemp, L. W. "Official Flags of the Republic of Texas." *Southwestern Historical Quarterly* 59, no. 4 (April, 1956): 487–90.

Kidd, J. C. *Texas, Her Flags*. Houston: Dealy-Adey Co., 1910.

Kiel, Frank Wilson. "A Fifteen-Star Texas Flag: A Banner Used at the Time of Secession — February 1861 and March 1861." *Southwestern Historical Quarterly* 103, no. 3 (January, 2000): 357–65.

Kinevan, Marcos E. *Frontier Cavalryman: Lieutenant John Bigelow with the Buffalo Soldiers in Texas*. El Paso: Texas Western Press, 1998.

Lack, Paul D. *The Texas Revolutionary Experience: A Political and Social History, 1835–1836*. College Station: Texas A&M University Press, 1992.

Lamego, Miguel A. Sanchez. *The Second Mexican-Texas War, 1841–43*. Hillsboro, Tex.: Hill Junior College Press, 1972.

———. *The Siege and Taking of the Alamo*. Santa Fe, N.Mex.: The Press of the Territorian, 1968.

Leckie, William H. *The Buffalo Soldiers: A Narrative of the Negro Cavalry in the West*. Norman: University of Oklahoma Press, 1967.

Linenthal, Edward Tabor. "'A Reservoir of Spiritual Power': Patriotic Faith at the Alamo in the Twentieth Century." *Southwestern Historical Quarterly* 91, no. 4 (April, 1988): 509–31.

Link, Miles V. *The Black Trooper*. New York: n.p., 1899.

Loomis, Noel. *The Texan-Santa Fe Pioneers*. Norman: University of Oklahoma Press, 1958.

Looscan, Adele B. "Harris County, 1822–1845." *Southwestern Historical Quarterly* 18, no. 3 (January, 1915): 399–409.

Lord, Walter. *A Time to Stand*. New York: Harper and Brothers, 1961.

Maberry, Robert, Jr. "Saving the colors: Flag Preservation in Texas." *Heritage Magazine* 18, no. 1 (winter, 2000): 6–15.

McElroy, Robert. *Grover Cleveland: The Man and the Statesman: An Authorized Biography*. New York: Harper and Brothers, 1923.

McGuire, James Patrick. *Iwonski in Texas: Painter and Citizen*. San Antonio: San Antonio Museum Association, 1976.

McWhiney, Grady. *Battle in the Wilderness: Grant Meets Lee*. Abilene, Tex.: McWhiney Foundation Press, 1998.

———. *Cracker Culture: Celtic Ways in the Old South*. Tuscaloosa: University of Alabama Press, 1988.

McWhiney, Grady, and Perry Jamieson. *Attack and Die: Civil War Military Tactic and the Southern Heritage*. Tuscaloosa: University of Alabama Press, 1982.

Madaus, Howard Michael. "Battle Flags of the Army of Mississippi/Army of Tennessee (1861–Late 1863)." Flags of the Confederacy Web Site, http://home.att.net~dcannon.tenn/FOTCaotm.html#hardee, September 24, 2000.

———. "Battle Flags of the Army of Tennessee (Late 1863–1865)." Flags of the Confederacy Web Site, http://home.att.net~dcannon.tenn/FOTCaot.html#cleburne, September 24, 2000.

Madaus, Howard Michael, Greg Biggs, and Devereaux Cannon. "Battle Flags of the Army of Northern Virginia." Flags of the Confederacy Web Site, http://home.att.net/~dcannon.tenn/FOTCanv.html, September 24, 2000.

Madaus, Howard Michael, and Robert D. Needham. *The Battle Flags of the Confederate Army of Tennessee*. Milwaukee, Wis.: Milwaukee Public Museum, 1976.

———. "Unit Colors of the Trans-Mississippi Confederacy, Part 1." *Military Collector & Historian* 16, no. 3 (fall, 1989): 123–41.

———. "Unit Colors of the Trans-Mississippi Confederacy, Part 2." *Military Collector & Historian* 41, no. 4 (winter, 1989): 172–82.

———. "The United States Flag in the American West: The Evolution of United States Flags Produced by U.S. Government Entities During the Westward Movement." *Raven, A Journal of Vexillology* 5 (1998): 53–78.

Marshall, Bruce. *Uniforms of the Republic of Texas, and the Men that Wore Them, 1836–1846*. Atglen, Penn.: Shiffer Military History, 1999.

Mastai, Boleslaw, and Mary-Louise D'Ortange Mastai. *The Stars and Stripes: The Evolution of the American Flag*. Fort Worth: The Amon Carter Museum, 1961.

Millis, Walter. *The Martial Spirit*. New York: The Literary Society, 1931.

Moneyhon, Carl, and Bobby Roberts. *Portraits of Conflict: A Photographic History of Texas in the Civil War*. Fayetteville: University of Arkansas Press, 1998.

Moss, Rosalind Urbach. "'Yes, There's a Reason I Salute the Flag': Flag Use and the Civil Rights Movement." *Raven: A Journal of Vexillology* 5 (1998): 16–37.

Myer, Michael C., and William L. Sherman. *The Course of Mexican History*. New York: Oxford University Press, 1995.

Nackerman, Mark E. *Nation within a Nation: The Rise and Fall of Texas Nationalism*. Port Washington, N.Y.: Kennikat Press, 1975.

Nance, Joseph Milton. *After San Jacinto: The Texas-Mexican Frontier, 1836–1841*. Austin: University of Texas Press, 1963.

———. *Attack and Counter-Attack: The Texas-Mexican Frontier, 1842*. Austin: University of Texas Press, 1964.

———. "Was There a Mier Expedition Flag?" *Southwestern Historical Quarterly* 92, no. 4 (April, 1989): 543–57.

Nelson, Christian G. "Texas Militia in the Spanish-American War." *Texas Military History* 2, no. 3 (August, 1962): 193–209.

New Larousse Encyclopedia of Mythology. London: Hamlyn Publishing Group, 1959.

O'Connor, Kathryn Stoner. *The Presidio La Bahia del Espiritu Santo de Zuniga*. Austin, Tex.: Von Boeckman-Jones, 1966.

O'Leary, Cecelia Elizabeth. *To Die For: The Paradox of American Patriotism*. Princeton, N.J.: Princeton University Press, 1999.

Over, Keith. *Flags and Standards of the Napoleonic Wars*. London: Bivouac Books, 1976.

Parker, Wylie A. *The Texas Flag and Texas Flag Week*. Dallas: George Colgin Co., 1934

Pastoureau, Michel. *Heraldry: An Introduction to a Nobel Tradition*. New York: Harry N. Abrams, 1997.

Power, Hugh. *Battleship Texas*. College Station: Texas A&M University Press, 1993.

Preble, George Henry. *Origin and History of the American Flag*. Philadelphia: Nicholas L. Brown, 1880.

Quaife, Milo Milton. *The Flag of the United States*. New York: Grosset & Dunlap, 1942.

Quaife, Milo, Melvin J. Weig, and Roy E. Appleman. *The History of the United States Flag: From the Revolution to the Present, Including a Guide to Its Use and Display*. New York: Harper, 1961.

Ramsdell, William. *Reconstruction in Texas*. Austin: University of Texas Press, 1970.

Richardson, Rupert. *Texas: The Lone Star State*. Englewood Cliffs, N.J.: Prentice-Hall, 1958.

Richter, William L. *The Army in Texas during Reconstruction, 1865–1870*. College Station: Texas A&M University Press, 1987.

Rogers, H. C. B. *Napoleon's Army*. New York: Hippocrene Books, 1974.

Rollins, Richard. *"The Damned Red Flags of Rebellion": The Confederate Battle Flag at Gettysburg*. Redondo Beach, Calif.: Rank and File Publications, 1997.

———, ed. *The Returned Battle Flags*. Redondo Beach, Calif.: Rank and File Publications, 1995.

Ross, Kurt. *Codex Mendoza*. Fribourg: Productions Liber, S.A., 1978.

Santos, Richard G. *Santa Anna's Campaign against Texas, 1835–1836*. Salisbury, N.C.: Texian Press, 1968.

Sauers, Richard. *Advance the Colors! Pennsylvania Civil War Battle Flags*. 2 vols. [Harrisburg, Pa.]: Capitol Preservation Committee, 1987.

Scaife, William R. *The Campaign for Atlanta*. Atlanta: privately published, 1993.

Schlesinger, Arthur M., Jr. *Running for President: The Candidates and Their Images*. 2 vols. New York: Simon and Schuster, 1994.

Schoelwer, Susan Prendergast. *Alamo Images: Changing Perceptions of a Texas Experience*. Dallas: DeGolyer Library and Southern Methodist University Press, 1985.

Shackford, James Atkins. *David Crockett: The Man and the Legend*. Chapel Hill: University of North Carolina Press, 1956.

A Short History and Photographic Record of the 359th Infantry Texas Brigade. San Antonio: San Antonio Printing Company, 1918.

Shrader, Charles Reginald, ed. *Reference Guide to United States Military History, 1865–1920*. New York: Facts on File, 1993.

Silber, Nina. *The Romance of Reunion: Northerners and the South, 1865–1900*. Chapel Hill: University of North Carolina Press, 1993.

Simpson, Harold B. *Hood's Texas Brigade: A Compendium*. Hillsboro, Tex.: Hill Junior College Press, 1977.

———. *Hood's Texas Brigade: In Reunion and Memory*. Hillsboro, Tex.: Hill Junior College Press, 1974

———. *Hood's Texas Brigade: Lee's Grenadier Guard*. Waco, Tex.: Texian Press, 1970.

Smith, Justin. *The Annexation of Texas*. New York: The MacMillan Company, 1919.

Smith, Thomas T. *The Old Army in Texas: A Research Guide to the U.S. Army in Nineteenth-Century Texas*. Austin: Texas State Historical Association, 2000.

Smith, Whitney. *The Flag Book of the United States*. New York: William Morrow & Company, 1975.

———. *Flags through the Ages and across the World*. New York: McGraw-Hill, 1975.

Spain, Charles A., Jr. "The Flags and Seals of Texas." *South Texas Law Review* 33, no. 1 (February, 1992): 216–59.

———. "Who Designed the Lone Star Flag?" *Heritage Magazine* 18, no. 1 (winter, 2000): 16–21.

Spurlin, Charles D. *Texas Volunteers in the Mexican War*. Austin, Tex.: Eakin Press, 1998.

Stampa, Manuel Carrera. *El Escudo Nacional*. México, D.F.: n.p., 1960.

Stewart, J. C. *Cowboys in Uniform: Uniforms, Arms, and Equipment of the Rough Riders*. Show Low, Ariz.: Rough Riders Publishing Company, 1998.

Sumerall, Alan K. *Battle Flags of Texans in the Confederacy.* Austin, Tex.: Eakin Press, 1995.

Sunderland, Glen W. *Lightning at Hoover's Gap: The Story of Wilder's Brigade.* New York: Thomas Yoseloff, 1969.

Texas: Biographical Dictionary. 2 vols. New York: Somerset Publishers, 1996.

Thomsen, Fonda Ghiardi. "A Flag's Story." *Heritage Magazine* 18, no. 1 (winter, 2000): 26–29.

Todish, Tim J., and Terry S. Todish. *Alamo Sourcebook 1836: A Comprehensive Guide to the Alamo and the Texas Revolution.* Austin, Tex.: Eakin Press, 1998.

Tolbert, Frank X. *The Day of San Jacinto.* New York: McGraw-Hill Company, 1959.

Toral, Jesús de León, Miguel A. Sánchez Lamego, Guillermo Mendoza Vallejo, Luis Grafias Magaña, and Leopoldo Martínez Caraza. *El Ejército Mexicano.* México, D.F.: Secretaria de la Defensa Nacional, 1979.

Tyler, Ron, ed. *The New Handbook of Texas.* 6 vols. Austin: Texas State Historical Association, 1996.

Wagner, Robert L. *The Texas Army: A History of the 36th Division in the Italian Campaign.* Austin, Tex.: State House Press, 1991.

Walker, Dale L. *The Boys of '98.* New York: Tom Doherty Associates, 1980.

Weinert, Willia Mae. *An Authentic History of Guadalupe County.* Seguin, Tex.: The Seguin Enterprise, 1950.

White, Lonnie. *The 90th Division in World War I: The Texas-Oklahoma Division in the Great War.* Manhattan, Kans.: Sunflower University Press, 1996.

White, Lonnie J. "Camp Bowie." *Military History of Texas and the Southwest* 17, no. 3 (1982): 55–88.

——. "The Formation of the 36th Division." *Military History of Texas and the Southwest* 17, no. 2 (1982): 25–53.

——. "Indian Soldiers of the 36th Division." *Military History of Texas and the Southwest* 15, no. 1: 7–20.

Williams, Amelia. "A Critical Study of the Siege of the Alamo." *Southwestern Historical Quarterly* 37, no. 1 (July, 1933): 1–44.

Wilson, Charles Reagan, and William Ferris, eds. *Encyclopedia of Southern Culture.* Chapel Hill: University of North Carolina Press, 1989.

Wooster, Ralph A. *Texas and Texans in the Civil War.* Austin, Tex.: Eakin Press, 1995.

Wooster, Robert. *Soldiers, Sutlers, and Settlers: Garrison Life on the Texas Frontier.* College Station: Texas A&M University Press, 1987.

Wooten, Dudley, ed. *A Comprehensive History of Texas 1685 to 1879.* 2 vols. Dallas: William G. Scarff, 1898.

Wythe, George. *A History of the 90th Division.* N.p.: The 90th Division Association, 1920.

Yates, Charles M. "The Alamo Flag." Texian Heritage Society Web Site, http://users.constant.com/~hts/, March 11, 2000.

Yoakum, H. *History of Texas from Its First Settlement in 1685 to Its Annexation to the United States in 1846.* 2 vols. New York: Redfield, 1855.

Znamierowski, Alfred. *The World Encyclopedia of Flags.* New York: Lorenz Books, 1999.

Theses, Dissertations, and Unpublished Articles and Addresses

Biggs, Greg. "Battle Flags of the Army of Tennessee." In author's possession.

Briscoe, Eugenia Reynolds. "A Narrative History of Corpus Christi, Texas — 1519–1875." Ph.D. dissertation, University of Denver, 1972.

Lindley, Thomas Ricks. "Alamo Strays." In author's possession.

Maberry, Robert, Jr. "Conservation of the Flags of Confederate Texas," address given to the Future of Confederate History Symposium, McMurry University, Abilene, Texas, September, 1998. In author's possession.

——. "Texans in the Defense of the Confederate Northwest, April 1861–April 1862: A Social and Military History." Ph.D. dissertation, Texas Christian University, 1992.

Madaus, Howard Michael. "Secession Flag of Augusta Georgia." In author's possession.

Pierce, Gerald S. "The Army of the Republic of Texas." Ph.D dissertation, University of Mississippi, 1963.

Purcell, Allan Robert. "The History of the Texas Militia, 1835–1903." Ph.D. dissertation, University of Texas at Austin, 1981.

—

Index

Note: Pages with illustrations indicated by italics.

honor, flags as point of, 70. *See also* battle flags, psychological importance of
Hood, Gen. John Bell, 76–77, 80, 86, 87, 105
Hood's Brigade Memorial, *109*, 109–10
Hood's Texas Brigade, 74–83, 104, 108, *plates 9–10, plates 12–14*
Hood's Texas Brigade Association, 105, 110, *110*
Hopkins, R. H., 86
Houston, Sam: and anti-secession stand, 55; and border wars with Mexico, 45, 47–48; and Lone Star flag origins, 19–20; as president of Texas, 37; at San Jacinto, 16, 17
Houston, Texas, provision of Civil War flag by, 90
Houston Light Guard, 122
Hutchinson, Lt. Col. F. S., 109

Independence (Texian ship), 36
Indians. *See* Native Americans
Indian Territory, Civil War battles in, 90, 91
Indios, 4
infantry, frontier duty, 120. *See also individual units*
Italian peninsula campaign of WWII, *plate 31*
Iturbide, Augustín de, 6, 7–8

Jackson, Andrew, 50
Jackson, Gen. Red, 92–93
Jackson, Gen. "Stonewall," 68, 77
Jefferson, Annie, 89
Jenkins Ferry, battle at, 101
Johnson, Andrew, 103–104
Johnson, F. W., 32
Johnson, Lt. Col. Benjamin H., 44
Johnson, Pvt. Samuel, 78
Johnston, Gen. Albert Sidney, 41, 88, 94
Johnston, Gen. Joseph E., 73, 85, 87
Jones, Anson, 52
Jones, Count, 90
Jones, Oliver, 37, 39

Kansas-Pacific Railroad, 120
Kelton, Capt. Mark, 87, 106–107
Kentucky volunteers, Texas Revolution, 26
Kettle Hill, Battle of, 125–26
Kilpatrick, Brig. Gen. H. J., 93

Kingdom of Anáhuac, 5
Knights of the Golden Circle (KGC), 54–55, 61, 90–91
Krag, Peter, 41

La Bahía Presidio at Goliad, 27, 28, 30, *31*
LaForge, Sgt. Maj. Andrew, 86, 108–109
La Grange company, 48–49
Lamar, Mirabeau B., 22, 39, 44
Lanco, Charles, 23
land availability, and lure of Texas, 25
leading edge, definition of, xxi
Leckie, William H., 120
Lee, Gen. Fitzhugh, 124
Lee, Gen. Robert E., 77, *81*
Liberty (Texian ship), 28–29, 36
Lincoln, Abraham, 54
Lindley, Thomas Richard, 12
Lipantitlán, 45, 46
Lone Star and Bars Flag, 79–81, *80*, 82, *plate 13*
Lone Star and Stripes Flag: and design of Texas national flag, 34, 37–38; naval uses of, 36–37; and secession, 57, 58; and Texas Revolution, 28–33, *29*
Lone Star Flag, mythological aspects of, xvii. *See also* Texian Flag
Lone Star flags: and Army of Northern Virginia (ANV), 70–83; diversity of, xviii; early designs for, 21–22; introduction, 19–21; in Texas Revolution, 22–26
Lone Star Rifles, 60, *75*
lone star symbol: on Army of Northern Virginia battle flags, 70–83; and electioneering, 52; and Mexican War, 54; red in, 86; as resistance to tyranny, 53; and secession, xviii, 55–58, 172 n. 11; in Texas flags of Civil War, 98
Long, James, 21–22, 169 n. 12
Long Expedition Flag, *22*
Longstreet, Gen. James, 79
Lord, Walter, 11
Lost Cause: importance of, to South, 102–103; and Lone Star Flag resurrection, 112–14; and Stars and Stripes return, 103–12
Louisiana, secession of, 56, *57*
Louisiana Purchase, 21

Lynch, Mrs. Joseph, 23
Lynchburg Flag, *24*
Lynchburg volunteers, Texas Revolution, 23

McCarthy, Harry, 55, 88
McClellan, Gen. George B., 77
McClure, Joseph, 86
McCown, Gen. John P., 94
McCown pattern battle flag, *96*
McCulloch, Gen. Ben, 61, 76, 91
McCulloch, Henry, 61, 62
McGahey, James S., 23–24
McIver, John S., 89
McIver, Mary, 89
McKinley, William, 122, 123
McLeod, Gen. Hugh, 45
McNair, Gen. Evander, 94
McPherson, Maj. Gen. James B., 177 n. 15
Madison, James, 21
Maine, state of, 111–12, *112*
Maltby, William, 100
Maltby's Company, 100
Manifest Destiny, 53
march to the sea, 86
maritime auxiliary flags, for Republic of Texas, *40*
Matamoros, Mariano, 15
Matamoros, Mexico, 44
Matamoros Battalion, Mexican Army, 15–16, 17, *plate 4*
Matthews, Charlie, 96–97, *97*
memorials, Confederate, 109–10
Mendoza Codex, 5, *7*
mestizos, 4
Meteor Flag design, 20, *21*
Meuse-Argonne offensive, 130
Mexican Americans: and revival of Mexican tricolor, 18; in WWI, 128. *See also* Hispanic Americans
Mexican-American War (1847-1848), 53–54
Mexican Army, in Texas Revolution, 12–18, 168 n. 44
Mexican Cavalry guidon, *17*
Mexico: in border wars with Texas, 41–50; and loss of U.S. southwest territories, 53; and Texan

Robinson, Andrew, 24

Robinson, Sterling C., 34

Romantic Flags of Texas, The (Cox), 33–34

"Rome Races" episode, 90

Roosevelt, Theodore, 108, 123, 125–27

Rosecrans, Gen. William S., 95

Ross, Col. Reuben, 43

Ross, Gen. Lawrence "Sul," 90

Ross's Brigade Association, 106

Ross's Texas Cavalry Brigade, 90–94

Rough Riders, 123, 124–25, *126*, 127, *plate 28*

St. Andrew's Cross, 73, *99*, 99–100. *See also* Southern Cross battle flags

St. George's Cross, 94–95, *95*

St. Mihiel, Battle of, 130

San Antonio: liberation of (1842), 48; Mexican capture of (1842), 47; as Spanish-American War muster point, 123; surrender of Union forces at, 61. *See also* Alamo

San Antonio de Béxar, Texian capture of, 9, 24, 27

Sanchez-Navarro, Lt. Col. José Juan, 12

San Jacinto, Battle of: commemoration of, 114, *114;* flags at, 31, 32, 180 n. 23, *plate 1;* Mexican losses at, 15, 16–17

San Juan Hill, Battle of, 125–26, *126*

San Luis Potosi, Mexico, 12

Santa Anna, Gen. Antonio López de: and border wars with Texas, 45, 47; and centralist takeover, 9; and Mexican Revolution, 8; no quarter policy of, 28; in Texas Revolution, 12–18

Santa Fe expedition, 44–45

Sayers, Joseph D., 108

Scates, William B., 34

Schofield, Gen. John, 86, 87

Scott, Capt. William, 23, 24

Scott, Gen. Winfield, 53

secession of Southern states, 53–55; and Confederacy flag designs, 62–64; lone star symbol for, 55–58, 172 n. 11; order of, 173 n. 18, 174 n. 65; in Texas, 58–62, *plate 8*

Second Infantry Brigade, Mexican Army, 15

Second Manassas, Battle of, 80

Second Texas Infantry, U.S. Army, 122

Seguín, Juan, 168 n. 35

Seminole Nation, 67

Seven Days Battles, 77

Seventeenth Indiana Infantry Regiment, 108

Seventeenth Texas Cavalry Regiment, 60, 85–86, 108–109, 177 n. 15, *plate 16*

Seventh Texas Infantry Regiment, 67, 85

Sharpsburg, Battle of, 77

Sheppard, John M., 112

Sheridan, Gen. Philip, 105, *111*, 111–12

Sherman, Capt. Sidney, 26, 28

Sherman, Gen. William T., 85, 86

Shiloh, Battle of, 88

silk, as flag material, 72, 74

Simpson, Capt., 91

six-point star symbol, 20

Sixth Texas Cavalry Battalion, 98, *plate 22*

Sixth Texas Cavalry Regiment, 90, 91, 93

Sixth Texas Infantry Regiment, 86–87, 107, *plate 15*

slavery, 54, 104

Smith, Gen. Preston, 94

Smithwick, Noah, 52

snake, as symbol, 3, *7*, 8, 15

social aspects of flag usage, xvii. *See also* flag presentation ceremonies; women

Somerville, Gen. Alexander, 49

South Carolina, secession of, 55, *56*

Southern Cross battle flags: and Army of Northern Virginia, 72–74, *plates 10–12;* establishment of, 68–69; in Heartland divisions, 85; and Terry's Texas Rangers, 89, *89;* and Texans in Civil War, 78; Third Texas Cavalry, *94;* Trans-Mississippi usage of, 99

South-North conflict: and Lost Cause, 102–14; and reconciliation in Spanish-American War, 124, *125;* and reluctance to admit Texas as state, 39, 50; and slavery in new territories, 54. *See also* Civil War

Spanish-American War, 103, 108, 122–27, *plates 27–28*

Spanish Fort, 96

Spanish government: lone star flags as protest against, 21–22; in Mexican Revolution, 4–5, 6

Spanish Viceroy's Flag, *4*

Sparks, A. W., 91–92

"The Stainless Banner" Confederate flag, *67, 68,* 68–69, 98

stands of colors. *See* battle flags

Stars and Bars: as battle flag, 73, 88; birth of, 63; confusion of, with Stars and Stripes, 68; Eleventh Texas Cavalry and, *95;* frontier use of, 119; and Gould's Battalion Flag, 98–99, *plate 22;* in Heartland campaigns, 91; lone star-style of, *65;* and Tenth Texas Cavalry, *plate 18;* and Twentieth Texas Infantry, *plate 19;* as unifying symbol, 67

Stars and Stripes: as Confederate flag, 63; confusion of, with Stars and Bars, 68; guidons and, 121; in Mexican War, 54; origins of, 20–21; over Texas capitol, 52; post–Civil War return to South of, 103–13, 115, 117–19, *plate 23;* removal at secession, 61–62; in Republic of Texas navy, 36; and Southern patriotism, 124–25; and Spanish-American War, 122–23; star origins for, 169 n. 8; at Texas annexation, *plate 7;* and Texian sympathies during revolution, 24; in WWI, 130

star symbols: five- vs. six-point, 20, 21; origins of Stars and Stripes, 169 n. 8; six-point, 12. *See also* Lone Star and Stripes Flag; Lone Star flags; Stars and Stripes

state flags, post–Civil War creation of, 113–14

states' rights, 54, 112

Sterne, Adolph, 10

Stiles, William, 103

Stiles family Stars and Stripes, *plate 23*

supply of Texas battle flags, 97, 98

Taylor, Creed, 23

Taylor, Gen. Zachary, 53

Taylor, Lt. Gen. Richard, 100

Taylor Battle Flag, 101, *plates 20–21*

Tejanos: and revival of Mexican tricolor, 18; in Texas Revolution, 168 n. 35; vs. Texians, 3; in WWI, 128. *See also* Hispanic Americans

Tenth Texas Cavalry Regiment, 67–68, 94, 96, *96, plate 18*

Tenth U.S. Cavalry Regiment, 119, 120–21, 126, *plate 26*

Terry, Col. Benjamin Franklin, 87–88

ISBN 1-58544-151-1